S0-AQK-530

speak art!

speak art!

the best of BOMB magazine's interviews with artists

edited by betsy sussler

with suzan sherman and ronalde shavers

G+B Arts International

Australia • Canada • China • France • Germany • India • Japan • Luxembourg •
Malaysia • The Netherlands • Russia • Singapore • Switzerland • Thailand • United Kingdom

Copyright©1997 New Art Publications, Inc., New York, NY. Published under license under the G + B Arts International imprint, part of The Gordon and Breach Publishing Group.

All rights reserved.

No part of this book may be reproduced or utilized in any form or by any means, electronic or mechanical, including photocopying and recording, or by any information storage or retrieval system, without permission in writing from the publisher. Printed in Canada.

Amsteldijk 166
1st Floor
1079 LH Amsterdam
The Netherlands

British Library Cataloguing in Publication Data
Speak art!: the best of BOMB magazine's interviews with artists
 1. Artists—Interviews 2. Artists—Attitudes
 I. Sussler, Betsy
 700.9'22
 ISBN 90-5701-341-X

contents

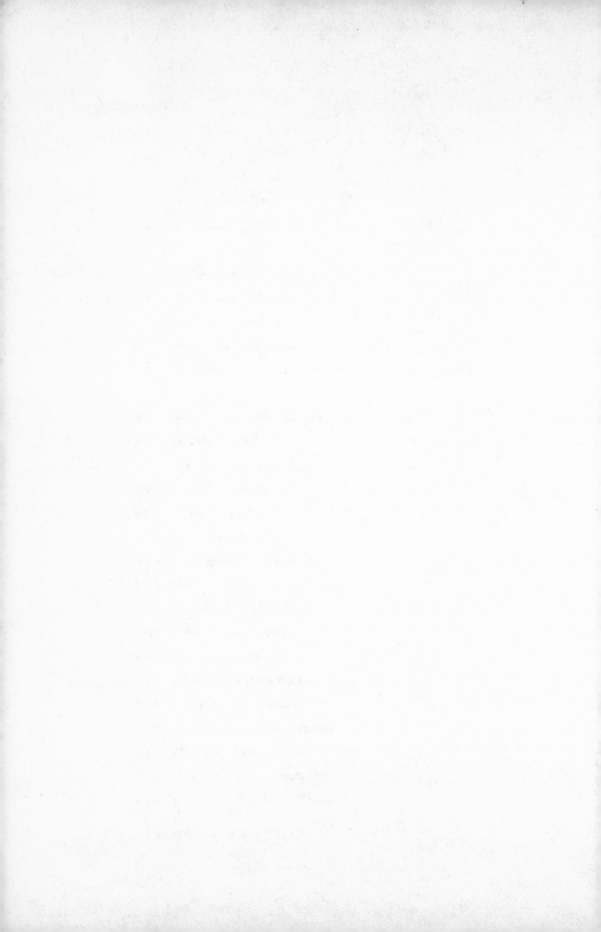

What does it mean to create something where there was nothing?

To pull a painting out of the ether; to squeeze from a tube of pigment sensations of ecstasy or loss; to mold from metal a form simultaneously lyrical and heartbreaking; to capture a vision of life on a frame of film is to be alchemist, shapeshifter, conjurer and intergalactic explorer. To make art is to act as archaeologist, psychologist, historian, scientist, hobo and comic—everyman and no man.

How does the artist go from idea to object? How does the intention differ from the finished piece—and how does the artist know when the piece is finished? What is the evolution of the work from one body of work to the next? What is learned? How does the artist measure progress? How do the successes and failures, both artistic and commercial, affect his or her courses?

To create, one must have supreme confidence and the irrepressible urge to express oneself. At the same time one must be humble, without ego, allowing the world to pass through (the artist as filter, interpreter). An artist must resist clinging to what he or she is making, not get precious about it, and be willing to abandon what doesn't work—to begin again from scratch.

To make art one must, in the same breath, think one is a genius and an idiot.

All artists constantly struggle with these contradictions, coming up against the physical and chemical boundaries of their materials, wrestling with the limits of their talents, or their psyches. One afternoon a work in progress might seem brilliant and the next morning it turns to shit.

To complete a piece of art is a heroic act.

Here are twenty-four men and women who live with these contradictions every day. Each is intensely engaged in an investigation that pushes past the familiar, digging deep into the self and society, into the personal and the political. In these pages, they bring you into their process: the rules they've established for their work; the significance of their materials; their influences—what they're reading, what they're looking at; how they reinvigorate themselves in their off time.

A.M. Homes

More than 150 artists have been interviewed in *BOMB* since its inception in 1981; all of them have our admiration and respect. The interviews chosen for this volume have become, either because of the chemistry between the participants, the revelatory nature of the exchange, or the fluidity of the language, singular events in their own right. These interviews are intimate, in some cases jocular, in others combative investigations into the mysterious process of making art.

There have only been two hard and fast editorial rules at *BOMB* since the magazine began: interviews conducted must be between peers, both participants must be professionally engaged in a creative medium. Interviews are edited by *BOMB* editors, as well as interviewer and interviewee. In this way, both participants get to say what they want, exactly the way they want, without misinterpretation.

The interview is a form unto itself. While questions can be prepared, and the artist's work researched, what takes place in conversation occurs at the moment and cannot be scripted; queries arise from responses, ideas are circled and searched for. While conversations often can seem elliptical or tangential, there is always, embedded in the transcript, a thread, a rhythm, a subtext, and an interior logic. Our job as editors, artists, and writers is to listen and, in listening, push and pull at the interview's dialogue until its substance reveals itself. This is the basis of writing. And while most interviews are spoken, ultimately they are written. It is in this way that the poetry and spontaneity of speech becomes a literarature.

Besty Sussler

acknowledgments

Many thanks to the editorial interns who served as avid and enthusiastic readers during the three years it took to complete this project, most notably: Amanda Junkin, Corinne Pierce, Leah Quin, Brandt Rumble, Matthew Simpson, and Chad Woolums. Mara Nelson took on the gargantuan task of inserting my edits and proofing. Her efforts are reflected on every page. (All of us hopefully become better at our craft with experience, and while the interviews have not been substantially changed, a few have been "spruced up.")

Editorial assistant Ronalde Shavers and associate editor Suzan Sherman were indispensable, their insight and opinions constant guides. Miyoshi Barosh, Ameena Meer, Lawrence Chua, and Jenifer Berman, our managing editors, helped make these interviews. Our contributing editors who helped instigate them: Bill Arning, Tina Barney, Ross Bleckner, April Gornik, Marvin Heiferman, Jeremy Gilbert-Rolfe, Roberto Juarez, Shirley Kaneda, Amanda Means, Olivier Mosset, David Pagel, Ellen Phelan, David Seidner and Mimi Thompson, and especially our art editor, Saul Ostrow.

Saul Ostrow encouraged Alfred van der Marck to consider the project. Their belief in *BOMB* made these books possible, and Saul and A.M. Homes have written about *BOMB* with such eloquence. Dan Mandel, our agent, maintained the patience and tenacity of a saint.

My gratitude goes to the artists and writers who helped form the magazine at its beginning: Liza Bear, Sarah Charlesworth, Craig Gholson, Mark Magill, Michael McClard, Stanley Moss and Glenn O'Brien; the 150 artists who helped form and support our editorial pages—without them we would not exist; and finally, to the artists and writers included in these pages for their generosity, honesty, and courage.

In writing the introduction to this collection of interviews published over the years in *BOMB* magazine, I have had cause to reflect not only on *BOMB*'s history, but also on the interview and its significance as a means to record cultural and artistic change. What makes this collection unique is its ability to represent in the first person the diverse views and experiences that made up the art world of the eighties and nineties. The extent of artistic practices and concerns voiced in these interviews indicates the wide range of contexts, metaphors and principles that characterizes the art of the last decade. Like snapshots, momentos, souvenirs, these interviews collectively record changing perspectives and values, forming an archive not only of styles of the eighties and nineties but of visions, issues and concerns. It is to *BOMB*'s credit that it has often given young artists their first opportunity to publicly voice their views, while giving older artists a place to reflect on their commitments and understandings, their doubts and misgivings. This involvement with artists' concerns rather than criticism supplies readers of *BOMB* magazine with raw material from which to draw their own conclusions.

BOMB magazine has changed dramatically since its founding as an organ of the then emerging generation of eighties' artists and writers. As many artists and writers who first appeared in the magazine's pages—Ross Bleckner, Kiki Smith, Carroll Dunham—have come to establish themselves in the mainstream, *BOMB* has also matured into an important showcase not only of new talent but for those who have gained renown—Brice Marden and Richard Serra—and artists who have the esteem of their peers—Larry Sultan and Catherine Murphy. What has not changed is *BOMB*'s fervent commitment to having artists speak for themselves. One reason it has been so successful in maintaining this format is that editorially it has no bias: figurative, abstract, and conceptual artists have all had access to its pages.

The principal criterion *BOMB* has maintained is that the work of those interviewed be challenging and the interview itself read well. Editorially, *BOMB* has always dealt with the interview as a literary rather than a documentary form, as a dialogue rather than as a series of questions and answers. The resulting conversations between

peers (Vito Acconci and Richard Prince, Shirley Kaneda and Philip Taaffe, Emmet Gowin and Sally Gall) or between people from different fields with comparable interests (Eric Fischl and novelist A. M. Homes, or Robert Gober and playwright Craig Gholson) became freewheeling, insightful exchanges touching on the wide range of issues and events that impact on the life and work of the interview's subject.

I have often thought it ironic that I, as an artist turned critic and curator, became the art editor at a magazine that shunned the practice of criticism and commentary. This policy of focusing on the artist does not arise from any anti-intellectual tendency but from the view that criticism, while it is a relevant pursuit, is nothing more than an attempt to supersede the voice and intentions of an author by substituting those of the critic. This attitude toward criticism naturally mirrored the suspicion and antagonism of artists and writers whose needs *BOMB* came into being to serve. In place of such surrogacy *BOMB* gives art and artists a chance to speak for themselves. In recent years critics have been allowed to do interviews, but only on one rare occasion has a critic been interviewed. Dave Hickey is included in this volume in recognition of the significance of his views on contemporary art, and the style and manner in which he puts forth those views.

What is perhaps most relevant is that *BOMB* established its format of interviews and reproduction in the eighties, at a time when theorists, critics, and audiences alike had become skeptical of the relevance an artist's intentions played in the understanding of works of art. This, after all, was a period in which the modernist paradigm of self-consciousness and self-expression was giving way to the idea that the meaning of a work of art was indeterminate and culturally constructed, in part a consequence of the tendency of artists of the fifties and sixties to use interviews and statements to either mystify the effects of their efforts or to overdetermine their meaning. Amusingly, with time and the advancement of postmodern theories of subjectivity and agency, *BOMB*'s focus on voice, biography, and the artist's thought process has come to be acknowledged as constituting indiscernible elements in the cultural process.

The interviews published in *BOMB* are conceived of as vehicles to gain insight into the relation between an artist's life and work, rather than as either a missive or exegetic device. They function as an aid in clarifying as well as extending comprehension or awareness regarding the broad modes of thought and the varied concerns artists face. Often these interviews reveal the artists' relations to tradition, as well as the cultural concepts that dominate their beliefs, which may affect the manner in which they develop their subject matter and practices. Interestingly enough, in this process both interviewer and interviewee illuminate their own experiences as well as those of their readers. Such associations, thought to be arbitrary or irrelevant in identifying a work's strength and weakness, are no longer summarily dismissed.

While the mechanics of an interview require both candor and prudence on the part of the participants, the resulting exchange obviously cannot lead to definitive readings of either the artists or their work. What these texts do supply is an understanding of those considerations and intuitions that may give a work its form and content. Such

considerations, which may not be evident in the actual work, are a determinate in the decision-making process. By supplying such insights the interview format pushes the reader to step beyond the conventional view of the relation between a work of art and its audience and affirms instead that works of art are an interface among several subjectivities: that of the artist, the viewer, and the culture of which they are a product.

Saul Ostrow

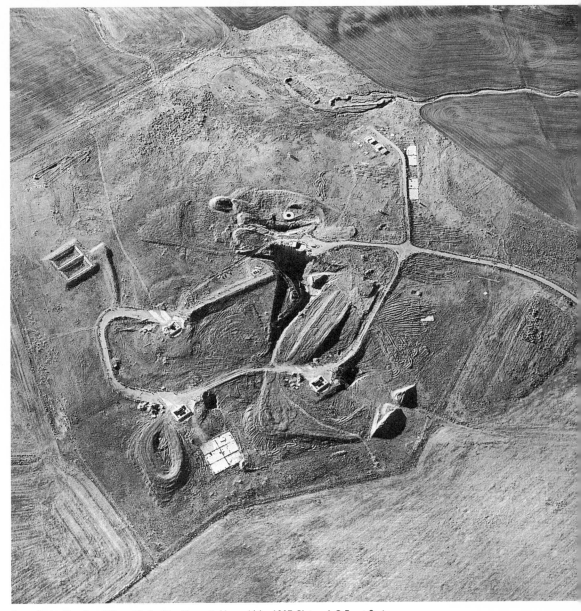

Emmet Gowin, *Abandoned Titan Missile Silo, Mountain Home, Idaho*, 1987. Photograph © Emmet Gowin.
Courtesy PaceWildensteinMacGill, New York.

EMMET GOWIN sally gall

BOMB # 58, Winter I 997

Not only is Emmet Gowin an artist whose work I am always excited by, he is also one of the few photographers who has successfully, and radically, made changes in subject matter. While being different in content—the early photographs of his immediate and extended family; his later works of aerial views of the landscape—each body of work is similar in emotion. The topographical views feel endowed with a human scale of reference, much like his family portraits. He so lovingly approaches all of his subject matter, and always from an intimate distance (despite the actual vast spaces in some cases). Perhaps because his work is an act of reverence, Gowin has also managed to make the viewer aware of a variety of environmental and political issues without seeming heavy-handed or overbearing. His landscapes show humans' use and misuse of the land. But it is their biblical quality, Gowin's willingness to confront mystery head on, that draws us into his work.

sally gall This is one of my favorite, all-time photographs. It just embodies everything: love, sex, death, masculinity, femininity, childhood, adulthood.

EMMET GOWIN The two children, the boy and the girl, are so simple and so complicated. I remember in the micromoment, I was aware that her hand was whiter than everything else. They were fighting, and they fought long enough that they went from being mad to being reconciled, and then they were tired. And they were in this little moment of catching their breath. I always loved his heel. It's a little bulb of a thing, and his little shadow. In any case it's good. It's good in all of its aspects, down to details you could never, ever orchestrate.

sg I'm curious, when did you make this transition from family pictures to landscape? Slowly, I would guess.

EG It was slow and it was fast. I recognized

it slowly and I recognized it fast, as it were. In 1964, Edith and I were married. Later, we had our own kids and I gained acceptance into her family. I love that family, and made pictures of their life. And then in 1972, Renée Booher, Edith's grandmother, died. And within that same calendar year, Raymond Booher, Renée's oldest boy, had also died, as had Willie Cooper. Raymond had been the storyteller and the curmudgeon. He was a delicate, bright-eyed, mercurial person. And Willie had been a really good friend. He was an ambulance driver in Europe in the War. Renée's family was so tender to us and allowed us to come and go. They were the key link in our acceptance everywhere within four or five houses of related people. And having those three elder people in the family die within one year . . . I always knew that it wasn't going to last. You can't be an artist and have your identity reside in only one thing. The thing that you master will become a stranger to you, and you will outlive it or you will need to live into something else. You will always need to be educating yourself to the complexity of your feelings as they grow, and you don't want to do something twice, really. Everything that makes you an artist in a sense is the way things are understood; how they fit together in ways that have not been understood before. How can you discover the inherent value that's hidden in things that you haven't yet seen? It's in that sense that you want to do something new. And you know that it's chance that's going to put those things together. Only

chance can bring together new combinations in a way that is revolutionary. No one ever discovered anything really important intentionally.

sg You can't will it into being.

EG If there were no problem there would be no discovery. But also, there has to be the confrontation with something inexplicable, something you didn't intend to do and that has so much presence you say, Okay, I don't expect you to go away, but I don't know what you're good for. Chemistry and the sciences are full of this kind of thing. And that's what's underneath the creative life for artists, how to grasp the interrelationships that exist in the world in a way that hasn't been done before. So I was sad for a month because I missed those people, but I'd already seen the seeds of what I was testing and trying to do. The kids had made this little tree house and I climbed up into it and sure enough there was this beautiful view. They made it possible for me, because I knew that there was something in me that was being spoken to by the distance between me and those houses. It was like I was backing off, taking on a bit more of a cosmic view of where we were. And I probably had already at that time blurted out to Edith, standing in the driveway or pitching a rock in the water, that if I were to leave here and go as far as I could possibly go, the furthest distance I could go would be to end up back where I had started. And that hit me, because at that time I was in the Robert Frank, Henri Cartier-Bresson mode. I had

seen their books and that was my apprenticeship. I wanted to be just like that. You see you can become successful at something that you've wanted to do for so long until actually being a success at it becomes a failure. The thing which was so desirable turns around and you realize now that you have this, you have to relinquish your claim on it. One day I made three Robert Frank pictures in the same day and I thought, You could do this every day for the rest of your life now. That's not right. They were pictures about something that I would never have seen if Robert Frank and Cartier-Bresson had not shown me how to see it. I would have seen something, but I never would have understood the connection between the experience and the photograph. Nor would I have sensed that in photographs would be the summations of thoughts that were only impulses until they became a photograph. The photograph gives a physical embodiment to our experience. We're looking for something that puts our unspeakable feelings into a discreet form, so that we ourselves can back off and study what we've done. And in a sense, recognize our own feelings as an object. In a very simple way that's what I've always been involved in.

sg So, after the family pictures, what was next, chronologically?

EG You know, one risks sounding very coy, as if you understood everything that you were doing, and I wouldn't claim that. The pictures of Renée Booher in the coffin were made in

'72, and the pictures from '73 are the still lifes and pictures of objects that become cosmologies. They're a view of life, the space in which life occurs, the local spot from a greater distance.

sg I remember that around the time of family pictures, or just after, you photographed small inanimate objects, still lifes for lack of a better word, mainly pages of old books in states of decay that seem uncannily similar to your later aerial landscapes, despite the huge difference in scale. Can you speak about these photos?

EG In 1973 we found a nineteenth-century geography book on the ground, in a ruined house, saturated with rain and eaten by insects and nearly gone. The object of the book is not only a storehouse of maps and symbolic terrains, but the book is in such a state of decay that it's becoming a landscape. It is turning into a terrain. If the map can become a territory, it's only because we privilege ourselves, we think of ourselves as being the only creatures, the only beings on the right scale. But on the level of a microorganism, the map was always a territory. And that scale became very important to me. If you circumnavigated the world and came right back to where you started—where you started was already exotic, and would have been more exotic to someone who was a stranger to that place. And I thought, Ah, now this is a real clue, because I have to become a stranger to my own place. I have to become detached from it so that I can actual-

ly observe it for what it is. And the camera was helping me to do that. Truly, you couldn't speak of discovery of the unknown unless you were unknowing. You have to make a room inside your own ego for what you don't yet understand, and hold open the possibility that this is what you're actually looking for. And that then becomes a very personal matter rather than a universal one, because you can't account for what other people don't know. But you can acknowledge inside yourself those things which you did not perceive until the encounter forced you into a recognition. You cannot keep score of that for anyone else, but you can acknowledge transformation of your own perception by experience. When you find something about yourself, you don't throw it away, it's a treasure. It's symbolically very important because it acknowledges a transformation in yourself. The Knopf book of my photographs from 1976 starts with two pictures—pictures of home. One of black people walking in front of a church in the moonlight, and another of three black men in front of a church, which is just layered with a symbolism that I was not yet ready to confront. But I could accept the pictures and let the pictures wrestle with the symbolism for me.

sg That's an interesting distinction.

EG Yeah, because then the struggle is outside yourself, it's on the paper. Let the picture take care of itself now. Let it make its own arguments and its defenses, let people say to the picture whether this is a true vision of the world or not.

sg Your philosophy is interesting and so different from most contemporary artists who claim a more intellectual methodology, whereas you're more intuitive and emotional, perhaps.

EG I'm happy for that distinction. I don't see it as an irreconcilable conflict. Those people still have an unconscious mind which is operative in them even though they claim to have a "driver's license."

sg It's interesting the degree to which people want to simply act like the unconscious is not important, or not really operating.

EG Well, they probably would be less interested in my point of view and even threatened by it if they knew that I have a religious background. I had read the Bible several times by the time I was twelve years old. It was expected of me. As a child I struggled with those texts and concepts, and I came to see that for me progress would come not by force of will. I knew too little of what I needed. I would be better guided by my feelings, and that I would just say in blunt recognition that I never made a picture that was exactly what I intended to make. And anything that was any good was always something of a surprise. If you live in a relationship to your work in such a way that each thing of value comes as a surprise, you stop disliking surprise. You stop having an intellectual argument against

that. It's not a question of whether a work is original or not, but who is the origin of it. Identifying very personally with what you make is to accept responsibility for it. Anyhow, after the Robert Frank, Cartier-Bresson period, I started to make pictures that were decisively timed with a view camera. The element of stillness really started to matter to me. So the rendering of grass, the rendering of moisture, anything—the little details of the picture made so much difference. But the big change was that I started to travel, and that was also the same year the elders started dying. The family was changing, and I started to make those symbolic landscapes, the little found object landscapes.

sg Did you have a mentor, someone who helped you through this change?

EG Yes, the photographer Fred Sommer. A great teacher is like a garden. Someone to whom you go and sit and talk, and maybe you don't do anything, yet you realign yourself to the task that was in a sense defeating you. You pick it up, get some courage and go to work on the next task. What Sommer was able to lead me to, and this is why he was such a great teacher, was the world of science. And he did it very simply, he bought me a book, and I started reading Werner Heisenberg's *Physics and Beyond*. And I realized that everything that I had expected from the poetics of the artist's life was in the poetics of the scientist's life—a theology within a conceptual framework. It put me in

touch with a foundation that couldn't be easily rocked. I'm interested in the eternal, and somebody who's working in the art world sees themselves focused in the moment, the temporal, the cutting edge, the forces where change needs to be made. But in time you can also see yourself discovering the long view, in terms of what science has done, which also has an element of the cutting edge and still honors discovery. I would read the art criticism, and it made me sad. I felt nothing deeply confirming in it. It was like a little guerrilla warfare undertaking, which is okay. But in science I felt a sense of the durability, that it would be worked out over time. And about that same time I came into a "deep" appreciation of William Blake. I like that Blake equates evil with energy and exuberance, with life, and places the human task as the reconciliation of these two opposites. The energy which drives us which is good; and the evil which drives us is as much a part of us as the good. It was so clear to me that Blake's personal vision was what he had to create because the world's vision didn't suit him. He would either have to rescind his own intimate vision to the world's vision or make his own. And I thought that's a *so much better* way to do it. Why give up what is living inside you for something you don't understand or don't feel, when in fact you're already situated in a life that you feel intensely? So the world of science and the world of William Blake let me see.

Fred Sommer's photographs have a very discreet way of expressing inhu-

manity *and* of reconnecting to the organic, biological world. And if anything was growing in me all those years, it was something that I felt as a child: that I was a piece of nature, I could have been born a duck. I liked that idea. I've known lots of people that I thought were really awful; I've never known an animal that I thought was awful. I have known a few animals that I thought were evil, but that's different: it's living out of its sense, out of its nature, its neurological makeup was evolved to behave that way. Much of our nature is evolutionary biology, although we think it's will. I'm sure that the New Testament prepared me to understand that there would be this doublesidedness to things. That a story told in one sense had a double meaning, had its opposite sense. That life would always embody some conflict.

I started to travel, began to make what I call "working landscapes," and in a simple way, I was very attracted to people like Robert Smithson, the sculptors doing earthworks. When I began to travel and look at the landscape, I saw that what I liked about what was being done in galleries worked so much better when it was in the living landscape, so that it wasn't just a pattern across the gallery floor and a symbolic world, but it had all these forces of nature clawing at it, working it, and the human thing that was being made always had to alter itself and accommodate what nature was doing to it. I just love looking at the natural landscape. And I love the hand of the human being on the landscape. The earthworks people were

really collaborative artists with nature. Symbolically I was for what they were for, but in execution the work looked like baby talk. It was on such an unsubtle scale compared to a four-or five-hundred-year-old field that's been under constant cultivation, and represents something of tremendous subtlety, and is actually more integrated than our eyes are really able to understand. The point for me in photographing the land was to try to introduce and reassociate myself with that subtlety. And often it would be years after taking the picture that I would realize: that's why I did that. That was not an irrational or an arbitrary move, it's related to the way things are in action on the landscape. And that's a pretty important point, that the living landscape is a field of action, not stasis. It's constantly evolving and adapting. One of the things that was sad for me about art practice was trying to bring the understanding of the natural world into the gallery. I knew that the photo was cut out and separate from the natural process, but it had a proper relationship. It was a time slice out of the natural process. And it had a secondary value, it was a comparative evidence against the changes. A field seen a second time or a third time is not ever the same.

So, travels in Italy, travels in Ireland—I made only one good picture that year, but it was still the year of big, big change. It was the year in which I understood that I couldn't be only a family artist, that I had to take the whole world as a subject. Oddly

enough, the picture *Nancy, Danville, Virginia* done in 1969 was probably the key. I didn't see myself with the "key" picture, or a moment of epiphany, but that was a big change. For fifteen years I had been watching this family and I loved those pictures. If I thought anything was original in my work, it was accepting the here and now, and then letting it show me what was important. The little child crossing her arms and showing me those two eggs. She just came to me with two eggs and crossed her arms. And I thought, that is the wisdom of the body. To whatever extent that she knows it, it's her body informing her. It's the same kind of intuition that I wanted to work out of. If she could invent that much, the thing that I could do is be open to the invention. And that is, in essence, just how it happened.

sg It's a fantastic picture. Her gesture and the look on her face . . .
EG See, I never thought I did that.

sg Really?
EG I always felt that life did that to both of us. It used her body to teach her, and it used her to teach me. Perception comes out of your own body. We don't have a mind separate from our bodies. I am somebody who thinks that their body knows just as much as any thought they ever had. And I like for my body to listen to my mind when it has a good idea.

sg Tell me then about when you started photographing what we would

consider "destruction" elements in the landscape . . .
EG That was abrupt in a way, and prepared for in another way. I'd taken this commission in 1980 to be part of a small group of people doing a survey of the state of Washington, and I thought I was going to photograph agriculture, and probably Seattle and maybe the coastline. Then Mount Saint Helens erupted, which held great mystery for me. At the end of six weeks I was there, and I worked every day for another six weeks and made four or five hundred negatives of the landscape, of which I thought two were interesting. But in a two-and-a-half-hour flight I had eighteen pictures of Mount Saint Helens that I thought were interesting. And I thought, that's about the right ratio. It took me six weeks to make these two pictures that I had to take five hundred to get, and in the airplane, because I was moving so fast. It was just right for my style. I couldn't control where the airplane took me, how the elevation came up to me and away from me. It happened so fast that it was out of control. And the quickness with which I would experience this loss of control was the creative element. I had to just accept what was there. But again, it was a gentle transition because already people had been saying, "This photograph is taken from an airplane." And I'd say, "No, it's just from a hillside." It felt like instead of photographing the whole body of the landscape, feet and arms and so forth, the toes, I was photographing the stomach or the heart,

the organs of the landscape. I was try-
ing to show what the beating heart of
the landscape was like. Not the
extremities, not the horizon line. Now
I wish I had been more sensitive to the
horizon. I wish I could have been two
people at once: the person who was
looking for the heart, and the one who
could have seen and recorded the
extremities. But you get ferociously
focused on something, and that's the
limit of what you can see. On the
other hand, if you didn't have that
drive, you would atrophy into despair
and think you could see nothing.

sg **You went to Jordan in 1982, and
photographed Petra, a site unavail-
able to most Westerners.**

EG Well, a former student of mine at
Princeton—we had connected on this
spiritual level, and she never forgot
that. She became the Queen of
Jordan. She was starting an arts festi-
val, and she called that summer I was
working at Mount Saint Helens and
said, "Wouldn't you come out and
then you could just look around and
see if you like anything here." And I
saw Petra. And it connected for me in
a very deep way. Like something I had
seen in my father's Bible, something
that I had always known, something
about the first century. The life that
had been lived before us. Whereas
with the Bible, I had shrugged my
shoulders and said what does this have
to do with me? Among those stones I
felt the living. I felt like, Yeah, this is
what it's like. Two thousand years
from now people will look at what
we've left and see it in the same way.

And that's a powerful thing; to
empathize with a race of people whom
you can never really see. And hear
them talking, see something out of
their lives, just in the inanimate
debris. I took a few pictures and I was
unhappy with them, yet I was really
drawn. Edith and I went back a few
more times and little by little I real-
ized that I had actually made good
pictures, but they needed the emotion
of color to embody what was felt
there. Since about 1968 I had tried
to do color. I'd always wished to work
in color, and then regretted how the
color looked. It looked like plastic.
Emotionally I thought that it was the
material of painting and drawing.
What I made in Petra were the first
prints, very much handmade prints
with their own individualized color.
And as they were being made I discov-
ered a dynamic of getting cool and
warm tonalities, hard and soft in the
same image. It was a discovery that I
had made almost ten years before, but
on people it looked awful.

sg **Well, yes, I guess because of the
flesh. But this is so otherworldly,
this color in here.**

EG The color has come to be like a quality
of drawing. A quality of structure and
of emotion. To have a picture that's
pure black and white would make me
shiver, it has to be black and white as if
the black and white were a color. I'm
enthusiastic about color, and yet after
over twenty years of making color pic-
tures and sometimes I have color nega-
tives of the same picture that I have in
black and white, and I have to say, the

color picture is not as powerful, it just doesn't do so well. And after a while I couldn't carry the expense. Now I've come back to it and I've begun to make two-and-a-quarter color.

sg **I'd love to hear you talk about the most recent photographs. The combination of the abstract quality of the image and the literal quality of what the thing itself is, plus the unearthly color, the warm and the cool creates an amazing sensation of space; simultaneously flat space, deep space.**

EG I like how you're saying that, the sense of: How do we stand in relationship to this world? Is this really in this world, are we really in the world that also holds this? Because many of the photographs are of things and places that are contaminated or represent practices that are ultimately destructive, nonsustainable. We don't have to know that it's nonsustainable to nonetheless feel the impending threat. When an agricultural pivot is pumping away in the middle of summer in Kansas, when twenty of those pivots use as much water on an August day as a city of two million people . . . We don't have to know that fact to feel uneasy about the relationship. It feels like it's stretching the skin of living things too far, right to the edge. It doesn't take too much imagination to think back on the long anguish of the nuclear age. A thousand missiles buried inside the body of our mother earth, ready to be sent to the other side of the world to destroy, supposedly our enemies, who were ready to do the same thing to us. And the by-

product? Mutual destruction of everything on earth. That we came to such low culture, to such poor solutions to the problem, that our theology of difference was so great that we could see no other path. That governments would allow a theological dispute to bring them to the brink of disaster is the way the human mind works, and it is why it is to be feared. But getting in an airplane, and looking back at the landscape, you look at what we do to the earth and you realize that we have written, symbolically, on the ground in such a way that people with feeling and eyes can recognize the destructiveness of the hand that's doing the writing.

sg **It's interesting you say that, because the photographs look calligraphic, as if something has been written on the earth.**

EG They're drawings. I am totally enthralled with the idea that for every action there is a trace, and to unfold the traces was to reexperience, to be reacquainted with the action. Everything which human beings do, every activity, leaves its mark. This is as true psychologically as it is physically.

sg **What's so interesting to me in many of your pictures is that you get the trace of the land moving, the actual geological upheaval of the land in addition to the trace of what human's have done to it.**

EG I have no choice but to try to reconcile opposites, because I respond to what used to be referred to in the nineteenth century as "the sublime," the feeling that something sparks an almost chill-

ing recognition of mortality, of the irreversible arrow of time. Time is leaving us where we are, and if we don't embrace it while it's here, it cares little. The energy which is driving the world cares little whether we take time for our intimacies. Whether we take joy in the living of those moments which were ours. Geological time scours away, tears the world apart and lays it back together; moves a mountain down to the ocean floor, builds a mountain where there was none.

sg It's incredible isn't it?

EG It's wonderful, and it's no wonder that it was Darwin, on a voyage around the world to set straight in his own mind the defense of the grandeur of a creative god who had made the world by hand, found that his theory didn't fit the evidence. The beauty of his discovery is that he would not let his theory interfere with the evidence. He accepted the world as it is, even though emotionally and psychologically, it took him some getting used to. It wasn't exactly what he had intended to show. When I said that it was the reading of science that brought me into this arena, it's just so. In that material I found a way of understanding myself in nature. Nature is another name for the reality of the world of which we are a part. It's not a stage on which we can perform any play we like. This is a world that carries its scars for millennia. The picture of Hanford, the city-site where thirty, thirty-five thousand people lived, it's a desert now, but it was an orchard and garden area. They were using water from the Columbia

to irrigate. Along the Columbia is where they had placed the first nuclear reactors. Later the entire city was dismantled. At first I thought it was because it was contaminated. Later, informants told me that part of it was contaminated, but if it wasn't too contaminated, if it passed these standard measurements, you could build a new house with that material. And in a way, that is in part the picture of the dilemma. Everything we eat is somewhat contaminated, everything we touch is somewhat contaminated, how much more of this can we have? A pilot in Washington state told me that he and a contractor had gone out into a field and bought fifteen miles of chain link fence. And they took a Geiger counter and measured the radioactivity in the field along the fence. It was no higher than background radiation, standard, ordinary, basic radiation. Then they took the fence down and rolled it up in great coils and loaded it on the back of a truck. And when they came to the gate a guy says, "I know this has passed, but I have to check it." And so he runs the Geiger counter over the fence, and of course you know what happens, in this new configuration, it's hot. It's highly radioactive because the form has changed. You've put a quarter of a mile of fence into one roll and now the combined radioactivity measure is potent and serious. That's an image, an understanding we very much need.

sg That's amazing.

EG For us to say what things truly are, we have to understand the form of these

things in their context. To the credit of postmodernism, one of their chief arguments has been that we have to understand things in their context. I think a rather spiteful, elitist language was used to make that point, which is too bad, for it could have been said so simply. But that's another issue. I didn't intend to use this issue to comment on postmodernism. Except, it's part of the atmosphere we live in. Thank goodness those battles are being fought by many people in many local, simple human ways. And the most important battles are being accomplished not as battles, but as acts of tenderness, of reconciliation or accommodation.

sg I love these topographical photos. These are sublime. I remember walking into the gallery and seeing these, and I got a shiver. They were so beautiful and creepy at the same time.

EG The thing that makes us ill goes the distance to make us well. It contains, as it were, some of the alleviation of the malady within itself. I'm not quite sure what I mean by all of that, except to say that the natural order has to be honored. Even in destroying the earth, we have to observe the natural order. Gravity still works, water still runs downhill. The comprehension that allowed us to grasp that is the same wisdom, the same understanding which is going to help us, so that we will not be guilty of bad behavior towards the earth, towards nature.

sg Do you say, I want to photograph

this uranium site in Nevada? How do you choose where you go?

EG Last year I received a Pew Artists Fellowship that allowed me to do things that I'd only had hopes of doing. I wanted to take photographs of the aftermath of the war in Kuwait, and I wanted to photograph the Nevada test site. I'd been turned down very nicely when I first asked them, some eight years ago. At the time, I was told there was not one chance in a million of ever being able to do that. But since then so much has changed.

sg But isn't it interesting that you're now allowed to go to this place? Maybe it is a collective thing, that people are now willing to look at what we've done.

EG I don't think we improve our health by denial. And it is an amazing thing itself, miraculous. That landscape is like none other on earth.

sg Your topographical photographs, for lack of a better word, also have an edge between being real and completely surreal. You cannot believe these exist in a real place in real time. It looks like somebody's scientific experiment in a petri dish.

EG Well, that I think is really good. We know that the earth is like our body. It has a circulatory system, it has a skin, it has its energy, has bowels deep inside and has this driving force. The *Hammer Codex* contains a beautiful passage by Leonardo da Vinci, in which he says exactly this: how the trees are like the hair on our skin. He talks about the deep, sul-

furous energies within the body, and the rivers of circulation like the bloodstream carrying the waters of life to the whole.

sg Can I ask you, are there artists and photographers working somewhat contemporarily that you care about? That move you?

EG Sally, that could be a long list. But let me say first that writing about nature and science have meant more to me, as I've aged, than art criticism. I'm turning your question slightly to say that there is a growing literature and a growing art that is taking seriously our connectedness to nature, and our responsibility to the future—writers like Wallace Stegner, Wendell Berry, and Terry Tempest Williams. In photography, Robert Adams, Thomas Joshua Cooper, John Pfahl, and Patrick Nagatani are a few of the many contemporaries for whom I feel a special kinship. Early on, I thought I might become a painter myself, so I continue to look at painting and sculpture with admiration. Painters like Lucian Freud and Anselm Kiefer come to mind. I have also felt a long and special affection for Mondrian.

sg Oh, that's not what I would have guessed.

EG And Cézanne. However, I have already mentioned the two artists who have given me the most guidance, and perhaps courage, William Blake and Frederick Sommer. Frederick Sommer who is ninety-one this year and still extremely vital, has

been a friend for almost thirty years. William Blake is with us only in his work; but I am grateful every day for the gift of the work and the thoughts of artists that I will never meet. Blake, who came to me more slowly, tells us that the task of the artist is to serve the creative imagination. Wisdom and a proper relationship to one's art, he says, emerges from the care and attention given to the "minute particulars." Blake's art is a cosmology of the heart, and the story of the mind's war with the heart, between reason and feeling. Fredrick Sommer says that "the important thing is *quality* of attention span, and to use it for acceptance rather than negation." I think he says this because he knows that even art can easily deteriorate into business, and because he understands that our worldview, spiritually and psychologically, is unavoidably linked to the quality of our own behavior. That's why he can say, "It's what we do every day, in the simplest way, that counts." These are straightforward ideas that emphasize perception, and the individual's dedication to the quality of acts. They also help us to realize that all our feet are standing on the same Earth, that our lives are endlessly interrelated. Thinking in terms of Sommer's "quality of attention span" and Blake's "minute particular" helps me to see the work of the artist in a more personal sense; using their ideas of what an artist is, you can see that the world could never have too many artists.

Brice Marden, 4 *(Bone)*, 1987-88, Oil on linen, 84" x 60". Courtesy Matthew Marks Gallery, New York.

BRICE MARDEN saul ostrow

"In the beginning there was the word and the word was made real." Creation therefore emanates from the act of *creating* the word. The making of this sign—the word—articulated the act, differentiating it from all else. In the tradition of the Kabbalah, God creates the word by using the "thirty-two Secret Paths of Wisdom." Each path corresponds to one of the letters of the Hebrew alphabet or the ten elemental numbers—the very means by which language is made real constitute a principle or a stage of the act of creation itself. This mute act of creation is necessary for creation itself to begin.

I begin this introduction to my interview with Brice Marden with this reference to the creation of language and the silence that exists before creation because it seems to metaphorically echo how Marden's paintings have developed over the years. In the early sixties he came to be known for his sensuous monochrome paintings made up of single and multiple panels. Like a tabula rasa these paintings mutely articulated a meditative silence as well as their own creation. For fifteen years he used this format to explore the expressive depth of color. Recently, though, as if all that came before were an act of clearing painting's space, Marden has begun to inscribe his paintings with gestural paths that map the transit of the artist's body across the emptied surface of the canvas.

saul ostrow I want to discuss with you my memory of your history; things that disappeared from the common reading of your history such as the postcard drawings, and those early works that are referential, iconographic; the early grid drawings. And the possibility that your early work was misread in relation to minimalism. In rethinking your work it seems much more rooted in Newman, Rothko, Still and Reinhardt, the sublime, rather than Stella and Johns.

BRICE MARDEN I didn't get Newman at all and Newman didn't show much. I saw the big French and Company show, it was the first show that he'd had in a long time.

so In ten years.

BM And then he had a Knoedler show and then he was in a show at the Jewish Museum. I didn't get it. Also Reinhardt's whole stance, that painting was anti-abstract expressionist. It really just pissed me off. I didn't like Reinhardt at all.

so I'm talking about the evocative. Newman's relationship to the sublime—the idea of painting that's here and now—the experiential, the sensuous end of it; painting in terms of the veiling, a skin that hides something. Your early paintings were a skin, a veil, like a theater curtain where the thin band at the bottom is that crack of light in the same way that Newman takes his zip with a crack of light. You also attempt to peek through to something else, which has less to do with the reductive aspects of minimalism and objecthood . . . does this make sense?

BM There are so many references. I didn't feel at all aligned with Stella's logic. I felt much more in tune with abstract expressionism—much, much more. The actual act of painting, the physicality of the thing, became the substance of abstract expressionism. Paint worked as an actual plastic element. And you know, the paint wasn't meant as a reductive thing. I would think to myself that this could be a detail of a Pollock line, it was spatial. Like my real early stuff, the first color paintings, came out of trying to paint grids, but I couldn't work out a grid. There are so many references. There's one painting that's two squares, called *Pair*. I was thinking of those two Rauschenberg paintings, *Factom I* and *II*, because *Pair* started out to be two separate paintings and then by the time I finished them they were one painting. I was also thinking of Giacometti's portraits—spatial exactness within the frame. I had done a painting that was two squares on a canvas and it was divided down the middle with charcoal lines—that was the edge. It wasn't about something coming through. The line was where things met as opposed to how you talk about the Newman zip.

so Does the cathartic content of abstract expressionism interest you?

BM The cathartic?

so Well, there are three different streams that all ended up being called abstract expressionism. There's the cathartic, the transcendental, and the surrealist, automatic writing which influenced Pollock. This last idea includes veiling, the embedding of images, the dissolution of them in space through repetition.

BM The surrealist thing didn't interest me so much. Jasper Johns did. What interested me about Johns was the reality. I could paint one of the rectangles and think of it as a wall but it was also just a rectangle. When I was in Paris, de

Gaulle was cleaning up the city, they were redoing a lot of walls. You could watch these guys plaster the walls, drips accumulating at the bottom, the physicality of it. And then I'd think, well, there's a perfectly valid painting.

There is one aspect of my thoughts in the beginning that could be considered reductive. In school the teacher would come around to us, look at our paintings and say, this part is a cliché on Kline, this part is a cliché on de Kooning, and this is a cliché on so-and-so, and it was. We students would run into the city to find out how de Kooning splashed. Those were our references. De Kooning was the reference, the model. Pollock was a man out of sight, dead, wasn't being shown. They'd had a retrospective, but I had seen it only briefly. There wasn't a lot of Pollock around. So when I tried to get rid of all the clichés, I ended up with a wall and a rectangle. That's reductive. Some people said it was nihilist. It wasn't.

SO **There's also the aspect of the process, the accumulation, the building up of the surface in your early paintings.**

BM It's a *memento mori*—you build up these veils of feelings. Because the early paintings were just one color, one could say, one color, no feelings; but instead of no feelings they were all this feeling. Each layer was a color, was a feeling, a feeling that related to the feeling, the color, the layer beneath it: a concentration of feelings in layers. The drips memorized the feelings, the layers, the colors. I always thought that was very

expressionistic. And that's what I felt with Johns's paintings. He took an absolute reality—a flag, a target—and made painting out of it. That really fascinated me. My fascination with the Spaniards, say somebody like Zurbarán, is this concentration. Where you see him take subject matter and go beyond it in a mystical sense . . . The way he would paint silk. I always imagined that he got so involved with painting the silk, that he must have looked at it and painted it so carefully, so intensely, that he went beyond it, and made it into something that was actually really felt or was being felt on different levels. So the silk robes ended up looking like cast iron. I remember Edwin Dickenson coming to Yale and saying, "I saw the great cast iron draperies of Zurbarán." I barely knew who Zurbarán was at the time. And then right after school, in Paris, I saw all the references. I mean in terms of getting out of school, working through influences, coming to New York, being here a short period and then moving to Paris, which totally removed me from the whole American thing. And then you're in Paris and go to as many galleries as you can. You don't have any idea what it's all about. You see Fautrier and Giacometti drawings everywhere you go—all the stuff we didn't have here—those references. I spent a lot of time in the Louvre. I couldn't paint in Paris, I drew. The drawings evolved out of the paintings that I was working on in that interim period in New York, they were things like Ralph Humphrey's last show at the Green Gallery. He was a big influence,

and Robert Morris, the grey sculpture show. Being in New York just out of school, being very involved with that milieu, everything was very upsetting. And then to suddenly pull away from it all, be off in some place where you're looking at walls and Giacomettis.

SO How long were you in Paris?

BM I was there for six months. And then to come back to a totally unstable situation, because I didn't know anybody here and had split up with my wife there. So you're in your studio fantasizing about Zurbarán paintings. That transference, like how you could paint something that was just one color and think it was everything.

SO Were those the paintings in your first show at Bykert?

BM I'm talking about the paintings that preceded that show. I was reducing. By the time I left school I was doing four rectangles brought together, painting a lot along the meeting edges. By the time I came to New York I did paintings with two rectangles, two greys and a lot of paint; movement and paint.

SO I remember seeing those at your Guggenheim retrospective.

BM I was on a grid painting, one half was a grid and one half was one color and then I just painted the grid out. That was really the first onecolor painting. They were viewer resistant. They had lots of varnish and lots of oil, highly reflective surfaces. It was like a hedge. There was this definite thing there, and I didn't want them to see it. The

paintings might have looked like they were trying to disappear, but I saw that they were trying to assert themselves. I wanted to make the color more interesting. One of the code readings of abstract expressionism was ambiguity. I saw you could make a color be ambiguous. A grey could turn itself into a green, et cetera.

SO The postcard drawings, even your announcements, had European cultural references.

BM All the postcard drawings were postcards of things I really liked when I was in Paris: *The Marchioness de la Solana*, that Goya piece; the *Venus de Milo*. I picked the cards up later. *The Marchioness de la Solana* was a real revelation, a coloristic and spatial revelation.

SO One of your announcements is a photo of you sitting on Cézanne's tombstone.

BM That is a base for a Maillol sculpture to Cézanne.

SO I was wondering how important those announcements were in terms of setting up the viewer's thinking, expectations.

BM They were meant as additional reference for the audience's information, like the postcard drawings. Obviously, the postcard drawings were very expository. They were little lectures on my attitudes about the plane and about images.

SO Equivalences.

BM And I saw them as almost embarrassingly literal. It was like giving a lecture. And nobody seemed to get that point. I

scraped away the paper so that the card was set into the paper on the same plane as the graphic image. The drawn image, a rectangle of black graphite in combination with the postcard, a flat reproduction of a work of art. They are not layered against each other. They exist in the same spatial plane.

so Given that, the announcement cards begin to carry a different weight. I remember them as a key to the paintings. They made the paintings referential.

BM Are you referring to a key, a code? Because I always used them that way.

so The Godard one, from *Alphaville*, is an incredibly spatially complex film still.

BM He's coming into the room and he's light against dark, and she's in the room, dark against light.

so Let's talk about your *Suicide Notes* drawings. The break between the grids in *The Suicide Notes* where the drawing went from dense and compact to the mark opening up, being stretched out across the paper . . .

BM The grids come out of the shape of the paper or the shape they define. There was always some sort of reference, very rarely arbitrary. But with the grids, I always thought drawing on the layers of graphite was the labor of the drawing. It's possessing it, making it yours. To start out with this rectangle and make it yours by marking it over and over. And it's still itself. Say in the graphite drawings, I have to go back so many times over to get that *black*. You

can think of them as a spatial layering in that process of making. And if you think about the process of making those, the *Suicide* drawings become much more understandable in terms of layers of imagined spaces.

so It's almost like looking at them through a microscope, the spaces between are magnified.

BM They're drawn very carefully, using a pen that could really get it accurate— how things ended, how things began, how things met.

so They have the same precision as the grid drawings?

BM The grids were always handmeasured and a bit off, never quite accurate. It was never mechanical, anything but that. I always thought the hand was about *making* something.

so *The Suicide Notes* began to open up to some invention, in terms of the range of mark making. The densities change. They became calligraphic. You couldn't avoid reading in terms of that calligraphy and of the collective title, *Suicide Notes*, the idea of notation—that thing that's left behind, the explanation. Now, in hindsight, from 1987 looking back, *The Suicide Notes* begin to announce the demise of the plane, the planar construction of the paintings.

BM Yes. . . . Well, how do you mean, planar construction of the paintings? The physicality can be very European, but spatially they're very American because they aren't cubist. American

painters came out of nature, whereas cubists seem much more interior related, a tighter relating of planes. Look at Still, Kline: it's American landscape. Pollock . . . I mean, mine aren't interiors, they're outside.

SO **I recall a lot of discussion about those drawings that comprised** *The Suicide Notes*. **At that time they seemed the antithesis to what you represented. You were doing the monochromatic triptych paintings.**

BM There was a lot of drawing involved in putting on that color in those paintings. I didn't just put down a color, I painted it. The drawing on of the paint from that point (1973) became much less idiosyncratic. I made it more planar. There could be more readings. I would make the stroke which would go right from the top to the bottom, this freehand stroke. But I would try to make it as straight as possible. There were always little marks and scratches. And that happened around the time of *The Suicide Notes*. I never made too much of *The Suicide Notes*, but then also right after the *Notes* I started doing these vertical/horizontal drawings. To me it was trying to feel out the plane.

SO **Was it trying to begin to understand your own alphabet? Your own vocabulary?**

BM Yes. And then I thought I could break down the plane more in the paintings.

SO **Like the** *Annunciation Paintings*?

BM I had these ideas about things moving through, moving across a plane—out, out, out. They were painted in such a way that the stroke on the right was echoed in the stroke on the left. They were working across and reverberating back and forth, but it was the kind of thing you couldn't see. It was there if you wanted to try and see it, but it wasn't there enough. So I thought, Well, I'll grow into it. I mean in a lot of ways I had to figure out how I wanted to deal with this stuff. In the end I think it was very evident—in those last panel paintings. The strokes set up a vertical grid work that was actual drawn tension. That vertical grid work continued all the way through and reverberated in the paintings from panel to panel. In the *Annunciations* I put the paint on working from right to left, but the light moved from left to right.

SO **And now I see seashells with natural marks on your tables and Chinese calligraphy around the studio. It seems like the shift is from formal concerns of process to another set of references.**

BM All of this drawing is a continuation of *The Suicide Notes*. There was this real dichotomy. The paintings just got more and more formal where the atmosphere has much more to do with color. And then the color ideas become either very abstract or very naturalistic.

SO **It sounds like the drawing takes on a life of its own and the painting continued its program in terms of the plane and the density of color. It's split, the drawing . . .**

BM Yes, the drawings are really good.

so You painted strokes across the surface of marble slabs, the veins in the marble function like the marks in your drawings. It's like a forced marriage, a forced synthesis.

BM The marble paintings were done in Greece on rubble that I found lying around; taking a given shape and painting on it; taking an accident and turning it into a form. There was another set of drawings in the last show at Pace that were really done in nature—outside—no formal ideas. Then there were the studies for *The Window Project*. I was making a proposal for a whole group of windows in the apse of the Munster in Basel, the windows were ready-made panels. I devised a program of images based on *The Revelations*. The drawings were related to my more formal ideas in painting except that I introduced diagonals. When I was working on the drawings for the windows, being glass they had a whole different reference to light, to drawing in space. So I'd have formal painting based on post and lintel structures, and these seemingly very informal paintings on marble; and then the drawings done outside—mostly from looking at water. In Greece you have mountains that diagonally frame the water beyond. They become vessels. So when I started using the diagonal, it had the same shape as the mountain/vessels. In a lot of the drawing I was taking a shape—an accident—and turning it into a form. So you take something out of control and bring it into control.

so Does this relationship, like Chinese calligraphy and the shells, represent that same sort of duality of nature and culture?

BM Yes, that is where the artist stands, as the intermediary.

so The shells are marked—it's a sort of mark making even if one doesn't call it calligraphy.

BM They're marked in a very specific way by nature. There are certain growth patterns, but I can't explain every mark on a seashell.

so The Chinese calligraphy, you can't explain those marks either; or can you?

BM I can't.

so So I'm saying that both the natural and the cultural here have the same sort of mystery. It almost becomes Kabbalist—the attempt to explain or reveal some sort of truth, or insight on the supposition that everything has meaning.

BM Yeah, I guess. That also comes out of making a painting. And to me a painting isn't just some facts. A painting is more like, you know, it's a lot of things, but it's frozen for study and for feeling. If there's any working method, it's just keeping it open so you can put in as much as you want to put in; having it be an open-ended situation rather than a closed situation—in opposition to formalism.

so Frank Stella: "You get what you see."

BM Yeah, the paint is what comes out of the can; what you see is what's there.

so And there is no reading because at

that point the painting is an icon, a location.

BM I think of paintings as icons—but the icon is really open to all sorts of interpretations. It doesn't just become some physical fact that you can't read beyond. There are fourteen icons that can't be traced to human hands, *acheiropoetos*, meaning not made with the hand. Icons made by something other than human hands. That to me is the kind of painting you strive for.

so The ultimate authority doesn't lie with the maker?

BM The ultimate authority does lie with the maker. I'm using the painting as a sounding board for the spirit. A painting can be a record of that. And I think of it that way. It's something you can get off on. You can be painting and go into a place where thought stops—where you can just be and it just comes out. And you can get there by starting from a formal proposition or . . . I present it as an open situation rather than a closed situation. You don't have to get it. I'm not giving you something you *get*.

so Or something that will stay the same, remain fixed in thought.

BM I'm giving you something whereby you *could* get something.

so It doesn't stay the same every time you see it.

BM It does. That's one of the great things about it. *It* stays the same but *you* change.

so I was talking with someone just last night about how with your ear-

lier paintings I always had a certain resentment. When they were present, I loved them. There was all this sensuality. But the minute I was removed from them there was a sense of loss, a diminishing. My memory of the image wasn't enough of a carrier to reproduce the experience. The paintings really demanded their presence.

BM I like that. That's what painting is about, it's about looking at paintings. It's got to be there to look at. One of the things that I most admire about Stella is his absolute willingness to get rid of any kind of bullshit, to hold bullshit in disregard. "I paint my color as it comes out of the can. What you see is what you get." All of my stuff is full of a kind of head-in-the-clouds hedging, but it's a perfectly viable stance. There are possibilities to make paintings that people don't pursue. The whole postmodernist thing is about closing down possibilities—which is just bullshit. What about magic? We look at all the religious paintings very formally, we look at them historically, but what about Zurbarán painting something and just going out of himself? To me it's possible. It was a big thing with the abstract expressionists. How you could go and paint and work but there was only a small amount of time when you really painted. And that was when you were in another state. You're coasting right along, you're not even thinking. You're the medium, and to me that exists. This could be an aim.

so I think Greenberg still has an incredible influence, albeit an

unconscious one, on a whole generation of painters who have never read him. It's as if Greenberg's some bogey man instilled in them via their teachers, producing this stifled self-conscious. There's a number of people called "postmodernist" who I would think would be Greenberg's dream in that they totally fulfill the menu: the frontality, the reinforcing of structure, the emphasis on color, right down the line.

BM Maybe. But now in an odd way, I see Greenberg as a romantic.

SO I'm probably going to agree with you.

BM What happens is he comes down to this belief that the painting is powerful, that you can reduce the most abstract element and have this really powerful thing there. He's not into mysticism, but the real belief in that abstract image and the strength of it can be read as romantic. He thinks Olitski is the best painter. Olitski's incredibly romantic looking.

SO There is within Greenberg—be it metaphysical—a belief in the potential of the human being to constantly transcend the moment. There is, in Greenberg, no end to history. He saw Noland and Olitski and so on as opening up that situation. Correct or incorrect in terms of his choices, the idea of that type of modernism interests me—sort of a self-critical practice that allows itself to say: That was that moment and this is now this one. Our audience would like to deny us that access, that ability to

say "We change." I remember the debates over Philip Guston, people bemoaning the loss of Guston as an abstract painter. It's as if one's not allowed to grow or change one's mind, especially after having succeeded.

BM Oh yes. There's so much that's extra, coming from power shifts in the art world.

SO I'm actually talking more about the idea of denying the artist the right to be affected by one's own work.

BM The audience has always denied the artist that right. I have always looked on the artist as this romantic character, who, no matter what, is striving just to be true. Making art is a moral endeavor. They try to knock it out of you by ignoring you, or they try to knock it out of you by accepting it and turning it into a commercial endeavor, but they always sidestep the issue of art. But artists are stubborn. It's personal, making this stuff.

SO For the most part it's a private thing then made public. I'll give you what my reading was of your new paintings, which was that having finally resolved the question of creating the tablet, it became a question of what does one inscribe on that tablet.

BM That's like my saying to Cy Twombly, "Well my paintings are just ready for you to work on." And he said, "No, mine are ready for *you* to work over."

SO Some of the newer paintings in your show last spring had brush strokes which seemed like a tenta-

tive attempt to add inscription. Here were these irregular grids, beautiful grounds as sensuous as the encaustic paintings with inscriptions, which were to me very much about the body, about one's reach; whereas your earlier paintings deny you any access to their making except for the band or the spatula mark. These recent works reveal their making—down to being able to locate where you were standing to make it. There's a game I play with Cézanne paintings where I keep moving back and forth in front of them until I can locate the point of distortion, back into almost irrational space. Cézanne's almost a rewrite of those Renaissance anamorphs— where you put the mirrored cone in the middle. They are paintings which are incredibly distorted.

BM Like the Holbeins.

SO Like the Holbeins. But that's what a Cézanne's like to me. And your new paintings were very much about that. I could locate myself and see your relationship to your arm reaching and the point where the body shifts, and that became the inscription. These are the tracings of your body in front of that plane.

BM I still think of them as using numerical systems that are very similar to the other paintings, in columns which can read as figures: say four columns of three, three columns of four. I mean it's one, two, three and it's right on the grid. It's coming out of calligraphy. Calligraphers wrote from left to right so they wouldn't smear the ink. When I

paint, I go and I work and I go back into it. I put something on and then I go right back and take it off. I mean, I don't take it off; I go back with a knife and redraw and take the paint off, trying to keep it as close as possible to the skin, trying to keep away from any kind of buildup. You put something on, you take it off. But, there's a thing there. There is a reference to the double helix. I make a point of not having diagrams of it around but—it seems to me that when you draw from a tree, in the time that you draw, you are getting the energy of it, and you go back and draw it some more, or the next day you draw a seashell on top of it, and then the next day you draw figures on top of that—a spiral begins to form. You're working off of the drawing you did yesterday; that energy is informing the drawing you do on top of it today; but every time you go back, you're different. It's layers of time. What happens between the layers.

SO The memory of that.

BM It's energy that I'm romantically linking with life. What I really like to make when I make a painting is to make life. I don't work from memory, I want it.

SO But it comes from . . .

BM It's not making a sign of it. I want it. I really want that experience. In the last panel paintings I thought I was trying to make life without chemicals. In alchemy, the primordial emanation, Telesma, leaves the sun and is carried by the wind to pass through the four material states of fire, air, water, and earth. I was trying to make paintings where if the colors were right—I was using color from medieval symbol-

ism—Telesma would emanate from the resulting form. A formalist would say this is romantic bullshit, but the belief that this can be done is really my subject matter. And as totally off-the-wall as my whole thinking about it was, still there's this vague belief that I could really do it, maybe really transform something. Those were the most abstract paintings I've done.

so Even the project of alchemy was to transform the maker. It was only through the transformation of the maker that they could transform lead to gold.

BM I never thought of that.

so Transmutation, in the same way you had to purify the water. The alchemist would go through purification rites, meditations, baths and so on, so that the materials wouldn't be contaminated by him.

BM I didn't know that. One of the things about working the windows—we took the *Window Project* on to force this change. The window panes are a real grid, a given grid, like my lines across it. We were suspending these images in light, glass, air, atmosphere, these colors floating. It's light and it's color—all that was euphoric. And in working out ways of depicting these for myself, the physicality of my paintings changed. Suddenly there is not thick and thin, there's a different atmosphere. The matter was no longer the carrier of light.

so It wasn't by accident that I made the reference to tablets—and the idea of inscription.

BM It's also the old idea of calligraphy. It really says something, but the best calligraphy often can't be read. Every Japanese restaurant with scrolls on the wall that I go to, I ask, "What does that say?" And they don't know. It's like the Greek temples. There weren't masses of people going to Greek temples and getting off on it. Say Athens has a population of twenty-five thousand people; five hundred could go up and really get off on the Parthenon, the whole physical experience. It's like painting.

so Is there a conscious vocabulary or is it just . . .

BM In the last ones I had really no idea of what I was doing. I was going in with the experiences of the last group of paintings, but I found the drawing I did over the summer became very confused. I think that's going to happen with these paintings. So I draw before I go back to work on them. Well, certain marks are happening over and over and I let it happen. Some drawings are just about those marks, this triangular thing; just introducing the diagonal into the rectangle opens the space to more implications.

so Do you think that painting can be euphoric? And that this euphoria can be experienced?

BM Yes. The actual aesthetic experience can be mystical. The Greek plays were supposed to do that. The Greek religious sites where the plays were performed, Delphi, et cetera, were chosen for the landscape's configuration as an image of a religious idea. In this atmosphere, when an actor performs Zeus, he becomes Zeus. There is a suspension of disbelief. Revelation becomes possible.

Catherine Murphy, *Persimmon*, 1991, Oil on canvas, 25 3/4" x 29 1/2". Private collection. Courtesy Lennon, Weinberg, Inc., New York.

CATHERINE MURPHY *francine prose*

BOMB # 53, Fall / 1995

Catherine Murphy is the sort of painter whose work makes you see the world as a huge Catherine Murphy painting, or a grand missed occasion for a Catherine Murphy painting. After you stare at one of her canvases, you may find that every pebble, every pine needle, every hank of wig hair and plastic trash bag will declare and insist on its beauty, its form, its own individual life. Her bright, warm, expansive personality gives hardly a clue to the obsessive, uncompromising maniac who devotes years to a single painting—sometimes working on each canvas for only the few hours each day when the light is absolutely perfect. Our conversation took place in her Hyde Park, New York house, in the upstairs bedroom that serves as her studio—and in front of a painting of a furry, gray tent-caterpillar cocoon, spun and wedged between the branches of a tree.

francine prose Oh my God! That is just the most frightening thing I have ever seen in my entire life!

CATHERINE MURPHY I was always terrified by it, but then I saw it as just another very efficient dwelling.

fp It's a dwelling for things that, if they could, would come out and eat the world.

CM They haven't come out to eat the world yet. A couple of trees here and there. They don't chop down rain forests.

fp They don't build McDonald's.

CM No, they just *look* bad. I often ask myself the question, Why do I make these depictions when the world has no respect for depiction, and yet I still keep having to make them?

fp Why?

CM It's about class. That's my theory. If you've been to college, especially a good one, depiction or representation is nothing short of believing in Jesus. You wouldn't admit to doing either one.

fp A similarly low-rent thing to do.

CM Absolutely. But in fact, it's in your gene pool. There were people who were born to depict and people who were born not to. It's like sexual choice. In the year 2050 they'll find a gene for the depictors and the nondepictors. And all the nondepictors were in the closet until about sixty years ago.

fp All right. My questions for you all come under the categories of

process, subject matter and vision. So . . . let's start with vision. A painter I know can look at a lawn for a minute and pick out a four-leaf clover. Your work is astonishing in that it notices gradations of light and shadow, every tiny pine needle and pebble, every dimple, every shading of flesh . . . Do you feel that you see more, or with a different focus or sense of detail than other people?

CM No, I don't think I see any more. If you gave yourself enough time, you would see the pine needles too. Everyone would. We've been so prejudiced by the camera. My paintings are not about that one moment of seeing. My paintings are about time passing. Time is depicted in a very different way than most people even think about time—which is cinematically, and through a camera's eye.

fp What's so amazing about your painting is that it documents a single moment that in fact takes you—the painter—years to document.

CM You couldn't see in one minute what the painting depicts. You'd have to stand there and say, "Oh, there's the light on the leaf, and there's the light on the car. Oh, yes, I see that shadow, but . . . hey!" All those things happen, and I let them happen in the painting. I don't copy a moment in time because that doesn't make the best painting. Conceptually, the reason I make these paintings is that I want things to slow down. "What's the rush?" as your grandmother would

say. [*laughter*] Time, that's the subject of almost all painting.

fp I was thinking of how one of your paintings might be about a pile of dirt, or a pillow, a blanket, an apple and a thigh, a wig, a curtain, a face . . . In that way they're very different from the paintings of, say, Neil Welliver or Chuck Close, who work out the same obsessions over and over. Your paintings are also about the same obsessions— but with very different subject matter.

CM The blue blanket and the Chinese pillow and the purple chair are all about rectangles. But what I compare them to, with great embarrassment, and you will understand this, is poems. Certainly in my relationship to the subject and form they're like poems. I'm not deriding what other people have done before me, but I want to be respectful of reality. Reality is not just there for my own greedy use. If I were to take the blue blanket and paint it over and over, it would be at the mercy of my formalist agenda. But that blue blanket has its own agenda, and I want to respect that agenda. Using it over and over again would lessen its impact as a subject, not just in the eye of the viewer, but in my own eye. I would be . . . using it. And I don't want to do that.

fp But these are inanimate objects, Cathy!

CM Exactly! That's what is a mystery to me. Because there's something that this object is giving me. I'm taking a

lot from the inanimate objects. I'm understanding as much as I can. And I can't go back and say I expect more from them.

fp Like going back and saying, "That wasn't quite good enough. Give me more."

CM That's also the way figurative painters have skirted around the issue of being figurative painters. They have said, "Really, I'm an abstract painter, and this is how I'm going to let you know it. I'm going to paint the *same* egg for the next thirty years, so finally after thirty years you'll understand that the egg wasn't really that important. It was the *form* that was important." And that's exactly what I don't want to do. An apple on a table is an apple on a fucking table. That's its reality. I know that's not very fashionable philosophically—to have the reading of something be the something that it is. And it is the something that it is—but it's very much more as well.

fp That's such a religious concept.

CM I was a Catholic girl.

fp It's almost like the medieval idea that everything on earth corresponds to something in heaven. You just take out the heaven part and put it into the painting. And this brings up something that's even more insane to talk about, which is that your paintings have a sort of visionary quality, the kind of visionary quality you see if you look at a fly in one corner of a Dutch Master still life—and you

see the whole universe in that fly.

CM I was being taught to be a painter within a very narrow view of what representational painting could accomplish—a very narrow place that you were able to go to.

fp And what was outside that place?

CM Religion.

fp Oooh! [*laughter*]

CM Really! We all loved Renaissance painting. And we had to make paintings that had subject and did not have subject at the same time. Narrative painting was all right. The great religious painters were good, but illustration was the bad thing. That was what we were avoiding, the big no-no, the bugaboo.

fp For so many thousands of years, that was all it was about. And then all of a sudden it became . . .

CM Right! Well, the great religious paintings had great subjects. That is, they had a subject that one could believe in, desperately, above all else. God, the Holy Ghost. So they could make paintings that were not illustrative, because they were depicting something that was sacred. . . . But life is sacred. I had an epiphany. But for years I said to myself, "No, you can't do that. That's too much, that's over the top." And finally I said, "Who the fuck cares if it's over the top?" You don't realize you're censoring yourself the whole time. As dear Miss Buckley, my color teacher at Pratt used to say, "It's only a painting, dear." [*laughter*]

fp How did you get through Pratt?

There must have been a lot of pressure on you to be an abstract painter.

CM There was, and there wasn't. I was such a big loud girl that I did very well at Pratt. We were taught the language of Picasso, and I'm very grateful for that. Cézanne allowed me to break up the canvas geometrically. I made representational paintings that were very loose, that looked influenced by the California painters. It was very gradual. I finally decided to commit to depicting what I saw. Planes in their proper place in space. I wanted to say, "Let's see what happens when I take away the veil." I also loved work like Robert Smithson's and Robert Mangold's. But I thought they had nothing to do with my paintings. Until finally I thought: Why wasn't I allowing these influences into my paintings? And this voice in my head said, "Because they are the other people. The people who don't like us." I call that representational painting paranoia. Thinking that nobody likes us, so we're not going to like anybody back. [*laughter*] And that's all bullshit. Any painter who has any brains has no prejudice against one kind of painting or another.

fp I want you to talk about how long these paintings take you. Let's start with this one: the curly ringlets of cut-off wig hair floating in water in a bathroom sink.

CM It started off as a painting without hair, a painting about the figure eight, the geometry of the sink with its reflection in the mirror; all beautiful shapes, beautiful geometry. In the middle of the night I woke up and said, "There's got to be hair." Because the painting of the sink alone was just too static. It wasn't going anywhere. It was over too fast. I was doing another painting of a wig at the same time. I had an extra wig, so I tried cutting it up and putting curls in the sink and then quickly into the painting. And what was really wonderful was that the minute I started cutting the hair, I realized I was cutting all the ringlets into small circles to reflect the big circles of the sink and its reflection. When I first started representational painting I would see something and paint it. Now, more and more I set up what I dream up. Anyway, this one winter I was working in a slot of three hours every afternoon. I was doing it with the shades drawn to control the light. We built another bathroom upstairs so I could use this bathroom exclusively for the painting. And then I knew the headache of, How long is this hair going to float in the sink?

fp Why didn't it move in the water?

CM Nobody was allowed to go into the bathroom. I had the plumber stop up the sink so none of the water could go down the drain.

fp Didn't it evaporate?

CM It evaporates very slowly. I would drip water in. But I was still scared the hair would sink. So this one winter I worked on it every day for five, seven, eight hours . . . as long as I could stand it. I worked into the

night. I finished that painting in two winters. And I was working full time. Right when I was finishing it, the hair started to sink a little bit. It was a miracle. [*laughter*]

fp You pick an image and spend years of your life painting it, thinking about it. How do you choose one image over another?

CM Really, so many of the paintings come out of geometry. That's why I'm attracted to certain things over others. Almost always, first, the attraction is in the form, the formality that is set up. And I'm very interested in the surface of the painting, the surface of the painting as subject.

fp Do you set yourself formal challenges beforehand?

CM No. I thought this painting of the shadow on the stucco wall was going to be an easy painting. Smeary, smeary, smeary—I'll be there in a minute! Then I started and realized: It's the surface I'm interested in, not the shadow. When you cast a shadow on a surface, a wall, somehow it doesn't feel like it's on top of the wall, it feels like it's coming out of the wall.

fp What about patience?

CM I have no patience.

fp I mean, the patience not to say: "Oh, hell, I kind of remember how this looked, I'll just . . ."

CM I'm the most impatient woman in the world. I can't wait fifteen seconds for something.

fp But Cathy, you can wait until next year to catch the sun at a particular moment.

CM Sure, but that's a different question. What I always say is that I'm a compulsive abstract expressionist. My pleasure is to be there when the light is right, when that dappling is moving around. Once I become one with the rhythm of that dappling, all desire is satisfied. So I can wait.

fp And are there ever moments when it eludes you, when it changes too fast?

CM Maybe it will elude you for a week, two weeks, the whole summer . . . so you go back the next summer. I'm making it sound great. Actually, the clouds would come, the wind would come . . . and I'd sit on the stairs and cry. But this kind of frustration was probably the mother of invention. It finally got me to set up still lifes in my studio so I could cope with doing the other paintings.

fp That painting of Harry lying in the driveway—that didn't come from geometry.

CM No. I'd done a lot of paintings with rocks on the ground, and I started to think about softness and hardness. How do you break up the canvas into equal parts of soft/hard? And then my husband Harry almost died, and I thought: It can only be one person, this painting has to be about Harry. And we both looked at each other and said, "Yeah, it has to be about Harry." It wasn't about the sadness until afterward—and then it became an exor-

cism of seeing him almost dead. He collapsed, and I saw him blue—and it was the most horrible moment of my life. Who knows what the genesis of paintings truly is? Maybe this idea of soft and hard came from this dangerous situation.

fp How long did Harry have to lie in the driveway?

CM For two full summers . . . on cloudy days. There was padding under his head. But it was bad. Real bad. [laughter]

fp Did you say that you wouldn't accept social engagements because on a cloudy day . . .

CM Oh, I never accept social engagements unless I have to.

fp You would be somewhere, and the sun would go behind a cloud, and you would have to rush home . . .

CM I was intent on finishing. Plus Harry hated it so much, he complained all the time. He knew it was going to be awful. But the part that nobody realizes is that Harry can actually sleep in any position. Not a full half hour would ever go by without Harry falling asleep.

fp And the twilight painting with the curtain—when did you work on that?

CM At twilight! I found that on cloudy days I could actually work out where the branches would go. I couldn't work out the color of the branches or the color of the sky, but a lot of the work is just figuring out spatially where these things are. I had a piece

of deep blue felt that I would put up, and I could work on the curtain during the night.

fp At what point do you know if a painting is going to work?

CM Oh, God, sometimes I don't know until years after it's done. I'm happy with a painting about two months before I finish it. And then I actually finish it and it turns into a wreck. And it's a miserable, miserable thing. I send it down to the gallery as quick as I can, because I know that I'm freaking and I don't want to go in there and screw the painting up. I don't want to hurt paintings any more. You don't need to hurt a painting more than once. If you haven't learned your lesson, you weren't meant to be a painter. I'll hurt chairs and plates, but I don't want to hurt the work.

fp What about that painting of the mouth with the smeared lipstick? It's very primal . . . and unsettling. Is that your mouth?

CM Yeah, it is. It started when I was looking into my compact, putting lipstick on. The compact is a rectangle, so I'm putting lipstick on and I think: Look at that, my lips are no longer attached to my face. That's why guys like it so much, you don't even have a face, it's just the lips. Lips and breasts. I thought: Isn't that interesting? So I started this little tiny painting. And while I was doing this little study, in my head the demon was saying, "Smear the lipstick. Just smear the lipstick." When the voice speaks, you

listen to the voice. So I tried it. And my heart started pounding. I was almost too breathless to think. It took me less than two hours to paint. Harry came home, and I said, "You gotta come upstairs." And he said, "It's really good, but it's got to be bigger." And I said, "Yeah, I know." So I made it bigger. That's where it came from. But it connected to my entire life, my entire past.

fp And future.

CM Finally it's a painting about a woman who is totally obsessed with being in control—and who is totally out of control. And I'm sure that's why I was so drawn to it. I feel like it's a payback for a miserable childhood. All is forgiven.

fp **Are there things that go through your head that you're afraid to think?**

CM No, not really . . . but the lip one scared me because it is macabre. I thought: Just a little. You won't do it next time. It's always a dance between "over the top" and "back off." I'm always giving and pulling back. I won't do two lip paintings. When it's this close to excess, it's a sign of insanity.

fp **Everything you're saying makes me think back to this idea of stopping the moment.**

CM It's so pathetic. It's impossible to be in control, and I know that my entire life is an illusion. However, this is what keeps me sane. Life racing away from me and death clomping towards me—and this, even within its impossibility, is the only thing I can do.

fp **There's a buzz you get when you're writing, and the work takes off and has a life of its own. Characters say things you don't expect. Is there a version of that for you?**

CM Absolutely! That's the reason painting is a living thing. And when you're lucky, it's better than everything you thought and planned for. You have to race to keep up with the painting. Painting isn't about being in control, it's about being better than you are, and that's a real gift.

fp **Let's talk about your trash bag painting.**

CM For years I tried not to do it. The snow is a metaphor for the canvas, which is what the garden hose and the melting snow is about. I wanted to create a space without a middle ground, just a foreground and a distance, because the jump from foreground to distance takes a leap of faith, and I like that leap of faith it takes to get from one place to the other. The minute I set up the trash bags in the snow, I thought it looked like the earth seen from the moon. But I really didn't want to do a trash bag painting because, well, I didn't want to do a painting with trash bags. I mean, the iridescent trash bag is an absolutely beautiful thing, but . . . I didn't want it to turn around and bite me. People buy subject, not form. And though I have no problem with trash bags in my living room, other

people might. But finally my better half wrested control, and I am doing this painting of the trash bags.

fp So partly what you're doing is making people pay attention, making people see the—excuse the word—beauty of things that they might otherwise not have noticed. They won't see it in a trash bag, but they might see it in the leap to a painting. It must be frustrating to think that there's something about the basic intention that can't be gotten across.

CM It's really hard for a fat girl. Any kind of prejudice that I can't surmount is infuriating. Something in me is the Don Quixote of the painting world. And there has to be a way. I keep thinking in my hopefulness that the drawing wasn't good enough, that perhaps this one painting will make them get past their own prejudice. I want them to see the object and then see past it and get to its higher order.

fp Meaning that someone will say: "God, I never thought that two trash bags could be so beautiful and moving."

CM That's right. I'm as much of an anarchist as any painter. I also want to defile. I'm defiling the regular perception of a beautiful snowy day with these very dark black-green trash bags. And I want them to love the defilement. I want them to love the anarchy of the moment. I want them to embrace the whole thing, the whole concept of defilement as a beautiful thing. That's a lot to expect. One of

the things that paintings do take—more than patience—is an act of faith. My paintings are very confrontational. I was talking about taking away the veil—really, I want to confront.

fp Once I read this article in the science section of *The New York Times* that said that one inborn genetic aspect of personality is the desire to do what you're told—or else the desire to go against the grain. And I thought, I was born wanting to go against the grain.

CM By the time I reached adolescence I wanted to go against the grain. I had friends, I had boyfriends, but I wasn't the cheerleader or the homecoming queen, I was outside what was normal. So of course I was trying to upset the apple cart because I wasn't in the apple cart. [*laughter*] It is probably all spite. My mother used to say, "You're a spiteful girl. You're so contrary."

fp When did you discover you could draw?

CM Third grade. Mrs. Burgess let me go to the back of the room and do things on the blackboard and cut things out and paint and paste. And when I came out for my confirmation, Cardinal Cushing asked if anyone had a vocation. I raised my hand and said, "I'm going to be an artist when I grow up," and Cardinal Cushing went, "Nooo." So that was my first public declaration. And the only paintings I'd ever seen were those little holy cards—and then when I was in junior high, my sister subscribed to that John Canaday

series on art history through the
Metropolitan Museum.

fp **I remember that series. They used**
The Marriage of Jan Arnolfini **in the ad.**

CM I love that painting so much! I did a
series based on it in college. I used to
sit on the couch and just look at them
[the Canaday series cards] and look at
them, and I didn't even know what I
was looking at.

fp **What about obsession? My expe-**
rience has been that I keep dis-
covering my obsessions little by
little. Something keeps cropping
up in my work again and again—
and suddenly I'll realize what
it's about.

CM Well, I was doing this large painting,
which took eight summers. Pardon
me, it actually took seven summers of
sunny afternoons. I took one summer
off because I thought I was going to go
mad. I so much didn't want to finish
the painting. All I wanted to be doing
was this little piece of pink way in the
distance of the painting. That's where
I wanted to be, that's all I was really
interested in. I was no longer interest-
ed in a very complicated narrative. I'd

done a whole series of paintings about
people arriving and then departing.
And then after that series of paintings,
I thought: Never. No more, done with
this. Finished. If you want to paint a
little piece of pink in the distance,
that's what you should be making
paintings about. That's when I started
closing in on my subject. It didn't
come from nothing, or from looking
at other people's paintings. It just
came from satisfying my own desires.

fp **It takes so much time, and you**
don't ever know if it's going to
turn out to be anything!

CM You have to listen to what's gnawing
away at your gut. If you can do that,
maybe you can continue until you die,
listening to this gnawing sound, and
gnawing away at it. But finally, the
painting is just an effort. When
they're not as good as you'd thought
they were going to be, then you can
move on to the next one. It's when
they're really good—then you're
stuck. If you look at it that way, then
you're really free to do whatever you
want. Which is what you have to be.
Because everything is courage. It's not
even brains. It's just courage.

Dave Hickey. Photo © O'Gara Bissel. Courtesy Dave Hickey, Las Vegas, Nevada.

DAVE HICKEY saul ostrow

Dave Hickey is a veteran of the culture wars that have taken place beyond the city limits of New York, Chicago, and Los Angeles. He grew up in the fifties in Los Angeles, where his father was a jazz musician. In the late sixties he opened "A Clean, Well-Lighted Place," a gallery in Austin, Texas, exhibiting young minimalists and conceptualists from both coasts. Subsequently, he closed the gallery to come to New York, where he first became director of the Reese Paley Gallery, then worked as an executive editor for *Art and America* only to leave art and commerce behind and become a Nashville songwriter, traveling with his girlfriend Marshall Chapman's band while writing music reviews for *Rolling Stone* magazine. After fifteen years of this nomadic life, he turned to the quiet life of academia and currently teaches art theory and criticism at the University of Las Vegas.

Like a rocket out of the great wasteland of the Southwest, Hickey became an art world cause célèbre. He found himself asked to participate in panels, speak at museums, and lecture at universities and colleges. No, the National Endowment for the Arts had not refused him funding, nor was he attacked by the religious right for his views. What caused all the fuss was that he had dared to use the "B" word [beauty] in public. Unlike the classical aesthete, he had not used it in some high-minded, elitist manner, but had introduced it as a social issue. In the four essays that make up the slim volume *The Invisible Dragon*, Hickey takes to task the received truths, the mechanical responses, and the conspiracies of silence that dominate the discussion of the social institutionalization of art and aesthetics.

BOMB #51, Spring 1995

This interview was done during a stopover in New York. He has been commuting for a semester between Los Angeles and Boston, where he lectures on architecture at Harvard. Given Hickey's enthusiasm for his subject and the wide range of cultural concerns, this interview could have just gone on and on, but after two hours we ran out of tape.

saul ostrow Your reemergence as a theoretician was based on your essays on beauty, which startled everyone because they thought it was a dead issue.

DAVE HICKEY Well, it may be a dead issue in the art world, but I don't live in the art world. For me, the possibility of some kind of visible excitement is a practical necessity. They pay me to write. They don't pay me to look. It's not my social *responsibility* to look at art, so I expect a certain quantity of experience. Since I've been living on the west coast, where everything is spread out, I've developed this criterion: if I can't look at it longer than it takes me to get there . . . [*laughter*]

so A three-hour drive.

DH The only works that really transcended this parameter were Richter's *Bader-Meinhoff* paintings. I spent a lot more time looking at those than I did driving out to the Lannan Foundation. It seems a pretty good rule of thumb. It's an argument about the virtues of visual complexity, which I discovered for myself back in the mid-eighties, when I found myself stuck in Fort Worth because my mom was sick. I was at loose ends, so I started going to museums a lot. In fact, I found myself going to the Kimbell Art Museum all the time, not out of any reactionary desire to return to the grand tradition of European painting, but just because I *could*. I could walk in there every day and look at those big Bouchers, at Caravaggio, Velazquez, Fra Angelico and they contained so *much*, so much raw information that I could keep on looking, day after day. It was "slow art," in other words, and it beat the hell out of walking into a chic gallery, seeing a bunch of sex toys in velvet bags hung from plant hangers with French titles on brass plates. How long does that take? Twenty seconds, unless you have trouble with the French. Then, out you go, having experienced art designed for the attention span of AM radio. I want an image that I can keep looking at, some kind of sustained eloquence, an image that perpetually exceeds my ability to describe it.

so The response to your proposal of the beautiful obviously struck a nerve.

DH Maybe not the nerve I was aiming at, but, obviously. I'm not the only one feeling deprived. It's not like I'm run-

ning a crusade or something. Beauty's not the end of art; it's only the beginning. It's what makes secular art possible, since it creates conditions under which we might voluntarily look carefully at something. So beauty is an issue. That's all. Unlike . . . uh . . . death or sadness, which are not issues.

so It's an issue in the psychoanalytic sense, as in the repressed.

DH Yes. Beauty is an issue insofar as the concept is repressed. That's why I find it encouraging that some kids have liked my book. That means the concept is not totally *absent*. If kids get it, it means that beauty is still a viable term in the ordinary cultural vernacular, outside the art world. Finding that you have written a "popular" piece of criticism, however, is not a particularly salutary experience. It really means that you've lost a step, that the world is catching up to you. Because criticism is not supposed to be popular, it's supposed to be annoying. If a lot of people agree with your criticism, you've stopped being a critic and become some sort of village explainer which, as Gertrude Stein noted, is all right if you are a village. If not, not. Because criticism is caused by art, it doesn't cause art, or it shouldn't. I mean . . . yikes! Think of all the bad art caused by Walter Benjamin. [*laughter*] I'd hate to be responsible for anything like that although I am being held responsible, you know, for every flower painting in Indiana, just because I said the "B" word. In fact, I am arguing for a much more secular and aggressive idea of beauty.

so Obviously we can never be responsible for that sort of permutation. It does open the door to the same subjectivity that the abstract expressionists ended up wallowing in. "I know what I like. It's beautiful to me."

DH Well, I *am* interested in what's beautiful to me. I'm not a civil servant. I feel betrayed by our cultural institutions because they aren't giving me any joy, any experiences that I may know in my body and confirm in my consciousness. A Marxist would call that subjectivity, I guess, but looking at art is a physical activity for me. So, let me make a distinction here between beauty and "the beautiful." The beautiful is a social construction. It's a set of ambient community standards as to what constitutes an appropriate visual configuration. It's what we're *supposed* to like. Beauty is what we *like*, whether we should or not, what we respond to involuntarily. So beauty is not the product of communities. It *creates* communities. Communities of desire, if you wish. I entered the art world, for instance, as part of a community which thought Warhol's flower paintings were drop dead gorgeous. I saw them in Paris. I thought they were fucking killer, which went against *everything* that I had been taught. Then, I met other people who loved those paintings too. Stevie Mueller, Ed Ruscha, Peter Schjeldahl, and Terry Allen. We constituted a community created by our subjective, bodily response to those dumb paintings. I still live in that community today, and in the commu-

nity of people who think Robert
Mitchum was pretty cool.

SO Thomas McEvilley accused you of
writing metaphysics. And a lot of
your underlying premises are simi-
lar to those of Greenberg. Though,
in your case, one could call it the
avant-garde of kitsch.

DH Well, you just introduced a whole
vocabulary of terms that are pretty
alien to me, so let me start at the top.
First, I don't write metaphysics. I do
write, however, and in doing so, I
make yes-no, right-wrong, good-bad
decisions and if I understand Derrida
correctly, the only way to not write
metaphysics is to defer such decisions
and to *not* write. "Writing meta-
physics" is a redundant expression, I
think. *Everything* written can be
deconstructed, not just the naughty
stuff. As to Clement Greenberg . . .
He writes beautifully, but he is an aes-
thetician, which I am not. Moreover, I
am *very* uncomfortable with every-
thing that he seems to stand for: with
the snobbery and elitism, with the
"Appolonian" iconoclasm, with the
transcendental materialism, the his-
torical determinism, the whole prissy
shebang. The only underlying premise
that I share with Clement Greenberg
I also share with T. S. Eliot, with
whom I have equally little in com-
mon. We all think that the experience
of art and literature is grounded in
joy—in enjoyment. Big deal. Who
doesn't? That doesn't make me an
"aesthetician." I don't even know
what "aesthetics" are any more,
besides a rather elaborate way to deny

the consequences of our desires. Nor
do I know what "kitsch" is, beyond its
snide imputation of petit bourgeois
class consciousness. Nor do I know
what "avant-garde" means, beyond the
image it conjures up of an elite cadre
marching forward, embodying the
"rationality" of our historical destiny.
This is simply an alien terminology to
me. I am a plain rhetorician, a visual
pragmatist. I chose to align beauty
with Roman eloquence as an agency
through which artists propose political
agendas by enlisting the bodily
responses of the body politic. I would
like visual culture to be more like the
Roman Forum and less like Plato's
Academy. It's that simple. In volun-
tary cultural activities, where nobody
gets killed, beauty is power. It has no
morality. Clement Greenberg writes
beautifully, even though everything he
stands for seems petty, vicious and
destructive to me. If the writing
wasn't beautiful though, that wouldn't
matter. The loveliness of the writing
endows it with political power, which
makes its political content more
urgent. It also makes that political
content more difficult to winkle out,
though considerably less arduous. Let
me put it this way: nineteenth-centu-
ry aesthetics essentialized beauty, but
the idea of beauty predates the inven-
tion of aesthetics by a millennium or
so. Obviously, the two concepts are
not bonded. Without aesthetics, how-
ever, beauty is power, *real* power. It
elicits our involuntary consent. This
is what beguiled Renaissance critics—
and it beguiles me, because I'm inter-
ested in works of art with political

power. If a work has power, then I am concerned with its politics. If the work is not "look-at-able," it just doesn't matter. It's not interesting art to me.

so Which comes close to the paraphrase of Greenberg's where look-at-able becomes equated with good.

DH But that's essentializing. Look-at-able is *not* good. It is *desirable*, and therefore efficacious. That's a *very* different thing. Greenberg wants *pure* look-at-ableness which enables us to submit to the materiality of the work and to its historical destiny. I find that a little creepy. Submission to inanimate material destiny? Aspirations to purity? That's a poisonous vocabulary in this century, an invitation to genocide. Purity is a virtue in drinkable water and narcotics. [*laughter*]

so The cleaner, the better.

DH So I've always found. Although I've always liked the analogy that Gorgias draws—the real Gorgias, not Plato's strawman. Gorgias argued that rhetoric is like a drug in that it can cure you or it can kill you. He thought this was the chance you took if you lived in a free society. I do too, although, obviously, Plato didn't. The thing about art, however, is that even though it persuades us instantly, it takes a while to tease that physical confirmation into something like moral consciousness. Take Warhol and Pollock. They both make persuasive images. The first time I looked at them, I felt that I could continue to look at them. To me, that means that they are persuasive in some degree. As

to what they were persuading me of? Well, that took a few years. I had to look and think, look and think, to feel the parameters of the space they made. *Ars longa*. Today, of course, I generally prefer what Andy was proposing to what Pollock was proposing. At first, I was only aware that these were persuasive objects that I had to come to terms with. So gorgeousness is always political in some sense. Unattractive images are simply inefficacious.

so It sounds like an argument for a kind of subjectivity which is so unfashionable.

DH Well, forgive me, but what do I care about fashion? I'm a writer, not a supermodel. What's more, I'm a writer who lives in *Las Vegas* [*laughter*], which is the opposite of everything right and good and fashionable. Vegas is a permissive, unfashionable, commercial town and I'm a permissive, unfashionable, commercial guy. I do retail. I write words, I get money, I buy Wheaties, I get calories, I write words, etcetera. That's commerce. Also I am an art critic, which is the single unfundable, ungrantable, unendowable endeavor that is even vaguely connected with the arts. And justifiably so, in my case, since I am not with the program.

so Most of us who call ourselves critics end up doing much more art writing than criticism.

DH Well, you can't really have criticism in a culture where all art is deemed worthy and interesting. Criticism flourishes in a less virtuous environment.

It assumes that some works of art are more worthy and interesting than others. So today, theory, advocacy and cheerleading are the genres of choice, because they all assume that art is really important. I'm not sure that it is, although I suspect that it has been at times. Ideally, I would prefer to write for voluntary beholders, for people who look at art but have no vested interest in its importance. People who hardly exist anymore. Peter Schjeldahl and Christopher Knight come about as close to being regular art critics, since they still write for readers who need to be convinced. And they try to convince them.

so Given that it is not a great living, why do you do it?

DH Because despair is inefficacious and unprofessional. Also, it's not a great living, but I have a great life. I get paid for doing what I like to do, which is write. I live where I want to live. I go where I want to go. Of course, American culture is getting more boring and virtuous by the instant, but that's not my fault and, fortunately, nobody lives forever. Although there are positive signs. I see the beginnings of a *real* underground forming again, and I am comfortable in secret cultures. My dad was a jazz musician and I grew up around that cool jazz world of Los Angeles, which was a real underground. This meant that if you knew where Chet Baker and Dick Twardzik were playing, you didn't tell anybody. You didn't want the *L.A. Times* to know. You didn't want to read about it in *Vanity Fair*. Right

now, I'm ready for some shade, to go back underground, back on the road or back to the beach or something. I'm not comfortable with art that isn't critical of the prerogatives of high culture. I'm not comfortable with a cultural climate in which works of art and the governmental institutions of high culture conspire to critique popular culture. Finally, I'm not comfortable with the assumption that, as an art critic, I might have a common agenda with a giant institution.

so How do you feel about having been discovered by those institutions and them loving you?

DH Well, I am uncomfortable with being discovered, but let's face it, those are the venues available. Also, I should point out that they are not loving me. Trust me on this, I've been out there. Occasionally the students respond, but, usually I'm invited to campuses to serve as a whipping boy for the tenured minions of political correctness. Though I can't for the life of me figure out just *how* I'm politically incorrect. I live on the margin and always have. I speak from the margin about other marginal types, and I am about as close to certified street trash as they are likely to encounter. The only problem I can see is that I don't really support art as a practice and a profession. But it's not my *job* to "support art," or the goals of an "American art community" to which I do not belong. I belong to the community of Andy's flower paintings, that's it. Also, art is not a *symptom* in my practice. It's a cause. Art changes

criticism, not the other way around. Art changes institutions, not the other way around. Art changes ideology, not the other way around. Tom McEvilley and I had a discussion about this: Tom was saying that art communicates to communicators, and then these communicators communicate with the culture. This may be *true*, for the moment, but I don't think it's right. It's much too clerical for me. I don't want to be the high priest of anything except video poker.

so **And we all know how powerful we are. [*laughter*] Making or breaking careers, and promoting a sort of culture that no one wants.**

DH Actually, it's the sort of culture that no one *can* want or *have* on a day-to-day basis. Most of its products are boxed up in institutions and predesigned for institutional destinations. This, I would suggest, is the consequence of our having thrown out the squalling baby of commerce with the bathwater of capitalism. I mean, I'm a pretty advanced dude, you know, but I don't want three sheets of raw plywood decorated with a clip lamp and inscribed with the word "boogie" leaning against the wall of my living room. This is scholastic postminimalism—"fast art" designed for the institutional, white-box quick take. I want "slow art" that flourishes in the problematic of its desirability. And I want it in my house, so I won't have to visit it, like some great aunty in a nursing home. And if my house is not "correct" enough for your art? If your art is too good for my money? Fuck you.

so **You used the word "image" a number of times. I started as an artist, I still am an artist . . . I tend to find the notion of the image reductivist, especially of late, in that increasingly one talks about putting it on a computer. We're ending up talking about a picture culture again. Almost a Gothic sensibility.**

DH Well, first, the uninscribed thing is simply nothing. It lacks predication. So I use the word "image" to acknowledge that once you contextualize something as art, it functions as a representation of itself, whether it's an object or a picture, in the same sense that the predicate of a sentence is always a representation of its subject. [*laughter*] Even so, I don't have any particular problem with a picture culture. Better a picture culture than a text culture.

so **That has to do with American literalness or the academic nature of culture, where we equate explanation with understanding, and collapse image into text.**

DH Right. I like the distinction that Jeremy Gilbert-Rolfe makes in one of his essays, which William Gibson makes in a different way in his book on vision. To wit: there is a difference between the visible field and the visual world. So there is a surfeit of available visible stuff that precedes and exceeds our visual decoding of images in a way that is quite distinct from our experience of decoding texts. Because of this, our experience of any work of art is always, in some sense, ahistorical in a way which our experience of text

never is. When I see a Raphael, it's right here, right now. My eye encodes it and my brain decodes it. If my brain finds what I have seen undecipherable, my eye tries to see it again, to write it again. [*laughter*]

SO Instant replay.

DH Sort of: the eye writes and the mind reads. And I can always have my eye rewrite the visible field, because there is always more there than the eye can write. This doesn't work with text, of course, because text is written, already encoded. In academic practice, though, these aspects of the sheerly visible that art shares with music [because of music's sheer audibility] tend to be suppressed in favor of those visual encodings that art shares with literature.

SO That's a great analogy, but we also have to remember that America hates jazz.

DH But there's this great quote from Kenneth Burke who says that a great deal of credit goes to any work of art that keeps a culture from being absolutely, profoundly itself. [*laughter*]

SO Your piece on Liberace has a lot to do with self. That's a fascination which also tends to send your work outside museums. Maybe it has to do with you coming out of the West, the other great American myth of rugged individualism and self-reliance.

DH Well, firstly, "self" is another word that has only historical meaning for me. It calls up Hamlet, Faust, Keats, and Freud. Secondly, what's this "coming out of the West" shit, Saul? You make me sound like Natty Bumpo, who is an Eastern figment of the West, anyway, just like all the myths about rugged individualism and self-reliance. You'll have to trust me on this, but people who live in the West cannot afford myths about it. It is a big, rough, dead, empty place whose basic virtues are the absence of trees, the absence of snow, and the impossibility of mistaking nature for culture. The best I can say for it, intellectually, is that the West is a more quintessentially postmodern environment than the East, by virtue of its decenteredness, its denatured culture and its population of decentered selves.

SO Now, we're talking about your sensibility, as opposed to the sensibility of the West, which, if it is postmodern, is very much more populist postmodern.

DH Well, to me, the West is a geographical void bereft of consciousness or sensibility. That is its virtue. As to populist postmodernity, I wouldn't characterize either the West or myself as manifesting anything like it. I am the farthest thing from a populist, although I have been called one because I like popular culture: In fact, I am no more a populist than my hero, J. L. Austin. Austin found ordinary language to be a more subtle, delicate and resourceful instrument than the scholastic, philosophical language of his day. That doesn't make him a populist, and I am interested in ordinary culture for exactly the same reasons. I find vernacular

culture to be a more subtle, delicate, adaptable and resourceful practice than that of high culture, which is burdened with a received vocabulary of scholastic terminologies. So I believe in vernacular culture; I think it works. And I am comfortable with commercial culture, because I am engaged in commerce myself, in the commerce of ideas. And in my sad experience, free commerce in ideas becomes a lot more difficult where there is no free commerce in objects. This, I fear, is not something I *believe*, it is something I have *found out* at the price of considerable personal anguish and expense. Simply put, the art and criticism that interests me seeks to reconstitute what we think of as "good." Maybe you don't have to be "bad" to make good art, but I suspect that there is no *need* for art in an environment where we all agree on what's "good" and agree on what constitutes "good" behavior.

so Your essay called "Enter the Dragon" is almost a romantic call for the reconstitution of the traditional avant-garde.

DH If so, I repudiate myself. All I hoped to imply is that art must violate our expectations, somehow, to become visible to us. So art must change, is *going to change*. But that doesn't mean that art is *going* any place, in a historical sense. I don't think it is, and I don't think it ever has been. Art making is a cumulative, serial activity, not a historical sequence of preemptive propositions.

so I meant that more in terms of an ethic than as a transgression.

DH Well, an ethic of transgression I can live with. That's why I think it should be at least as difficult to be an artist as it is to play in a rock and roll band.

so Start off in a garage. Travel around to places you never heard of.

DH Exactly. Young artists are put in a terrible position these days, especially in graduate school, because if you are an artist, you are really working for your peers. They are the people you live with 'till you die, and kids today end up pleasing parent figures well into their thirties. The effect of this has been to slow down the style wheel enormously. I remember when I was a kid I used to hitchhike to New York all the time, every chance I got. I got interested in art from hanging out in galleries, because the Janis brothers would let me use the bathroom when I was in Midtown, where you can never find a place to pee. So I was hanging around in galleries a lot, being scruffy, when pop swept abstract expressionism away. It happened almost *overnight*. It was fucking cataclysmic and great, you know. We could use another cataclysm, not for the "good" of culture, but just for the bloody *excitement* of it. But the institutional gridlock of the contemporary art world makes this sort of revolution just about impossible. What we have today will fall down before it changes, because institutions fall down. Markets change . . .

so Greenberg made the argument that those institutions, having missed out on abstract expression-

ism, geared up never to miss out
on anything ever again.

DH They turned museums into bou-
tiques. Hell, I'd be happy if museums
wanted to be conservative institutions
where you could see something
unfashionable. I'd be delighted if
museums were free enough from fash-
ion to provide some knowledgeable
counterpoint to the discourse. But
they can't, because they're even more
market driven than the market. So we
end up with the the scorched-earth
trendiness of boutique commerce and
the vicious hierarchies of guardian
institutions. I keep fumbling around
in the past, trying to figure out where
it all when wrong. What made it pos-
sible for museums to become bou-
tiques masquerading as *kuntshalles*?
When did secular Anglo-criticism
become German "higher criticism?"
When did people start thinking you
can learn how to be an artist in col-
lege? Stuff like that.

SO We're stuck with the fact that
institutions took the critique of
the sixties and understood it in the
only way institutions can.

DH I understand what happened, I just
don't understand why people bought
into it. Obviously, American culture
took all the negative freedoms from
the fifties and sixties and turned them
into positive freedoms. So Thomas
Jefferson's "freedom from" became
John Adams' "freedom to." Freedom
from status and virtue became free-
dom to *have* status and *be* virtuous.

SO Do you think that's just genera-

tional? Or is it you and me feeling
that way.

DH Well, if 98 percent of everybody
younger than you thinks things are
peachy keen, I think we may presume
it's generational. But that doesn't
mean I can't whine about it. I mean,
this may sound elitist, but given the
social advantages that most artists
grow up with, the extensiveness of
their educations and the enormous
public and private investment in their
artistic freedom, it seems to me that
art *should* be more interesting and
exciting than rock and roll. Maybe
others find it so. At the moment, I do
not. I think you have to break some
rules that actually *snap* when broken.

SO So how do you feel about gangsta
rap in that context, or do you care
about that?

DH Well, I don't listen to it a lot, because
my car speakers aren't big enough, but
I do listen to it, because I love it when
people redeem the vernacular. I love
the *prosody*—those physical, classical
cadences. Jesus, I heard something
the other day and the weighted sylla-
bles just *marched* along. They were
positively Virgilian—like Latin hexa-
meters, you know. Bang! Bang! Bang!
Bang! And I always find myself think-
ing, when I listen to this stuff: is this
meaner and more cynical than *Exile
on Main Street*? Is this worse than
"plug in, flush out, and fight the fuck-
ing feed!"? One of the few enema
lines in rock and roll. [*laughter*] How
does this anomie compare with Lou
Reed, with *Street Hassle*, for
instance? Of course, when you're

dealing with popular music, you're always dealing the heartbreak of crazy hormones at some level, but I'm not shocked by it. The last time I was shocked was by a poorly grounded Stratocaster. I mean, gangsta rap is dangerous: it's at the edge of being deadly, but, for all the death around it, it's *not* deadly. It's so desperately American. Just the act of *speaking* it, you know. Just the idea that these kids from fucking nowhere would work their butts off to remake the language to *make* it speakable, just stand up and *speak* it—that betrays a level of innocence and aspiration that breaks your fucking *heart*. I've played in a band; I know that double bind. Jesus, you're fucking nothing from nowhere. You're standing up there in your idea of a cool costume like a six year old in a school pageant, begging for approval. So you need all this *face*, all this aggressive *front*, to protect yourself from total humiliation, to disguise your infantile vulnerability. Because that's absolutely *all* you've got. Face. Front. So you *demand* a response. And sometimes you get it. So, gangsta rap will probably have more palpable social consequences than postminimalism, because it's braver and it wants more: these people do not want to die in the street.

That's all I hear when I listen to it, and we *will* come to terms with that. We *will* respond to that demand.

so But how does one resist license? Being a product of the sixties, one has a real desire to construct something that constitutes a resistance. Increasingly, what we're finding in our environment is the promotion of the idea that art should become a part of the entertainment industry.

DH If I have a choice between art being education or entertainment, I go with entertainment. If that's the option, give me the glamour. What is this presumption that art *cannot* be entertaining? Holy shit, what else could it be? It's fun. It's kinda scary. Nobody gets killed. That's entertainment!

so You're talking about entertainment in nineteenth-century terms. Entertainment at this point is a diversion.

DH Well, I take a more flat-line view of human destiny than you do. For me, Ice Cube's gangsta rap and Gay's *Beggar's Opera* are similarly entertaining. For me, *Oliver Twist* and *Pulp Fiction* are similarly entertaining. Academic, body hating, pretentious art is a distraction.

Coco Fusco and Guillermo Gomez-Peña, *Two Undiscovered Amerindians Visit Madrid*, May 1992. Photograph © Peter Barker.

COCO FUSCO AND GUILLERMO GOMEZ-PEÑA
anna johnson

BOMB #42, Winter 1993

In March 1992, performance artist and MacArthur Fellow Guillermo Gomez-Peña and writer/artist Coco Fusco locked themselves in a cage. Presenting themselves as aboriginal inhabitants of an island off the Gulf of Mexico that was overlooked by Columbus, their spectacle provided a thorn in the side of post-colonial angst. Enacting rituals of "authentic" daily life such as writing on a laptop computer, watching TV, making voodoo dolls, and pacing the cage garbed in Converse hightops, raffia skirts, plastic beads and a wrestler's mask, the two "Amerindians" rendered a hybrid pseudoprimitivism that struck a nerve. Interested members of the audience could pay for dances, stories and Polaroid photographs. Guilt, molestation, confusion, and letters to the Humane Society were among audience responses. Nearly half the visitors that saw the cage in its successive sites:—Irvine, London, Madrid, Minneapolis, and the Smithsonian in Washington D.C.—believed that the two were real captives, true natives somehow tainted by the detritus of technology and popular culture.

GUILLERMO GOMEZ-PEÑA We performed the piece in Irvine, California, which is known for its incredible xenophobia towards Mexicans. We also performed the piece in Madrid, in Columbus Plaza, the heart of the quincentennial debate, and later on in London, at Covent Garden. People of color were exhibited at Covent Garden and many other places in Europe, from the seventeenth century to the early twentieth century. In all of the cities we have performed, there have been a range of responses from absolute tenderness and solidarity—people giving us presents, offerings, quietly being with us, sending notes of sympathy—all the way to extremely violent responses. In London, a group of neo-Nazi skinheads tried to shake the cage. In Madrid, mischievous teenagers tried to burn me with cigarettes while some handed me a beer bottle of urine. There were business men in Spain regressing to their childhood, treating us as if we were monkeys—making gorilla sounds or racist "Indian" hoots. I think we have touched on a colonial wound in this piece.

COCO FUSCO When we created this piece, our original intent was not to convince people that the fiction of our

being Amerindians was a reality. We understood it to be a satirical commentary both on the quincentenary celebrations and on the history of this practice of exhibiting human beings from Africa, Asia, and Latin America in Europe and the United States, in zoos, theaters, and museums. When we got to Spain, more than half the people thought we really were Amerindians. Then there were others who came to watch those who were taking us seriously. There were people who were not sure whether to believe that we were real. Other people were absolutely convinced that they understood Guillermo's language, which is virtually impossible because it's a nonsense language. One man in London stood there and translated Guillermo's story for another visitor. We had a lot of sexualized reactions to us. Men in Spain put coins in the donation box to get me to dance because, as they said, they wanted to see my tits. There was a woman in Irvine who asked for a rubber glove in order to touch Guillermo and started to fondle him in a sexual manner. There were several instances where people crossed the boundaries of expected sexual behavior. I think that was provoked by us being presented as objects, by their sense of having power over us . . .

GGP the boundary between ethnography and pornography. To add to what Coco has said, this endemic dual perception of the other, as either noble savage or cannibal, has existed at the core of European and American relations since the very first encounters. We try to play very much with these

dualities. When we appear in the cage, I am the cannibal, I am the warrior, this threatening masculine other who causes fear in the viewer. Coco performs the noble savage—you know, the quiet, subdued innocent. The response people have towards her is either one of compassion or one of sexual aggression.

CF We had the most hysterical reactions we had to the piece when we appeared at the Smithsonian. One alarmed person called the Humane Society. The Humane Society told that person that human beings were out of their jurisdiction. The responses we had from Native Americans and Latins were more interesting. They tend to find fault with the hybridity of the contents of the cage, while Anglos take this as a sign of our lack of authenticity. In Washington, for example, there was a Native American elder from the Pueblo tribe of Arizona, who was interviewed by a Smithsonian representative. He said that our performance was the most real thing about Native Americans displayed in the whole museum. He said the installation and performance ought to be permanent to give people a very clear idea of the Native American experience. Then there was a man from El Salvador who pointed to the rubber heart hanging in the cage and told everybody, "That heart is my heart."

anna johnson In your performance, you presented artifacts from a fictional land, including a laptop computer, a video, a bottle of

Coca-Cola . . . poking fun at the idea that you were authentic savages from a foreign place. Could you talk about your idea of authenticity and ethnic identity?

CF We were trying to blast this myth that the non-Western other exists in a time and place that is completely untouched by Western civilization, or that in order to be authentic one would have to be devoid of characteristics associated with the West. It's reasonable to say that non-Western cultures have a better understanding of Western civilization than Western civilization has of other cultures. In any case, we introduced into the cage some elements that shocked and bothered many people and became the focus of a lot of questions put to the zoo guards. People said, "How could we be authentic if he smokes Dunhills? How could she really know how to use a computer if she is from this undiscovered island? Why is she wearing Converse hightops?" Everything they viewed as part of their world they didn't want us to have. That would mean that we were inauthentic. However, if you see Conchero dancers in Mexico City, they do wear Converse hightops and Adidas and Nikes. They probably listen to hard rock when they are not dancing to traditional music. We wanted to make fun of this very Eurocentric notion that other people operate in a pristine world untouched by Western civilization.

GGP To me, authenticity is an obsession of Western anthropologists. When I am in Mexico, Mexicans are never concerned about this question of authen-

ticity. However, when I am in the United States, North Americans are constantly making this artificial division between what is an "authentic" Chicano, an "authentic" Mexican, an "authentic" Native American, in order to fulfill their own desires. Generally speaking, this authentic other has to be preindustrial, has to be more tuned in with their past, has to be less tainted by postmodernity, has to be more innocent, and must not live with contemporary technology. And most importantly, must have a way of making art that fulfills their stereotypes; in the case of Mexico, magical realism.

CF This fetish about authenticity is connected to an idea that the non-Western being doesn't have a sense of reflexivity about him - or herself. I think, for example, of the videos being made now by Kayapo Indians in the Amazon. I was at a conference this year where American academics questioned the Kayapos' interest in filming themselves filming and editing. They want to talk about the process while they're making it, and that blows American academics away.

GGP The bottom line is they don't want us to be part of the same present or the same time. They want us to operate outside of history.

CF The Kayapos aren't allowed to be self-conscious. If you can be ironic, if you can be reflexive, it's because you can think. Ethnography and anthropology have consistently negated that dimension of non-Western cultures. It would threaten the veracity of the Western observer's "information."

GGPA lot of the work that our contemporaries are doing, like James Luna and Jimmie Durham, attempts, through performance, to take identity out of this historicists' ice cube and bring it back into the present, to tell North Americans, "Hey, we're members of the same society and the same historical moment."

aj Guillermo, in a recent article you referred to the Western view of Latin American culture as a fantasy of descending into the underworld, and the Latin American perception of the West as an ascent. Could you expand on this?

GGPEuropeans and Euro-Americans utilize a Dantean model when they deal with other cultures. For them to abandon the United States or Europe (conceptually or physically) implies a descent to hell. It is very much part of the Western psyche: you descend in search of enlightenment, sexual pleasure, magic, exorcism . . . and come back.

aj In your performance, *Border Brujo*, you use kitsch imagery, Mexican visual mythology, plus references to the 1940s Hollywood conception of Mexico as a libidinous and carnival atmosphere where servicemen could pleasure themselves. The young Jane Powell could go down to Mexico, warble a few musical numbers and, perhaps, lose her virginity. What conception do Mexicans have of the way in which Americans present them? As you were growing up, how did you respond to those Hollywood images?

GGPObserving Mexican culture, you can find two very schematic responses. A more politicized response is that of anger, realizing that an extremely complex culture that is two or three thousand years old has been reduced to an inventory of very simplistic stereotypes. We are viewed as lazy, oversexual, romantic, irrational. Then the other response is that of simulation, which is the saddest one for me because of the way the United States has broadcast these stereotypes through movies, television, and art. The publicity has been so powerful that we, in fact, have internalized many of these stereotypes and regurgitated them. You have the situation of many cities in Mexico creating simulated environments after the meta-Mexican environments created by Californians. Tijuana is a perfect example; like many of the border towns, Tijuana has recreated, as reality, this fantasy about the "amigo country" that Hollywood invented forty years earlier. It's like a game of mirrors in which images and symbols reflect and ricochet off each other and, at some point, reality gets lost for good.

CF The situation is even more grave among Latinos in the U.S., many of whom lose direct contact with their culture of origin after one or two generations. Their primary experience of cultural identity becomes the reductive stereotype broadcast via mainstream United States culture, which, in many cases, they assimilate as "real."

GGPHope for Latin America really lies in

the incredible capability that Latin Americans have to subvert these stereotypes and bring them back in a politicized manner. Unlike the Left, which traditionally holds the notion that everything the United States sends to Latin America is damaging to Latin American identity, we strongly believe that Latin American popular culture has creative capability. It can take this information—plastic, and neon, and cheap industrial materials—and turn it into art. It's called *Rascuachismo* in Mexico, a form of voluntary kitsch and political practice: an altar from hubcaps, a temple from plastic, a decoration for the house from cereal boxes . . .

CF This does not square very well with this very Anglo and European notion of authenticity. A very banal example of this is the reaction of many Americans who went to Nicaragua during the Sandinista revolution. They would get to Managua and be upset to find Sandinistas playing baseball and going to *la ciudad plastica*, "the plastic city," or mall, to eat at McDonald's. The gringos wanted to go to the mountains to find the peasant.

aj **How does this bear upon the mid-to-late eighties obsession with everything border and everything Latin, the revival of the kitsch invention you're talking about?**

CF The United States has been enamored with Latin culture on and off since the transfer of Mexican territory in the 1840s. It's a cyclical thing; every once in a while there is a return to this fetishistic fascination. Usually,

what is appealing is what Americans perceive as the spirituality, the carnality, the sentimentality of Latin culture. We are there to fill a void for Americans every time they recognize or they sense that they have no meaning in their lives.

GGP It is very symptomatic that the "Latino boom" and the multicultural craze and the border hoopla that hit the United States art world around 1987 coincided with a realization that the United States was headed towards an economic disaster, the crumbling of the American dream. It is precisely at this moment of disenchantment that Americans look towards the other to seek those answers they can no longer find inside themselves. The United States art world is fascinated with the form and the carnality, but really not with the political content. They want enlightenment without irritation.

aj **That's why Frida Kahlo is such an appealing icon. She was a martyr and she suffered. Even though she was strong, she was literally pierced through the middle.**

CF What is interesting is that the Frida Kahlo venerated by American feminists is a very different Frida Kahlo from the one people learn about in Mexico, in the Chicano community. In her country, she is recognized as an important artist and a key figure in revolutionary politics of early twentieth-century Mexico. Her communist affiliations are made very clear. Her relationship with Trotsky is underscored. All her political activities with

Diego Rivera are constantly emphasized. The connection between her art and her politics is always made. When Chicano artists became interested in Frida Kahlo in the seventies and started organizing homages, they made the connection between her artistic project and theirs because they too were searching for an aesthetic compliment to a political view that was radical and emancipatory. But when the Euro-American feminists latched onto Frida Kahlo in the early eighties and when the American mainstream caught onto her, she was transformed into a figure of suffering. I am very critical of that form of appropriation.

aj **You have both been received on a very literal level. The reviews in** *The New York Times*, **the audiences around the cages . . . Why do you think that people always address the superficial aspects of your performance? Are they discomforted by the more subtle anxieties and antagonisms?**

GGPOne of the most popular traditions of North American literature is that of the testimonial-style narrative, the confessional mode that comes from a Protestant tradition. In Mexico, a transcendentalist Catholic culture, allegorical symbolic thinking is more popular. We don't have a tradition of psychological realism in literature or in theater. Social realism was really known in Mexico after the Cuban revolution, and more as a fashion than an organic tradition that came from within. As a result, you have two drastically different world views that create incredible

misunderstandings between artists living a border experience like me. I have learned to create a metacommentary that makes these misunderstandings evident. I have referred to the border as a place where symbols crack open. I try to make this evident on a stage right in front of an audience.

aj **How has your cage performance altered over time?**

GGPIt is becoming more focused and cleaner. The first time it was performed, it was excessive in all ways. We are much more conscious of the piece as a visual performance. Now that we have tried so many possibilities, we know exactly how to trigger reactions. We have added to our list of activities: mine is walking around with a kitchen knife, and as members of the audience ask to be photographed with us, I sometimes take out my knife and pose with it. The police have gotten very upset. Dark skin, a mustache, and a knife are a deadly combination.

CF Something else is happening. There is this feature film about Ishi the Yahi, the Native American who was made to live in a museum in California for five years. He was the last of a tribe that was wiped out by white settlers. Meanwhile, there has been all of this press about Ota Benga, a Pygmy who was brought to the U.S. in 1904 and exhibited at State Fairs and in the primate cage of the Bronx Zoo. He wound up shooting himself. Tri-Star is now making a movie about the life of Ota Benga. In addition, many women have done work on the

Hottentot Venus lately. For some reason, this history of human exhibition is receiving a great deal of critical reevaluation.

GGP People believe these practices are extinct. We say it still exists in more benign forms. While we were in Minneapolis a month ago, we were invited to the Minnesota State Fair. There was a freak show, and one of the people exhibited was called Tiny Tisha, Island Princess. We entered, completely shocked to find a Haitian midget on display in the same way freaks were displayed in the late 1800s. In fact, her donation box was strangely similar to our donation box.

CF You could take a picture of her for two dollars.

aj **In Queensland, Australia, they actually had plastic versions of Aborigines in glass cases. That was about fourteen years ago. Today, the museum has changed in many respects, but it was a very colonial museum.**

CF Those museums owe the existence of their collections to colonialism. The relationships are now somewhat more egalitarian because museums are realizing that they are not always entitled to objects they have laid claim to. We saw this happening in Minneapolis where there is a dispute over the exhibit of Native American sacred pipes. The curators of the museum felt they had every right to them. And Native Americans protested. It lead to a long series of discussions that the Native Americans wound up winning.

GGP This is one of the most important

aspects of the battle right now in this country. Who is in control of the means to represent otherness? Our national institutions are part of this struggle, and there are two sides. Although it's taking place in the field of the emblematic and the allegorical, nonetheless, it is reflective of the larger political struggle in this country. If we can contribute to giving light to this conflict, we would be very satisfied.

CF Why do people feel the way they do when they see us in a cage? The image and the chronology that we present is something people don't want to see, it implicates the audience. That understanding is very difficult and painful. Many would rather operate with the belief that racism no longer exists because legal segregation is part of the past.

aj **Your image of the woman in the cage is a very sexually loaded image.**

CF Eliciting the same type of comments women hear on the street. I think men do that because they think they can get away with it—I'm in a cage; how can I understand? Or even if I can understand, I'm in character, so I can't react. A lot of guys get a kick out of that. Also, I had very little clothing. To repressed Westerners, my costume represented pure sexuality.

aj **Like dressing up Naomi Campbell as a Northern African tribeswoman, or Gaugin's Tahitian odalisque.**

CF In Minneapolis, people tended to be less verbally aggressive, choosing instead to

take pictures, more than the Spanish or British had. I decided that their way of sublimating was voyeurism.

aj People feel that with a camera, they have the right to make a theft. Do you feel stripped-down, exhausted, after you've been in the cage for a few weeks?

CF It's physically tiring, but nonetheless fascinating.

GGP I think every human being who undergoes the experience of living in a cage for three days would have a different experience according to their degree of familiarity with being exposed to the public eye. Coco and I had very different experiences. Coco,

as a woman, has had to face this sinister experience of always being objectified. Because of that, she has already developed mechanisms of protection against that gaze, which makes her seem very tough. She can turn off an inner channel and disconnect from that experience, just as she would riding the subway.

aj And you, as a male, experiencing the perpetual gaze?

GGP I had a more emotionally involved experience. I don't know how to turn off. As a result, I came out of the cage three days later completely spiritually devastated. And Coco was complete and whole and ready to do the next piece.

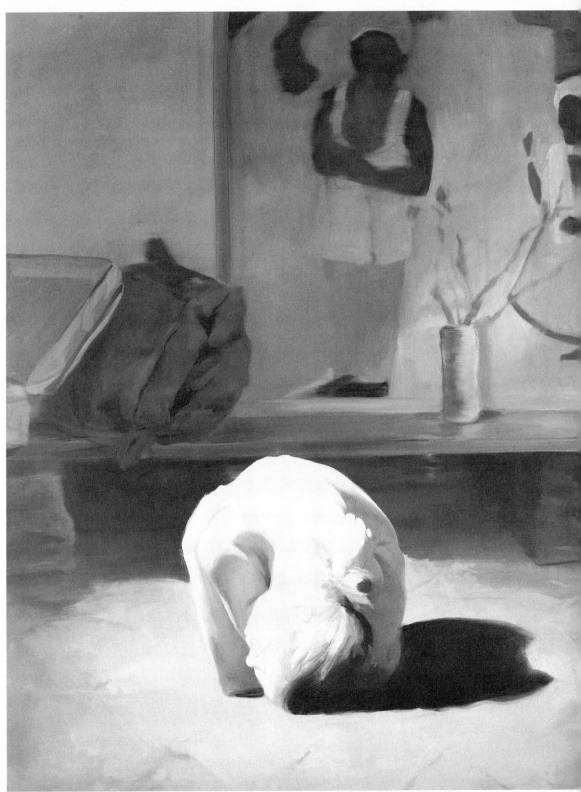

Eric Fischl, *Scene V,* 1994, Oil on linen, 70" x 54" Photo © Dorothy Zeidman. Courtesy Mary Boone Gallery, New York.

ERIC FISCHL a.m. homes

It was the timing, the deft nearly comic timing
that first drew me to the work of Eric Fischl. It
was the thing about to happen, the act implied but
not illustrated, the menacing relations between
family members that made Eric Fischl's paintings
disturbing. It was the way in which he forced the
viewer to fill in the blanks, to answer the question:
What exactly is going on here? In his early work
invariably the answer was sex; first sex, illicit sex,
weird sex, seeing or touching something you
shouldn't, rubbing up against the taboos of famil-
ial flesh, interracial relations, etc.; the kind of
thing you've considered, but aren't necessarily
willing to admit. Yet, in order to read the paint-
ings, one had to participate, to admit at least to
oneself that yes, we have noticed. It was that,
exactly that, the way Fischl subtly and subversively
required the viewers to call upon their own expe-
riences, fantasies, nightmares, that impressed me
most. Now, having moved away from the psycho-
sexual drama of the suburban experience to focus
on the figure, Fischl remains a compulsively hon-
est painter, depicting the very parts of ourselves we
work so hard to keep hidden. In his nudes the
body becomes a landscape, the expression of the
life lived, physically and emotionally. He turns
paint into folds of flesh, curving, contorted, ever-
evolving shapes that contain the person we've
become. His unblinking, melancholy celebration
of the body and all its apparent faults are incred-
ibly significant given the current climate of era-
sure—surgical cancellation and correction of the
very marks that other cultures celebrate: age,
weight, and the like. In an America that has
developed an addiction for blotting out physical

BOMB # 50, Winter 1994

characteristics—our most basic identity—by embracing what is plastic and preserved, Eric Fischl has produced perhaps the most terrifying body of work to date: a series of nudes where we see that even the nude, the stripped figure, wears a kind of psychological clothing that goes beyond the skin. What's hidden is in the thoughts; and this time the figure, the gesture comes closest to the disconnection of madness.

a.m. homes In writing, in order to pull a story out you go so far into your mind that when you come out you feel you've traveled through time and that either you've been somewhere incredibly different or that the world has changed. And that's a good day's work, but it's not necessarily a pleasant experience. In painting, where do you go?

ERIC FISCHL You go into the painting. I mean it's the same thing, I would imagine.

ah Does it hurt?

EF Well, every day there's the technical side of the discipline and there are good days and then bad days where the painting is giving me resistance and I don't know how to paint anymore. But there's also the emotional side of the work, the psychological side where you go in and explore feelings and relationships and memories. Often times you find things you're not ready for and you can't bear that this is in front of you. I assume that's the vulnerability you're talking about. I certainly have times where I walk around in my studio thinking: I can't paint,

I'm not as good as I think I am, I'm certainly not as good as everyone else thinks I am. And I'm freaked. The other side is when you've opened a door and you feel the weight of the responsibility. There's something sacred about paint. You make a pact with the painting, you will be responsible for whatever you're putting on it, what you find out.

ah I make a pact with myself that despite how I might frighten myself, I'll keep trying. I'm not going to compromise the work because I'm scared. I think your paintings are scary.

EF What paintings? My paintings?

ah Yeah.

EF If you think things and hear voices, that enters you, it touches you but the image can evaporate in some way that when you actually see it in front of you it becomes terrifying. Your imagination can invent and conflate and interpret. Some of it is from what you've experienced, but a lot of it is from things you've heard, things you're imagining could happen. When I went to more realistic representations . . .

ah How and why did that happen?

EF I wasn't good as an abstract artist. It wasn't fun to paint. A good abstract artist doesn't feel the limitations I felt. Also, I went to representation because I wanted a broader audience. I didn't like the pedantic language the formalist painters used. I wanted people to know what they were looking at whether they liked it or not. And then of course, in moving to representation came the question, What are you going to represent? I never felt confident talking about anything I didn't know much about. I didn't see my source as being greater than myself, my experience.

ah David Smith said an artist can't create outside his time, outside his own experience. Do you think that's true?

EF I was very nervous about getting specific. You start to think: If I paint what I know, how much do I know? Who cares about the little life I came out of? This is before you realize how big everybody's life is. At first I kept it general, I made everything a noun: The TV, The Chair, The Window . . .

ah What would happen if you made it specific?

EF I thought it would become a narrow autobiographical experience, or a narrow class experience, and objects would lose their potential for metaphor. I've always tried to edit the objects in my work so that they'd resonate and not be locked in time. I don't engage the world in a direct way. I need the painting to mediate my relationship to it. I need to have the physical distance of a painting to understand life.

ah I'm thinking about the spareness of objects in your paintings.

EF The objects that surrounded my earlier work were objects that extended perception: the telephone, binoculars, a Walkman, a television . . . I have mixed feelings about those objects. You rely heavily on them, and at the same time they're alienating devices. You're actually listening to something that's not there. You decontextualize yourself. You're hearing stuff that's not where you are. TV blends into the room situations and events that don't take place in that room. The other kind of objects that I employ would be exotic ones, like statues, and things from alien cultures.

ah Like that one in *Slumber Party*, the figure with many arms.

EF The voodoo doll. I grew up in a house with one of those, and all my friends' houses seemed to have a Japanese scroll, a Kontiki head, something that represented otherness, an exoticism. It is not unlike the way we deal with pets, which is that they connect us to something that we're not, something that remains a mystery. It's a prelinguistic experience. Also, putting these objects in your house decontextualizes them and renders them impotent.

ah By taking them out of their culture.

EF Yes.

ah There are some interesting

objects in the room in your new paintings, like the tapestry on the wall.

EF It's the room I stayed in in India, that tapestry was on the wall. The first painting is of a woman crouching, looking away, with a black man standing next to her who is very animated and seems to be trying to affect her in some way. As I was looking at this painting I realized you can't see the two figures at the same time. It was the weirdest experience because they're standing right next to each other. You look at the woman, you get so totally absorbed in her inwardness that you don't even know there's this guy right beside her. Then you look at him and he's so different than she is, so animated, half-hidden, half-exposed that you forget all about her. They don't exist at the same moment. That became interesting for me because it posed a question: Is he real? Is she real? Is he a figment of her imagination, a fantasy, a demon? Because this room has suitcases in it, is she leaving, or has she just arrived? And I began, in that room, to chart the journey. The black guy disappears after that first painting, but his presence is always there. She's crawling across the floor. Is she crawling to him or away from him? The painting is stopped at a moment when she is just beginning to unweight one arm. I didn't know if she was doing it as though she were going to move forward or if she was beginning to retreat. She's looking at something off the canvas, there is a presence outside of the painting.

ah So much of your work has been about the interaction of people, the tension and subtlety of that. And in the new paintings it's so markedly different. The woman is looking outside of the painting, but you get the feeling she's not seeing anything. It's not outside, it's in her head.

EF Totally internal.

ah Her pose and position become animal-like, primal. Have you seen people who have gone crazy? They squat.

EF Well there's *Diary of a Mad Housewife*. She crawls under the table, totally gives up. And the table becomes a compelling object, speaking of objects as metaphors.

ah The woman is in another state that we can't quite get to. There's no relation between her and the outside world, or us.

EF These new paintings are the scariest paintings I've done. They are the most vulnerable. At my opening I didn't come out of the back room. I didn't invite anyone to my opening. I really surprised myself. I'm confident this is some of the best work I've ever done, but it's also so exposed. Someone described the last painting as the "redemption painting," the one of her all balled up, sort of exploded by light. When I was painting it, I couldn't be sure. On the one hand, I felt that she was being annihilated by the light, and that she was returning to the shape with which she had started. Only now, she's completely alone, without even a

fantasy, just herself. The tragic end of something. At the same time, there is something so warm about the light. There is a kind of hope from it, that you will transcend your body. The scene with her crawling across the stone floor became an important part of the characterization of the whole environment, the floor turned into a spider web. And the question is: Is she predator or prey?

ah Is she a victim?

EF I think she's a victim of her own desire.

ah What happened to her?

EF She came to that room looking for something. If she was trying to leave the room, then it was a total failure, because she doesn't get out. And if she came looking for something, then maybe that last painting is redemptive. What she first thought she was looking for wasn't what she finally accepted, which was her aloneness. I'm not saying that this is the only experience one can have, but I know what's in the paintings. Before this series, I had my own reasons for making paintings and other people would find other reasons in them that would actually contradict my reasons. But both were equally valid because there was ambiguity in the work. I don't think there's ambivalence in these because the emotional core is so clear. First of all, they're not funny.

ah That was another question people had.

EF Did you interview thousands, take a poll before you got here?

ah I like to get lots of points of view.

EF Anyway, in comedy you're always giving up something of yourself. You're always taking something that you feel and care about and parodying it. There comes a point in your life when you have nothing left to give away and you take a stand and say this is what there is. And what there is is usually tragic. You were going to ask me about bodies?

ah The whole question of the male gaze. What does it mean for a male painter to be painting this lonely female nude?

EF What it means to be me, a male, is precisely measured by the work itself. I don't take a generalized view. In that series of paintings I chose a black man because he was equally distant from me and her. There were three "others" involved here, three different kinds of experience: me, a white male; him, a black male; her, a white female. All other to each other, an equilateral triangulation of distance. I managed to project into those differences and see, record, what I imagined.

ah Voyeuristically.

EF They're not passive though, they're not pornography. You have an emotional relationship with the person you're watching. I don't think you're seeing things that she's not feeling. It's not as though she's a tragic character and you have the comfort of knowing her fate. You don't stand outside her. You participate in her feelings. Maybe women do not need to meditate, to construct the other in

order to measure the distance as a way of understanding themselves, but I think it's very much a part of the male psyche. We are defined by that which we are not.

ah I can't think of another painter, white or black, who paints black people and white people together, especially nude. You've done that a lot. I'm curious about that.

EF It's sexual. I knew that I was dealing with taboos, and that those taboos carry a tension that needs to be explored, maybe exploded, maybe upheld, I don't know. But I knew I was playing in that terrain.

ah But white and black seem quite comfortable with each other in a lot of the paintings.

EF In most cases the white person would feel like they don't belong there rather than the black character. The white person is the odd man out.

ah But I want to know where their relationship comes from. How do they end up there together?

EF I did a painting that started out as a wedding. I painted quite a lot of it— the ceremony, the bride, the groom— before I thought, I don't like this, there's no interest, why am I doing this? So I moved it to the reception after the wedding, from inside to out- side, so I could paint Japanese lanterns, people dancing, night light . . . it would be visually more exciting, theatrical. And the bride was really cutting loose, slugging back a bottle of Jack Daniels and there was a black

jazz musician whaling away on the piano. Then that got painted over. The painting ended up being three people around a pool, absolutely calm, late at night, like four o'clock in the morning. A white woman sitting in a butterfly chair with a glass of wine looking off the side of the canvas. Leaning against the chair was a black man in a bathing suit with a glass in his hand looking down at this white kid who is sitting by the side of the pool playing with a windup toy, a monkey that beats a drum. It's a thin- ly veiled racial slur. The painting's called *The Brat*. This kid is willfully sitting there because he's jealous of his mother's relationship. The black guy is totally, confidently there and looking at the kid like: deal with it. The wedding is hidden underneath it.

ah There seems to be a determination to be completely honest. I don't want to see this, you don't want to see this, but if I don't show it to you I'll be lying. Could you talk about that compulsion towards honesty, despite the fact that it may not be pleasant?

EF My imagination is not about flights of fantasy. It's really a process of discov- ering who I am, so it's about peeling away and peeling away. It's about meeting something essential. The body poses the biggest question for me. It's a question itself. It's all about needs and desires and union and one- ness and aloneness. It's all about the edges and boundaries of the flesh, the needs of the flesh. I'm trying to find out what my relationship to the body

is, the comfort and discomfort, the appropriate and the inappropriate. You know what I'm saying?

ah **Some. Your paintings exist in a very traditional form, yet they're subversive because they do the things that they're not supposed to do. They show you what you don't really want to see, and in such a way that initially the viewer doesn't necessarily notice it.**

EF Part of the compulsion comes from growing up in an environment which was both middle class, which has its own restrictions on character, and alcoholic, which has another set of restrictions. The middle class is always en route. It's not a resting place. It's not a place where you want to stay, it's a place that wants to continue to grow. And so it's horrified by any reminder of where it came from, and envious of things that it has not yet attained. The middle class has this denial built into it. Add to that denial the fear that they will be revealed for what they are, that their ambition would be revealed. Then the alcoholic thing was stigmatizing when I was growing up, to the point where you couldn't even acknowledge that it was taking place. It's a world in which you couldn't say things which were painfully obvious. If you live in that state then reality doesn't have much meaning for you. Reality became a passion of mine. I willfully chose to be painfully honest. Initially, my paintings pushed it too far. They wanted to be too painful, too confrontational, but in a way that wasn't authentic. It went past the real

content to a sensationalism. A lot of the paintings were melodramatic rather than purely dramatic.

ah **The lighting in the new work has become much more heightened, more dramatic.**

EF It's become almost theatrical. There's not a major work of art that isn't invested with light. Light is absolutely an essential aspect of painting.

ah **How do you paint light? It's ethereal.**

EF You don't paint light. You feel light. You paint towards a kind of illumination. It's both a psychic illumination as well as a physical illumination. You feel your way towards it through how color works, your relationship to shadow and to highlight, all of those. Each one's a metaphor. There is such a difference between something that is spotlit and something that is luminous, shade and shadow. Very different states of being. It's about casting something in light too. To be an artist you have to engage an audience. You have to use all these things to pull them in, to seduce them. Light is very seductive because it contains mystery and revelation simultaneously. It's also totally outside modernism because in order to really play around with light you have to get past the flatness that is part of the modernist ethic, surface. Light is not about surface, it's about non-surface.

ah **Henry Miller talks in an essay about what would happen if he could turn up the light past the**

full brightness of day. That's part of what's happening here.

EF I started going to art school when I was living in Phoenix. I was influenced initially by the light in the Southwest because it's a very intense flat light that renders everything in two dimensions. You get this cardboard reality. Everything is hard edged, delineated, stark contrast, dark shadow to bright. A lot of my early work used that kind of light. It was part of my ambition to pull these people into the harsh light of day and say, "This is it." Now I'm definitely looking for a much more complicated, emotional light.

ah You paint a lot of naked people. What is nakedness to you?

EF Nakedness is nakedness. I'm affected by it as well. I'm not above it. I have self-consciousness about my body, not unlike most people. But I wonder why it is that the essential self is the uncomfortable self?

ah Any thoughts on that?

EF [*laughter*] No, I just have a career based on wondering about it. On thinking about it. I don't have any answers.

ah You've taken a lot of photographs. They're very snapshotty and yet they're perfectly like your paintings.

EF I was really surprised when I put this portfolio together by how much they looked like my work. My experience is that I watch, I see things. And when I find myself riveted, before I'm thinking anything, but just fixed, that's when I know that this is something I want and

I don't know why. My process of painting is trying to contextualize that.

ah When did you start using photography?

EF In 1980, in St. Tropez. The experience of being there was so overwhelming that I couldn't believe what I was looking at. I had no idea how I felt about it. I was so compelled by what I was seeing, I didn't know whether it was a joke, or whether it was wonderful, or horrifying, or stupid, or everything.

ah What you were seeing being . . .

EF I was seeing people on the beach who were naked, who were behaving in a totally socialized way. So that their body language was social language rather than private language. But they were naked, which was the most private place. And so that contradiction was compelling in and of itself. A lot of the gestures were ones that I could take off the beach and put in a living room, or in a bedroom, or in a car, and they would still be active and not about lounging on the beach, which is a whole other kind of body language.

ah Which is what we do, we're not very good on the beach.

EF No. We don't live on the beach the way the Europeans live on the beach.

ah Speaking of photographs, Sally Mann's work on the parent and child relationship shows something so incredibly intimate which we don't otherwise get to see.

EF She's speaking of the reflections of an adult on childhood from a point of

sexual knowledge, and we're talking biblical.

ah A lot of your paintings do that as well.

EF To an artist that's absolutely fertile territory. It makes sense to go there because so much of what we're about comes from there. But if we were on Sally Mann's porch watching her kids play in the sun we would not get a drama out of it the way she pulls it out of the black and white. It's sensibility and vision.

ah In your earlier work, a little boy showed up in various incarnations, and then around the time of the India paintings he disappeared. What happened to him?

EF I haven't been able to go back to him. I mean, he is gone.

ah Why?

EF He grew up. He got past the outrage of a child's psyche when what they're promised and what they're given aren't the same thing. You know what I'm saying, right?

ah Yes, I do.

EF We'd all love to find something that gives us fertile ground and makes us famous that we could do for the rest of our lives and that we'd still be good at doing all the way along. But what happened psychologically and emotionally for me was that the early paintings looked up into the adult world, literally, from the point of view of a child: The planes were tilted, the scale was larger than life. At some

point after going through the emotional stuff, reliving, reexperiencing, and expressing that emotional discomfort that was there as a child, it was like clockwork. The plane came down, the gaze became eye level, became a one-to-one relationship, it had nothing to do with becoming happy or those kinds of things.

ah That's good to know. [*laughter*]

EF I just started to see it in a more ambiguous way. An adult can accept that situations can be ambiguous, you can have multiple feelings, multiple relationships to the same thing.

ah You literally left and went to India, producing this entirely other body of work.

EF The India paintings were not as different as people think. They were attached to the same impetus. I left that which I knew, went out into a world in which I didn't know anything, and so all I did was watch. The experience of the India paintings was one in which the audience feels alien, even though they're looking at an alien culture, they are the ones that feel alienated. Yeah, it was a fantastic break. It had a particular life . . . intense.

ah That image from the India paintings of an incredibly large nude adult male, standing on his head—you're working with imagery that's at once archetypal and entirely your own.

EF First of all, I'm attempting to do that in lieu of the absence of myths that

united society. We used to explain ourselves to each other through our mythology.

ah Which is also moral.

EF Yeah. I prefer the Greek pantheon which divided the human character into all its parts, made each one a god and projected them out into their world to watch them behave. And the way they behaved was instructional. You could see when Eros became a little too needy or insistent or obsessive, bad shit could happen. Or when somebody became too greedy or too powerful, you understood it because they were all parts of something you knew yourself, you could moderate your own behavior accordingly. You had the ability to judge. Americans don't really focus on their history as part of their myth, except the myth of the individual. So I wanted to find within daily life the things that become mythical. Needs and passions. That's why I focused on the family, the most basic structure. Every matrix combination is in there.

ah And the American dream.

EF I've become much more sympathetic to the mentality of the middle class and to their fright.

ah Why?

EF In a way, it is the most interesting aspect of American life. It's the biggest, filled with ambition; the class of transition that tries so hard to uphold the values of the culture. It's tragic and compelling.

ah I have to tell you an Eric Fischl

story. One day I look out the window and on the terrace far across the way is a nude man, gardening. I go and get my camera, thinking I'm seeing an Eric Fischl painting, a nude man in the city, gardening. I crouch down because I don't want it to seem like I'm taking pictures of some nude guy gardening. Then the guy goes into his apartment, gets his binoculars and all of a sudden I'm watching a nude guy, who's watching someone further downtown. Then he starts masturbating. And I'm thinking, charming, this is really charming. Then he turns and looks at me with his binoculars. Caught. I totally freak out, drop to the floor of the apartment and literally crawl away. I felt caught and embarrassed.

EF So listen to this. If this happened on the same day, it would blow my mind. My assistant was working over in the West Village renovating an apartment. They were having lunch, and they looked out the window and saw this nude guy on the roof who eventually saw them. They had binoculars and they were checking it out, and then he got binoculars and he was checking them out. And then he started to masturbate.

ah I think there must be a lot of this.

EF Now which part of that do you think is me? You said the Eric Fischl story . . .

ah You would rarely see a picture of, for lack of a better word, an imperfect person naked. And he

was doing it publicly and unself-consciously. There was this hyper-moment around it, this extra-large frame. And then the binocular part got really weird.

EF Yeah, absolutely. Masturbation would be present but it wouldn't necessarily be a thing I would depict. Because at that point it becomes a different relationship. It comes to be about something he wants. There's a revelatory moment before the masturbation happens when you see something that is compelling but out of context. This naked person, private and public, gardening and urban, work together to create this weird context. The metaphor that's there isn't there when he starts to masturbate.

ah What makes it erotic is that he's not doing it, which means you're participating by involving your own sense of what is erotic.

EF Exactly.

ah The most fascinating part is how the viewer chooses to participate. Which also makes them have to take a certain amount of responsibility.

EF You always have to include the audience. One way to understand the relationship between an artist and the audience is to look at tennis. In tennis you have yourself and an opponent. And the opponent is going to give you the most resistance to what you're trying to do. And your effort is going to be to dominate that resistance so that you win. That's the battle. And in a sense, your opponent is your audience, because they're the ones who are going to feel and understand all of the intensity and all of the subtlety of your strokes. They're going to know what it feels like when you ace them or you cram a ball down their throat or you drop shot 'em or you pull 'em wider or you mix up the pace. They're going to be affected by it and react to it.

ah Where are the critics?

EF Critics are like umpires. Referees. They're the ones that try to call the out balls, but in my game of tennis, I don't need referees. You don't write for the audience that sits in the stands. You don't paint for those people. But you know that they're watching, and you hope that they're aficionados of the sport, so that they can also appreciate when you do something with incredible touch, or when you masterfully work your way out of a situation, or change the momentum, that they can perceive that moment the way your opponent does.

ah This is the last question. There is an enormous sense of alienation in your work and yet you seem perfectly fine. Are you? And if you really are okay, how did you get to be okay?

EF [laughter] Now we are getting to the part where we swap questions, aren't we?

ah No, but literally . . . you do seem fine.

EF Affable and sociable and . . . I don't see a contradiction in any of that. First of all, what do you

mean by alienated? The figures
seem alienated?

ah Well there's pain, this last set is in
more pain than ever. You're enor-
mously successful, a lot of good
has happened, how do you recon-
cile that pain in there with things
on the outside? You're trying to
expose yourself each time as much
as you possibly can. And then it's
this weird moment where you're
saying, "I hope you like it."

EF Steve Gionakis gave me the best defin-
ition of art: "Art is a desperate
attempt to make friends."

ah I think it is. People constantly dis-
cuss your work in psychological
terms, by the narrative. There is so
much storytelling in Freud. Do
you read Freud?

EF No. I don't know anything about psy-
chology. To me psychological means
full of character, and also that the

meaning is unconsciously perceived by
an audience. Psychology has replaced
religion in the way that it can explain
the world and the phenomena of the
world, our sense of beauty and our
sense of purpose to us. So it would
make sense that you would make a nar-
rative out of that psychological setting.

ah Do you think people should
attempt to tell the story of your
paintings in their own psychologi-
cal narrative?

EF I like that, because it means they are
possessing the work. You want pos-
session. You want somebody to inter-
nalize it and interpret it in terms
that they understand themselves. It's
about them. I seek that. What I try
to do is narrow the possibility of
interpretation to a certain area so
that they're never that far wrong.
You don't want to control it so much
that they have no room. You want
them to participate.

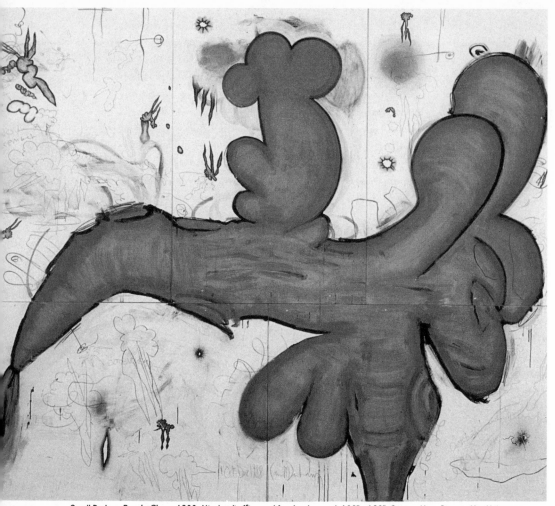

Carroll Dunham, *Purple Shape*, 1988, Mixed media (five panels) ragboard on panel, 100" x 120". Courtesy Metro Pictures, New York.

CARROLL DUNHAM betsy sussler

BOMB # 30, Winter 1990

Carroll Dunham's paintings cross the boundaries of taste, belching disorder in an experience of painting that is simultaneously accomplished and uncivilized. What is beautiful and what is grotesque become mated in a world that uncovers a revelry of the spirit. Paul Radin, in his book *The Trickster*, writes: "Disorder belongs to the totality of life, and the spirit of this disorder is the trickster. His function in an archaic society, or rather the function of his mythology, of the tales told about him, is to add disorder to order and so make a whole, to render possible, within the fixed bounds of what is permitted, an experience of what is not permitted." Dunham's early work on wood—dreamscapes elaborated from the whorls—solidified in his later work into polymorphous animae that to my mind recall the function of a trickster.

betsy sussler Much has been written about the dream world that seems to be in your paintings. Do you think it's true?

CARROLL DUNHAM True that that's what's been written?

bs Do you create a dream space when you paint? A space for revelry.

CD I think of it much more in terms of just a painting space. The paintings don't specifically represent a dreaming part of consciousness.

bs There's one called *Left Side*.

CD That title was meant to be prosaic. It's a description of how the shapes relate to the edges of the painting. Then it started to seem more interest-ing as a title because I'm left handed and so, in a sense, everything I do comes out of my left side.

bs Do you think about other painters?

CD It goes in phases. I appreciate a lot of different paintings.

bs Like now.

CD Right now, I'm thinking about myself. I'm very preoccupied with the idea of trying to find more of myself in my pictures.

bs There's a character who runs throughout mythologies and folk-lore called the trickster. Have you ever heard of him?

CD Isn't that a figure in the tarot deck?

bs There's a joker in the tarot deck. That's one aspect of the trickster. I have thought of him when looking at your larger amorphous characters; the sort in your paintings who are noisy, sexual, and busy. The trickster's the great deceiver, who is duped himself. He's the creator and the destroyer, not a god and not the devil, amoral—the transformer. The Sioux describe him at one point as having so large a penis that he wraps it around his neck like a tie, his scrotum hanging off his waist. He takes an elk's liver, and fashions it into a vulva, marries the chief's son and they make children together.

CD Sounds like quite a guy.

bs Brer Rabbit, Reynard the Fox . . .

CD I know what you're talking about. A lot of those characters are in African fables.

bs Exactly, the spider. There is a character in your paintings who has always been but who has recently come to the fore. He reminds me of the trickster.

CD Well, that's a very appealing reading to me.

bs Good. Do you think of the figures in your paintings as characters?

CD I suppose on one level I do. I don't mean them to be necessarily funny and certainly don't mean them as a joke. I'm trying to draw and paint things that are true for me.

bs I mean a joke in the mythological

sense in that they contain both good and evil.

CD It relates more to ideas about beauty and ugliness. I don't know about good and evil.

bs Inside and outside. Order and disorder.

CD I don't see them as pictures of anything specific. But they certainly are pictures of something. I don't think I would have said that so clearly a while back. Part of that central shape becoming dominant in the paintings had to do with accepting this. It's a picture of something that I have to draw somehow, flush out and see. That's why, coming back to dreams, I know what people mean when they say that, but dreams are not abstract. In my dreams I use images from the world to make stories. I don't think of my work in terms of storytelling. Perhaps as instantaneous potential for a story, you could look at one of my paintings and say, something's happening. But not in the sense of a plot line.

bs James Hillman in *The Dream and the Underworld* posits an idea of the dream world as the place where the soul tries to get back to not only heaven, but hell. That ultimately dreams are about coming to terms with the soul, and the soul with death. His ideas reminded me of your work, so I brought some notes. He describes the dream world similarly to how I think of your paintings: "Dreamworld is an experience of

limited space where the psyche is crowded, pushed to the wall. Chaff, lots of chaff, day residues, junk and garbage make our dreams. The fundamental image of the underworld is contained space." Contained space, as in painting. Have you ever looked at your earlier paintings and said, this could have taken place in hell? I have.

CD Yes, I have, actually. And I probably would have been resistant to discussing it in those terms when I was making them, because I would have been afraid that it would have trivialized them. I also thought they could have been taking place in heaven. I've had both thoughts. The idea of making a picture that could allude to more exalted states of mind is as interesting as one that alludes to more base states of mind.

bs Well, this man's idea is that they're part of a whole. They can't be separated.

CD Well, I suppose that I feel that. That seems true to me in terms of what life feels like.

bs Did you know that "shading" and "scenes" came from the same word?

CD Shading?

bs Yeah, shading, like defining a shape, forming a scene.

CD Is that a Greek word?

bs Yes. Hillman refers to the dream as "not a narrative so much as scenes that define the psychic position of

all the events in the dream . . . The dream has no end. It is not going any place else and it is always going on." Ancient dream interpreters always asked about the hour the dream took place. You usually incorporate the date into your paintings. Why do you do that?

CD When I started doing a lot of drawings, I wanted to be able to track them, to order the chronology and also the space and time that separated one idea from the other. Things come about in time. Time is one of the materials. I don't plan things and then execute them. They come about by me doing them. And some notation of time seems important to their truth. It comes in and out, you know. In my new paintings, it's a fairly conventional dating and signing type of thing. There have been times when it became much more of a graphic element—an element of drawing. Time seems to be one of the really basic things we have to work with.

bs You do drawings on file cards. It seemed that you separated one set into two categories: one about shape and the other line.

CD The ones you are referring to are half ink, and half are pencil: an investigation of the new shapes I was drawing, half in terms of their volume, their shadedness, their sexiness, and the other half in terms of their structure, the mechanics of it. I don't know if you ever really know why you do some things but I had a story that I told myself when I started those that had to

do with being interested in the tabs on the edges of the file cards as a way to identify one side of a rectangle. I was in the process of trying to rotate my paintings. For years they had all been vertical and I wanted to make them horizontal. The change to these amorphous shapes becoming dominant in the paintings was simultaneous with the paintings' becoming horizontal. I did one group of drawings using a whole set of file cards and rotating their orientation. I was trying to see if the space changed, how the space changed. What was implied by focusing on up or down or right or left. Now I look back and that doesn't seem to be their most important characteristic. It just seems like it was probably a way to get myself started on something. The file cards imply order.

bs **They order time.**

CD Yes, they order time and you are always going to look at them and say, A is before B, is before C. When I'm drawing I do one drawing after another so the order in which I did them seems crucial.

bs **Why is that?**

CD This idea that we're working, living in time and that events unfold. Because of the limitations of what humans can see, it seems that time goes in one direction and my experience of my work unfolding as I do it is that it happens in one direction. Yet it's much more complex than that, because things come back to you— there can be trains of thought you think you're done with that you're not

done with at all, that crisscross in a very complicated way.

bs **It's odd to hear you talk about ordering, I look at these paintings and see the most anarchistic characters. Implicit in their wild, unruly shape is the possibility that they might explode or implode at any moment. They know no bounds. In terms of the imagination, they leak all over the place.**

CD I feel a lot of the time as though my imagination is very limited. It's not okay for me to just do anything. It's not automatic in that way at all. It's a very clear family of shapes. They can evolve. Part of the function of drawing is to try and figure out new ways that I can push them or have them sit in their space, relate to the edges of the painting. But . . . what am I trying to say? They aren't just anything. They're these things. I like your description. It appeals to me, but I feel in a way that they don't deserve that description because there are such clear limits on what I can do.

bs **Let me put it this way. I'm calling them characters, meaning that there are certain things they might do that would be out of character.**

CD Yes, that's true.

bs **They're defined but they can have great range within that definition.**

CD In my private lexicon I call them shapes. They probably have aspects of them that are like characters. They certainly have approached having some kind of personality at times. But

they are first and foremost shapes in a figure-ground relationship. That's the situation I have to work with. I like to avoid talking about them in a way that would push their meaning too far in one direction. "Shape" seems the most general term. But, again, they're specific types of shapes. There's a fairly limited set of approaches that will make me feel the things I want to feel when I'm drawing them.

bs What do you want to feel when you're drawing them?

CD Well, it's some feeling of familiarity and rightness to the whole thing. I want to be excited by them.

bs Do you think of them as being alive? You do, don't you?

CD Yes. Honestly [*laughter*] I suppose I do even though I know they're not.

bs I think of them as being alive.

CD Even though I know they're not, I do. I imbue them with all sorts of traits of living things. But I project all this onto them. There's one way to look at how I work where none of this has any bearing.

bs How's that?

CD It's about deciding on procedures and then following them out.

bs Structure.

CD Procedures and drawing structure. I seem to begin a painting by following my nose. I always begin by drawing a shape and I usually change the shape while I'm painting it. I have an idea about how I want to paint the shape

and there may be a general direction about the color that I want to use. Then I try to go into it and let the painting be around me over a period of time so that I can get to know it and how it feels. And nudge it in one direction or another. But when it clicks in, when the painting seems to be done, is when it becomes itself. Its character is established. I don't mean its character in terms of a character in a story. I mean its nature. The emotional tone is clear and not garbled. It must have to do with something I want to feel when I look at them. Obviously the thing becoming finished has something to do with the thing coming alive for me and not just being a mess of stuff on a surface. And when this happens, I think I have completed a painting and then I spend a long period of time looking at the painting and trying to hear what it's telling me. There's an idea I have that I'm receiving this rather than creating it. I'm allowed access to these paintings.

bs Any writer will tell you that at a certain point the characters they've created will lead them. You watch it happen. The character lives and it starts telling you.

CD That's certainly my experience making art work. I'm very interested in a certain area of imagery and I try to work with that, but the imagery runs me more than me running the imagery.

bs It's hard not to think of the word chaos when one looks at your paintings. That's not because they're

structurally unsound, they're very well formed. But it feels as though these could, at any moment, explode and become chaotic again. There's a violence to them. You must have heard this before.

CD Yes, I have and I can see it myself sometimes.

bs But you don't feel that way about them?

CD No, I think I probably do. I feel everything at one time or another. What I'm amazed by is how little of what I feel seems to have to do with what I do.

bs For instance?

CD It's not like, Dunham is happy today so he makes a happy painting. There's no correlation. There's some deeper level—whatever force one has that gets one to work, that gets one to just keep doing this. It goes through permutations and takes years to gestate. There was a long period of transitions to move from the paintings on wood and the more complex space that those entailed. In a way, it seems like somebody else did those paintings, even though I also see, the more I work, that these paintings clarify earlier paintings.

bs In what way?

CD When the paintings became horizontal, the central shape became the dominant motif. Those are things I was working with before. I just wasn't as developed in what I was doing. They look different but there are a lot of shared aspects.

bs The shapes were certainly the dominant force in the wooden pieces. Did you paint by working out of the whorls of the wood, like Rorschach tests?

CD I worked in different ways at different times within each painting. One level was to use the wooden surfaces as points of departure for compositional or spatial developments. Another level was to draw shapes and let their nature and placement affect the space and atmosphere of the painting. I've always been drawing shapes and filling my paintings up with shapes. But I began to see that the shape and its surrounding and the relationship between the shape and its surrounding could be the painting. That seemed like a beautiful idea to me because it was so clear. One to one between me and the painting, between me and the shape.

bs What would you say the primary event is?

CD Well, in terms of making the painting, the primary event is probably the first thing I do, drawing the shape with lines. In terms of looking at them, you see a shape and you can get it pretty quickly but then you can begin to feel things about it and view it in different ways and it slows down. It becomes more engaging. I don't think in terms of the primary event because I look at things for a long time.

bs There's a lot of smoke in the wood paintings.

CD Smoke?

bs Smoke is the intermediary sub-

stance between spirit and body in alchemy. How did you think of it when you were using it?

CD There's this gap between what you think of while you're working and what you think about when you look.

bs Right. So, smoke.

CD I never thought of it as smoke, exactly. It's not so different but I always thought of it as—what did I think of it as?—this very thin stuff spread out over a painting.

bs Yes, vaporous.

CD Well, it's about smearing and throwing liquid around and thinness, veils. Veils of paint as opposed to opaque, really applied paint. It always seemed to have a use—deepening the space in the painting, creating spatial relationships between different events in the painting. It seemed to fit in the atmosphere that I was trying to make.

bs What atmosphere?

CD This atmosphere of possibility, of movement, where things seem to be in a kind of motion. They seem to imply movement. The movement could be going forward. The movement could be going backwards. You're only seeing a second of it. Part of the problem I have responding to this is that I don't think symbolically. I never thought about the veils of paint in my paintings as having symbolic reference. They seem to feel true to me and they feel like something that I have experienced. You are in an area of association that I feel comfortable with. The area in which I tend to wan-

der when I'm thinking about my own work is the area of how the mind works. How the personality is constructed. What parts of me can be allowed freedom and what parts can't, all of which in the end come down to questions of the soul and what the soul is. But I would be horrified to go through—like Flemish painting where you can go through and attach symbolic meaning to everything. That was a very important, different way to read pictures. It gave rise to incredible pictures. I love Bosch, but the way that you need to understand Bosch is completely different than the way I think about my own paintings. I'm not thinking symbolically or in literary terms. The things that come up in my paintings tend to be much more an expression of an attitude about process than they do the expression of an attitude about subject matter.

bs Why use sexual organs?

CD Well, that's something I feel like I have the right to draw and paint.

bs A man's sexual organs?

CD Well that's something that I have. I'm creating things and there's some sort of a drive to do that. I don't know what it is. Something gets me out of bed in the morning to do this and not something else. It's one area where I'm willing to be explicit and it would be coy of me to say, "That's not a penis." It would be ridiculous.

bs I agree.

CD But it seems important. I'm trying to think what I would really want to say

about it. They come and go in the paintings. Just in formal terms, certainly it and other parts of the body inform a lot of what I draw. But it's the only one that I'm willing to really draw explicitly. I just don't want to be repressed about it. I want to do it. I want to draw it and I want to look at it when I draw it. I want to attach it to other things that I draw. Like sticking it on top of one of these shapes. These things feel true when I look at them. In order for them to seem plausible, they must reflect something back to me that I feel. Because they aren't about ideas. They aren't about having a good idea and then painting the idea. Something feels right to me about seeing them, having some of them with penises attached to them.

bs **There's something very innocent about wanting to keep looking at one's sexual organs. Going back to** *The Trickster,* **Paul Radin says, "His mythology of the tales told about him, is to add disorder to order and so make a whole, to render possible, within the fixed bounds of what is permitted, an experience of what is not permitted." Your shapes used to be much more transsexual—almost hermaphroditic. Am I just imagining that?**

CD No, I think that's right.

bs **And then they became more and more male. I'm talking about them as if they're portraits and they're not.**

CD No, no. They're very schematized. It's not drawing the figure. It's much more schematic than that and I'm only interested in it as a kind of schematic, as another thing to think about when looking at them.

bs **Sometimes they look like human organs and other times they feel like mammals. There's always a transformation going on, as if you are looking at a body's outside and its inside at the same time.**

CD There's an issue of inside and outside in terms of the shape in the field and how they interact. That's something I'm trying to make more complicated in these new things. I think inside and outside, my inside and my outside, all that preoccupies me.

bs **Let's go back. The inside and outside, the shape and the field—you mean the place, the site itself?**

CD I think the shapes have to have a place to be. If they don't have a pictorial place to be then they would be silhouettes, shapes cut out of something. And that's not interesting to me to do. They come about inside a rectangular picture space and something has to happen between the shape and the rectangle. That can be all different kinds of things. It needs to be a place that's just about absence or it can be something more physical, more up front with the shape.

bs **For instance? They're not landscapes.**

CD No, no, no. I don't mean it in that sense. It's a psychological place, a

psychic place. It's not a place in the world. It's pictorial. Part of what gives them their feeling is the nature of the place that they are allowed to be. I'm trying now to put them somewhere, to make the painting cover the whole painting. You can see these new ones have paint all around the shapes. I don't know what that means. I know that it's what I'm trying to do. It's one of these procedural ideas.

Roni Horn, *Things That Happen Again: Things That Are Near*, 1986-91, Solid copper, (two units); 53" x 17" to 12" diam. Courtesy Matthew Marks Gallery, New York.

RONI HORN mimi thompson

BOMB # 28, Summer 1989

Roni Horn works in a Brooklyn studio full of machined objects, drawings in progress and pink cone-shaped molds—the beginnings of new sculpture. On a table are photographs taken in Iceland, a location that has been an inspiration and key influence. We had fun doing this interview, so much so that we forgot to record some of it. Roni's notes fill in the blanks.

mimi thompson How did you end up choosing Iceland as a place to go?

RONI HORN It's a question that I'm always asked and I don't have a real answer for it. I once looked Iceland up in the dictionary and it fell between ice hockey and ice-skating. That's pretty much as controlled a choice as I made. But having gone there, there evolved a relationship from which I couldn't separate. Each time I'd go, there would be engendered the idea to go back and back and back. I guess the real reason is the relationship to yourself that is possible in a place like that. There's nothing mediating it. There is nothing to obscure or make more complex a perception or a presence.

mt And yet it's highly dramatic.

RH The drama comes from its youth. The landscape is unique in that the geology is very young. It's like a labyrinth in the definitive sense. It's big enough to get lost in, but small enough to find yourself. There is little erosion and, as a result, unexpected symmetries exist in unexpected places. America has everything Iceland has, but it's ten thousand, twenty thousand, one hundred thousand years older, depending on where you look. Growing up in a very "old" landscape—New York City—its origins are secreted from the present. I mean that the geological aspect of the landscape in New York City can only be experienced theoretically at this point. In Iceland, you understand empirically exactly what this place is: its what and how. That accessibility affects the nature of one's experience, the experience of the world. Any place you're going to stand in, in any given moment, is a complement to the rest of the world, historically and empirically. What you can see in that moment, what you can touch in that moment, is confluent with everything else.

mt Is this country a kind of armature for your ideas?

RH No. If you've been eating something for a long time or if you've been committing certain acts for a long time, they enter your vocabulary and you piss them out in a certain way. Iceland is something I've been consuming for a long time. How it affects what I do or my products— excrement or sculpture—is not in a particularly graphic way, but in a palpable and undeniable way. It's definitely not a literal influence.

mt There seems to be a romantic notion in your work—a search for purity of form, of an ideal state.

RH I don't know about purity.

mt Few of us do.

RH I see these objects that I produce as existing in a very impure world, fraught with entropy and dirt. But the impurity does not come from the dirt. That is, the world is also fraught with Plato, so to speak. The world is a kind of hybrid or amalgamation of these forms; an impurity with pure elements. [NOTE: *The dirt I am talking about is not just the literal debris of time, but the nature of circumstance which is the condition of things as they are. Usually this condition is extremely complex and less than ideal. I believe the objects I make must recognize these extremes actively and, to some extent, as the conditions of their existence. In the most recent installation,* Pair Object VI: For Two Locations in One Place, *two solid machined copper cones are dumped on their sides. What are normally the bases are now visible as two thirteen-inch disks, directly addressing the viewer's descent*

into the space. Until the viewer is actually in the room, the two disks are present only as graphic two-dimensional forms: a circle and an ellipse, operating in three-dimensional space. These are objects to which the words platonic and pure would not be inappropriate. But that is only true if you consider them as objects in themselves. The installation of these forms reflects an acute awareness of circumstantial reality. In this sense, they cannot be taken simply as objects in themselves. There is also the issue of their being a pair. That is, the pair form, by virtue of the condition of being double, actively refuses the possibility of being experienced as a thing in itself. The simple state of doubleness includes, as integral, the space or interval between. So twice over, this work insists on a recognition of circumstance. I completed a work last year which also uses the pair form, Pair Object II: For Two Rooms. *Two identical solid machined copper objects are placed in neighboring spaces. The viewer walks into the first room and sees the first object, experienced as a unique thing. Walking into the second room, an identical object is present in an identical relation to the world. The viewer runs through a very complex narrative in real time which is the experience of the work itself.*

Basically, I'm talking about things which are formally redundant and experientially cumulative. The narrative involves the recognition of uniqueness through the sequential experience of things which are identical, and then the subsequent and irreversible loss of the unique identity. Obviously the notion of being identical is a purely ideal one since when you have two things, no matter

how perfect the identity, you always have a this and a that, a here and a there. In both pieces we're talking about the critical role of relation in defining the form.]

mt Is this pure/impure a romantic ideal?

RH My work certainly includes elements which might be understood as romantic. But the overall synthesis lies elsewhere. Here in February 1989, if you look at most contemporary work, we're talking about sculpture that is produced to fulfill the needs of domestic space to a degree that is not acknowledged. You have this highly tamed, conventionalized context in which the art object is perceived to exist. The notion of domestic space accounts for maybe five percent of the options of the existence of space, so it's possible that five percent of the work would address domestic space. That kind of pastoral comfort that's offered in domestic space—that scale of events, that kind of inertia—my sculpture is rarely able to exist in those terms. On a physical level, if you think about sculpture existing in geological terms, which are the terms I think about (and I don't mean that as a conceit), then we're talking about a material, physical reality being present in the world of natural forces. Getting back to the *Pair Objects*, these aren't pretty shapes standing in a space and using material in an arbitrary way. The whole tradition of making attractive shapes with attractive materials—the bronze casting tradition, to name one—is really offensive at this point. This tradition

strives for the same advantage over pragmatic reality that paintings achieve through their existence in a conventionalized space. But this conventionalized space is also part of their form. I am talking about a gross misunderstanding of sculpture. That is, the making of objects merely as things that have shape in three dimensions, but refuse the responsibility of existence in three dimensions.

mt Your interest in landscape has been about changing certain urban or architectural environments by, in your words, "resetting" the space. Do you ever think about working more directly with nature?

RH I think about what I have access to. Outdoor pieces interest me a great deal, but I refuse to produce objects which will exist for two to six months on budgets of $10,000. This is not something worth entertaining. And, for the most part, I rarely entertain competitive commissions as options because I feel that if you're going to develop a form, the necessity for the form is also present. It means you must realize the work. It's a piece of your identity.

mt It's a piece of your time.

RH Yes, and it's not a divorceable flirtation with a socially acceptable possibility.

mt So you see the need for the piece to continue for a long time.

RH In real time. I don't care if it's long or if it's short as long as it's real.

mt You wouldn't work with materials that disintegrate?

RH I have—powdered graphite pieces.

mt But not actually in the land, in the dirt, in the landscape that involves you.

RH I think the longevity of the pieces depends on the object's relationship to the world, but it's actively chosen and actively congealed in this form. Its longevity is a product of consolidating these relationships. It's not something that's expedited by a political decision. The duration of a piece should not allow itself to be compromised by these things.

mt I agree with you there. But what I'm thinking about is your desire to get as close as you can to the source without anything mediating your relationship to the material. You want to get as close to the sun as you can.

RH Thoreau said that. And his life was really spent getting rid of any mediating element. I did this gold piece in 1982, a product of being a pawnbroker's daughter. My father had a pawnshop in Harlem and it was an inventory of objects, most of which were made of gold. The thing that was most impressive about my father's gold was that it was just a very anonymous yellow metal. I could never reconcile it to the literary experience of gold, which was this material capable of splendor like *Jason and the Golden Fleece*. I never had the experience of gold.

mt It was a commodity.

RH It was a commodity, but it was decorative and you could alloy it with materials that would ultimately take away its identity. It had this image value which was never held up by its corporal reality. The gold piece was about taking away all of these civilizing corruptions that gold had gone through, whether being used as a surface phenomenon or as jewelry. My idea was to give back to gold its corporal presence, to let it be 100 percent what it is. You've got this extraordinary material which is capable of existing in mundane reality. It's not so platonic that it won't admit to a very direct relation with natural forces. When it interacts with the sun, you get the sun as first experience, as an empirical reality. I understood *Jason and the Golden Fleece* when I did that piece, but I didn't have that experience *until* I did that piece. Back to the landscape—mall architecture is vernacular; mall as a landscape. Usually vernacular architecture is associated with indigenous materials. Now, however, we're talking about a landscape dictated by social and political parameters. These things dominate the context.

mt The fact of architecture using indigenous materials isn't really a factor now. Materials are global.

RH You have postindustrial indigenous now. Most petroleum products are coming from the Middle East. Salman Rushdie is affecting the price of plastics today. The vernacular encompasses the globe in a very literal sense in 1989. In the past, the notion of globe

was a romantic gesture. That is, the experience of other parts of the world was largely a gesture of the imagination. People didn't know what went on beyond their immediate surroundings. Kafka wrote *Amerika* out of this awareness. Even though it is a kind of comedy, his knowledge of the country is half fantasy. Obviously now, the media makes the distant near and entirely visible. It gives concreteness and credibility to what is not immediately present. Now we've really got it and I don't think it's romantic and I don't think it's quantitatively less.

mt Just radically different. So your choice of landscape as an inspiration and reference is really a political choice.

RH Yes, because I don't see it as being about trees and dirt. I see it as defining what the identity of a given place is.

mt I was interested in the change in surface in these new pair-object pieces in contrast to the earlier lead pieces which were very handled.

RH The lead pieces are really one-on-one objects. They needed a shape that was unique in order to rid them of metaphor or to approach that. These pair objects are machined. They are quantitatively identical and qualitatively identical. And that is why I used machine technology, to create *identical* things. I have no special attachment to hand techniques or to the use of advanced technology. The techniques are selected freely based on the form I am working with.

mt It's about replication.

RH Yes, it's about replication and identity, of being able to reproduce identities, but not infinitely, although machining holds that possibility. It's just about two objects and the space between them which is inseparable from them.

mt You're starting with two instead of one; denying one individual thing or a sense of oneness.

RH Yes, I think that's true. With one object, its presence is emanating out into the world with it as its center. With two objects that are one object, you have an integral use of the world. You have the necessary inclusion of circumstance.

mt It's like having two suns, two orbits.

RH Two s-u-n-s? Yes. There is a piece I did in 1986, *When the How and the What are the Same*, which is two spheres. The condition of the sphere is that you can approach it from any point in space and still see the same thing. It's pretty radical, conceptually. The other aspect of the sphere is that it's actively a noun and a verb; it carries both identities. It centers and it is the center, simultaneously.

mt The viewer approaches your work from above. Usually, all the pieces sit on the floor.

RH There were the *Post Works* which are up above. They lean against the wall and all the action takes place up above. They're all approached from the point of view of the average

human presence. Things don't exist unless you experience them. From the point of view of the maker, they all necessarily exist a priori. They are essential to the artist's existence. These objects exist in a very literal relationship to human presence, not without human presence; not in the making and not in the viewing.

mt So you really disagree with some of the basic tenets of minimalism?

RH I'm not attempting to discount it in my work. But, in many ways, my work is a criticism of minimalism. Using geometry isn't enough to place it in the context of minimalism. The attitude towards making objects as separate from human experience is not one I can participate in. I don't see geometry as an abstract or conceptual thing. La Fontaine said, "Shall it be a god, a table or a pot?" That seems to come to mind with pieces like the cones. My use of geometry and the geometries themselves are so mundane. It is their connection to circumstance—this adulterates the purity, makes the geometry—the cones are *of* the world, not idealistically detached. There is a sense in which the cone shape I'm using now has no identity other than a set of proportions and a shape. It has no material reality. It has no analogue in the real world. Its use value is the experience it provides for. As a human being, the epitome of use value is experience and this is your consumer product.

Robert Gober, *The Upended Sink*, 1985, Plaster, wood, steel, wire lath, semi-gloss enamel and latex paint; 30" x 37" x 28 1/2".
Courtesy the artist.

ROBERT GOBER craig gholson

BOMB # 29, Fall 1989

Robert Gober's sculptures call everyday objects into question.
And what he discovers in calling the common into question, is
the disquieting, the disarming, the unnerving and the discon-
certing. Taking objects—a bed, a crib, a door, the accou-
trements of a pet—which, while anonymous are also universal,
he plays with the tension between the neutered forms and the
strong emotional and physical connotations we attach to them.
In the alchemy of transforming these objects, Gober trans-
forms a viewer's emotional and physical reality; the common
made uncommon.

craig gholson What would you say if
someone called your work perverse?
ROBERT GOBER I would like that, and I
would say that they were right.

cg What about it makes you think it's
perverse?
RG [*pause*] How can I answer that?

cg Maybe you could try and define
what perverse is?
RG You know, this interview is going to
be a problem, because I'm not
innately drawn to coming up with
sentences about my work. What I
cull is more of an emotional feeling,
and to me it's not important to put
that into words. Or at least to put it
into words to make it communicable
to a general readership. That's not
where you're going to gain an

understanding of my work. I'm not
gifted that way. I'm not drawn to it,
right now.

cg Did you study art?
RG Yes. Although, I went to a liberal
arts college.
cg Where you read art criticism?
RG Sure.

cg So you did have to talk about
work in that way, but it's some-
thing you just decided wasn't valu-
able for yourself.
RG It's something that you learn to pro-
tect; your relationship with your work,
and you can only talk about it so
much before certain things get
spoiled. What is at first a discovery
when putting something into words
loses meaning the second time.

cg No, I understand. When I'm beginning to write a piece, I know that if I talk about it too much, I will never write it, because, in a way, it is out in the world already.

When I was preparing your questions I realized that I had loaded them all with such heavy information. I couldn't figure out a way to talk about the humor in your work. It's much easier to talk about it's more psychologically charged elements.

RG The humor is very important. A lot of times in the studio, I push the pieces until they make me laugh. It's a way to let people enter into the piece, where you can give them more complicated and fraught material. It's a disarming device, but it's also a pleasure that comes with the piece.

cg Because your work has that heavy, serious side to it, but is also very playful, it has an ironic level to it. How would you define irony?

RG How would you define it?

cg I would say it's a comment on something while still being that thing.

RG But yet giving you different information, a different slant on it. I don't think irony's all that important an issue. I mean, what isn't ironic?

cg I had a list of some ironies that I thought about in your work, like the idea of handmade readymades.

RG Right.

cg Banal objects as art objects.

RG Right.

cg Basic forms deformed; the intimate personal thing that looks mass-produced; the cradle as grave; the nurturing parent as sadist . . .

RG That's all true. I guess I don't think about irony; it's such a given. I mean, can art be interesting and not be ironic these days? Maybe. I don't know.

cg The dadaists and the surrealists used familiar objects as art and were very involved in verbal aspects in their art making, like Magritte having a painting that says, "This is not a pipe," underneath the pipe. That is obviously ironic, but what ends up being irony in the latter part of the twentieth century is just to call a piece *Untitled*. The literal has become ironic.

RG It's true.

cg Did you consciously decide not to deal with the verbal in your work?

RG Do you mean as literally as using words in the art?

cg Yes.

RG Is it a conscious decision? Well, there are words in that piece—in the cat litter—although they're tangential. They're subsumed within a structure of the sculpture, but I guess that's the first time.

cg Do you have a title for this piece?

RG Probably *Cat Litter*.

cg Your earlier pieces were titled. All

the sink pieces had titles to them: *The Upended Sink*, *The Split-up Conflicted Sink* and *Two Bent Sinks*. Gradually, you moved into calling them *Untitled*.

RG There was a phase, when the sinks were mutated and distorted. It felt very useful for me to give them poetic titles, because I could load up the information even more. But in certain instances, it seemed better to hold back and not direct people.

cg As a playwright, one of the things that immediately strikes me about your work is that it has a narrative to it. I see an object and it has a history; it seems like a summation of personal experience. I see an emotional object. Do you think that there is a narrative to your work?

RG Yes, I do. There's a narrative unfolding.

cg And is it a personal narrative?

RG I don't think that it could be anything but. You try to place it into a larger consciousness; you try to place it within perhaps an historical perspective, a broader American view. But, definitely, it's always a personal narrative.

cg So when you look at a specific piece, does it take you to an emotional location or a physical location?

RG You mean like a memory?

cg Yes.

RG That's one experience. It's not enough to make the piece interesting as a sculpture. It has to be resonant for me. It has to entertain me.

cg Did you have a dog when you were a child?

RG Yes, I had two dogs at different times: Suzie, a long-haired mutt, and Mitzi, a beagle.

cg Was your dog bed piece a dog bed one of them had?

RG No.

cg Your work seems almost inherently anti-editions. Can you imagine doing editions?

RG Yes. This whole show will be editions. Like anything else, what starts out as a liberating gesture ceases to be if you do it enough. At first it was liberating not to do interviews, to make that choice. But after a while those decisions that initially free you, like not to do editions, just to do unique pieces, becomes as much of a cliché as anything else. So I thought this whole show would be a challenge to do multiples and interviews.

cg In looking through your review file, a number of the discussions of your work seemed to center around whether it was cynical or not. Do you think it's cynical?

RG No, do you?

cg No.

RG I don't think art is inherently cynical. I think it's inherently hopeful.

cg Definitely. Though it's curious that they would read that in your work. Do you think it's a function of being a journalist?

RG God knows. Part of the problem with

Robert Gober, *The Split-up Conflicted Sink*, 1985, Plaster, wood, steel, wire lath, semi-gloss enamel and latex paint; 81" x 81½" x 25".
Courtesy the artist.

the discussion that's clustered around my work has been the fact that I haven't given them a structure to bounce off of and to comment upon, so until pretty recently it's been rare that someone has written something original or smart.

cg Were you raised Catholic?
RG Mmm-hmm.

cg Do you think that your work is informed by any kind of Catholic guilt?
RG When you're raised a Catholic—at least in the way that I was, which was very strict Catholicism—and you make the choice to reject how you were brought up, the rest of your life becomes a redefinition.

cg As an ongoing process.
RG Yes, at least right now, for me.

cg Are you still Catholic? Do you go to church?
RG Thank God, no.

cg Do you believe in God?
RG I don't think so. Do you?

cg Yes.
RG Really?

cg Not *God* God, but a spiritual force, definitely.
RG Oh, I envy people who do.

cg I'm sure being a Catholic probably drove it right out of you.
RG The Church was a very sick place. The Church that I knew was an

extremely hypocritical institution. That might be where I got my initial inspiration of perversity, growing up within the Catholic Church.

cg Well, if anything could do it, the Church could. Where your work is extremely psychologically charged, at the same time, it's almost anonymous; in a way, because of what the objects are: a sink, a urinal, a bed . . .
RG Yeah.

cg It's a depiction of a kind of universal individuality.
RG Mmm-hmm.

cg Now, that could be a definition of spirituality.
RG Huh; interesting.

cg Could you imagine that the psychological, for you, is spiritual?
RG Yes . . . Yes.

cg And do you see a difference between the spiritual and the psychological?
RG [*pause*] Sure. But there are points where they intersect. And that might be the point of an artwork—sometimes.

cg What are you thinking?
RG I think it was Tim Rollins who said that to him, paintings were like prayers. Beautiful.

cg Yes. Do you consider all of your pieces childhood oriented?
RG No. For instance, I don't think the

piece of plywood necessarily has anything to do with childhood. Nor does a sink, necessarily. Although I think that until recently, a child's perspective informs a great deal of my work.

cg Yes, definitely. Your studio is across from a graveyard. Would you consider yourself obsessed by death?

RG You make it sound pejorative.

cg What brought that to mind was that the sinks sometimes look like tombstones, they have a tombstone curve to them. And in fact, *Two Partially Buried Sinks* is basically a grave. To *sink* is a downward motion. The doorway pieces are essentially passages from one room to another, which could read as from life to death.

RG For the most part, the objects that I choose are almost all emblems of transition; they're objects that you complete with your body, and they're objects that, in one way or another, transform you. Like the sink, from dirty to clean; the beds, from conscious to unconscious; from rational thought to dreaming; the doors transform you in the sense that you were speaking of, moving from one space through another. But about being obsessed with death, it sounds a bit . . . depressed.

cg [*laughter*] Yes, it does.

RG Of course, it's hard living in New York right now not to be. It's always on your plate.

cg Yes, as I choke on a sip of water. One idea that occurred to me was that nostalgia might be equivalent to terror for you.

RG Oh, how interesting. How interesting. Yeah.

cg You think so?

RG I think it's a very interesting comment.

cg The objects that you choose are in your past, from your history. Then you twist them in a way where everyday objects have a nightmare quality to them. Or as seen in a dream. Is that true of your reality? If you look at a chair, does it have this kind of horror for you?

RG [*laughter*] Only when I'm inspired.

cg Do you get images from your dreams?

RG I wish it were that simple. Once in a while; yes and no. With the sink, only after I was making it as a series did I realize that I had had, years before, a recurring dream about finding a room within my home that I didn't know existed. That room was full of sinks, but it was very different . . . there was sunlight pouring into the room, and there was water running in all the sinks. They were functional. So it was an image that I had a recurring dream about, but it's not like I woke up and said, "Gee, that would make an interesting sculpture." It's more after the fact. You look back and you see all these different influences: dreams; people you've known; things you've read.

cg That's curious, because your work seems to be very much about making the unconscious conscious; pulling those objects from somewhere really deep inside; taking the nonreal and making it real and then making it unreal again.

RG Yes. That's true.

cg You were familiar with Duchamp's urinal?

RG Sure, who isn't?

cg That's the other thing that reviewers always bring up.

RG I know. They say it preoccupies me, but to me what's interesting is that it seems to be preoccupying them. They're the ones who are always writing about it, not me. It's not a piece that particularly lives in my soul. It's an interesting piece, it's a great piece, but it seems to be on their minds, not mine.

cg Do you like the surrealists?

RG To a degree. When I was a teenager I loved Dali.

cg But not now.

RG I don't think about them now, no. Not much.

cg It's interesting that you liked them as a teenager because I think that it is work that is almost inherently adolescent—offensive behavior to challenge a cultural norm, an authority figure, the father. At a certain point in your life, it seems very puerile.

RG Right, but that's a staple of the avant-garde, isn't it? Of shocking the bourgeoisie.

cg But your work does that and then does something else, as well. It gets into more interesting terrain.

RG How so?

cg The sink pieces must have mortally offended some people.

RG Someone put their cigarette out in one.

cg That's a comment, isn't it?

RG Of a sort, yes.

cg But they have a deeper meaning. There's something else going on other than just offending someone's sensibilities. Whereas with the surrealists, I often get the sense that it is not about much more than that.

RG Even someone like Magritte? I think he transcends what you're talking about.

cg Maybe. At different times in your life, you go back to work and you like completely different things.

RG Isn't that interesting? Certain things at certain times.

cg It's the cross between the surrealist and the minimalist in your work that gives it an edge. They aren't two movements that one would think could, in any way, be essentially compatible, yet you've managed to merge them. And it's not just by sticking one element in there with another.

RG That's true.

cg This interview is ending up being all my theories about your work.

RG That's fine.

cg No, it's not. It's got to stop. Plus, I don't think I have any more theories.

RG Oh, that's the problem: You're at the end of your questions.

cg What's an area of your work that you think has really been misunderstood or not read properly?

RG The sense of humor doesn't get mentioned, which, to me, is enormously important.

cg I asked the sculptor Jackie Winsor what she would ask you.

RG Oh, yeah? And what'd she say?

cg She said to ask you what your experience of being an artist was; how you experienced being an artist.

RG [*pause*] It's not something I'd wish on anyone. It's not an easy occupation, if it's an occupation at all. But in what way being an artist? There are so many different ways to look at that. I look out my window and I see guys washing windshields. There are so many miserable professions in the world; so, as a job, how can you complain? But I don't think it's easy—that exposing of yourself continually to the public. And for what end, you know?

cg For me, the difficult part is having to dredge the stuff up from inside of you. It can be so excruciatingly painful.

RG Yes. And without guidelines. How do you do it, and in what form do you put this information? How do you make it interesting to other people? How do you translate it in formal terms?

cg It's that Greek idea of hubris, where once you've crossed a line, once you've brought something up and you have knowledge of it, you can't go back. And, you know, sometimes you would really rather not know or have to confront that.

RG Yes. [*pause*] Making sculptures has taken me places emotionally and intellectually I would never have gone to if I wasn't an artist.

cg And do you have any regrets about that?

RG Sure. [*pause*] Do you?

cg No, not so far.

RG Really?

cg I like to confront my fears. I suppose it could be termed suicidal, but if there's something that I'm really afraid of, I usually force myself to do it. I use it as an indicator to do exactly that.

RG Yes. When I talk about regrets it's that life is short; there's only so much time; you can only do so many things. An extraordinary amount of my time is focused on myself and my work, and there are so many other pleasures available in the world.

cg Do you consider being an artist a selfish job?

RG No, do you?

cg I think it can be. For people who make bad art I think it is. [*mutual laughter*] Do you have any sense of where you want your career to go?

RG My career? That's very different from saying my art. What do you mean?

cg Do you have specific career goals?

RG Well, in a certain way, you can't plan opportunities. You never know where they're going to come from or how they're going to present themselves. Career goals . . .

cg Is there something you really want, like you really want to have a show at the Modern, or . . .

RG Oh, no. I'd like to work in the theater.

cg Doing sets?

RG Not necessarily doing sets, more conceiving the whole overture of the look of a particular production, whatever it is, in the same way that I've created an environment within the gallery. The stage is a logical, and maybe even a more useful, platform for that.

cg And would you imagine doing this in relation to someone's text?

RG In some way. But it's a vague idea. Who knows? Who knows how it'll happen?

cg Psychology deals with things as problems; metaphysics deals with things as a journey. Do you have a problem or are you on a journey?

RG Both. Both.

cg Can you define what the problem is?

RG I could avoid the question and say the problem is how to make viable sculptures.

cg But if you weren't going to avoid the question, what would you say?

RG I couldn't answer it publicly. There would be no point.

cg Do you have a sense of what the journey is?

RG It's the same answer as the first one: how to make a viable sculpture. No, that's not true—it's more than that. It sounds so corny—it's the journey of life. It sounds so silly; it sounds so stupid, doesn't it?

Adam Fuss, *Love,* Unique cibachrome print, 1992, 30" x 40". Courtesy Robert Miller Gallery.

ADAM FUSS ross bleckner

BOMB # 39, Spring 1992

Adam Fuss makes intensely beautiful photographs. The first time I saw them, several years ago at Massimo Audiello's gallery, I couldn't figure out what they were. They seemed like paintings. They were constantly emerging and disappearing. No matter what the imagery, they are about the alchemical nature of photographic transformation: perception, light, and magic. I finally found him, and after exchanging studio visits, we sat down in my studio apartment to talk.

ADAM FUSS It's nice here.

ross bleckner You make things to compensate, that's what being an artist is, right? Compensation.

AF What can you compensate for?

rb Not having a love in your life. It's not permanent, Adam. I always look at the positive side of things, what I have to look forward to. When I have a boyfriend, I'm very settled. When I'm alone, I'm curious to find out who my next boyfriend's going to be. I'm much more motivated to go out. I do these things that I would never do. That I don't even like to do.

AF Really?

rb It sounds like you have some very problematic relationships. I wouldn't stand for that shit from some kid.

AF That's just what I realized actually, yesterday.

rb How old are you?

AF Thirty.

rb Well, you're not that much older, either. The benefits of having a relationship with an older person is that hopefully they know certain things that you don't know yet. I wish I had had an older boyfriend who could have said, "You know this hysteria you're going through? It passes. It's really not a big deal." If someone had said things like that to me, it would have been very calming. Just to have known what's normal and not to have had to personalize things so much.

AF I've never had a relationship with a normal person; I mean a physical rela-

tionship. It would be a great thing. Not to say that older people aren't as fucked up as younger.

rb Well, it's different. People who are more mature, are more ready in their heads. I know I'm ready in my head for things . . .

AF When I'm in a relationship, it's this big thing. This is it. We're trying to build something that's going to last for the rest of our lives. We're not just experiencing the moment. There's an agenda which is the marriage of two people. Maybe that's an unrealistic expectation to have when you meet someone.

rb Ridiculous.

AF You think so?

rb Yeah, it's completely juvenile. That's what I think. Why can't you just say, Let's enjoy each other for now?

AF Now? When does now finish? Does *now* finish when you walk next door and fuck someone else? And *that* becomes now?

rb No, no, no. The point is that if all the nows are good then it lasts for a long time. If you really enjoy each other and let each other grow and one of you wants to fuck around, then that has nothing to do with it. So what do they do, this twenty-five-year-old you're with?

AF Film.

rb Really, how long have you been together? [*eating*] Good!

AF It's ummm . . .

rb Fattening.

AF It's all-grain almond flour with almond paste, I don't think that's fattening. I mean, it's not full of sugar or anything.

rb Right. No sugar, I'm sure.

AF You know, I met this person and I had a very intense experience. I really wanted this person, and they didn't want me.

rb Are you talking about right now?

AF No, I'm talking about a year ago.

rb Not the same one you're with now?

AF Yeah . . . yeah.

rb What do you mean they didn't want you?

AF Just what I mean.

rb How frustrating. So you're still with them?

AF Well, no. I mean, look, a period went past like eight months. And during that eight months I was still mentally with this person even though they didn't want me, I wanted them.

rb What do you mean? You weren't together?

AF No. And then a month ago this person comes to New York and says, "I want you, and I want everything."

rb How did they communicate with you all those eight months?

AF Very badly.

rb Were they involved with someone else? [*pause*] Huh?

AF I would say, yes.

rb Did you tell them, "I love you," and all this crap?

AF Yeah.

rb You wrote her letters?

AF I beg your pardon.

rb You wrote her letters?

AF Her. [*laughter*]

rb Assuming it's a her.

AF I was wondering when this person was going to have a gender. Yes, I wrote her letters. Actually I made her tapes. I like making tapes.

rb Wow, that's so romantic. I wish I would like someone enough to pursue them.

AF Well, the energy to pursue came from wanting this big story, of wanting this one person.

rb I don't see what made you think you had a chance. I don't get it. You forgot about her? And then eight months later she shows up.

AF No, I didn't forget about her, that's the thing. She knew eight months later that I hadn't forgotten.

rb When you first met, what happened?

AF The very first time?

rb She's not just a woman you saw in the distance and you started writing letters to her in order to meet . . .

AF No, not at all. I was in Paris and I was in the mood to meet people. And I met this person, it was nothing particularly . . .

rb So it's not like you met, had sex and fell in love, and then she said, "I have to go away. I can't be with you."

AF Well, that is basically what happened.

rb Oh, I see.

AF I mean, that was extended over a period of time. But that's basically what happened.

rb Interesting. Fantastic.

AF And somehow the connection made something really strong in me that lasted. And it didn't in her.

rb [*screams*]

AF And then she shows up here and says, "yes."

rb Without a warning?

AF With a little warning.

rb So why is it so complicated? It sounds like a lover's story with a happy ending, so far. A pursuit, a courtship, it sounds very traditional.

AF A mating. [*laughter*]

rb A mating.

AF A spring-off and a separation.

rb And a reconciliation. This [*the food*] was so good and it is all healthy and not fattening, right?

AF I suppose if you sit in a chair all day, it will make you fat.

rb I know, that's why I have to go to the gym in an hour.

AF Ross, that's a little soon to go to the gym!

rb No, an hour's fine.

AF Your food's not going to be digested at all.

rb I always do it.

AF I'm assuming you exercise at the gym.

rb I'm not just cruising there.

AF I like this painting of yours, it's like a lifetime of moons.

rb [*screams*] That's such a great name!

AF Three thousand moons.

rb Exactly. That's such a good take, Adam. I'm going to write that down. A lifetime of moons . . .

AF You don't have to write it down, Ross.

rb What are you talking about? I'm going to rename the painting.

AF Yeah, but it's on the tape recorder. [*laughter*]

rb Oh.

AF A lifetime of moons.

rb Adam, how long has the tape recorder been on?

AF The whole time? What's the title?

rb It was called *Wind*. Weather like this, when the rain blows into the window so you can see the rain-drops and they have this funny perspective as they're breaking open. Wind-driven rain.

AF That's too scientific.

rb But I like scientific names for poetic art and poetic names for scientific art. I like to enhance the inherent dichotomies in paintings. How long has the tape recorder been on, Adam?

AF All the time. But it's probably not working.

rb Did we talk about anything?

AF We only talked about important things. [*laughter*]

rb Okay, come on, I'll ask you more specific questions then.

AF That's a wonderfully good holly tree in your courtyard. I love holly. It's a very medieval, ancient tree, full of poetry. And rhododendrons. These are all English plants, you'd like England. You can find a wood just of holly trees, or a forest of rhododendrons.

rb Were they planted at some point?

AF No, they're indigenous. Actually, I think rhododendrons might have been introduced from the Himalayas.

rb But the cultivation of everything is not indigenous. The way things grow. Liquid Light.

AF Liquid Light?

rb You know what that is? I want to work with it.

AF Tell me what you want to do.

rb I don't exactly know. I want to make drawings I can brush on: Photosensitive emulsion on can-vas. I just want to do simple little things, very basic, elemental, ichnographic presences.

AF I got it. There's a canvas that's like photographic paper, it's sensitive to

light and you can buy it in rolls. Do you want to make paintings with light or . . .

rb I want to paint over light. You do that in your work. How important is that to you? What kind of light exists in your work?

AF This paper I was telling you about, there's a whole world there. You can make emulsions that have a specific tonality. You can work with platinum. You can work with silver. You can tone with gold. I'm going to order a few sheets of linen for you.

rb Really? Adam, let's talk about your work now. Okay?

AF Light. You asked me about light. Listen, Ross, light is a physical sensation. If you look at it with purely scientific eyes, it's a particle that behaves like a wave or a wave that behaves like a particle. No one knows exactly what it is. It travels very fast. It has something to do with our perception of time, and I think when it's reproduced or when one works with the idea of light, one's working with a metaphor that's endless and huge and unspecific. Because you're talking about something that's almost just an idea, we can think about it but we can *never* grasp it. The light of the sun represents life on earth. Light represents the fuel that is behind our very existence, and I don't think any person can really be expected to be able to say what light is if you look at it in that way. It's a mystery. It's an unknowable value on one side and on the other there's a disco light, and a 186,000

miles-per-second light, and a light coming through a stained glass window or the light in the desert when you don't have any water.

rb From what I can see, you use it as a very visceral element in your work, as an absence and a presence in relation to an image. An absence and a presence which a lot of the time is as strong or stronger than the image.

AF Yes, but Ross the light's always present because it's always photography. The inescapable physical manifestation of photography is light, a record of light. The table is wood, the photograph is light and so the subject is also light. I think you're asking me what the subject is.

rb Your concentration in the work is on something that can loosely be described as phenomonology. And one of the things that fascinates me is how you've used this as a subject, what you've created through photography. I don't see your particular perception of light that often, it has to do with spirituality. That's really the question. I feel a sense of yearning in your work and I wonder if spirituality is what it's relating to, or is it something else? You've talked to me about certain philosophies, I don't know what relation they have to your work, or what you're involved with outside of your work that informs it spiritually. I'm very curious.

AF [*long pause*]

rb You could talk into the tape recorder and I could leave the room. No, I'm kidding.

AF Don't you have to go to the gym now?

rb No, I want to hear what you have to say first. It's an easy question. Don't you think? No.

AF Well, I think there is a lot of yearning.

rb What about the first one? The use of light in your photography as being something more than the image of light?

AF You could look at photography in many different ways, one being an alchemy where you're working with two elements, light and silver. You work with oils. Photography's exactly the same. One can make a painting which is bullshit and with the same material make something that's genuine to one's experience. I approach photography in the same way you approach painting, with the same ambition.

rb I understand that. I see similarities and obviously, I relate very much to your work. I'm asking you the other questions because they're questions that I think of, like the idea of yearning. It's a dumb word, maybe.

AF It's not a dumb word. It describes a feeling.

rb I see a description of a feeling in your work. The idea of transubstantiation.

AF Ross, then you see the work in the correct light. Then you see something which is essentially beyond work. This

making of art is really just a shadow of the real yearning.

rb But could you define it?

AF The yearning?

rb For what? For whom? I'm curious to know what the expression under the expression is.

AF Well, let's say the light. I work with light, and the light represents understanding. Understanding that doesn't have an end to it. Not understanding of a problem, but being able to embrace with understanding.

rb Embrace what? I'm trying to be a little more . . . definitive, in a sense.

AF I don't think you can. I don't think I can.

rb That's okay. If you can't, you can't.

AF Light is a metaphor: where you have a dark place, and where that place becomes illuminated; where the darkness becomes visible and one can see. The darkness is me, my being. Why am I here? What am I here for? What is this experience I'm having? This is darkness. This is a question I ask, and when I ask it, it's like looking into a black space. Light provides an understanding. Not physical light, but an understanding of this question is like light. I have this dark space in me, and when I ask a question, that is a desire for light, and perhaps the light will come. I'll be able to *see* something. Like the way I make photographs with a flash. You may see something for a flash . . .

rb You're talking about an epiphany. No? You're yearning for an epiphany. That's what it sounds like, this kind of cosmic big bang.

AF That's exactly it, Ross. That's exactly what light is. It is a cosmic big bang, physically as well. The stuff that we're subjected to here is actually coming from out there. It's old. It's been coming for millions and billions of years, and it's coming from billions of miles away. It's coming from the big universe. We don't know what it is. We don't know where it's coming from. It's not really of this world.

rb You were going to talk about yearning. Maybe you could discuss it more in relation to yourself. What you're saying is very broad. Where are you from?

AF I don't know.

rb I mean where are you from?

AF I don't know. That's the answer to your question.

rb I like the way you don't think literally. It's very nice. You're not a literal thinker although you deal with the mechanism of things. What country do you come from?

AF I grew up in London, and in the English countryside in a small, medieval village . . .

rb Did the English countryside have any effect on you?

AF . . . and in Sydney, Australia on a suburban beach. Yes, the English countryside has had a tremendous effect on

me. It's the part of the world that I feel is my land, my backyard.

rb And you went to art school?

AF No. Did you?

rb Yeah.

AF I made an application to go to a photography school, and at the interview, they said, "What are you interested in?" And I said, "Psychology."

rb That's what you were interested in, Psychology?

AF Not specifically, I was interested in the mind.

rb And you still are.

AF Of course.

rb And you are heterosexual?

AF That's none of your fucking business. Actually, I think it's a legitimate question. Why are you asking?

rb I'm just curious.

AF Why?

rb I'm trying to get all the relevant social, cultural, extenuating circumstances that might inform your image repertoire. The fact that you're male, the fact that you're English, the fact that you think this way or that way . . . I think these things all have an effect of some sort.

AF Absolutely, but do you think that if I say "yes" to a question that it necessarily has to be true?

rb No. It's not? I'm just curious as to what theatrical nuances you would

put on the presentation of your self as an artist.

AF Theatrical nuances?

rb How you construct yourself as an artist. It's an invention. You're inventing yourself as we're talking, as you're thinking, as you're growing, and as you're being an artist. Right? You revise it, you adjust it, you erase it.

AF It's true, but somehow there's something which isn't adjusted or changed or erased.

rb Which is what? This is what I'm interested to hear.

AF You look back on your life and you don't know where the point is that you have become something, or where something has started. Let's take this picture for instance. Perhaps you remember an experience . . .

rb I do.

AF . . . that you had when you were a child which has some relation to this image. Are you reproducing that experience of your childhood? I mean were you an artist then? Where does your fascination for life come from? Can you say exactly from what, from a specific experience that you had . . .

rb I'm getting in touch with the child within. [*laughter*]

AF I had a very strong experience with . . .

rb Just a joke.

AF Yeah, I know. It's a great joke, Ross. We're gonna play it back so you can hear it yourself.

rb Oh God, I'm getting silly. Go ahead, you had a what?

AF Look, light is incredibly beautiful. You have to be an asshole or blind not to appreciate light. I had an intense experience when I was eighteen. I had this mystical experience, where for a few moments, I lost my selfishness.

rb What kind of acid were you on?

AF No drugs, Ross. I just became . . . I lost my ego for a few seconds. I loved someone more than myself. My self disappeared for a short time.

rb You are such a romantic, Adam.

AF But listen, I had this experience where I felt there was a light above me. You can say that a person has seen "the light." In this moment I understood exactly what that phrase meant. I had seen "the light."

rb That's fantastic. Now, I want to ask you something. Are you looking for the kind of love that reconciles you with that original love that a child experiences; the love of reunification, of completeness, of being one with somebody else? Unconditional love?

AF No. In a big sense, yes. I mean, yes, reunification.

rb So have you found that at all?

AF Give me a break will you?

rb Have you?

AF Ross, Ross, look I don't . . . have I found it? Sometimes. [*laughter*] I don't think that's what it's about. I

desire that reunification. I'm not sure I can define exactly what it is.

rb There's no definition, I suppose.

AF The issue is not about another person.

rb What is it with?

AF It's more about a rediscovery of the kind of energy that is untouched by human cultural experience.

rb My God. Is that possible?

AF Yeah, look if the energy that exists in the physical conception of life—when a new life is formed—is cosmic energy. This sounds terrible . . .

rb I understand what you're saying.

AF My whole life is a record book, a memory machine of all the experiences that I've had. But beyond that, there's also something which is mine. And perhaps that is this pure energy. If I can stop reacting and responding to the information that I've received in my thirty years of life, I can stop being Adam and can just be alive and

feel that energy, then that is a reunion. That is, the reunion.

rb Fascinating.

AF And I think sometimes in a relationship you can touch that, because when you are in a relationship you throw everything away on some level.

rb Through love?

AF Not through love . . .

rb Through sex?

AF No, no, no, just through having this relation to an other person. You connect to a part of yourself that's basic, and pure, and selfless. I don't know from my experience whether that's something that can survive.

rb Sounds very intriguing.

AF But I do believe that I can have a relation to myself that can produce the same growth or light. It's the yearning to touch what you are. To find what you are, and light facilitates that process.

Larry Sultan, *Pictures from Home*, Photograph, 1989, 20" x 24". Courtesy Janet Borden Gallery, New York.

LARRY SULTAN catherine liu

BOMB # 31, Spring 1990

Larry Sultan documents the American Dream. He makes stills out of his family's 8-millimeter home movies: oneiric, grainy images of his childhood that move from traces of personal history into the realm of twentieth-century mythology. These images are moving in their specificity: they evoke the collective fantasy of an elusive suburban utopia. The artist also makes starkly intimate photographs of his parents in the present, in contemporary settings that resonate a fifties decor: his parents more contemplative, profoundly cognizant of the camera. The details that come into sharp focus in these portraits are crystallizations of the blurry past evoked in the stills. The films were someone else's representations, hope frozen in the arms of a father and child. In the contemporary images, Sultan takes control of the apparatus, and the viewer is witness to a gaze shaped by memory and desire. Sultan is currently at work on a book which he has described as a kind of "photonovel."

catherine liu I was incredibly moved when I saw your photographs—the stills from your father's 8-millimeter films—they could have been stills from my family's films. You grew up on the West Coast, in an American family, and I grew up on the East Coast, some twenty years later, in a Chinese family. Yet I had this moment of vertigo; I realized that all of us who grew up in suburbia come from the same place, which is nowhere.

LARRY SULTAN Yes, we had a franchised childhood.

cl I felt embarrassment looking at your photographs. There was an aspect of betrayal.

LS Let me just say how I got involved with this. The home movie stills were my point of departure. At that time in my life I was obsessed with memory. I would watch my family's movies as a probe—Proust's *petites madeleines*.

cl As if some secret would be revealed.

LS We all have our ritual snapshots. These are very precious and constitute a personal archive.

cl A change has taken place in the past hundred years because of the snapshot.

LS Oh yes. To be able to see yourself is very dislocating. To see myself as I was. Photography allows you to carry a trace of the past with you. While my photographs are specific and I have that very personal relationship to them, the images also possess the quality of cultural myth: footage of a bear chasing somebody through Yosemite, a boy jumping through a Hula Hoop; a parent holding a child at a waterfall, children measuring each other next to a '55 Buick. We all per-formed rituals. These images consti-tute icons of a family.

cl You talked about your family mov-ing from the East to the West, in search of a better life.

LS Families did involve themselves in these mythic quests. And my family's myth was part of the cultural phenomena of the forties: to go West. To get out of a five-story walk-up flat in Brooklyn and move to the land of opportunity. My father went out there without a job, without any sense of what could hap-pen. Just this desperate hope for change.

cl They thought California was the land of milk and honey. They'd get there and the oranges would be dropping off the trees.

LS In fact, my father bought a one-way train ticket and left us in Brooklyn. On the train somebody says, "Hey man, there's a depression in L.A., there's a water shortage, there's no work." He gets there—he was a cloth-

ing salesman in New York—and stands in line waiting for jobs at unemploy-ment offices. There was nothing. So there was this terrible sense of disap-pointment, initially. He made a home movie of his trip, what he was seeing outside the train's window: landscapes going by; the winter storm in the East when he left; huge vistas in New Mexico and Albuquerque. He stopped in Albuquerque. And then the next cut is L.A; he's mowing the lawn. [*laughter*] Now I never understood that.

cl What a transition.

LS The lawn is the perfect myth of the West. You tend your garden, the gar-den of Eden. It was a suburban garden with marigolds, manicured lawns, and a barbecue pit in the backyard. When we came out—he finally did get a job—he filmed us. In his movies, we're running into the backyard and mother has this huge turkey to barbecue. So they did live out a utopian dream. With movie stills, the event has been distilled into myth. I would imagine that's why it looks like everybody else's past. By taking stills, I've transformed the movies themselves, otherwise the general effect would be that of an edit-ed, distilled recreation of cultural his-tory. By isolating the stills, I can make my own incision. The off moments, that look of worry on someone's face, in the middle of all this . . .

cl Feasting.

LS Yes, yes, there are picnics and then there's a look, just a look that betrays a little bit of what else was going on. It seeps through in film. Which doesn't

happen in snapshots. The interesting thing is that my images are both highly fabricated and mediated. But the fact that they have this filmic quality or this sense of family archive makes them seem very personal and real and, hopefully, they are able to do exactly what they did to you, which is to make you think about your own past.

cl The colors in the contemporary photographs, the ones of your parents in their suburban home—the quilted bedspread, the wall colors— it was almost painful for me to look at these things, embarrassing. All this postmodern good taste in interior decoration surrounding us in the art world is a complete reaction to that suburban space, that failed utopia; a reaction to that disappointment. What our postmodern objects of good taste communicate is the message that we can be liberated through consumption: buy this and you'll be free of your past, free of that pink and avocado playroom you played in. But the gaze that you directed towards your parents or those objects in your work wasn't a gaze that was ironic or cynical at all. That's what made them so painful.

LS It would have been very easy for me to emphasize from a very cynical perspective how their taste, in relation to ours, is bad taste, or kitsch. I loaded the deck by doing this project. If I had gone into someone else's home in suburbia, I would have gone in as a voyeur. What is crucial here is that this is my family, these are my parents, and I care deeply for them. And I have an enormous argument with their culture (perhaps it's my culture as well), but I have something else, too: compassion. It's the depth of love. The hardest part of the work was dealing with the question of whether or not I was betraying them. I could be using them, as a symbol of the failed American Dream. Coming to terms with those questions has been very difficult and that's why the text is there—I want them to have a voice in this.

cl If the work consisted only of the photographs, you would be subjecting them to all of our gazes. By giving them a voice, you allow them a little space to exist outside of the photographs.

LS It is absolutely crucial. All photographs raise the issue of voyeurism—it's unavoidable. I mean, no one believes in photographs, right? We're much too sophisticated. Yet, in fact, we do. There's always a photograph that will wound us still, that will, as you said, make us feel something painful or embarrassing. It's because of the intimacy of photographs. The collaborative work I have done, and still do, with Mike Mandel, has been mostly about media and advertising and is presented on billboards. There was something missing from that work for me. And it is this notion of how we function or don't function on a daily level. My daily issues are about family and relationship, success, failure, and disappointment. And the everyday was the site for this work. And I wanted to approach it with tenderness, rather than with dismissal.

Larry Sultan, *Practicing Golf Swing*, 1989, Ektacolor Plus, 30" x 40". Courtesy Janet Borden Gallery, New York.

cl There's something of stripping the object naked—the photographs are without artifice.

LS I disagree. That ambiguity is interesting to me. I use the suburban house very much as a stage. I'm conscious of what the bedroom signifies and how it's arranged. I do see it as a theater. Sometimes they're not posed at all, yet those can look the most posed.

cl What did your parents think of this project? How did they feel about their participation?

LS The major problem has been more my guilt than their ambivalence. There was a point when I realized, after a few years, that I had to show them the pictures. I'd bring them the pictures, but I'd edit them.

cl You mean you didn't show them all the pictures?

LS I'd show them a selection. There were pictures that were very troubling. Of course, when I'd show my father pictures, he'd say, "Well, why should I be sitting on the bed with my suit on? Why do you want that image?" We would actually discuss what my point of view was and how he felt about it. Of course, whenever we're photographed we want to look good. Vanity cuts across all the cultures. We think we're clear about how we're going to be portrayed, how we want to appear. So that was an issue. But when I showed him these pictures, he said, "Well, why are you so upset about these?" And I said, "I feel like I have a responsibility to show you in a way that's accurate for me, but that doesn't violate you." And

he said, "Hey, I know who I am. This is your point of view." I thought, what a remarkable sense of self-knowledge that he could allow me—these pictures were becoming public at this point—to have these images. That generosity was part of their relationship to me.

cl You were afraid that these pictures would change them, like the old Indian myth.

LS No, not change them.

cl Diminish them.

LS Yes, very much. I think pictures diminish us.

cl Do you?

LS Absolutely. Absolutely. We exist in time. That's who we are. Our whole identity is about change and temporality, and a photograph is a slice, a stoppage of that. When you take an image out of time, it's like an insult. It's when someone says to you, "You are this." We can always become something else, something fuller. I think photographs take the richness of our temporality and reduce it. To me, it is the most crucial part of photography. This project was changed for me when I was looking at a particular picture I had made, writing about it, decoding it, and it struck me that this picture might outlive my parents. And it became like an elegy, a memorial. It's not that they're just symbols. They're not just symbols to me. It shifted from something very distanced, a sociological or deconstructive analysis to something much deeper than that. There was a sense that these images are traces of

them, their existence is necessary. It's
the bottom line of all photographs.

cl So behind every photograph is the
idea of a death or an absence . . . I
want to backtrack a bit. You men-
tioned your billboard work very
briefly.

LS Coming from L.A., where most of the
culture is automotive, and most of the
images are things you don't choose to
see, billboards are a powerful context for
imagery. In fact, growing up in L.A.,
you'd drive down Sunset Strip and look
at billboards instead of going to art gal-
leries. It's an awful thing to admit, but
the advertisers were the visionaries of
our time. They gave us the notions of
what we should become. Our myths of
heaven and hell were right there on the
billboards. So, while in graduate school,
I began to collaborate with Mike
Mandel. We wanted to work in a way
that would give us that kind of immedi-
ate access to the public. We just called
up the billboard companies to get free
billboards. That was in '73.

cl What were some of your slogans?

LS "Whose news abuses you?" "You're so
easily influenced." "We make you us."

cl I like that, "We make you us."

LS A lot of our billboard images come
from advertising that we just alter
slightly. Recently we produced a series
called "*Trouble Spots*," scenes from a
fifties Bible.

cl Billboards?

LS Yeah. Trouble spots: Japan, Russia,
Nicaragua, Arizona, et cetera.

They're difficult to describe except
that they're very simple. We wanted to
display the fifties vision of what these
places used to mean to us, especially
Russia and Japan, and what they mean
now. For instance, the image of Japan
is an arm pulling back a curtain,
revealing six Americans in suits;
behind them are flames, hot, glowing,
yellow flames. The flames suggest
both Nagasaki as well as Japan's cur-
rent economic power. The myths of
these places are changing. Yet, we still
hold on tenaciously to our past fears.

cl How do you feel about being
labeled a post-'68 artist?

LS I wouldn't think of myself as that but I
was influenced and affected by that
time. I was in political science at UCLA
and UCSD and I became a photogra-
pher as a way of participating in those
times—as a witness and a creator.

cl Those were formative years.

LS Oh, I don't think I'd be sitting in this
room without the sixties. The sixties
gave me permission to stay right where
my values were and that was really cru-
cial; the times gave me my role as an
artist. It was a confusing time. I was
both part of it and also very isolated and
alienated from it. There was a great deal
of paranoia in the sixties. If one wasn't
correct—it's the same kind of paranoia
we have now—none of us are correct; in
our deepest souls we're all very incorrect.
Who do we share that with? It becomes
a very alienating paranoia that we carry
with us. In '69, I joined VISTA
[Volunteers in Service to America] and
worked in South Chicago as a commu-

nity organizer. I also joined Newsreel, a radical art collective. I was in it for about two weeks before I quit because of the in-fighting, everybody calling each other pigs. We were all trying to get up the heap, and you got to the top by climbing up the bones and annihilating everybody else philosophically, ideologically.

cl Back in the sixties, activists thought you could make this terrible short cut, leap into a kind of liberation or total freedom without having to deal with personal memory at all.

LS Growing up in the sixties, one had to turn against one's parents in a much more substantial way than that process of differentiating ourselves from them which naturally occurs. There was an institutionalized form of rebellion that was really an attempt to sever family ties. The image of both my mother and father for me still carries some of the stain of that conflict. Now I have a child and I, of course, see myself as my father, and I'm no longer afraid of that. It's no longer some awful echoing. I embrace it. That reconciliation for me has been crucial. It doesn't mean that I have to embrace their values, but I understand how they were formed by a time, by an historical circumstance, and I don't see them as victims: I see them as active players. That's where the compassion comes from.

cl Isn't it funny, how compassion is something you have to work through to find?

LS Yes. You're not given it. In the tradition of documentary photography you're mostly thrown out to photo-

graph that which is different, the other; you can have a general compassion, but there's not the sense of intimacy in contact. To me, that's very problematic. I don't know where I fit in. I don't know whether I'm considered a documentary photographer or not. I love realism, but I don't think I could go out into a war zone right now and deal with the spectacle of war.

cl And play the role that you'd have to play there.

LS To me it's very important to deal with something I am in contact with and know. It's crucial to me.

cl It's the intimacy of your work that is so disturbing. The form of photography hasn't been one in which we see a lot of intimacy. Advertising and fashion photography, portrait and realist photography, are really all about distance. It seems that only in that distance can we achieve some kind of relationship to desire. We seem to be looking at everything from very, very far away. Your images are very, very close. What you're asking the viewer to do is assume your position. We all feel a terrible resistance to it because it is so intense.

LS The great influences on me are James Agee's, *Let Us Now Praise Famous Men* and *Death in the Family*. The novel allows for an intense intimacy. We locate ourselves differently in written narratives than we do in photographs.

cl You're writing the text for your

book now. It makes sense that you should be moving into this form. Writing is about interiors, about opening a kind of inner space.

LS Yeah. That sense of a life lived and how we participate in it. What concerns me is setting the portrait back in time. To set memory in its place in cultural history. That's maybe the only way to make history real to us again. The novel does that. I see my work as a mutation between fiction and nonfiction. Divergent stories. Pictures say one thing, texts another. There's a set of contradictions between text and image which places the viewer in an awkward position. Who do you believe?

cl I love that statement your father made, about how he doesn't see himself in any of your pictures.

LS Yes. He says to me, very clearly, "That's you you're photographing. That's you sitting on the bed," and he's right. And he says, "I'm glad to help you with your project." It's funny because he's participated in this in such a way that I feel like I'm back in the state of being an adolescent. He calls me up and says, "How's the project coming?" And I say, "I haven't been able to get to it." He says, "You've been procrastinating, haven't you?" I feel like I'm back mowing the lawn again. So, I have the opportunity to work out the things I didn't do very well when I was fourteen. Originally my interest was to deal with the male vision of success and career. This work is not just home movies and family pictures. The work

in the book form is about corporate life—public and private.

cl I saw something at MOMA about that. There was a copy of a letter of promotion that your father had received, praising him as a good employee.

LS He began as a traveling salesman for Schick Razor, and then he became one of the vice presidents. When he was first hired, he was told that he was a team player on a smooth working team. It's such a wonderful analogy to baseball because, in the beginning, you are a team player until you reach a certain age and then they trade you away. That's the American story: when a corporation changes hands everyone on the top is let go, because you have to bring in a new team.

cl Disposable razors, disposable people.

LS Exactly. Part of what that brings up is the notion of identity and how we form our identity through this duet of corporate and private life. It creates major conflicts in our notion of the self.

cl Especially in the male notion of the self. Especially for the father, breadwinner.

LS Well, when he lost . . . he didn't lose his job but when his job was finished with him, my mother got her driver's license. She didn't drive until I was sixteen. And then she got her real estate license. Now she's a very successful businesswomen. For the last twenty years, she's been doing that. Yet there is still continuity in their roles in the family. He does some

cooking but she is still seen as the housewife even though she is also a career woman.

cl **What's the object of desire in your work?**

LS [*pause*] Longing. Enormous longing. It's hard to say. I'm trying to think what I'm really longing for. I am still caught in that longing for that same utopia my parents were longing for by coming out West. And I'm caught between knowing better and still desiring that security and some past that doesn't exist except in home movies.

cl **It's interesting, your relationship to utopia as a past and your father's relationship to it as a future. He was riding out on the train, making that 8-millimeter film, thinking about California, as if utopia existed. It did—in the collective imagination. Utopia was the future.**

LS The home movies seem to me the visions that a family in Flatbush, New York dreamed up. If you took all our hopes and projected them onto emulsion, it would look like those movies. The home movies are utopian because they're so selective. When I had the show at the Modern, an artist who grew up on the East Coast said, "I can't believe that this exists, that these are real. You lived that way? This was your past?" Because the images seem so impossible. They are true and they're not.

cl **It's like discovering what being American is about.**

LS It's a very middle-class American

story. I don't know if people outside that experience have the same feeling.

cl **Like Proust, you are telling a story whose intense specificity made it able to speak to so many different kinds of experience.**

LS That's the key, the specific. That's the beauty of the photographic image. It's always the detail. There's a picture of my parents sitting on their bed and they're turned slightly to each other. It's just the degree in which they're turning to each other. It's the fact that my mother's bra strap is showing and my father's underwear is coming up, and that there are sweaters folded on the bed. This image opens up to an enormous amount of conjecture—what are they talking about? What's happening? But the first thing that's established is the authenticity of that moment.

cl **So no photograph lies. Each photograph has a kind of truth, a testimony to the moment. But somehow photography is not enough for you. That's why you have to write.**

LS The meaning of that image is incredibly compelling and I feel the need to anchor that complexity into a larger discourse. I could fetishize that moment and I do. I want to make beautiful, powerful objects but I also want to have it the other way. I want that image to also become part of a larger narrative and to slam up against other images, an afterimage. I want to measure how a life was lived against how a life was dreamed.

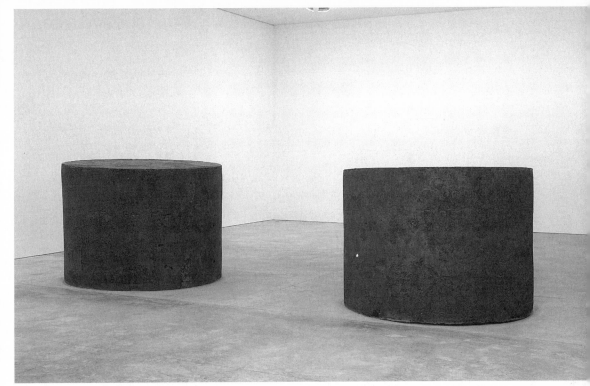

Richard Serra, *Two Forged Rounds for Buster Keaton*, 1991, Forged steel, two elements, 64" x 89" each. Courtesy Gagosian Gallery, New York.

RICHARD SERRA david seidner

It is revealing that one of Richard Serra's earliest memories,
as a boy in San Francisco, is of driving over the Golden Gate
Bridge to a shipyard where his father was a pipe fitter. There
they found a tanker, in way, being readied for a launch
which seemed, to his four-year-old mind, "as big as a sky-
scraper on its side." As the cables were released and the ship
ripped through the scaffolding on its way to sea, the boy
watched, transfixed. Suddenly this dead weight became a
graceful, buoyant mass of steel. Serra says of the moment:
"All the raw material that I needed is contained in the
reserve of this memory which has become a reoccurring
dream." The year, 1943.

Cut to 1992, New York. Interior. An all-white loft, top
floor, skylit with sparse pieces of mission furniture. A few of
the artist's drawings propped up on the back of a worn
leather sofa. Extremely articulate, Serra talks about his
sculptural concerns: "I think I've chosen particular aspects
in the making of sculpture that locate content in various
areas: balance happens to be one of them. Mass . . . weight
. . . placement . . . context. But to say that those have par-
ticular metaphors in terms of my work in a larger aspect
would just be untrue."

If truth be told, there is no metaphor, and Richard
Serra needs no introduction. This firey, fifty-three-year-old
modern master has permanent installations in fourteen
countries and his work figures in collections of contempo-
rary art in most major museums. In 1983 and 1986, his
work was the subject of comprehensive retrospectives at the
Centre Pompidou in Paris and the Museum of Modern Art
in New York, respectively. He has been decorated by the
French government and been awarded many honors. The
definition of modern sculpture, which began with Rodin and
continued through Picasso and Brancusi, has been extend-
ed through Serra's installations and interventions. If there
is any romance to be found in the work, it's not from the

BOMB # 42, Winter 1993

cliché of the sculptor toiling alone in his studio, but from the sheer audacity of the aggressive forms in landscapes and interiors, the rusting steel, the beauty of thrust and weight.

Last year, he completed *Áfangar*, an installation of stone plinths extracted from the side of a mountain, erected on an island in Iceland where there is nothing else, recalling images of Easter Island . . . one man's own Stonehenge. An ambitious project, mammoth in scale, and no small feat.

david seidner I noticed on your work table several books of late Cézanne. In *your* work, his shifting perspective is taken on by the viewer in regards to the experience. Did the anamorphic projection in Cézanne's late work influence you?

RICHARD SERRA You're extracting a whole scenario from the fact that there are three Cézanne books on the work table. The reason they're there has nothing to do with my work; it has to do with Barnett Newman's work as I've been asked to participate in a symposium at Harvard on Newman. I think Newman's final break up of the picture plane relates, primarily, to drawing. His vertical division into components and the bilateral symmetry of his paintings comes right out of his '46 and '47 drawings. If you look at those drawings carefully, you come to the conclusion that the way they make a volume out of the negative is directly attributable to Cézanne. So I was looking at Cézanne to see if this insight I had into Newman was true and I think it is. The second part of your question is based on the assumption that the development of art unfolds in a linear sequence. It doesn't happen that way.

ds In Cézanne's late pictures there is no frontality. And in your work there is no preferred viewpoint. One is forced to look at it from different places. What I'm doing is equating two very different processes: one comes from the artist seeing and one comes from the viewer seeing.

RS To relate my work, which is three-dimensional, to the problems inherent in the flat picture plane constrains how one would understand the real problem of three dimensions, which is probably better served by using analogies from things that actually exist in space—whether it's from pots to architecture, or from a sow's ear to a silk purse doesn't matter. Sculpture is not the handmaiden to the theorems and axioms of painting. Sculpture has its own space, which exists in time and which is very different from the flat picture plane.

ds That's not to say that it doesn't figure in a continuum of art history. You had Cycladic sculpture before you had wall painting.

RS No, no, no. They were way down in the caves of Lascaux before they were hammering away on the Cycladic

Islands. But there must be a way of talking about paintings and sculpture without relying on a model that goes back to the origins. Those analyses never seem to take into consideration how artists develop.

ds That's because they're not written by artists.

RS I don't think that's the problem. I often find that historians who only seek the solemnity of the ivy halls and stop partaking in the everyday world don't understand the art of their time.

ds Do you take responsibility for how other people see your work?

RS That's impossible. If I am lucky, someone comes to the work with a greater intelligence and sees relationships that I hadn't seen. Usually what I find is the opposite—that people don't take enough time to give the work the benefit of the doubt, because they come to it with a lot of preconceptions.

ds In your mind, is there ever an ideal viewpoint for your work?

RS Certainly not for any of the pieces that deal with the landscape or urban sites. If we talk about works which deal with interior spaces, that either locate an aspect of the architecture or create a volume, or distort the space, or bring another meaningfulness to the relation of wall, to floor, to ceiling. Then it can arise that the work itself directs the viewer to see the space in one way. A simple example would be a prop piece in a corner. But if you're talking about pieces which divide the

space, or hold the field of the space, or psychologically activate the space, or make you walk into, through, or around the space, or compress and extend the space, or deal with different densities or weights, then the options of understanding the work are open ended. The character of the space often comes into play, whether the space is open at both ends or has side aisles, the height of the ceiling, where the entrances and exits are, the physical materiality of the space, how people move through it, whatever.

ds With the installations of huge steel plates in rooms, there's almost no place to go, no way to view them in the conventional sense. Is the experience, in your mind, more important than the viewing? Does the content of the piece come from the relationship of the viewer to the piece?

RS I got stuck in the question when you said that there's no place to go and if by that you mean that the entire space is the piece, then that's the intention. You're not asked to look at them like you look at an object on a table. You are inside of them.

ds That's why I'm asking if the experience is more important than the viewing.

RS I don't think you can separate it. It's like saying, because I'm not seeing these in a conventional way, the experience is therefore something other than "seeing." What is it you think you're not seeing?

ds I'm not seeing it from a distance, the way I conventionally see sculpture.

RS You have to say why it's not a perceptual experience.

ds It's a complete perceptual experience: I have experienced them; I enjoy experiencing them. Do you think the content in your work comes from the relationship of the viewer to the piece?

RS I don't know where else it would come from. Where else would content come from if not from the experience of perceiving the work?

ds From references. When you look at a portrait of a woman by Manet, or a fleshy woman by Courbet, you do have an experience, but there can also be a number of conditions set up in your mind.

RS Well, if you ask me, "Do the works fall into an obvious historical readout?" I hope not. If they do, then they're probably not worth much; then they really become a footnote in the sequence of history.

ds What about the idea of the vertical sculptures framing the sky when you walk into them? Is that a conscious idea with a spiritual equivalent?

RS It's not a spiritual equivalent. If the vertical pieces were closed, you would walk into a totally contained space which would beg the reference to architecture. The structure of the vertical pieces implies that they are open. Framing the sky is the result of leaning and overlapping plates.

ds So it's not a conscious poetic metaphor? Like Gothic spires?

RS I've always thought that Gothic has something to do with ethereal surrealism.

ds You mean the idea of polyphony?

RS It's not something I'm involved with. I've chosen particular aspects in the making of sculpture that locate content in various areas: balance happens to be one of them. Mass . . . weight . . . placement in relation to context. But to say that those carry any particular metaphorical meaning is just untrue. However, I can't deny other people's readings.

ds In your *Dead Weights* show at Pace, there was the idea of the top compressing the bottom. This dynamic became a kind of vocabulary.

RS A vocabulary in relation to drawing?

ds To drawing in relation to form.

RS I've made sculptures where the supporting element has been the compressed weight overhead.

ds The *Skull Cracker* series is like that.

RS Yes, it goes back as far as the early seventies. One of the things that impressed me in Egypt was that they used the same method; it may be an overzealous or a heavy-handed way of building. It seemed very clear to me that the aspect of placing something on top which compresses and supports the weight underneath isn't something that has been part of the language of sculpture.

ds No. This idea of compression

sometimes looks precarious and a little frightening. Is the title, *Skull Cracker*, intentionally threatening? Is fear part of the emotion that one is supposed to feel?

RS I didn't invent the title. The title was the name of the steel yard I was working in at Kaiser Steel in Fontana, California.

ds But there are pieces that feel dangerous.

RS Since 1969, I have had everything I've made verified by structural engineers. The work always complies with the required standards of safety—even considering things as far fetched as earthquakes where there aren't any earthquakes.

ds Is the idea of fear or provocation in the work when you make it? You understand the experience that one can have looking at one of these works?

RS I understand that people are fearful of the pieces, but that has to do with their lack of information about how rigorously the pieces are worked out beforehand. If they understood the engineering that went into the pieces, it would relieve their anxiety. They're probably fearful because the pieces present physical and mechanical propositions they haven't seen before and are predicated on a balance that looks haphazard even though it is not.

ds What do you think of Richard Tuttle's work?

RS I think Tuttle is a poet. I don't think of him as primarily a sculptor or a

painter. Tuttle's one of those guys who hits a chord that we all lack. He has a particular sensibility that's missing in the New York art world. He is not constrained by a particular style; in that way he reminds me of Polke. I just saw those Polke paintings which look like he dipped them in caramel or something.

ds Resin.

RS Polke has a flexibility that allows him to be aggressively cynical and still make something that's interesting to look at.

ds It reminded me a little of some of Fontana's surfaces.

RS I think they are more perverse. Some surfaces are granulated, and very transparent, and a little disgusting but also superelegant. I'm not saying that he's just playing off taste, I'm saying that the guy really does understand the potential of painting and that he's not limited by the conventions of painting, whereas Richter is a master of the conventions of painting, but may also be limited by them. Richter has made very interesting paintings by taking a postmodernist appropriation strategy and painting abstract expressionist paintings with a two or three inch brush.

ds I think he scrapes them.

RS They're painted with a small brush.

ds Are they really?

RS Yes.

ds They're not . . .

RS No. [laughter]

ds They look like they're pulled . . .

RS Yeah, they look like they're screen pulled. That's not how they're done. At least I've been told that by several people.

ds Do you consider yourself an antiformalist?

RS I think that the words are silly. Antiformalist. Formalist. You know, five years ago, formalism was a bad word, and twenty years ago, it was an interesting word, and now it's probably a revival word. I think it's meaningless.

ds Can I tell you what I think?

RS What?

ds I think that you were an antiformalist, that you created your own vocabulary and through seeing it over and over again like one sees the films of Godard or the paintings of Picasso, that it's become formalist, because it's become accepted.

RS You might call it formalist because it has become a decipherable language. If one were to look at an early rubber piece, a neon piece, a lead *Prop*, a landscape sculpture, one might think that taken on their own they were singular antiformal gestures. However, once the interrelatedness of the work is understood, it reads as a language. It's hard to be working for twenty-five years and not develop a language.

ds Hopefully, I don't think it happens so much anymore. I mean there are no more Erik Saties

using their scores to keep tl drafts out.

RS No, but I think that there are _____nizable authentic languages that emerge and that have an impact . . .

ds There's such a glut of information that it seems really impossible to experience something that we haven't already experienced.

RS If you're not able to translate information into meaningful activity, then you're paralyzed by it; but, if you can translate whatever the information is into terms that relate to everyday living, then it's all useful.

ds You mentioned that the forged pieces at Gagosian Gallery were not new work, and it disturbed you that people came to them and thought that it was new work. What is new work?

RS The process of forging is not new to my work.

ds I mean what is *your* new work?

RS To say "new works" sounds a little bit like a change of fashion every year, a novelty. If you have a body of work that is developing, then work comes out of work, onionskin by onionskin.

ds Are there times that you feel there are breakthroughs, that you're doing something you haven't done before?

RS If I work on a piece where the outcome seems knowable, I stop. The resolution of each piece usually spawns new ways of thinking about how to continue.

ds I see most of your work being about perceptual problems: where the viewer relates him/herself to the work. Of course, there's mass, and weight, and displacement, and all of those things. What are the perceptual problems with the forged pieces?

RS They're the same in that they are about walking, and looking, and anticipation, and memory, and location. But because they are about weight and mass, they are different in that they make the volume of a space manifest in a way that allows you to experience it as a whole.

ds Do you think artists work for other artists?

RS Yes. Not consciously, but for sure they're the first audience you care about. Every artist has a particular group of other artists whom he would like to have see the work.

ds Where do you see your work going? Do you think about that? Are there times when you're thinking more than you're making, and vice versa?

RS There are times when I am on the road almost continuously. I get off the road for two or three months in the summer. The time in the summer is replenishing, like filling up the reservoir. I get a lot of work done on the road. If you are continuously traveling, you have to adjust to different situations and your response is different than it would be if you were confined to your studio. For me the changing conditions open up a lot of possibilities.

ds Here's another question you're not going to like. Can you define early Serra and late Serra?

RS If you talk about the pieces that were done in '66, that's early work. If you talk about the work I'm doing now, I wouldn't call it "late work." But I would call it work that's certainly more developed.

ds Speaking of the early work, is it true that at Yale you put a live chicken in front of Rauschenberg's face?

RS No, I actually tied it to a dowel, which was anchored into a block and the chicken was in a box. And when Rauschenberg opened the box, the chicken flew up in the air about fifteen feet, and then stopped, because it was tethered. It began to flap its wings; it crowed and shit. [laughter] They kicked me out for two weeks. They told me I wasn't "polite to guests." How can they kick you out of art school?

ds Why did you give up painting?

RS I was using paint with a certain disdain, with the attitude that any material was as good as any other material. And once you find that you're not using paint for its illusionistic capabilities or its color refraction but as a material that happens to be red, you can use any material as equally relevant. I started using a host load of materials. I was living in Fiesole outside of Florence at the time and I started

using everything that was in the parameters of my surroundings: sticks and stones and hides. I did a whole show of twenty-two live and stuffed animals.

ds Cages.

RS Well, cages and habitats. I got very fascinated with the history of zoos. The first zoos were in Florence and the Florentines saw zoos not only scientifically but as aesthetic displays.

ds That was the bridge for you between painting and sculpture?

RS Yes, that was the bridge; I referred to Jasper Johns' beer can—Is it real, is it painted? At one stage, I had a double cage with a live chicken and a stuffed rabbit. I showed the work in Rome and all the Italian artists came and screamed, "Ignoble, brute!"

ds The Arte Povera artists?

RS Arte Povera hadn't started at that time; a year and a half later Arte Povera began and they were all too willing to line horses up in a basement. But up to that point they looked at my work as not being legitimate, it wasn't even dada.

ds Had you seen Eva Hesse's work before you made *The Splash* and *Cast* pieces?

RS I knew Eva quite well. I have enormous respect and admiration for her. Right after she died, Lucy Lippard asked me what my relation to Eva Hesse was and I said "technical," because I really didn't think that after Eva died it was up to me to be

telling people what our relationship had been. It was too personal to be made public. I responded the same way when Smithson died. He was my closest friend. After a death there is a kind of vulturism that sets in. But to answer your question, when I was first in New York, in '67, Eva was one of the prime influences for a large group of people, people as different as Newman and Bochner. I knew her work and I would visit her on the Bowery. Eva was quite shy; people were hanging out at Max's, and when Eva would show up, she would keep to herself. She always had a very difficult time meeting with larger groups. One on one, Eva was terrific. Very, very thoughtful. She represented a real foil to strict minimalism even though she used repetition. She was very, very concerned with putting her inner feelings on paper or in form.

ds And the process of the hand.

RS Yes, that was an extension of her skin; the ability to manipulate form was an expression of her feeling. For a lot of people that was almost a taboo concern because they were interested in things as bland as permutations and serializations and logical equivalents and God knows what. Maybe it was because of the demythologization of abstract expressionism.

ds Or an extension of Newman.

RS I never thought of Newman as having anything other than a great amount of passion in his work; you

can't look at Newman as a geometric painter. One of the constraints of minimalism . . .

ds You don't see Newman as reductivist?

RS Not any more than Mondrian is a reductivist. I don't think it matters if you reduce form, if you can carry an engagement with content. People who wanted to eradicate all content in favor of the explicitness of form end up like Vasarely.

ds Where do you see your work going?

RS [*laughter*] Up and down and sideways. And in between.

ds You mentioned to me that people loved your drawing show at Matthew Marks because the small drawings were easy to relate to in an art-historical continuum. Does that imply that you think the large drawings are difficult to relate to?

RS For most people they are more difficult to relate to. They present more of a challenge since they can only be seen in relation to space. The piece at the Carnegie consisted of two forty-foot-long, twelve-foot-high canvases covered with paintstick. One canvas was twelve feet off the ground, whereas the piece on the opposite wall was down to the floor. When you walked into the room, the floor shifted, you felt like you were standing on the deck of a boat and the ballast had rolled. To articulate a space through the location and delineation of a

plane on the wall is an extension of drawing that most people seem to be unable to comprehend, but they respond to it physically.

ds One of the most beautiful perceptual pieces I ever saw was by Doug Wheeler, at the Ace Gallery in the seventies . . .

RS I saw the same piece.

ds . . . where he painted two walls and the floor black, and two walls and the ceiling white . . .

RS No, that wasn't Doug Wheeler, that was Michael Asher.

ds It was Doug Wheeler.

RS No, no, it was Michael Asher, because the same piece was at Documenta in '72.

ds Anyhow, you walked in—and with a can of paint, literally, the means were so simple—it completely threw you off.

RS Yeah, that was a great piece; however, it was an illustration of a perceptual problem right out of *Scientific American*. I think that the piece at the Carnegie is more subtle. But there's a relationship in that the placement of the paint on the surfaces of a room allows you to experience the volume of a space. And that's very different than hanging something flat on the wall.

ds Do you make objects?

RS I don't think so, no. Objects are really of a different order. Like, how many cars did Ford make in 1991?

That's different from the number of lithographs in an edition. I'm not saying that just the number in which something exists makes it more or less of an object. Uniqueness and intentionality make a difference. Also, most objects imply usefulness, whereas art is purposefully useless. You *use* a chair but you *experience* a sculpture.

Sue Williams, *In Denial of the Shady Boner Motel*, 1992, Acrylic on paper on canvas 42" x 48". Courtesy 303 Gallery, New York.

SUE WILLIAMS nancy spero

BOMB # 42, Winter / 1993

I first saw Sue Williams's work two years ago, and thought, Wow, they bite! Her paintings galvanized me: violent, cartoonish, obscene, voracious . . . A chosen few, mostly other artists, were impressed, yet the work seemed to slip by oddly unnoticed. Times change. Political thought returned. Sue Williams has been there all along. And now, we're ready to see her.

nancy spero I express anger, dissatisfaction, in my art work. I also show women enjoying their own sexual pleasure. But let's say in conversation I will not be as confidential or expose myself to the degree that I do in my art. So, with that in mind, I'll ask you a few questions that could refer to both of us.

SUE WILLIAMS People think that I'm like my paintings, liberated and aggressive. When they meet me, they find that I'm shy and not too in control of my life. The work helps me to evolve.

ns What I first saw in your work is anger, it's palpable. How autobiographical is it?

sw It's more autobiographical than I used to think. The earlier imagery wasn't so explicit. I used to not want to talk about it as being autobiographical. I thought people would say, "Well, that's what happened to her, she was a nut." But I've gotten more

nerve because it wasn't just me, it's also a reflection of the status quo. I have a feeling that along with therapy, I should have learned hand-to-hand combat, because I've been in therapy a long time and I still feel I'm in danger of being raped and attacked.

ns All women carry this inherent knowledge, that we can be raped, that we are in danger. Both of us are figurative artists whose work is very personal, although my work comes from an entirely different impetus. I have wanted always to override the personal, to step into a more public arena. But it was also this reluctance to turn attention to myself.

sw I didn't want people to know my personal victim history. But this show was explicitly about violence. And I got such a reaction. I started talking to women. I was so surprised to find out how many people have had to deal with incest, have been molested or raped. I couldn't believe it. People almost take

it in stride. And that's the way it is, it's always been this way. This is a horrible thing that I went through. I had no awareness of my rights as a person, I did the classic thing. It's so humiliating. People would ask me, "He beat the hell out of you and you went back to him?" I thought that this person loved me and that that was my home. I didn't like it, but I was used to it.

ns In varying degrees, a person's art-work embodies self-identification, the artist's reflection or mediation of the personal. When you do a but-tocks with a bat being shoved into it, you are saying that this happens, per-haps to me, but maybe just as likely to you, the viewer.

sw Mine are events, the feelings are actual-ly, for me, still mixed up.

ns Your art comes on angry and now, with a more public persona, a larger audience: what do you want? Is your art to instruct the viewer? Is it to relieve yourself of anger?

sw To relieve myself? No. [laughter] Do I want to instruct? I don't know. I think I'm pissed because I went through all this horrible shit, and I want to do something for other women who are going through that. I just figure that everyone does.

ns Your work is critical of abuse of women. Is it a call for action, getting out on the streets?

sw It's different than wanting to do real things. They're my babies, those paint-ings, so they're not strictly teaching tools. They're things that I create, and I

like to create them. Somebody had told me that women thought my show was negative, which I had never heard before, since most people only want to say nice things to your face. And I thought, neg-ative? I had always thought the work was kind of happy.

ns You use a lot of jokes, lively car-toon-like figures. We're told that art is a mediation, the removal from the real body, a privilege dealing in the symbolic.

sw The images are pretty direct. But there's unconscious things too, if you try to get rid of that, you lose out on the things that aren't words. So, yeah, it doesn't necessarily work literally.

ns Canadian law has taken over Catherine McKinnon's definition of pornography as "material that sub-ordinates or degrades women." [read-ing:]

"We cannot ignore the threat to equali-ty, resulting in exposure to all audiences of certain types of violent and degrading material. Material portraying women as a class, as objects for sexual exploitation and abuse, and the negative impact on the individual's sense of self-worth and accep-tance."

When you depict a baseball bat shoved up a woman's butt, that could be vicious porn. Let's say you are considered showing in a Toronto gallery—Canada is the first place in the world that says what is legally obscene and what harms women. How do they know that your piece harms women?

sw They lay out little doilies. [laughter]

ns There's a slogan: "Pornography is violence against women." It doesn't say that it causes violence. If it depicts it, is that in itself violence against women?

sw You can say that men cause violence to women, so they should be banned, not just the photos. The photos aren't the violence.

ns I have the book by Donna Feratto, which you displayed at your show. [*flipping pages*] It's absolutely graphic displays of battered women's faces and bodies.

sw I brought that book to my exhibition because I had gotten a review from this obnoxious guy saying that *I made* up a war against men, that these things don't really happen. So I brought in that book, with the statistics and the pictures, so I could show it to anyone who thought I was imagining or just trying to make trouble. One of the reasons my show is so popular is because this year it's fashionable to be interested in women's issues, even in art.

ns In the early seventies that was true too, but it was more conceptual. And now, the body in art has returned. During the eighties, I was attacked for using images of women. This has to do with one feminist theory that women artists should avoid creating a woman's image for men.

sw Right, that's the party line.

ns I could not abide more limits and regulations—you and other women like Kiki Smith, Lorna

Simpson, Clarissa Sligh are all involved in the images of the female body in very different ways. Shifting times and interests.

sw I never thought of that, not being able to use the body, but your work is conceptual. You take from what's already out there, don't really alter it a lot—you're not messing with it. The work becomes a whole new language; it's not male art.

ns It's a tool to investigate, to attack, to celebrate. In *The Second Sex,* Simone de Beauvoir discusses women and their smiles, smiles to please, to accommodate. A woman has to be ready with a smile to ward off potential aggressors, not to give signals of fear.

sw I had this positive review from Betsy Hoffstead in the *Voice.* She mentioned that she got from my work that I was afraid of men. And I've heard that before from a shrink. It always makes me gulp because it's true. I am really afraid.

ns She sensed from your work that you showed a certain fear?

sw Yeah, I was surprised because I didn't think that it had come out in the work, that fear. It threw me because I wasn't aware of putting that in; I like to be in control. The criticism I don't like is: "So you hate men?" and "So you're an angry person?" It makes it sound like it's not my body, that it's not just a logical reaction to violence I've experienced.

ns I'm married to Leon Golub, and we

have three grown sons. I would imagine that some women who don't know me but have seen my artwork wonder how I have been associated with a male artist all these years. Or male artists, or men in general wonder how he could be associated with me. It may seem illogical to them, but that's not the point. We respect the straightforwardness of each other. We were discussing how, in the eighties, a few feminists condemned the visual depiction of the female body because the woman's image had been so subsumed under the "mastery" of the male artists' gaze. An interesting point, but not necessarily to turn it on ourselves, and once more limiting emotionally what "good girl" artists are supposed to represent. But I wanted to investigate women's conditions from the extreme repression and torture of political prisoners to that of women as protagonists, activators freed of male control. I am trying to set things in motion, to reinscribe women in history. We've always been there but we've been written out.

SW You know it's very interesting because mine comes from down in me, and yours, really you know . . .

ns No, the very act of your making it externalizes it. Battered women see your show and suddenly you represent something that is not just held within oneself. You're exposing this to the world. That image isn't actually your body.

Your body is the jump-off point. From autobiographical circumstances you can make universal statements. Do you think that your work would be less appreciated by some women of color? Would there be a resentment towards your experience as a white woman? You might even still, in this terrible situation, be more privileged.

SW Yeah, I probably am more privileged in some ways, but then again, the system is the system. A busload of predominantly black women from Atlanta who had been abused came in to the show and wrote some comments. That's quite a compliment for them to come and see my work, for them to see what an artist is saying about them. That made me feel really proud. At the same time, I saw Lorna Simpson's show. It was really heavy work and it made me mad because it was true, and I don't want to feel privileged. Maybe they had resentments because the lady was white.

ns Allegiances are mixed, many black women feel white women have not treated them equitably. All these differences of class, race, ethnicity, age, culture.

SW Males see my show and they don't like it, they almost don't believe it. I had the same reaction when I saw Lorna's show. She was saying things as a black woman that I don't know about. Each little thing was representative of her culture.

ns I'm wondering about yourself as a

younger artist, or artists in their early twenties, who have a lot of attention paid to their work, get sudden fame and then think it's the normal thing. In truth, it doesn't happen that often.

SW Well, I'm not that young, I'm 38.

ns You're not that old.

SW I see women who are really young having shows, and that seems unusual to me. I don't remember that happening. I didn't have a show 'til four years ago. And with this last one, I'd just come back from my honeymoon.

ns Is this your second marriage?

SW No this is my first, I'm a virgin. [*laughter*] I had come back to all this publicity in *The New York Times*. So a lot of people who wouldn't normally see the show came. It was something new for me, I ate a lot of chocolate and went shopping. I am very self-conscious and I don't want to get distracted. That's a problem. I like living out in Brooklyn where I do because I don't know anyone. I used to live in the East Village and I thought people were looking at me even when I was inside. I couldn't work. I don't know, I hope it doesn't unbalance me, the little attention I have.

ns It's great you have success. Can you enjoy it?

SW I always forget that I am, supposedly, successful now—I am successful now. I was on welfare until I started selling. I didn't have any friends, and I wasn't on anyone's mailing list. So this has been kind of a shock. Of course, it's

really nice because my self-esteem is so low. I need this kind of success so that I feel like I have the right to walk outside. It really has helped me a lot in that way.

ns I should think that would be an indication that it can't be entirely superficial. And you're happier now, you mentioned your marriage?

SW Yeah. I'm happy again also because I'm working. I'm just as isolated as ever, except—no, that's not true, that's not true. I've gotten to meet a lot of people and I just forget to call them. See, the thing I went through, being beaten and all this stuff—I'm so different, no one likes me. A lot of people feel that way.

ns It wouldn't seem that way, from the positive response to your art. What are you working on now?

SW A sculpture idea from the last show that didn't get done. My blow job fountain. A head, a couple of hands here, and a cylinder to her mouth. The water comes out of her eyes and nose and mouth. I decided I really like working in wax, at this foundry. So, I've been working on all these different things. Suddenly, I've been focused on the work instead of who hates me this weekend.

ns Making art is this unholy mess of pleasure and pain.

SW You find it very painful?

ns Sure, there's a certain pleasure in working an idea through, but I

find it difficult and perverse
always fighting oneself as well.
The tension, the irritability; trying
to get it just right. It's painful
because "it" is so elusive.

SW At a certain point, I get into it and it's
just a blast; it's like being in my play-
room. But those times are hard . . .
and there's this weird putting it off that
happens. It's a whole state of being,
almost. And the transition—some-
times you don't want to go, you don't
want to lose control. Art takes an inor-
dinate amount of time. Answering let-
ters takes time, living takes time. I
mean we all live complicated lives.

ns Not to mention terrible experiences.

SW Oh, that's outside of art. [laughter] You
know, I always trivialize this stuff when
I talk about it because I've had so many
really bad things happen to me and it
just seems absurd. Yeah, I was raped and
sodomized and there is so much autobi-
ographical stuff in the paintings: A
woman is being raped and sodomized by
two men in one of my paintings.
Actually, one of them said, "Put some-
thing in her mouth to shut her up." So
you can just imagine what they thought,
in their creative minds. It's just too
embarrassing. Totally embarrassing.

ns You are victimized but you are the
one embarrassed!

SW I know, but I can't help that.

ns The vulgarity, hate and arrogance
of it . . .

SW It was very horrible. I have all these ter-
rible things happen to me, I told you
about being shot. When I was nineteen.

ns How'd that happen? In New York?

SW No, I was living at home, Chicago. A
date shot me. And he left me to just
die and somebody else called an
ambulance. And then I had to go to
the hospital and have my whole lung,
the outside of it, removed.

ns So are you okay, now?

SW Yeah, I just get cramps.

ns You have often been victimized—
abused.

SW A succession. I was coming from a vio-
lent household. So I couldn't really tell
that these guys were violent, although
other people could. It would get bad
and then I would try to get out of it.
Once, I moved out, and he broke in
and tried to kill me. I went through the
court system and all that stuff, getting
orders of protection and I even tried to
put him out by smashing a bottle over
his head. He tried to beat me to death
several times. I was walking around
with my face kicked in over and over
and looking horrible. And people really
look at you like, what is your problem?
Running for your life is just so horri-
ble. It was just like living in this hell.

ns Where could you go? What did
you do?

SW I wish someone at the end had told
me something, anything. But I left
the country, that's how I got away.

ns You came from a violent house-
hold, these things perpetuate
themselves.

SW Yeah, I didn't know how to get out of
them. I drank and I took drugs. I was

pretty out of it. I would have known to leave if I wasn't so out of it, but that's how I would stop thinking about it. It just gets worse and worse as the pattern progresses. And me not really being very aware—they would remind me of my family.

ns Do you, because of your experiences, envision continuing your art with this kind of content? Violence and women's subjugation? The abuse in power relationships?

sw That was the problem with getting all this attention. If I don't do that anymore maybe people won't be interested, or, is that a stigma? I hope not. I'm an artist and my work wasn't always about abuse. It may come out in different ways but it is only recently that it has become so . . .

ns . . . overt.

sw Almost literal and sometimes not even interesting.

ns Which I don't think is true.

sw Well, whenever things bother me that I am not aware of, once I have a show, they look really clear. Did you ever notice that?

ns Having work up in a neutral space removes it from the private domain—the studio. But a neutral space can neuter too, make the work seem bland and sterile. However, this did not happen to your work, your art is shockingly externalized, a subject of discourse. The personal shame and battering is brought into the open, you declare it in our faces.

sw Well, I know that those subconscious things are weird and obscene and then, if I put it in a social context, it comes out so literally and it makes more sense but . . . I used to do things and not know where they came from. They were often weird and gross, and that's okay. It's good to be able to do things that have no conscious meaning.

ns Artists are, or ought to be, deviants in our society—we don't represent the norm or play the cover-up game, although a lot of art does.

sw I had never thought of doing autobiographical stuff until my medium suggested it.

ns Who said this?

sw The spirit energies, through my medium, actually a year ago.

ns And what were you doing before that?

sw Well, it was there, but I wasn't thinking about it.

ns Let me ask you this. Do you think men pay as much attention to your work as women do? Women artists?

sw No; uh-uh; no. I don't hear much feedback from men at all.

ns What about the critics? Has there been equal, both male and female critics?

sw At first I had male critics and now I have female critics, and I am so glad because I like the way they look at it. They take it seriously. The men who

liked it, liked it for reasons that you might like Mike Kelly's art. Mike Kelly's is serious social stuff. But in a goofy kind of way. Some men talk about the paintings as if I were a crackpot. And that made me sad because, I really wanted to be considered . . . It was the way I had always felt about men, this was subject matter to be discussed by someone who never talked. That was me, I never talked. So I was speculated about like an eccentric. One review said, "It leaves you wanting more." Like more S&M fun! I see the women in my paintings as going along with the men because they see it as the only game in town and they don't have any choice. I wanted to ask you, do you feel like you have a voice and you can speak?

ns It took decades but now I get my message out. I'd been working as an artist for thirty years without much response. Then around '83 the situation changed, or partially changed. The work reverberated, the same stuff hidden all those years. I infiltrate and subvert and celebrate, as I wish. Earlier in my career, I was excluded, ignored. I was angry and frustrated in my attempts to get some sort of dialogue going. I used fragmented writings of Antonin Artaud collaged with painted images as a means to express my rage at being silenced as an artist [1969–72, the *Artaud Paintings* and *Codex Artaud*]. Artaud's tirades and screams of rage and anguish, his extreme introspection of physical and

mental states resonated for me. If his hysterical and insane ravings would have been written by a woman, they would not have survived nor gained this recognition. But women artists are in the world too and will not be silenced.

sw I had no world. I could not function in the world I was in.

ns It's tough entering the art world, becoming a participant. It's a small elitist enclave—a special world, but then one may find a place.

sw It's such a relief. I almost feel like a human being. I still have a prejudice against women. I mean why would I want to look at the past of women? It's boring. They are not the ones who really did anything.

ns It's a matter of learning the histories of other women—how women have been written out of history. How the struggle for equality has to be fought and won, over and over. It's as if we always have to start from zero.

sw That's what happened to all our energy. It's gone somewhere else, not into the world.

ns So what's next?

sw I want to play with oils, goof off, and see what happens.

ns And then there's success!

sw These kind of successes are a little like flash-in-the-pan things. I don't want to take the opportunity and go hog-wild endorsing things. I would love to have a career.

Philip Taaffe, *Necromancer*, 1990, Mixed media on linen, 89" x 69". Courtesy Gagosian Gallery, New York.

PHILIP TAAFFE shirley kaneda

BOMB # 35, Spring 1991

Philip Taaffe is one of the most significant young painters to have emerged from the postmodernism of the eighties. His unorthodox approach to painting employs linocuts, paint, and canvas, which produces exotic and compelling images calling to mind Matisse's cutouts and synthetic cubist collage. His paintings combine cultural synthesis and art-historical references, addressing such marginalized issues as pattern, decoration, and opticality of painting with thoroughly fresh, yet critical and thoughtful eyes. Our conversation began while he was passing through New York on his way back to Naples, where he lives and works, and continued—in true contemporary epistolary fashion, layering text upon conversation—via fax between these two cities.[Philip Taaffe has since moved back to New York City.]

shirley kaneda Do you have any interest in Matisse, Klee, and Delacroix, and the nineteenth-century romantic artists?

PHILIP TAAFFE So you're going from Matisse, who's a world unto himself, to Klee, who is really the key Bauhaus spokesman, reading back to Delacroix, the most vital heroic romantic painter. I agree it's interesting to consider how their intentions may tie into one another. For Delacroix, handling of the heroic frequently involved exotic subject matter. But one gets the sense, from the way he painted these themes, less of a frozen moment than of a scene of ongoing participation, less demonstra-

tive and more highly egalitarian. Something of an eclipse that has marked its passing and will inevitably occur again.

sk The notion of the romantic and the heroic carried on through to the abstract expressionists. But in this day and age, heroism is definitely not part of romanticism.

PT [*pause*] It's as though the two words have become deflated. Both concerns—the issue of heroism and the issue of romanticism—are questionable in practice. From the point of view of a contemporary philosophy of art, I suppose it has to do with the impossibility of these. It is merely

necessary to look for ways of continuing within traditions that can be made workable on some level, to develop and reexplore themes that have been understood perhaps in too limited a way. In any case, the idea of finding an exemplary method or approach for defining a romantic subject is something well worth looking into.

sk **Many artists are working out of the postmodern concept of anti-romanticism, a somewhat cynical point of view. Your work is very optimistic and you utilize what's available to you from art history without becoming reductive or purely formal. It's more of a cumulative approach.**

PT Mine is more of an inclusive idea. Although it's hard to be optimistic, my feeling is that in the end one *must* believe in the infinite perfectibility of every human being and in the perfectibility of the culture that we are shaping. If one cannot accept this fundamental hope or desire, it seems to me that things get seriously lost and paralyzed. And this hope has nothing to do with some kind of step-by-step refinement, but with the chance to have the insights that may lead to a freer development of world culture. And investigating themes within diverse cultural situations, seeing what they do to one another—in terms of ideas, appearances and motifs that have never been related—making those kinds of juxtapositions and associations is something that artists are more capable of doing. One must always try to look for possibili-

ties within an impossibly closed framework; there is already too much closure within our cultural situation. That sense of closure, of impossibility, needs to be constantly, vigilantly reobserved to understand how we can make progress in our own thinking towards other cultural realities, and how we can make connections with ways of looking at life distinct from our own. That's part of the responsibility, from my point of view, of art: to see how these very specific and diverse cultural realities can be described or redefined, assimilated or reconciled, from our highly individualized way of thinking about artistic involvement.

sk **You find that the authority is in the personal, rather than in what is given.**

PT It's important to find the most open way of looking at the world and at one's life and trying to make a valid exploration, a valid research, that has something to say about where we want to go, and that indicates what we can personally do about getting us there.

sk **Do you think abstract painting is still viable and possible in attaining this?**

PT When I was visiting Puerto Rico, I was introduced as a painter and people would ask, "What kind of paintings do you do?" Well, how does one go about identifying one's work? If you say, "I make abstract paintings," then people say, "Oh, yes. I know what that stuff is like . . ." [*laughter*] Obviously, my problem with abstract painting lies in not wanting it to be more of *that*

stuff. There are essential distinctions to be made. Of course, all art is abstract. References are always drawn from external sources, no matter what degree of intrinsic formal specialization is adhered to. Also, for example, in thinking about the distinction between abstract painting and representational painting, in my case, there have been many works *about* abstract painting, which look like abstract paintings, but which are more clearly, to my mind, representations of abstract painting; or else they share equally the identity of abstraction and representation. This ambivalence I have towards the nature of the term "abstract" also applies to my use of certain architectural elements, sometimes on a very large scale, in an effort to compress fragments of real architectural space onto a relatively frontal idea, vis-à-vis Mark Rothko for instance. It's one way of pushing the dimensions of what an abstract image can contain. Within the framework of the way twentieth-century art has developed, the language of abstraction—as a basis for synthetic ordering—comes closest to the process of musical composition, or the possibility to make a pictorial parallel to the work of, let's say, symphonic . . .

sk . . . orchestration.

PT Yes; something that allows for this kind of freedom. It also allows so much more historical material to enter gesturally into the structure of the work.

sk Would you say this is your rela-

tionship to history in your work? That you can utilize whatever has been and pick and choose from all the available elements?

PT After a great deal of deliberation, yes. One goes back and forth between bathing in the insight of the past, trying to feel these insights, to bring them forward to make them visible in a new way.

sk Do your paintings relate to Matisse's formalism?

PT I have a hard time with that expression. If we're going to refer to "Matisse's formalism," we may as well put Picasso in that category, too.

sk Clement Greenberg always asserted that Matisse was superior to Picasso. An article about your work by Jeff Perrone in *Arts* magazine refers to Clement Greenberg's extraordinary idea that the "decorative" is analogous to the Marxist Revolution. He thought the decorative haunted modernism in the same way the Communist threat haunted capitalism.

PT I wonder how Greenberg felt about the decorative in his earlier, Marxist influenced writing. Maybe he found it threatening then, too. I find this statement to be perfectly consistent with his other opinions from the same period. And I would be perfectly happy to think that he was correct in his judgement. Anyway, getting back to Matisse, here was someone capable of assembling a great deal of pictorial information in his paintings. They

are laden, bursting. But they're also quite breezy in a certain sense, inspired like the wind. He always tried to put his paintings in full bloom. Matisse is the painter of this century that I am most impressed with, actually. In looking at everything he accomplished, so much complexity and grace is just astonishing.

sk The type of images that you use, then, are they an indexing of twentieth-century culture, and/or painting, for you?

PT Collage is the big artistic invention of the twentieth-century, one might say, but what do you mean by indexing?

sk That you are accumulating images available to you, but you are not compartmentalizing them.

PT I like that word. It has a strange bibliographic connotation, doesn't it? Like trying to imagine a card catalog for the library in ancient Alexandria. But there does exist a common archive, so to speak, which can be delved into and reflected upon as a matter of course. It's part of a continuous process of inquiry: discovering how things have been stated and, based upon an awareness of new circumstances, understanding what needs to be stated further.

sk What about the process in which you work; how did you arrive at this process?

PT It was necessary to find a means whereby the edges of these elements and lines could be applied in a way that gave an immediate visual acuity and

believability to them as they entered the paintings. My feeling was that if, after I'd worked on it for awhile, a painting could be filled with sharply defined lines and elements that had arrived there in an alternate way— through printing and collage—that this would reveal something other than the idea of my having directly painted those same lines and elements. Also, I find it helpful to be able to move them around and take them away until I know exactly when and where they need to be in a given work. It's a process of indirection, really. Most of the time, all of these elements are pre-drawn and printed without knowing how they will eventually interrelate. This liberates the vocabulary and extends the range of possibilities somewhat. I like the fact that a gesture or a line can be confined within and multiplied onto individual pieces of paper. And can then be tentatively applied to a painting, marking the surface with a sharply delineated texture that is present before it is actually . . .

sk . . . assembled.

PT Yes. So it can be structured more freely and with a greater degree of intensification. An intensified line or an intensified graphic area is important for me to have in order to know how they might converse with other concerns that are waiting to find their way into the various paintings. This process gives me a greater opportunity to be more deliberative in terms of what enters a work; for example, making a jarring, unexpected transition from the stage of having these raw

elements to the idea of wanting to put them together in a way that has another meaning could never have been predetermined. So the images and lines are graphically predefined, but the field of possibilities for orchestrating these elements is completely open, and I think it becomes possible to achieve a greater assimilated space.

sk Why did you choose canvas as the site of assemblage?

PT My earliest large scale collages were on paper. Even though I liked the paper's unwieldy character, the canvas was just a more practical support.

sk How does your work relate to cubist collage?

PT Cubist collage was a piecemeal introduction of found fragments. I prefer to pretend that I *find* collage elements even though I make them. I prefer the illusionistic quality of flat pieces of paper with these edges because if you put a found object onto a painting it becomes the key ingredient of the work, whereas what I do has a more generalized effect. It allows the thing to be constructed in a more abstract sense—getting back to that word [abstract] again. It's more plastic for me, more malleable. An object has its own implications as a determinate physical reality, whereas the paper comes closer to pigment, to being just a graphic gesture or mark.

sk You mentioned that you like the way the edge of the paper functions, you like the way it looks.

PT It's simply a response to physical reali-

ty and how we all perceive edges and surfaces, identifying one object next to another in physical space. It has to do with focusing in on the visual sharpness of perceived reality and transferring that to a pictorial situation.

sk What do you look for in your work and other people's work? What do you see? It seems that you have a very precise way of looking.

PT Essentially, what I try to see in other people's work are the central motivations, the spiritual, emotional, and intellectual forces that allowed the things to exist. I'm always curious about what something meant at an earlier point in time, as opposed to its present significance; and I like to see how people deal with that issue in their work. Where something is produced, the cultural or geographical origin, is obviously of great importance as well.

sk Which leads us into the question of why you chose to live in Naples and what your fascination is with North Africa. You were speaking earlier of the events in the Middle East in terms of how you feel personally involved.

PT I like synchretist cultural situations, the kind of situation where incursions from many different geographical sources have a layering effect of cultural and historical density. Naples is certainly one of the foremost cities in the world where this sort of evidence is amply felt. And from the standpoint of other parts of Italy, Naples is considered pretty much an African city.

Although this perspective may be changing as Naples begins to lose some of its traditional qualities, becoming wealthier and more like other bourgeois European cities. It promises to be a relatively slow process however, given the perversity and defiance of the Neapolitan race.

sk It's the gateway to Africa, with the influence of North Africa and other cultures. There's a strong decorative element in your work. What do you think of decoration and pattern?

PT This is an important issue for me and I haven't talked very much about it before, partly because I'm not sure how to enter into a discussion that reflects what is going on in the paintings. Very often the paintings contain elements from decorative sources, and yet the paintings themselves never assume a decorative character. I love to look at decorative art. I have a collection of books and other materials concerning the decorative arts. I always enjoy going to museums of decorative art wherever I visit. I look very closely at architectural decoration and the design of public spaces, gardens . . . But from another artistic point of view, in Béla Bartók's music, for example, the uses of folk art or what one might call "local melodies" in his compositions are put through his own psychic filter, so that they become deeply expressive and meditative. Of course, it's not a question of applying decoration or applying a folk melody in a certain pattern. It's a matter of researching the melody, of repeating it to oneself, and trying to

understand the lived reality out of which this imagery came. And then to form a statement that allows these melodies to speak for themselves, in all of their vitality and beauty, but using at the same time another voice that says something that the decorative, in the ordinary sense, just could never say. Decoration is usually derived from a local natural situation; it can epitomize the lush quality of, let's say, palms or lotus flowers or jungle overgrowth. Decoration in this folk sense is a culturalized representation of nature, it's closest to the raw elements that reflect a very specific geographical location in historical time. The importance of it for me is that I can have these circumstances of time and place in crystalline form, and I can feel those realities, feel the history that they inevitably speak about in this natural, cultural sense. It would be presumptuous to say that I go beyond that or transcend them, because I really don't consider that it's *just* decoration and that I am merely interested in transcending its meaning as decoration. I primarily want to feel the living reality of these elements, and to respond to them in a personal way by making a composition that allows these other voices to speak again in a way that I've understood and responded to. These voices are part of this lived experience represented by decoration, and I would like those voices to share a dialogue with the formulations that I produce. The fact that one can repeat something in order to achieve a dynamic synthesis, a sort of crescendo of decoration—

having this possibility of tempo, change, and restructuring—means that these voices can be amplified and joined together in a way that I couldn't have anticipated. And I want to see, I want to hear, I want to experience this. I make decisions on the basis of what I want to experience, and how I feel this relates to my own life, and what I have imagined is the lived experience that generated these images and decorative fragments. I don't use them only because they're interesting or exotic forms, or because they can be used in a certain way structurally or formally. It's always a matter of feeling that, the intention or desire behind them, and shaping something out of that enthusiasm, that passion.

sk What I like and admire in your work is how you synthesize culture and history, ours and other peoples, so that somehow we can have a phenomenological experience here and now looking at your work. Do you see your paintings as masculine/feminine, as opposed to the gender of the maker?

PT Yes, I like the paintings to participate in this sexual ambiguity and to have an erotic tone to them. I like to cultivate the presence of both the masculine and the feminine in the work.

sk Sort of hermaphroditic?

PT [*laughter*] Yes, in the Duchampian tradition! Certainly they're not completely masculine. Collage helps me with this kind of indirection. Actually,

the work that I've done that I've liked the most has a strong erotic current. I think this often has to do with the tenderness of proximity within a painting—how elements interrelate, their positioning, the internal play.

sk Would you see something sensual as feminine, as opposed to something logical as masculine?

PT Then maybe the paintings are completely feminine! [*laughter*] I suppose the architectonic condition of the work is masculine, and my fascination with structure and sharp edges, maybe that's masculine as well. But I've tried to place them in a way that undermines that masculinity.

sk I think you do, too. A lot of people would be very happy to hear that.

PT Well, I'm very happy to say it.

sk Is it a conscious effort on your part, to undermine the masculine?

PT I think so. But it would be very difficult and somewhat pretentious for me to discuss the cultural implications of my paintings in any ideological way. I mean, I know they do have cultural implications, but *how* they do is almost impossible to answer. I wouldn't want to set up an agenda for the paintings in a programmatic sense, because then they wouldn't have to be made. I do try, however, to show a position that is first of all more pluralistic, completely nonauthoritarian, and which doesn't overly exalt the heroic or the masculine. It's a genuinely deliberative research that is, I hope, as open, embracing and nurtur-

ing as I can make it. I like to think
that I am lending my voice to themes
and melodies that are not often heard
or stated.

sk **Does your work have anything to
do with theory?**

PT It would be much closer to my think-
ing to state what theories my paint-
ings don't participate in. I prefer the
apophatic or negatively rendered posi-
tion, something along the lines of

how Ad Reinhart handled the ques-
tion of art theory: painting is not
this, it's not that, it's not another
thing, nor is it anything unstatable—
one can only recite a mantra of facts
surrounding an activity. Reinhardt's
method, incidentally, seems similar to
the approach of medieval theology,
wherein they sought to define a con-
cept of the divine by elaborately stat-
ing how exactly this could *not* be
adequately characterized.

Kiki Smith, *Untitled*, 1994, Plaster body cast with four glass, ink, lead solder and wood objects, 70" x 34" x 14" including steel plate base. Photo Ellen Page Wilson. Courtesy PaceWildenstein.

KIKI SMITH chuck close

Kiki and I have periodically had lunches over the past few years. I've loved our rambling conversations and always wished they were recorded. *BOMB*'s request for an interview was the excuse I needed to try and get one of these conversations nailed down. Kiki is disarmingly open and honest. She refers in a charmingly self-deprecating way to her limitations and the neurotic underpinnings of her work. That same openness and willingness to share is evident in the way her sculpture is so accessible. It is the product of a generous spirit. It's also compelling, disturbing and beautiful.

BOMB # 49, Fall 1994

chuck close What have you got there, pictures?

KIKI SMITH They're pictures of these wax sculptures I was making at the foundry. This one's for a park project of contemporary sculpture in Düsseldorf. In the park there is a big column with a statue of the Virgin Mary on top of it. I thought it'd be nice to make a sculpture of Mary Magdalene as a primitive woman, maybe with a chain on her leg, looking up at this statue of the Virgin Mary. In Southern German sculpture, from the early Renaissance and the Gothic stuff, Mary Magdalene is portrayed as a wild woman. They had hairy, wild men in German folklore too, like dancing bears. I used the wax to sculpt the hair. Her face and bosoms, hands and feet, knees and elbows are smooth, but then the rest is all hairy.

cc I love the streaky hair stuff, that's great. She has a very specific body, too: the stomach, and the shape of her breasts, great nose, great profile.

KS She's not too sexed up.

cc It reminds me of that carved wood sculpture, *Mary Magdalene* by Donatello, that has all the incredible surface activity. This has such extraordinary energy, and of a real woman, not some mystical creature out of the Bible. It's going to be cast in bronze?

KS Yeah. I thought, why not make her hair a lighter color, and then her bosom, knees and face will be a darker bronze patina. There may be a couple of versions. All my stuff ends up being much easier to make by hand. So each one is like a handmade reproduction, and each time I redo it, it changes. Like in this one, the veins of the arm are on the outside—and then I made all these casts of roses, and they hang off of the arm.

CC I love the veins on the outside; it's like a cage around the arm; it looks like those tubes they pump blood through . . .

KS IVs. There are these women who perform, piercing their skin with studded bells so that when they dance their blood comes out of them and the bells ring. I thought it was really sexy. [laughter]

CC [looking through Kiki's photos] There's something wonderful about the way the veins go around the thumb in this sculpture of yours; it looks the way a catcher's mask goes around someone's face. We've talked about those incredible wax medical models in Italy and Austria from the nineteenth century, Botticelli-like wax figures of women with real hair implanted and real eyelashes and glass eyeballs all in these beatific poses. They're smiling, and their eyes are open, and then their guts are pulled out onto the table. Some of the most amazing images I've ever seen.

KS They're beautiful. When I first saw them, in Vienna, I made the muscle-meat heads.

CC With real meat?

KS Yeah, with meat, to make muscles on the face, which were then cast in bronze.

CC [shuffling photos] Where did you do all this work? You're never in town.

KS In New Mexico. I stay there for a couple of weeks. I love it, I work nine 'til five every day. You can go there and make secret art and nobody knows what you're doing.

CC Like going to an arts and crafts camp.

KS Yeah, and nobody is watching you, that's what I like. I feel much more free there.

CC Did you ever go to camp?

KS No. We did yard work.

CC 'Cause there is a wonderful kind of "arts and crafts" quality to these. Everything is sort of gerrybuilt, and you are working with time constraints, and the material's unconventional, and yet here are these incredible things.

KS This is an eye that I made into a water fountain. I put little ducts around the bottom part of the eye so tears come out—it's crying, and in the middle of the eye, water shoots straight out of the pupil.

CC Like the weeping Madonnas in the churches?

KS Yeah [*laughter*].

CC **You'll probably have thousands of people praying at the feet of your sculpture thinking it's a miracle.**

KS This is the one I like: I cast this girl who is about four foot seven inches. When you make a mold it shrinks, and then when you make that mold into bronze, it shrinks about four percent more. So she ends up being about four feet tall.

CC **Wow. Child-size but a full-figured woman, as they used to say in those bra ads.**

KS It's out there. That scared me the most of anything I've ever made, because it's a real figurative sculpture. Like you can't hide anywhere.

CC **I know that you have also done death masks. Do you feel different casting live people than when you do the death masks?**

KS I like dead people better. Casting is problematic. It's like playing freeze tag, you cast people in all these different positions and they're frozen. Casting, like photography, is a single moment. Whereas if you sculpt people's faces, it's a more generalized version of the person, but in a certain sense it's more accurate than one specific second of them—which is what you get when you cast people. Casting makes for a kind of stiffness, and unless you really fuck around with the cast, there's something dead about it, especially when you go from the cast into metal. Bronze is dead material, so you have to have some kind of texture to make it live. Whereas the translucency of the wax is like skin. In any case, dead people are just dead; you don't have to make them look alive. [*laughter*]

CC **I know you've cast members of your family as death masks. Have you cast any other . . .**

KS I cast one guy—a friend of mine asked me if I would cast someone who had died of AIDS. It came out better than any of the ones I'd done of my family, just because I was getting better at it. When I start, I talk to the dead and say what I'm doing, in the same way I talk to live people, I talk to dead people. Because they haven't been dead very long, you don't know whether they're still around. So I tell them what I'm doing. And then it's just work.

CC **When you were studying anatomy, you worked from cadavers?**

KS Yeah. I mean, I actually went into class to look at cadavers. That's where I got that noninvasive thing, because I would see these students hacking up bodies. Most people think that when you die, your soul leaves your body. I don't know. The way they touched dead people's bodies seemed disrespectful. But still, in some ways . . . when they cut the chest and abdominal area, you could see through the ribs like the top of a basket, and they lift off the whole top of your chest, your muscles, take out your organs. You're left with a basin. I would still love to cast the interior of the abdominal cavity and the chest cavity. We're

like a bowl. You know, in a cannibal-
istic sense, we come with our own
serving bowl.

cc Did your pieces with the spine on
the outside of the body come from
looking at those cadavers?

ks I don't know about that. I bought a
spine, a plastic one, and I made a
mold off of it, and made one sculpture
in glass, one in paper, one in wax, and
now these in metal with the flowers
coming out of the spine. The best
things that I saw in anatomy, besides
the spine, were the brain and the
nerves. The nerves go all the way
down the middle of the spine. I saw
them hanging, and I'd like to make a
sculpture of that—it gets really long,
all the stuff in the body, miles of stuff.
But it was beautiful, you see how the
back of the brain comes down like fish
scales. When they take out veins for
bypasses or for varicose veins, other
ones take over. You have a certain
amount of regrowth. Like reptiles
whose tails grow back, or a worm cut
in half. We don't tend to think of
that, regeneration.

cc Nerves can regrow. They can't
regrow in the spinal column, but
nerves in the rest of your body can
grow the length of a cigarette a
year. It follows the path where it
was.

ks I was on a plane talking to some envi-
ronmental scientist and he said that
after one year, you've breathed all the
air that everyone's breathed in and out
in that year. I always think the whole
history of the world is in your body.

cc You've been traveling a lot, you
seem to have a reasonable amount
of wanderlust. And then you work
in these incredible bursts. What
percentage of your time are you
doing each?

ks I do a little bit of work every day
somewhere or another. I went to
England and spent every day at the
British Museum taking notes.

cc I'm not saying that's not work.
But work as in when you're actual-
ly at the studio.

ks I don't know what percentage.

cc Never mind, it doesn't matter. I'm
just obsessed with that since I have
to work all the time. I'm jealous
that you have time to go to the
British Museum.

ks No, it's hard, too, because I go to the
British Museum and all the sculptures
tell me what to do. This time I wrote
down the numbers for each sculpture
that I liked and took pictures of them,
and their captions. So that if I make a
catalog, I can say this is where it comes
from: it came from my trip of being
there. But then I lost my notebook, so
[laughter] now I have to make it all up.

cc Have you always sought this kind
of connectedness with other art,
other cultures, other traditions?

ks Yeah, I get ideas from them. Because
everyone's figured out all the technol-
ogy, how to combine different kinds of
material together—you don't have to
make anything up. You just have to
pay attention to what's discarded, or
disregarded.

cc A friend of mine says you're as good as the obscurity of your sources. If you're working from something no one else is looking at, your work will automatically be more individual.

KS My work all comes from other work. It's like putting some personal desire on it.

cc But it differs so greatly from other forms of appropriation that we've become inundated with.

KS That's because most artists appropriate contemporary American culture, and I don't relate that much to American culture. I didn't grow up with television, so I didn't connect to it as a source. The Middle Ages is interesting because it was a time of enormous technological change. Also, you see this really big love factor, people took great pride in what they made. I think that's important.

cc Though you generate a very different kind of work, it reminds me of the period of the late sixties and early seventies when people were looking for material that didn't have historical baggage so that they could push the stuff around and see what it would do. You use bronze and other traditional materials, but it seems to me that that kind of engagement with materiality and physicality is a large part of your work.

KS Well, materials do things to you physically. Traditional materials do have heavy historical baggage. But they also have this physiological aspect: different materials have psychic and spiritual meaning to them. If you make bodies out of paper, or out of bronze, they have different meanings. So you get to choose which materials are appropriate and contain the meaning you want. Or you can make something in five different materials to have different emotional effects.

cc You are a great recycler. [*laughter*] How important do you think it is that you're a woman? What was always thought of as "women's work"—ritualized, repetitive activities and all the stuff I love so much—you sometimes construct your work that way.

KS Well, your art is like that, too. It's natural, and a cultural given, but I've always felt really comfortable with it. I like work that you can take anywhere, like crocheting. You take love and devotion and put it into something.

cc Every quilt, every sweater, was made for somebody, which is a real act of love. I think your work is very generous. It's work that is for the viewer in a very generous way.

KS Thank you. I like looking, seeing everything that everybody already knows and using it. Or you start making the sculptures and then they start explaining to you while you're making them, telling you more and more what it is that you're doing. I started looking at Egyptian art, then reading about Egyptian cosmologies, and I realized I was making things that had some relationship to that, but subconsciously: sirens, then Inanna, Lilith and Ishtar.

cc My favorite movie. [*laughter*]

KS Ancient goddesses that are birdlike. You can educate yourself with how they fit together historically or what they mean and what meaning you are attributing to them and what they mean to you emotionally. It's home investigation.

cc In our Western arrogance we looked at Egyptian or African work formally without knowing its ritual uses or original intent. But there was still some felt urgency; we knew it wasn't made just for decoration, or as sculpture, but that it had some profound reason to exist, mystical or religious. Do you like to find out what the actual uses of these things were?

KS I don't think you can really understand it, but it comes into you, and tells you to pay attention to it, and that it has something to teach you. Then you start trying to understand it. I talked to an egyptologist at the British Museum. And I realized all this unfolding stuff I started doing about four years ago, all these pictures with my head unfolded and my hands to my ears. There is a sky god I'm crazy about, Nuit or Hathor. She's a cow— big cow head, and her hair is in a flip. This egyptologist was saying that in a lot of Egyptian sculptures they bring the ears forward to hear better.

cc Like a wolf.

KS Yeah, it changes your hearing, amplifies your hearing. But, it's like an unfolding face.

cc At the Children's Bronx Zoo,

there's a sculpture in which you can stick your head that has bronze animal ears which funnel the sound into your own ears. It gives kids a sense of what it's like to hear like a fox.

KS They say cows like to hear classical music while they're being milked.

cc Milk from contented cows. That used to be an ad for Carnation milk. [*laughter*] One of the things that we share and talk about is the effect of being learning disabled on the choices we've made in our lives, and ultimately on the kind of work we do. I believe everything I do is totally influenced by it. Do you?

KS Well, when I grew up, I was always in the lowest section of my classes because of it. It took me a long time to realize my classes were with working-class people, immigrants and black people. Which is what has made me want to make my work accessible and informative. Also, at a younger age, I was against medicine, the disrespect of Western medicine toward people; that it makes a separation of the parts of the body that don't work or don't function. The dysfunctional are separated out, and that's a model for other things in society.

cc Western medicine treats one little part of you, gives you a drug that does one thing, and they study that without any attention being paid to the side effects, or to the other parts of your body, or to what else it's doing to you.

KS It's terrible. That's why accessibility is important, so that it's not a class issue.

CC That's what I meant by the generosity. The accessibility is generous.

KS The group of artists that I come out of are populist artists. From that feeling of not having access in the society, it seemed important to make things accessible and to demystify the work. That's probably not true in all of my work—there are contradictions—but that was an important part to me, having grown up as a "stupid person."

CC What or who do you think made you feel special enough to even try to succeed at something? There is a certain arrogance in wanting to be an artist in the first place. You have to feel you have talent. What gave you the strength? What kept you from not feeling like a dummy?

KS I don't think of it as a strength. I just looked at it as a last resort, I didn't know what else to do. I really wanted to be an historian, but I am so lazy and undisciplined in terms of studying.

CC When I was a student at Yale there was a seminar on the history of religion taught from the point of view of marketing: why a religion caught on, what needs it served its community, what the belief structure did for people, why it died out when it no longer seemed relevant, and how offshoots of that religion were picked up by another. It was amazing to see how from the earliest religions on through now, things from one religion have been picked up by other religions.

KS The biblical myths are from much earlier stories.

CC Yes, it was an oral history. Was your family religious?

KS Yeah, my mother's a converted Catholic, and she's also a converted Hindu. She calls herself a Catholic-Hindu. She's religious, or spiritual. My father was raised by Jesuits, whom he said he hated, but it was in him; he was stuck with it. Some people get free. Some people say that you don't have to be, but I'm stuck with it. I've always been spiritual. That's always been the most important part of my life, thinking about God or gods. My whole life I've wanted to believe in a god, find some kind of god that I could make a shrine to. But I can't. I never do.

CC Well, maybe you are.

KS I always say that everything I make is my dowry. That's the great thing about being an artist, you make this enormous wealth for yourself. Even if you don't end up with it, you have the evidence of it.

CC Well, the detritus of all your efforts are a kind of immortality. They prove you were here.

KS I like that art is accumulative by nature, that you are physically creating the world, making physical manifestations of the world, and that you are, in one sense, responsible for the world, for the image you're making it in.

cc You have the wonderful legacy of your father, Tony Smith, all of his work; that could be a burden too, handling it well.

KS It's hard because it's a responsibility as well as love. But I don't mind it as a burden if it's sitting in my living room. I like that. I'm super into inheritance; I love that objects have histories and are passed down from one person to another. Chinese paintings are stamped by everyone who owned them. It makes the work interactive, like if I went and wrote my name on your pictures. In India you see sculptures that are rubbed away from so many people touching them in devotion. When we go to church, we touch the feet of the saints.

cc Until their toes are worn away.

KS Yeah. Every time we go, we touch their feet and pray. It's this marking by the external, by other people, so that the sculptures embody something. That's what makes the sculptures live.

cc That reminds me of what you were saying earlier about the smooth parts of your recent sculptures.

KS I made the stomach and the bosoms traditional, but there are these places people can touch. I love the elbows. The thing is that the Mary Magdalene one will be outdoors, but there's no insurance for outdoor sculpture in Germany. People can just take it and sell it for scrap bronze.

cc What do you mean?

KS My father once had a sculpture in a town in Texas, and it disappeared one day, and they found it six months later in a junkyard sold for scrap metal, a fairly large sculpture. [*laughter*] But no, I like things that people get to touch. It makes a whole history that evolves, where everything holds information.

cc I just saw a huge sculpture in Munich that was made from the cannons of a retreating army.

KS Metals are always recycled. When ideologies change, everything is destroyed. Like all the Lenin sculptures coming down; they'll recycle the metal. If you buy rings in Europe, you could be wearing Egyptian gold that was remelted. Or all the nineteenth-century parlor sculptures of fake Daphnes or mythological figures that were used for weapons in the United States during World War I.

cc I read somewhere that all of the existent gold in the entire world, discovered and undiscovered, is only a cube one hundred yards square. And much of it has been recycled over the years; but then to think that a great chunk of that is around the necks of people who live in New Jersey is kind of scary. [*laughter*]

KS I'm totally into gold now. I went to the Metropolitan last year and looked at the selection of Central American gold sculpture, and it's just unbelievable, how it's made. Then I went to Copenhagen and Ireland to look at what the Celtic people did. They got all this gold from the Mediterranean and hoarded it in the ground. They

buried massive quantities of gold and silver as offerings. I got into some weird thing of making flowers last year in gold and silver and then everywhere I went there were these votives with gold flowers underneath or little devotional things. The Egyptians made gold and silver flowers. Everybody's making the same thing. I think you're recreating the way the world already is. But you don't have to be conscious of it, once you make it, it starts telling you that it's in a continuum. The thing I love about going to museums is that it's a confirmation. Your ancestors tell you that there's a reason for doing a particular activity, or that they liked doing it too. I got to try on the ceramic rings of the mummies from the Egyptian collection, the ones for the Pharaohs. I kept thinking they must be doing something. We don't believe in the supernaturalness of objects. If you make figurative sculpture, they have real power in them; they take up some kind of psychic space. I think that objects have memories. I'm always thinking that I'll go to the museum and see something and have a big memory about some other lifetime.

cc **Do you feel that way about used clothing?** [*laughter*]

KS I don't like buying it anymore, because of that. Objects do carry memory.

BROUGHT TO BEAR

LAID TO REST

Lawrence Weiner, *Brought to Bear or Laid to Rest*, 1995, the language and the materials referred to. Photo © Dorothy Zeidman.
Courtesy Leo Castelli Gallery, New York.

LAWRENCE WEINER marjorie welish

BOMB # 54, Winter 1996

Conceptual art is visual art that is not retinal, or that at least resists appealing to sight at the expense of thought. It often manifests itself in language that assumes the entire burden of compelling the viewer to read the signs on gallery walls. Conceptual art persists and is not amenable to the merchandising that subsequent decades have brought about. Whether they knew it or not, formalists of the 1960s presupposed the early modern achievement of Russian and French artists and writers. Conceptual artists as well show the formal and structural bias of manipulating language operationally. Sites formerly intended for live events or "actions" now allow mental operations to substitute for physical behavior. Lawrence Weiner is among the most respected in the loose federation of artists that includes Robert Barry, Douglas Huebler, and Joseph Kosuth, and extends to Sol LeWitt, who remains a key figure in artistic formalism. Weiner's language refers to works both specific and general. In sites that are specific, yet treated categorically, Weiner's words occupy the book, the gallery, the street, the stage. His words and work act as cultural irritants wherever they appear. Ranging from mildly to aggressively interventionist, Weiner's verbal art uses formalism to drive a wedge into the cultural status quo.

marjorie welish The retrospective of your books and posters at The New York Public Library was titled *Learn to Read Art*. That's just what viewers resist—why do you give us that imperative?

LAWRENCE WEINER That phrase is advertising a particular means with which you can go through life, it doesn't tell you that if you don't learn to read art you're going to be fined, it just says: Learn to Read Art. I don't see that as an imperative. All artists are attempting to communicate, in whatever form, and if you can learn to read that form then you can either accept it or reject it. If you can't read it, then it doesn't mean shit to you.

mw The word "read" replaces the word "see," and so is provocative to those who somehow insist that art be taken in through the eyes.

LW Blind people read without seeing.

mw It's both an invitation and a challenge—to read and, as the word implies, interpret—to engage in the visual in a more comprehensive way than through sight alone.

LW But we live in a world where each individual is unique and alone—and this is the definition from a $1.98 dictionary of existentialism—in an indifferent and often hostile world. If one finds oneself by virtue of one's existence in an adversarial position to the world, if I find myself that way, then there must be at least another million people who do as well. That's a lot of people. That's a gold record.

mw What exactly was included in your show at the New York Public Library, and how did the show come about?

LW It was a presentation of all the books I'd made over the years. Small editions of about three hundred to one thousand so they are now quite rare. Robert Rainwater is one of those curators who is legendary in the United States. He doesn't have any trouble with: Is it poetry, art, drawing, mock-up . . . he can read it. I had a curator who could read. And a library that was devoted to reading, and they showed my books. And I was pleased as punch. It was probably the big show of my life. For a New York City kid from the South Bronx, the library was the most important part of my entire education. And having been involved a lot in political activity from civil rights on—I spent reasonable amounts of time in New York City lockups and holding tanks, so it was

really rather nice that every son of a bitch who ever thought I was crazy had to go by for four months and see my name on the front of the New York Public Library. I liked it.

mw In doing the show, did you learn anything? As you were reviewing the material, seeing it on display— did anything occur to you?

LW [*pause*] Quite frankly, no. I'm an artist, which means I'm in a position every time I start doing something to review things from the beginning. It's only the production of one person, and sometimes as enormous as it looks, it's still comprehensible to me. So I don't think I learned anything aesthetically. Emotionally I learned a lot. I had to admit to myself that I made art because I was unsatisfied with the configuration that I saw before me. The reason I make art is to try and present another configuration to fuck up the one that I'm living in now.

mw Where do you see yourself now and where would you like to be artistically in, say, three years?

LW I see myself now, personally, in a very complicated part of my life—it's not mid, late, or early, it's basically nothing. I am one of those lucky artists who has been able to remain in exactly the same position as a human being as when I first jumped onto the ice floe. And luckily people have dropped sandwiches and cigarettes on the iceberg along the way, so I can sort of sit there. Where I'd like to be tomorrow is where I am now, doing public installations about things that

interest me. I'm doing one in Denmark which takes over this whole city. I'm building the piece out of cobblestones. The cobbles lead from a house into the highway. And on the highway people are offered a choice between paper and stone, and water and fire. Every single child knows what it means. I don't know if adults know any longer. Fire and water means joining the circus; paper and stone is to make yourself a stable set up in that society. The piece runs through the vestibule of a building into this enormous courtyard, and in this courtyard it says, "When in doubt, play tic-tac-toe and hope for the best." And all through the town this slogan is reiterated. So what do you do when a society starts to destroy its circles? You play tic-tac-toe and you hope for the best, you don't just sit there and watch. That's what we do as artists, our responsibility is to try to survive within society saying what the society might not be interested in hearing, but still surviving. Which is against this idea of the leftover Left, that you have to lose. You don't have to lose, but you do have to do what you do.

mw **Then resistance in the form of silence is not an option?**

LW Not for a person who stood up at one point in their life and said "I am an artist." If you are a fireperson and there's a fire you are expected to go put it out; and if you are an artist and there is absolute brutalizing of the material value of either human beings or objects, you are beholden to say something.

mw **A recent installation of yours at the Castelli gallery emphasized the word "stone" by incising that word many times into the gallery wall. Ampersands were introduced between each of those words. What did that mean?**

LW What do you mean, what did that mean?

mw **What did the introduction of the ampersand, as a graphic notation in a lexical display of the word "stone," mean?**

LW I use the ampersand because of its difference from the plus sign. Plus is an additive thing and ampersand is an accompaniment thing. Sticks and stones with an ampersand is one thing. Sticks plus stones is another thing. But in this particular case— this was my twenty-fifth year of showing with Leo Castelli. (We've had a very wonderful, strange relationship of a dealer and an artist that was not about art dealing.) Leo always had a fantasy of having something cutting through the walls of the gallery. I figured, after twenty-five years, if that's what Leo wanted, I would incise it into the wall. And it worked. Incising is how I address the idea of stones and stones and stones. With no implication of pond, no implication of thrown, no implication any place, just stones and stones and stones.

mw **Incision induces a kind of materiality.**

LW It's a tattooing, that's what it is. And once it's tattooed, it's just like painting it on the wall, the viewers still

have to decide what to do with it. They have to decide if it functions for them or not.

mw That leads me to think about the nature of the sense and reference in what would otherwise seem to be a perfectly straightforward presentation of words. I've noticed elsewhere in your work that the words may seem to refer to something direct, but they do not mimic.

LW No, they don't resemble, they present. You ask where I want to be, I want to be able to be engaged in my existence. And at the same time I want the work that I'm doing to be informed by my contemporary existence, my existence now. I have to look at situations, at configurations, and essentially translate them into what their components are. The components themselves connote what will happen. There can be, as far as I can determine, four coherent truths for each individual act. The fifth has a tendency to contradict one of the four.

mw What are the four?

LW Whatever the four happen to be. That's the point. If you mix stone and water, you will get about four different results—depending on what climate, depending on this and that. That means that I can determine and present what I see in the world without a metaphor. I place it somewhere, and the society that's either trying to reject it or use it will give it its metaphor. That's how art functions.

mw Then, insisting on the formal relations between signs is a way of keeping the language on the level of language.

LW Because you really think that there's a significance to the use of the ampersand, which for years I called the "typewriter and." It's like the choice of saying "they are not" or "they ain't." They're both correct, but they both connote a different placement within society.

mw I'm interrogating you on the uses of language in your work. Formalisms that withhold their hedonism, or their hedonist possibilities, even as they present the challenge to create meaning, or an impression of meaning, is one of the most consistent principles I see when I look at your work. Does this ring true? And does material form not make your work, at least, in some general sense, a kind of concrete poetry by emphasizing?

LW I don't know how to read hedonistic as nonsensual. If nonhedonistic is nonsensual, then, I don't agree with you. One of the hallmarks of art is its sensuality. There is a sensuality in all materials. There is certainly a sensuality between any relationship of one material to another. The acceptance of sensuality is a necessity, and its existence is not hedonistic, it's just realistic.

mw Many people would respond to your work as a cerebral enterprise, a withholding of pleasure.

LW We'd have to get into what constitutes pleasure. But, withholding is a whole

other story. I'm not withholding anything from anybody, because nobody asked me anything. That's what everybody seems to forget with an artist. Everything I've done is this self-standing "thing" . . . it's not really in response to anything; I'm not trying to be a pied piper, I'm doing my job. I have to be a personality in order to get paid. Someone has to know where to send the check. We accept that. But the work itself, nobody asked for it! There's no withholding. This is the way I would prefer people approach their relationship to the world. So I present art in the manner I would prefer they approach it.

mw Exactly, against certain expectations of what "art" ought to be. The withholding could be perceived by some as, "Where's the visualization?"

LW There is no analogy that I can make. Because it's not foreplay, it's the whole thing: the immediate tactile response. There's nothing, nothing being held back. That's all there is. And if that's not enough, then I have a problem, and maybe contemporary art history has a problem. As far as its relationship to concrete poetry, there is none. Most of our academic concrete poetry is nice, but it's bourgeois, it's "Let us go against this."

mw I'd like to discuss the process of making your work: looking at some of the plans for works in progress here in your studio.

LW You don't see work in progress on the walls. What you see is the means of

figuring out how to present it to a public. If I want to be allowed to have this straight relationship to materials, and to live my life amongst objects, volatile and nonvolatile, as an artist I have to present that, and each individual situation becomes the best way to present that particular kind of work. It may be a movie . . . it might end up in three or four different works, looking for its place. Almost every work of mine doesn't have a place. It doesn't belong anywhere.

mw Are the works conceived before opportunities for showing take place?

LW I get fascinated by materials, and then I get involved in the fact that without any kind of watching, these materials start to mix together. They molecularly bind in some way. The work itself never has a place. Neither has it to be installed at any given time. It's information being passed on. I just did a show in St. Gallan, in Switzerland, based on this idea. For years we've been stuck in this problem of geometry being the necessity of our existence, geometry as we know it, because you have to get from one side of the river to the other. If you go to a place like New Guinea, they still accept the idea that they can build a bridge that's not geometric, and it still gets you across the river—you don't fall in the river, and you don't get eaten by crocodiles. That's the whole point of a bridge. So I would like to deal with the fact that the reason materials work and don't work is not because the culture has found, in

Calvinistic terms, the correct way things should be done; but it's because for that particular point in time those materials chose to work that way. What's interesting with quantum physics is that they've discovered they can have no theories, because if the metal is not enticed, it might not hold together that day, and it just falls down. Each individual material has with it a certain amount of energy, and the material itself, by response to the stimuli presented to it, decides whether to function that way or not.

mw And what do we see here on the wall?

LW You see here the rough scheme of a piece for Barcelona, a place called L'Avinguda Mistral. You see here, within a city resplendent with statues standing high above the population, podium after podium, marked with the words of Frederik Mistral, this poet from Provence. The populace walks among the piece. There are three concrete pillars, or blocks, which are found standing among the fallen podiums. So what we have are the concrete pillars themselves taken off from their essential stance, and placed within the landscape, which is rolling. I had an intuitive feeling about the size of the concrete slabs. I wanted them to be six meters long and they said "No, why don't you go for twelve, because there's the problem of seeing and not seeing." I said six, and we went out, and it turns out in the old town from facade to facade, it's six meters. So there's six-meter-long slabs of concrete to

which I mixed color—terra-cotta, ocher, blue—essentially as close as one can get to the concept of Mediterranean and Catalan colors. And then I decided what the substance of a popular sculpture would be. This is a working-class district, and I'm a working-class person. So essentially what became the necessity became the text: "And something given to the sea, and something woven, and something forged," in Catalan, in stainless steel inside the concrete.

mw I want to discuss the drawing for this piece. Hand-drawn phrases, "Atop, the placement of the place."

LW That is just so the architect knows where they go. Then there's a cut in negative stencil . . . there's a poem about the language of Provençal; it's in English, Catalan, Provençal, and I fought for Spanish. They didn't want Spanish, and I said, "You can't do that, 40 percent of the population speaks Spanish, and just because someone is racist towards you, you don't have to be racist towards them." These are the things which human beings have brought from the objects and materials of the earth, which is what artists are supposed to deal with. That's why they hire an artist to do it. They want poetry, they go to a poet.

mw A slogan, actually hand-lettered on a diagonal, crosses the represented site. And on either side of the drawn park on this piece of paper are large Xs whose size are the same size as the lettering of the slogans themselves. To the

right of all this is a legend of graf-
fitied plinths in their site, and off
to the right is Mistral's poem. Your
graphics reveal stylistic choices.

LW Artistic notations.

mw They are and they're not. They're
more of a visualization of the ver-
bal content than the final result,
what the actual sculpture will be.
They're a totally graphically
dynamic presentation of some-
thing that will be much more
homogeneous once existing in an
actuality.

LW Okay, what you're reacting to is inter-
esting, it's different publics. This is
for the people who have to build it,
the others are for the people who can
use it. In fact, they can't use it until
they've built it.

mw But this drawing implicates a
rhetoric—this is not a challenge,
it's an observation—the rhetoric
of the Russian avant-garde in its
self-conscious visualization of the
space of the page. [*Vasili*] Kamensky
slices the corner of his page, so
that his four-sided page becomes
five-sided.

LW His interest is for it to become five–
sided. I used to take this paper and
say, "I'm not going to sit here and say
this isn't an object." It is an object
and with it comes a tradition of design
and political decisions on how to pre-
sent things to the people who are
going to build them. So, you take off
the corners, and you make them into
an object, there's no more question
that it's some sort of ethereal thing.

mw Exactly. This is the real space of
the page, not the illusion of the
page. In these drawings, if I may
call them that, these schemas,
dynamism is introduced within
the given space of the page. But
it's decidedly there. The diagonal
alone gives you away.

LW It's the street—the diagonal is the way
the street is designed.

mw Yeah [*laughter*], but the style of
your artistic solution is deliberate;
the style itself signals a choice for
semicontrolled anarchism.

LW I have something to say. And it's
about class. And it's about consump-
tion. Yes, whatever you're saying is
correct. But you have to remember
that when you consume a CD, a play,
an exhibition . . . that's your interac-
tion, not yours personally, but one
part of the public's interaction with
the work. That's the consumption
aspect of the work. In order to build
anything, there's another whole set of
problems, and in order to solve those
problems and to make meaning clear
to somebody else, you are required to
make real political decisions about
how you want to explain things to
working people. I chose to be able to
explain things to the installers who
work in museums, and in public pro-
jects, and in movies, by telling them
how I would like it to be—and take it
for granted that although I'm sup-
posed to know an enormous amount
about this, at the same time, I want
them to bring their craft to it. And if
they know they can build something
that's not going to fall down by adding

two millimeters or two centimeters to it, it's not a question for me. If they can mix the same color that I want by using something different, it's not a question. My point is to get across the general idea of what I'm putting out. So these drawings are for the people who have to pour the damn concrete, who have to haul the stuff, and place in the letters. They are for them to read, and to give them a general sense of—I hate to use the word—the grandeur of whatever the object is that I'm trying to present, or whatever the experience is that I'm trying to present to somebody else. I'm having a relationship with them through these drawings that has really nothing much to do with the public. Often they print these drawings along with the presentation of the piece. I always think that's funny, but I like the drawings, so it's okay.

mw Of course these are functional drawings. But I can't help noticing that along with their functional aspect is an aesthetic and it is an aesthetic that accords with certain avant-gardes, Russian avant-garde, perhaps, in this case, Dutch avant-garde notation.

LW Or Dutch socialist aesthetic, like Piet Swart, whose drawings of a telephone instruction manual set the tone for how generations of Dutch people relate to the telephone. Sunlight in Barcelona is intense, so anything that's Inox stainless steel will reflect onto something else. So you might see "something given to the sea," or parts of it, reflected from the stainless

steel onto trees backwards or onto the sky because there's a mist. This is a place that has more sunlight than you could ever imagine. It's going to glisten, and it literally is going to have that ephemeral feeling of glistening in time. You can't see stainless steel buildings in the heat without them having this funny fuzz and aura around them. And you'll see in every one of these pieces, 70 percent of their existence will be glimmering in front of you. That's the sense that I'm trying to convey. I want the builders to understand that when it's sitting in the concrete it doesn't have to be read like an advertisement. It's not selling a product. People will have to move in order to read it, they have to get the glare, the glint, out of their eye.

mw Then this drawing would represent an effect or an expression of the intended material result?

LW For the people who are building it. It's being socially responsible and allows me to question myself as to how I want this to look. Once this exists in society, they can print it in the back of a book, on a banner, on their ass, it's all the same.

mw In the course of doing this presentation or any other, were there any stages in which heavy revision was necessary, a revision of your concept that shows in the drawing proper?

LW Yes. Installation drawings or instructions of mine from the sixties and seventies attempted to incorporate what I saw as a rejection of the superfluous

within drawing. Slowly, I began to reexamine what was superfluous and what was not superfluous and how you can do it in a clear way.

mw But in the course of introducing many variables into an installation, surely you have determined how it will look. I'm asking you to recall an instance in which some revision of the concept was necessary.

LW I wouldn't be able to determine that, it's a natural process. I see decisions being made every day. So when you ask about developments within projects, let's just say, you play games with things. It's one of your prerogatives as a poet, and it's one of my prerogatives as an artist. You're allowed to play games with things, but in fact they're real. So once you play that game and you find that it's doing what you want it to do, you just keep playing it and you forget that you ever played it another way. So when you ask me to remember an incident, I already don't. I remember necessities where I think something is not working.

mw But the nature of the game that's being played is a kind of formalism with real results. Addressing the issue of that: Has there been revision, or if revision is an unacceptable word, how do you adapt the concept to . . .

LW There are things politically I will not accept in presentation.

mw I'm talking about the present, a given drawing at a given time, in which there is a problem to be solved. I'm not talking about how the past looks upon the future or the future on the past, but about the nature of thought within the process of arriving at an installation or a presentation. Let's then talk about another presentation or drawing; this one is a stage set.

LW The *kyogen* is the entr'acte in Japanese Noh theater, a skit within the play. The Noh theater is quite idealistic and involved with the history and pageant of life. In the middle of this, somebody comes out and presents a skit that reminds you that you shit, piss, eat, and fuck. It's very earthy, and it's always about that kind of thing. I'm making a little stage set edition that's about the stage set they want to do. It pops up and says, in Japanese, "apples and eggs" in blue. Then it pops up and says in Japanese, "salt and pepper," in Loony Tunes colors: blue, red, yellow, black, and shiny white. Then in English it says: apples and eggs. Salt and pepper. That's the set for *Madame Butterfly*. Apples and eggs are something the Japanese culture is very involved in. And the American naval officer's idea of refinement is salt and pepper. It's called *Stage Set for a Kyogen for the Noh Play of Our Lives*. Our lives, meaning the Japanese and English. I made this out of cardboard, it's an inexpensive edition.

mw Is this a proposal for an actual stage set?

LW You can get it built. I would like to see a stage where they came out with

these things on cardboard plaques with a triangle on the back to hold it up, like a paper doll, do the kyogen, clear it off, and let the actors come back out and finish their Noh play. See, art's not supposed to interrupt the flow of life, it's supposed to bring to you information that changes the next course. Do you understand what I'm saying? It's not a barrier, it doesn't stop you from doing what you're doing, but it changes the flavor.

mw **In this case it doesn't stop the action, dramatically speaking. What would constitute a failure in the conception of a style of one of your installations?**

LW The content of the work is something which fails for me when it has no material relationship of substance. When the material relationship that I've become fascinated with, in fact, has no significance. It has no substance, and that happens often.

mw **Is that because the site that you had anticipated was other than expected, or is it about a formal relation that doesn't kick in?**

LW You're still not allowing me to have this divergence between what's being presented and the presentation.

mw **Well, I'm investigating . . .**

LW Presentation can fail because it's klutzy. You're a pro, you go into a situation, it could be the worst, broken-down alternative space situation or the worst, overdesigned contemporary museum situation or the worst off-Broadway theater. Whatever it is,

your job is to be able to present your content within that in a correct manner. And if you don't do it correctly, you fucked up, you're klutzy. You just didn't have enough of an attunement with what the space was. You couldn't determine the space in a way that your content was not lost. Content is something else: the sculpture, the whole reason for doing all the rest of the stuff. That fails when it becomes obvious that the materials which fascinated you had too shallow a relationship or a relationship that was imaginary, and the materials themselves are not of enough substance to constitute any meaning for anybody.

mw **Among the kinds of discourse floating around the art world now are those resisting rational language, structural relations, formal relations, and even a certain disposition of material relations in language. One sees it in art writing and art criticism where deliberately and lavishly irrational subjectivity is the very point of the discourse. It's meant to confront the tradition of rationalism. Do you see this effort as an alternative world of language that is interesting in itself but of no interest to you, or do you see it as totally misconceived and misguided?**

LW I'd say I'm not a believer in inherent structure, and yet I find this phenomenon of the irrationality you were just speaking of—although it does produce interesting products every once in a while (and certainly not misguided because it does serve the intellectual

views every once in a while), it is effec-
tively bourgeois. If you're only reacting
to one specific idea in the structure of
language, one specific idea of the
structure of history, and one specific
idea of the comprehension of language
and history, then you're accepting
something that your work is claiming
it does not want to accept. Why not
just do something without having to
make the reference to what is not
acceptable? That would be my major
complaint with the whole thing.

mw There's a precalculation of the
reception of something that puts
the sociology ahead of the ideal or
the problem being addressed.

LW But that's rather shrewd. My parents
were from the South Bronx, Jewish,
working class. I never graduated from
college. Yet I'm considered to be a
paradigm of the American WASP
intellectual because I'm blonde and
blue-eyed. In their eyes I was able to
do what I do because I was that
WASP. Now, I never said I was; I
never said anything. Their presuppo-
sition was a commodification of the
artist. I was on a panel once in
Belgium. And somebody in the audi-

ence asked, "How do you people
intend to make a living?" This was
maybe 1971–72. I had a child I was
raising and sort of getting by. But not
enough in their eyes. And Carl Andre
looked up and said, "That's not my
problem. The genius of the middle
class is that they can figure out how
to buy *anything*. My problem is to
make it." As an artist, as an *artist*,
your concern is to make this product,
this thing, to stand for exactly what
it's supposed to, and not to worry
about how somebody is going to put
it in a bag and carry it home. They
can figure that out, that's part of
their job. That's division of labor.
That's the same thing as these draw-
ings you've been looking at. I give a
dignity to the people who say they can
build something. I don't have to tell
them how to do it. To put that on
paper would be a gross insult to their
skill. Their skill is to translate my
intentions into this thing. The artist
presents art, it's useful to the society;
the society knows it's spending time
making money. Society pays the
artist for that which enriches life, and
the artist uses the money to buy time
to continue this work.

Lari Pittman, *This Desire, beloved and despised continues regardless*, 1989, Acrylic, enamel on mahogany, 72" x 60".
Courtesy Jay Gorney Modern Art, New York and Regen Projects, Los Angeles.

LARI PITTMAN david pagel

BOMB # 34, Winter 1991

Lari Pittman's paintings indulge a sensualist's love of the visceral. Rendered with a fanatic's precision, his Victorian silhouettes, imaginary organic forms, runaway arrows and arabesques, transform ornamentation into a contemporary narrative of life and death, love and sex. Frenzied yet sophisticated, Pittman's operatic pictures propose that the world's complexity does not override passion, sincerity, and individuality. A Los Angeles native of Colombian heritage, Pittman was born in 1952, attended UCLA and graduated from Cal Arts. Inspired by the school's strong feminist program—which challenged the devaluation of art forms traditionally associated with women—Pittman embraced decoration. His paintings combine meaningless "surface embellishment" with "outdated" figurative imagery. Since 1983, Pittman has had annual solo shows at Rosamund Felson Gallery. He lives in Echo Park, California, with Roy Dowell, whose collaged abstractions influence and play off Pittman's promiscuous pictures. History? Who is he, where's he from, where does he live, paint, show, who are his contemporaries . . . ?

david pagel From one body of work to the next, your paintings change quite a bit. Do you have a plan?

LARI PITTMAN For the last ten years, at the beginning of each body of work, I have made a list of things I can no longer do. When, in previous bodies of work, there would be text, no more text. Or, in the last body of work with the psychological and sexual narrative, no more for the next. Aspects of the sense or sensibility of the work cannot be repeated, even though I might be drawn towards doing so. It's a sweet deprivation. Whether it's a romantic notion or not, it must seem new—to me, at least. I don't really know what new means, and I think that it is a romantic concept.

dp That it's fresh or it's something unexpected or undiscovered?

LP Mmm-hmm. And hopefully that will translate to a broader world, or at least to the world that I am painting. I mean, I have no tolerance for boredom. I'm very allergic to my own mannerisms. In other words, the work has always been mannered, but if the mannerism is repeated, I rebel against it, and that's why the work changes.

dp The last body of work was titled . . . was there a title?

LP All of the paintings have the same title, *beloved and despised, continues regardless*; And then it becomes: *This Desire, beloved and despised, continues regardless*; *This Wholesomeness, beloved and despised, continues regardless*; *This Machine, beloved and despised, continues regardless*. It's a litany of sentiment. There are aspects of behavior that are entrenched and change very little. And aspects of desire or longing that are very strongly entrenched. And there's discussion on both sides— they're either loved or despised. And there's really not much you can do about it.

dp There's a lot of sex and death in these paintings.

LP Yes. Sex. Death. But then life and love are further declensions of those. Life, being a segue from sex to death, and love to sex, and all those intertwinings. But it's not about polarizing them, which, at this point, American culture is incredibly adept at. It's really about democratizing their function within a larger setting:

that sex is equal to death, that death is equal to life, that life is equal to love. One doesn't supercede or exclude the other. In reality, it's much more inclusive. And if, indeed, they can disembody one from the other, it's our puritan heritage that has polarized these concepts. Because actually, life, sex, death and love sit very comfortably next to each other. They're not in opposition. The object of that body of work was to clarify aspects of this. My own particularized sexuality is not necessarily the lens through which I view sexual activity or desire. The work has always embraced a much broader form of sexuality and sexual activity. And that pansexuality was literally shown in the work. It's funny and somewhat ironic because I'm beginning to feel that it's incredibly outdated in attitude. *[laughter]*

dp Or just up in the future a little bit.

LP Hope?

dp Yes.

LP That's very kind.

dp Lately, sex and death have been brought together pretty closely with the AIDS crisis. Were you thinking of that in the work?

LP I think that course is inescapable. But this is in a culture that has steadfastly kept them apart. Out of this trauma and tragedy of the AIDS crisis, what I would like to see are the healthy ramifications—that because of the AIDS crisis our culture might be able to incorporate concepts of mortality. It can become a very natural filter, which

it should be, through which you view and appreciate life. There is no such thing as "Now we're alive and now we're dead."

dp Were you born in Colombia?

LP No. But my mother's family and my mother are Colombian, my father's family is American. And I think that was a vantage point from which to see how American culture functions.

dp So you had one foot in and one foot out.

LP The added thing, the one foot in and one foot out, is being homosexual. I've always, as an artist, seen those as really advantageous positions from which to view a culture. I like being slightly outside, but maybe I also don't have much choice. [*laughter*] But I insist that it be an advantage.

dp Your work is incredibly optimistic.

LP Again, I don't think we have much choice, do we?

dp I don't think so. But there isn't much optimistic art being made these days.

LP One can be incredibly critical of culture and still be equally optimistic or perversely optimistic about it. One can be dissatisfied with one's life, one's relationships, one's culture, one's specific, immediate world; but sitting next to that is an insistent optimism that it can be better. The core of cynicism in American art of the last decade is linked to a xenophobic cultural era which artists are not above and beyond—artists still believ-

ing in "first-world" culture. They aren't privy to observations of the world culture. Since first-world cultures are having a hard time, you assume that there's no hope for the world, no hope for culture, or your own immediate world. American artists are not beyond those gross assumptions—the intrinsically offensive concepts of first-and third-world culture. That is what I mean by cultural or xenophobic arrogance. A word I've never been scared of, even though it has, in recent times, been insistently linked to modernism, is the word "visionary." I don't "pejoratize" that word, and I don't necessarily link it to modernism. That is a link, but that is only in terms of art.

dp Well, that visionary look was otherworldly, or it slipped off into the clouds pretty quickly. Whereas, yours is picking up the pieces and stirring them up.

LP The work has always been hopeful but part of it is that I can't remove my work from my life. That insistence on projecting into the future with some criticism, but hopefulness, kicked into even higher gear five years ago when I was shot.

dp I read that; in your apartment.

LP And critically wounded. I had a hard time recovering. If you are so violated by violence that personally not only do you have to physically reconstruct yourself but you have to start from scratch philosophically . . . I found that completely liberating.

dp That was in '85, yes? [*Yeah*]. And

your work really did kick into high gear after that; it got more complicated, more dense and crazy.

LP Understanding mortality at a fairly young age opens things up instead of closing them down. What do I have to risk? Rather, what do I have to lose?

dp So you risk everything.

LP I feel that. And I don't mind the work being embarrassing or laughable. It doesn't bother me. There's a certain perversity in the work being ridiculed.

dp Does it get ridiculed?

LP Perhaps in my romantic mind.

dp It's some of the only work that really makes me smile.

LP But isn't that, at this point, ridicule?

dp No, not at all. It's rare to go to a show and respond by scratching your chin, frowning and saying, "Hmm." You get that twist, that spin that puts a smile on your face. It's not a silliness.

LP No, it's a hysteria. At times, I purposefully orchestrate the work so that you do have that comfortable laughter when looking at it—it's full-hearted and enjoyable internally—but it's also a laughter linked to nervousness. And that's the laughter I particularly like cultivating, parlor laughter, where there's always the subtext of conversation going on, but everyone is very agreeable.

dp Uh-huh, keeping it on the surface. You don't think of your work as particularly Los Angeles or California?

LP No. That's not an issue. It's made here though.

dp But at one point you chose not to live in New York?

LP Well, being an artist is certainly an important factor in my life, but of equal importance are my personal relationships. And those actually take precedence many times. Career is wonderful and satisfying, but . . .

dp . . . it's not the bottom line.

LP It's not the bottom line, and I don't like an empty bed. To put it bluntly.

dp What led you to the Victorian silhouettes—fin-de-siecle sensibilities, contemporary prudishness?

LP I've always employed elements of abstraction and narrative, and I never really know how to resolve them; I don't think I ever will. In this last body of work, I wanted to increase the narrative. The way to do that is to put ourselves into the work—the figure. I didn't necessarily want to paint the figure; hence the idea of the silhouette. But I didn't want to do contemporary silhouettes because then we could say, "Oh, there I am in that painting. I'm that type. I look like him or her." That's already an identification that gets too immediate, too fast and too close. Since they are from other centuries, you're not identifying with types of people but with types of behavior. Even as a male, you could stand in front of a female and say, "I behave like that," or conversely. They contain the possibility of crossing gender and sexuality by identifying with behavior and

things. And behavior has changed, unfortunately and fortunately, very little. So it was a way of making the work more narrative. Sometimes I rebel against levels of abstraction. Unlike Roy Dowell—the water he feels completely comfortable swimming in is abstraction. You know, we've lived together for almost sixteen years.

dp I didn't know that.

LP And that's been our difference as artists.

dp But you both flirt with the other sides.

LP Of course! How could we not? And we influence each other tremendously. Vocally, there's a symbiosis. But I'm more drawn or driven to picture making that has a sentence to it. Periodically, we do distinguish our work. And we're aware of where it meets and crosses. We have made very distinct decisions to move away from each other or to separate the work. And many times that reinvestigation is the reinvestigation of the stronger points. In my case, I'm happiest with the work that tends to be more conversational and chatty. I literally ask myself, "Lari, what do you want to see in your work?" I would look at this thing, which is very dead—a painting's a dead, pathetic thing if we're going to talk about it. It is. It's a sad thing.

dp Do you always paint on mahogany?

LP Wood.

dp Any kind of wood?

LP Mahogany. And so I wanted to look at this thing that's dead, and have you walk in on this intense chatter and conversation and engagement and activity. That's what I wanted to see in the work. The increase of the narrative becomes a way of giving life to the painting. And in that sense, it has a full life of its own. It's mildly indifferent to the viewer, which I like.

dp More than mildly. [*laughter*] It seems as if it can carry a conversation on its own, even if no one is in the room.

LP I hope so. The pedigree, or knowledge of the viewer, is not the main operating battery that empowers the painting. Hopefully, the viewer comes upon the work, which is alive and functioning on its own—at full throttle.

dp Do you think that just painting is dead or do you think any . . .?

LP Not dead, but lifeless to people. What we're seeing right now is a very heavy reliance on materiality. There is something that materiality brings to it that's different from illusion—a different type of life. I'm wondering if the reliance on materiality is, at its core, an incredible conservatism? I'm feeling that.

dp You dream in illusions. You don't dream in materials.

LP Well, but also, I love the properties of things. I've tried to do some three-dimensional work . . .

dp What have you tried?

LP Well, I'll look at this last body of work

with the silhouettes and think: Why
don't I literally create these tableaux?
But then I'm always slightly dissatis-
fied with the materialization of these
pictures. It always leads to disappoint-
ment. One of the things I rely on in
picture making is that it is illusion,
and therein lies a certain ephemerali-
ty. And all of a sudden, when you're
making something concrete . . . it
makes me nervous.

dp **It's more of this world.**

LP Yes. I don't think you can project or
dream as much.

dp **Do you think abstract paintings
are more in this world? Ones that
deal with materials? That they're
somewhere between an illusionis-
tic, representational image and
sculpture or three-dimensional
things?**

LP I have tremendous respect for abstrac-
tion, and I envy it, actually.

dp **Oh, really?**

LP But I wouldn't know how to go about
doing it. I don't really know how to do
it. But in my hierarchy, it's very high
on top.

dp **But your older works are more
abstract. Or the narratives are
more vague.**

LP The narratives are more vague, but if
indeed it was abstraction, it was strong-
ly linked to what have been termed as
biomorphic or biological references.

dp **You still have the plant forms in
the work. You always have this**

sense of organic life teeming up
and decomposing and rotting and
starting all over again; seeds grow-
ing. That's carried over.

LP The idea of cycle has always been a
part of the work and always will be.
The fascination with cycle is my utter
fear of it.

dp **How so?**

LP I get tremendous anxiety during the
fall. I don't plant anything that loses
its leaves. I have a very hard time
with that.

dp **No kidding? So that's why you're
not in New York.**

LP Evergreen. Everything has to be ever-
green. I have a hard time planting
perennials. I'm sorry . . . what is that?
I'm fascinated with the pulse of birth
and decay, birth and decay. But at the
same time it's horrifying. You know,
repulsion is fascination.

dp **In one painting, you have the
cycle of the commodities circling
around. Instead of plant life or
organic life being born and rising,
growing old and dying, you have
cars and video cassettes and TVs.
The urban or cultural equivalent
of that process.**

LP Regardless of ideas of romantic love,
there is an insistent and very strong
aspect of bonding that is about eco-
nomics; whether it's there at the begin-
ning or not, it's certainly formed at
some point. Relationships are not sim-
ply informed by concepts of romantic
love. There is a very distinct and tawdry
expediency to why people bond.

dp The nitty gritty, economic under-side of it. Do you have a favorite piece?

LP I like qualities in pieces that I've made. I like it when I overstretch myself, when it's beyond my grasp and it alerts the viewer that I'm trying too hard. Not in terms of dimension or size or materials, but in trying to tackle some-thing enormous—this tremendous, elegant endeavor. There's a pathetic quality to that type of overreaching, in trying to say something. It's embar-rassing that I even had that ambition and that I wanted to say so much. And that becomes touching and pathetic at the same time. These are qualities that are romantically linked. I like that in the work. People will respond, "Oh, come on, Lari, please stop!" [laughter] If I have favorite pieces it's because I secretly know how they relate to my life directly. But that's personal and really of no use to the public. *This Wholesomeness, beloved and despised, continues regardless*, where, in the bot-tom half of the painting, two men meet and construct a bridge that emanates from their erect penises. In the evening, they're done with the day's labor. The bridge is in the background, fully employed by pedestrians crossing over, and they're lying on the bank of the river where the bridge spans. It is about desire becoming real, desire becoming productive, and desire pro-ducing something of use to a broader world—this physical bridge. And then, simply, a celebration of that accom-plishment. But, in this case, it was all being accomplished by people of the same gender. So I think that is a favorite of mine. I'll say it. It's a favorite of mine. Ironically, or maybe very purposefully, even though the painting is centered around this dynamic, two men, it has nothing to do with sexuality.

dp Nothing directly?

LP Not really. This is a much greater bond than what physicality or sexuali-ty might intimate. In reality, the core of this emotional and sexual bond is not about a certain desire or attrac-tion to each other. In the painting, it proposes that the outcome is some-thing else which is building.

April Gornik, *Whirlwind,* 1989, Charcoal and pastel on paper, 38" x 50". Courtesy Edward Thorp Gallery.

Sally Gall, *Bukit Jati,* 1993, Gelatin silver print, 19" square. Couresy Julie Saul Gallery and the artist.

SALLY GALL APRIL GORNIK

A Dialogue

A few years ago, I was asked by a magazine to take portraits of several landscape painters (what an assignment for me, an on-site photographer). I walked into April Gornik's studio at our appointed time and was swept into this large shimmery mass of paint: a row of planted trees and their reflection in water below. I couldn't believe how much it looked and felt like a photograph I had just made of a similar place, feel, and mood. Not that the subject matter was particularly bizarre, in fact quite the opposite, but that we were both attracted to this situation and had made it seem so familiar— until you really looked—and that we had both made it at the same moment, seemed uncanny. I guess we just figured we would be friends. At least I did. Those moments in April's studio were the start of a long conversation, sometimes casual, and sometimes very serious— and of a friendship.

<div align="right">Sally Gall</div>

Sally said our work had a lot in common, but until I saw them I would not have guessed how amazed I would be by her photographs; by their beauty, complexity, and sensibility similar to my own. Sally and I have discovered that we can both speak articulately about landscape, that most verbally elusive subject matter, and so decided to make our conversation public.

<div align="right">April Gornik</div>

SALLY GALL Are you saying that landscape has no real narrative content?

APRIL GORNIK I'm saying that landscape is essentially metaphorical. It doesn't lend itself to narrative. It lends itself to abstraction.

SG But since your subject matter, as mine, has turned almost exclusively not to the depicting of a certain landscape, but to the elements of landscape . . .

AG It's such an experiential situation. The most potent experiences I've had, particularly growing up, have been being alone in the wilderness. The problem is that landscape as art can get very corny and very romantic—Freud's ocean of the unconscious. But I do remember as a child these moments of feeling, having an experience outside of myself, bigger than just me. These experiences were rooted to being in a place where I felt physically, emotionally, and even intellectually stimulated and enthralled—outside of my own, immediate, day-to-day life, sort of the classic, romantic experience. Now I make my landscapes so that I can be in them. That's why I alter them, that's why I make them somewhat artificial, because I want to take possession of them. My relationship with landscape is somewhere between being enthralled by it and wanting to be in control of it. Wanting to be invited into it, and to invite the viewer in, but wanting it to remain enigmatic or inscrutable. Do you do that in photography, manipulate your work so much?

SG I want to re-create the visceral experience of being in a landscape. The visceral experience is both physical—the way sunlight feels on the skin, or the way we hear the wind rustle—and contemplative and meditative. What compels me is that I walk outdoors in some beautiful, natural space, and I feel very content. I look at things long and hard, and staring at the meadows and woods becomes a springboard into free association about bigger things. Taking a picture out of the experience is putting myself, and thus hopefully the viewer, into that state of reverie.

AG That's where our work is linked. Bachelard talks about reverie and poetry as the point at which your perception of the world becomes the world scaled to your size. Often times I'm drawn to an image, and then as I'm working, I start to have this dialogue with it. I'll think, I have to paint a depthless blue. But then how solid does the thing next to it have to be for it to be "depthless"? How to paint that becomes the life and the meaning within the painting.

SG This past summer I was in northwest Scotland, fascinated by this brutal, rocky, unsensual, sparse landscape. I started taking long hikes, carrying the camera with me, enjoying the sport of walking through it more than anything. Now, I'm quite conscious of what attracts me to certain landscapes, mainly tropical and warm, and balmy, and leafy. But this one in Scotland . . . At one point, I got to this mountaintop and looked around: it's a very watery landscape, lots of lakes on the edge of the ocean. I real-

ized that the experience of this land-scape was understanding how the land was made, its geological features were the remains of the earth's movement. It was like seeing the earth's skeleton. That landscape had an indention, a footprint of its formation. That became intellectually fascinating to me. It seemed the origin of *all* land.

AG You said you're drawn to warm, trop-ical, balmy places. I've been to the Caribbean three times now and that experience as a particular type of landscape is starting to creep into my work. And it's not about humidity and torpidity as I would have expect-ed. There is a certain kind of stark-ness, a severity to the Caribbean land versus the warmth of the air that I want to exaggerate. The landscape and the quality of light seems hyper-bolic, the essence of tropicality. The colors are so lush, but the light is so blinding. Yet ironically, both of my paintings influenced by the Caribbean have to do with the severi-ty of night, with this undercurrent of warmth and heat still coming out of the land.

SG Your experience of the place is what you're trying to paint?

AG Definitely. Even if it's not my actual experience of the place. It could be a retroactive experiential depiction. [*laughter*] My paintings are fictional-ized, recognizable but always riding that edge of artifice. I'm too self-conscious at this point in the twenti-eth century to be oblivious to that, or to think that I could simply depict the sublime.

SG I hate to admit this, it seems so unpopular today, but that is what I'm interested in.

AG What?

SG Those aspects of the sublime in nineteenth-century romantic ideals. That might seem ridiculous at this point in the twentieth century, but I want to make an absolutely gorgeous photograph of physical nature where millions of thoughts about life and fertility and burgeoning things—some great and enthralling experience—occurs when you look at it. I want to make images that are so beautiful they lift you out of everyday consciousness and take you somewhere else. These things are seemingly older, not rele-vant to our lives anymore, or so our culture thinks.

AG When I make something that I think is sheerly beautiful, people see some-thing ominous. Maybe what they're seeing is mortality or the frailness of the fiction of it. Existential con-sciousness, if you will.

SG I hiked one clear and sunny day to the top of a mountain in the Rockies. I got higher and higher and suddenly, in the middle of this amazingly beautiful day, a storm rolls in. And I am in this very exposed place. There's a seeming contradiction between the beauty, the benign peacefulness of the day and suddenly, out of nowhere, this scary rolling thunderhead. I felt very exposed and was anxious to get away from the impending storm. That seems so metaphorical. For what? For every-thing. That experience fascinates me

and that's what I want to take a picture of: that which feels inclusive of seemingly contradictory things. It's like getting rid of all the traffic. It's elemental and it's raw. Early American landscape photographers went out west with geological survey parties and took pictures literally to show people what the landscape looked like. There was no other way to see it, short of walking into it yourself.

AG Did they make beautiful photos?

SG Many of them are fabulous photographs. Many of them are purely descriptive. Many of them are purely descriptive, *plus*. They didn't go as artists. They didn't go with the self-consciousness of making a beautiful picture. I feel the same impulse, the same impetus: to go into unexplored territory—personally unexplored territory—and to photograph it and bring those pictures back.

AG Your fantasy is of someone going to the farthest reaches and bringing back evidence of what's out there. My fantasy is more like Rimbaud—I'm finding the underside of everything. Like how incredibly brief a moment of beauty really is. How intense can it be? Compositionally, when I'm finalizing a painting, I'm going for a tension in which it could almost come apart. Take one little element out of it and it wouldn't work at all. But that's the fantasy of a poet, not the fantasy of an explorer.

SG I can actually go into the field and rub elbows with it. I just go into it, I walk into it and walk through it. That's

why I became a photographer rather than a painter. I want to physically be in the stuff of the world. The photographs become—somehow that act of being in it, of being hot or being cold, or being afraid that the waves are going to wash you off the lava rock on the edge of a Hawaiian beach—I seek the experience as much as I seek to make the photograph. And yet, the experience is one thing and the photograph is totally different. It might contain the experience, but it also fails to contain it; the depiction of the photograph becomes its own thing. I do use a lot of artifice. I've taken pictures of places, and then I've altered them so much, subtly, that people can't believe it's the place that I say it is. Even I don't see it as the place where I was.

AG Are you altering it with the specific memory in mind?

SG I'm adding on another layer. I have the memory of the place. For instance, it's been snowing as we've been sitting here, and the sun has just come out. It's an enthralling moment—it's been gray and snowy all day and suddenly the sun comes out. I find it so profoundly beautiful and amazing that I want to hold that moment, and that's what I want to photograph. The change that just occurred in the moment of illumination. That's my whole impetus for the photograph. Then I make the negative and I'll go to the darkroom, and I'll start messing. That's when the memory level comes on, and I'll start thinking, I can make this a little more

extreme, more ominous, more threatening, or whatever. But it's such a simple beginning moment. That's the reverie: you contemplate what's been here forever. To contemplate the constant in the midst of everything else, I find to be a very exalting experience.

AG I've never started with a blank canvas. There's always a vision that I've had, perhaps a photograph of a rainstorm with a certain kind of light. Looking at the painting is like looking through an exterior into an interior, on either side of which is the wet center of this rainstorm. These two different sides are like a mirror image that doesn't mirror evenly, it poses a mystery that doesn't have a specific interpretation. I want to be somewhat confounded.

SG You give people enough opening to come into the paintings and have their own emotional experience, which is what I crave in my own work, in looking at other people's work. It's a form of generosity when the artist allows the viewer to come in and have their own experience. It brings out the semiconscious. The work acts like a trigger.

AG When a painting is done I feel it actually recedes from me. Everything coalesces and moves away, and I can no longer focus on a single part of it. It suddenly does this gestalt.

SG It is its own being, its own self.

AG Does that happen to you in the darkroom?

SG No, taking pictures is a different experience, it is about time passing. Subtle changes in where you hold the camera make radical differences in the way you see the photo in terms of space. But it is still already an entire image. My role in looking at contact sheets is to recognize that moment in which I made an image that appears whole.

AG "It's me, I'm the one you can print!" Does it identify itself to you in that way? In your case it separates itself from the others, in my case a painting separates itself from me.

SG It is fascinating because the process of making paintings and making photographs is so completely different. And yet, there are several of your paintings that are so similar in matter and emotion to the things I photograph that it is uncanny. Your painting of a dark thundery sky with water and rocks where the gravity is uncertain: What's land, what's water, what's moving, what's still? An enveloping world of water yet a charged world comes from your head as you are putting paint on canvas. One can't make a photograph without having something in front of the camera, and yet I find that I try to obliterate the detail in a "real" place because I don't want it to be that specific, that much of a document. I want the "camera never lies" to make the picture believable as a real place, but then to undercut that too—make it surreal, superreal, abstract, not-of-this-world.

AG There is a rhythmic punctuation to your photographs. The one with the branch sticking out of the water slows the rest of the image down.

Orchestrally it would be like a long viola note in the midst of busier things.

SG It is like a punctuation mark. The issue of choice of subject matter becomes specific and unique to photography. I'm always thinking about subject matter, and I'm drawn back and back and back to these places where everything is lush and developing, earthy and moist, rocky and watery: primal, alone and in contemplation.

AG In your photograph of a girl sitting on a rock in the middle of a pond, the girl is about the same size as the rest of the landscape. One has this experience of her flesh and the water. It's monumentally sensuous, monumentally physical. It's about the equity of flesh as nature.

SG That was a quarry and it kept conjuring up this figure. It's a visceral moment we all experience—skin feeling water, water feeling skin—that seems very potent. I'm working in an archaic tradition in a traditional sense.

AG We both read a lot of fiction. What I'm looking for in fiction is to be moved, shifted. Not necessarily taken out of my present reality and put into some fantasy land, but jarred by something. Most of contemporary art is too self-conscious in saying what it already knows, what it's doing, where it fits with art history. It's almost an apology or a correction for art. I get so frustrated because I'm not moved by it and I know from reading great contemporary fiction that that's what art can do. I know when looking at

Matisse for example, that's what art can do. I don't want to look at art that doesn't move me, it's a waste of time. Much of the art that's going on right now is so like the art that was happening in the early seventies, it's like a déja vu.

SG But you make paintings in a traditionally established method.

AG Not only that but I use space. The whole message of the twentieth century is to be flat, but I want to go into the work. That's where I'm happiest. I look at Piero della Francesca and I see these paintings with weight and sculptural presence, and strong, dumb forms. I can move through that, I get the most intense sense of satisfaction from it. I get more satisfaction from that than I get from most contemporary flat images, that tell me they are aware of their own physicality.

SG What you're saying also implies a narrative, implies that you enter into a picture and go somewhere, not necessarily in the sense of a story, but in time.

AG I guess, if you define narrative in that sense. I want a bigger territory, frankly, a much bigger more visually lush territory to roam around in.

SG Let's talk for a minute about the impulse of art making. I want to tell you a little story. Years ago, when I was sixteen, I went with my mother on a trip to Scotland.

AG Oh, you were there before?

SG Oh, I've been there a lot of times. I went to southern Scotland with my

mother to visit this uncle. I had—in my typical researching of every-thing—gotten my hands on some information about a place like Outward Bound, an adventure camp in northern Scotland. I was deter-mined to get myself to this place for a week and take these courses on kayak-ing and sailing and living on the land: survival. But the week in which I was to go, my father got really sick, so we were forced to cut short our trip. This past summer, for a number of other reasons which are unimportant to this story, I decided to go to Scotland again, almost by accident. I had this visual image of the brochure for that place that I had wanted to go to when I was sixteen. I couldn't remember where it was in Scotland, what it was called. All I could remember was a ter-rible Xerox reproduction of the cover of that brochure—a rocky, black land-scape and a desire to find a landscape like that and to make photographs that were in my vague memory, simi-lar to the image on that brochure: dark, murky, and disturbing. So I go to Scotland, get in a car by myself and start driving. I figured I'd just drive, drive, drive and go all around the east, north, west coast and I'd stop at places I liked. I had a month. The first few days I had anxiety about not quite liking where I was, but I kept going, going, going, until I got to this more interesting landscape area: really remote, hardly any people or civiliza-tion, one lane roads for both direc-tions. Incredibly odd peat-flow landscape, kind of ugly, but exhilirat-ingly barren. Hotels were very few and

far between, and often full, and I started worrying about where I was going to spend the night. So I arbi-trarily picked this place on the map. It started to get dark and the landscape started to get more and more beauti-ful, but I thought, You cannot stop until you get to the place you're going to stay, and when you get to that place you can stay for a few days. But I started getting into more and more beautiful landscape and being so drawn in. I wanted to stop and photo-graph, but I didn't want to get lost in the dark. I didn't want to not be able to see. So I kept driving and driving, and finally the landscape got so amaz-ingly weird, I thought, I have to stop, it is too fantastic. So I rounded the bend, got out of my car, and right there it said: The John Ridgeway School of Adventure, which was the place on my brochure.

AG Oh my God! That's wild. And was it the picture?

SG Yes, but I don't actually remember the exact picture, I just remember a dark, murky, compelling landscape. Somehow you get these images of places or the desire for places, the desire for a certain experience. This story has no moral to it, simply because twenty years later I ended up in this exact same place. How did that happen? My unconscious led me there? I stayed there for about two weeks and I had the most exhilarat-ing time that I have had for as long as I can remember. Completely by myself, photographing, going out everyday, all over the place. I had

reached this primal experience; But that somehow I had known it, had gone in search of it. Somehow, I had picked this place out at age sixteen because it was going to offer that to me? That landscape reveals how it's made. There are all these fissures and places where you can rub the grass off the earth, and there's rock. It's so old and it's so uncultivated, so un-manmade, so raw, so wild. Barren wilderness. There are no trees, it's like the moon, there's nothing soft, nothing "ornamental."

AG Do you have ideas of why you're drawn to that psychologically? I won-dered if you had anything about a pri-mordial landscape, a particular kind of light from your childhood that had some mnemonic import for you?

SG I just remember that wild, or seeming-ly wild, landscape without any human evidence, was a big draw. There were woods behind the house where I grew up. My friends and I would go into the woods; it was possible to be deep in the woods. We created a world there. We play-acted there.

AG And that's where you felt self-expressive?

SG Yeah, I went there by myself a lot. And I pretended I lived in the woods, I had another house and everything. I felt like I was making my own world.

AG Right. I remember going outside in the summer on certain mornings when the air was sweet and warm, and the light was very particular on the grass. The light was still low and everything was back lit and sparkly,

and feeling this absolute sense of inner joy and freedom.

SG Yes, I can connect to that feeling right now looking out the window at your yard.

AG I was attached to the light. More than anything, I want light. I want to experience it, which is essential to spirituality.

SG Often I look forward to being by myself, to getting away. I go off into someplace that's wild and I make art in it, and it is the opposite experience of my day-to-day interactions. It's a respite. It is a time of solace, a time of solitude, a necessary period of time to balance the other activities. And that's the time that I always feel the most intuitively in touch with . . . [*pause*] . . . with my emotions and my vision. It's not like continuous time. It's really blocks of time that I stake out in which to go away. I like to make photographs in blocks of time.

AG Do you take photographs in more mundane surroundings, or do you find it's necessary to go further away?

SG I've gotten criticism from people who suggest I need to have exotic locales to take these pictures, that the loca-tions themselves have their own inherent surreal or picturesque quali-ty. There is a part of me that seeks something unfamiliar, journeying, the experience of going someplace totally unknown and totally alien, a different culture and a different look. It's such a jolt to all of one's ideas and visions, to go on an adventure to

an unknown place. And then, after doing that for a number of years, I went to MacDowell, an artists' colony in southern New Hampshire. I'm not particularly interested in New England. I wanted grandeur, which it doesn't offer. I went to MacDowell thinking I would use the time to print in the darkroom for an upcoming exhibition, but I became fascinated by the benign quality of all the fields and meadows and ponds that immediately surrounded me. I ended up doing a body of work in the same small place, at the edge of a pond. That opened up a whole new world, that intimate edge of water and rock. But grand exotic locations do draw me because they are infused with their own sense of the romantic; these typical tourist romanticized destinations: Scotland, Bali, Hawaii, the Caribbean. The challenge is to have to deal with the inherent exoticism and romance. I like to go to a place that already has associations—either make more of them or go in a different direction.

AG When I first started painting landscapes, I thought that I had to make everything up because only that would be true art. I was painting dreams. Then I went to the Southwest, and I saw what I thought I had been making up. It was a profound experience to see what I thought could only be imagined. In a funny way, since then I've had to become more imaginative, to draw out a vision from something real.

SG I print to soften, to diffuse—get rid of detail. I want one foot in the real

world and one foot somewhere else. It's very important for me to have something real depicted believably, to take what's familiar, what's known, what's specific, and make something else out of it. Sometimes I think I chose photography not only for my physical interaction with the elements but because it gives so much believable, specific detail. But it also gives me all these manipulative tendencies. I work with black and white, which is already abstracted. Your work looks at the same time to be a wild landscape and a formal man-cultivated landscape. I actually go to places that have that combination. I took a photograph of a wonderfully overgrown urban tropical garden in decay—it looks like a tropical forest but then you take a little closer look. Some of your paintings are like that—like stage sets. I don't mean contrived, they're sets for activity.

AG Well, the activity is what you do when you're in it. What your mental acrobatics become.

SG That, I think, is where we are alike.

AG Yes, that's true, there are elements of theatricality in our work. Nothing's really happening in it but once you get in it, what you do with it interpretively is a lot. You end up being the action. In your last show, there was one shot of just a cloud above the shore. It was poised there, it looked so artificial, so peculiar, like a ball in the sky. It had such a specific type of dimension. It was a little more aggressive than normal cloud-in-the-sky behavior, it came forward. That is pivotal—it makes

you see the landscape completely differently, otherwise it would have just been a shoreline. But it was two things happening at once: the slow flatness of the shoreline sitting on the bottom of the paper and the mass on top made this beautiful strange combination. Once you have two totally different things functioning in tandem then you have everything. It throws consciousness and your own sense of looking in back at you.

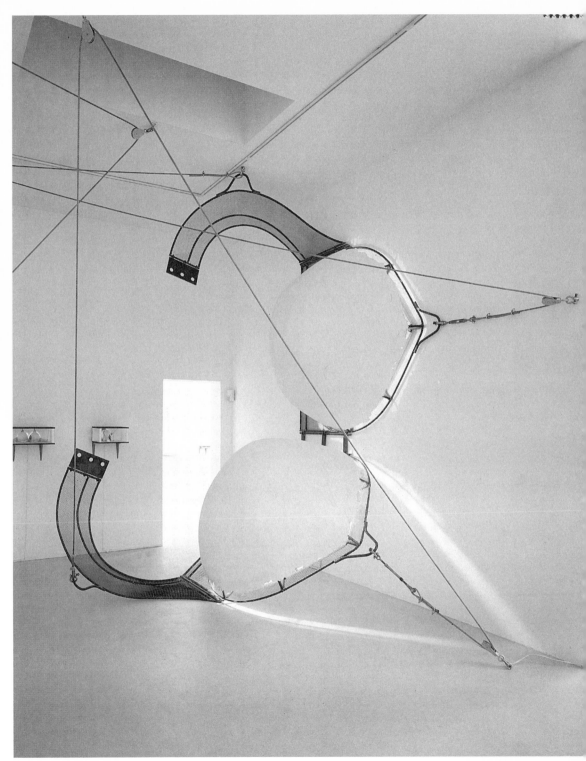

Vito Acconci, *Adjustable Wall Bra*, 1990-91, Rebar, plaster, canvas, steel cable, audio, and lights. Each cup 8' x 8' x 3'.
Courtesy Barbara Gladstone Gallery, New York.

VITO ACCONCI richard prince

BOMB # 36, Summer 1991

I met Vito in Vienna in 1986. We've been following each other around, in a way, ever since: we both showed at International with Monument and now we both show with Barbara Gladstone. He just had a show, and my show followed his: I told him I felt like the Rolling Stones following James Brown at the Tammy Awards in 1964. I wanted to talk to him about mainstream cults.

richard prince Born in the Bronx, 1946?

VITO ACCONCI 1940; I wish you were right with 1946.

rp And graduated from Holy Cross in 1962?

VA Went to Catholic elementary school, high school, college. There wasn't a woman in my classroom between kindergarten and graduate school.

rp When did you come to New York?

VA I thought I was always here; the Bronx, after all. But then again, in retrospect, it was like the country, a wild country where I grew up, but at the same time, a kind of Midwest in New York. Then I went to the real Midwest, graduate school in Iowa City. I came back to New York in 1964 and saw a lot of movies. I was writing poetry then; I saw a Jasper Johns for the first time, and realized that I was at least ten years behind my time.

rp 1971: John Gibson Gallery—who were some of the artists around then? Was anybody else doing things like you? What about minimalism? Robert Smithson?

VA I thought everybody was doing things like I was. I think we all shared the same general concerns, to break out of, and break, the gallery system—to range the way the *Whole Earth Catalog* ranged—to be as articulate as possible about work so that art wasn't mystified, to see art as just one system in an interrelated field of systems, to hate the United States, and power, during the Vietnam War. Minimalism was my father-art. For the first time, I was forced to recognize an entire space, and the people in it (I had to look at the light socket on the wall, just in case, I wasn't going to play the fool). Until minimalism, I had been taught, or I taught myself, to look only within a frame; with minimalism the frame broke, or at least stretched. Smithson

was probably everybody's conscience. Maybe because Smithson went outside, I could go inside—I had to go somewhere else—inside myself.

rp What about someone like Dennis Oppenheim?

VA He's the art-context person I've been personally closest to, from the beginning. He's the most restless artist I know.

rp Chris Burden was somebody on the other coast who got a lot of publicity for that gun shot piece. I always thought that was a major network piece, something the prime-timers, *Life* or *People* magazine, could get, whereas your work was more a mainstream cult. Your pieces didn't have any hambone or dancing bear stuff in them. Your work never seemed to have a facelift. What did you think of that Burden piece—cheap shot? Good shot? Cornball? Did you roll your eyes and say, "Please?"

VA I didn't take Chris seriously enough until later; maybe at first, I saw him as a competitor—anything you can do I can do better, anything you can do, I can do more tortuously. I pay more attention to him now than ever: he grabs particular situations better than anyone else—for that situation, after careful consideration, he performs a serious prank.

rp I see the media as the Antichrist. How do you view the media?

VA My early work depended on media. An action needed reportage; it didn't exist unless it was reported. For my work

now, I see the media as a travel guide, it points out places. But the situation hasn't changed much, most of the public stuff I do doesn't get built. It remains in model form, the embodiment of the idea. A model space is a purified space, away from the changes of place and time and people; media can put it, if not into an actual place, at least into the news. As long as there are multiple media, I love the "distortions" of media, because those distortions are multiplied and contradictory.

rp What about feminism? The difference between the seventies and now?

VA My early work came out of a context of feminism, and depended on that context. Performance in the early seventies was inherently feminist art. I, as a male doing performance, was probably colonizing it.

rp Pornography—what do you find pornographic?

VA A conversation in which a man keeps touching a woman's arm, a man on the street looking back at a woman who's just walked by; a man kissing goodbye a woman he's just met . . . and probably a woman doing the same. I don't know if these things are pornographic, but they're probably obscene.

rp What kind of sex do you like?

VA The kind in which two people use every part of their bodies and every secretion of those bodies and every level of pressure those bodies can exert.

rp Did you have any encounters with

the Vietnam War?

VA I was in the usual demonstrations. I was one of the usual suspects. My early work came out of the context of the Vietnam War: self-immolation, boundary protection, aggression. The problem was that the work generalized those themes away from a particular target. It made them "ideas" and not political action.

rp **They always talk about your voice. You really think you would have been able to fuck anyone without it (using your voice as a sexual persuasion)?**

VA Anyone? Well, that's probably exaggerated. But there are people I would never have fucked with if I hadn't been an "art star." It's not that I've used my voice as a sexual persuasion. I hope I've never tried to persuade anyone to fuck me. My voice probably has, for some people, a storage of sexual associations (Humphrey Bogart, Ida Lupino). Also, it seems to come out of some depths, so it probably promises intimacy, sincerity, integrity, maybe some deep dark secret (it ties into biases of Western culture, it seems to go beyond surfaces).

rp **You live in your studio.**

VA I can't separate living and working; I like to sleep for an hour, get up, work, sleep again, etc. I need to have books and records (tapes, CDs) around me at all times like pets, like walls.

rp **You're Catholic. Is that like being . . .**

VA *Was* Catholic. But you didn't finish the question. The thing that still interests me about Catholicism is the number of saints. There's no void, no distance between "person" and "God." There are all those saints in between: every misfit, every problem has a patron saint attached. So you're always part of a crowd, and there's no abstraction, everything's tangible.

rp **What kind of drugs have you taken? Have they done anything for you?**

VA The usual late sixties drugs: pot, hash, mescaline, not even LSD. And hardly more than once. I was only a tourist. I get woozy, I'm afraid of losing control.

rp **There's an old joke, "Sex between two people is beautiful. Sex between five people is fantastic." What would be an ideal sex situation for you?**

VA Theoretically, sex with everybody. In fact, sex with one person I feel inextricably connected with.

rp **What are your favorite TV programs, if you watch it at all?**

VA Mainly watch when I'm eating. It could be anything (eat anything, watch anything). Eat late; so I see news; *Nightline, Night Heat,* ends of ballgames, commercials.

rp **Movies? Which one comes to mind?**

VA *The Searchers, Videodrome, Blade Runner, Detour, Phantom of Paradise, Shock Corridor, Double Indemnity, The Killing of a Chinese Bookie, Last Year at Marienbad . . .*

rp Do you ever feel like disappearing? Your early pieces had an appearance/disappearance method to them.

VA The early work applied stress to the body that then had to adapt, change, open up, because of that stress. Remember, this was just after the late sixties, the time—the starting time of gender other than male, race other than white, culture other than Western; I wanted to get rid of myself so there could be room for other selves.

rp You've said a lot of the early work focused on your self so you started using a camera because one thing you were sure of was that "I had my own person." Do you see a difference between personality and person?

VA Personality fixes person, makes it static. That was a flaw of my early work: it started by being the activity of a person, any person, like any other—but once that person became photographed it became a specialized person, the object of a personality cult. After a while, anyone who knew work of mine knew what I looked like; action had become trademark. So I had to disappear from my work, certainly. And that takes us back to the question before this: I don't know if I ever feel like disappearing—spreading out and branching out maybe—but I'm stuck with old habits: I want to keep working, other people work with me, there's got to be someone for them to work with, I have to be around somewhere so work can be around elsewhere.

rp Do you still see yourself as a male cartoon?

VA When I said that, I meant—I hope I meant—not "myself," but "myself as performer" in some of the early work, where maleness was made so blatant that it stood out like a cartoon: so then it could be targeted, it could be analyzed, it could be pilloried. I still see a lot of my work as cartoon-like: turn a house upside down, build a miniature Supreme Court that's "ours" and submerge it in the ground in front of "theirs." I'd like a piece to appear in the world, on the street, like anything else on the street except that maybe it's in a dot matrix, maybe the colors are too simplified, maybe it oozes.

rp Polanski?

VA Except for early stuff, like *Knife in the Water*, I haven't thought about his movies much. I think of the person, or the myth of the person, more than the work, and I don't like that myth; I've been in relationships with people much younger than I am, and he makes a relationship like that look ugly, and I don't want to believe they have to be ugly.

rp Have you ever had someone who you've been close to come to some unspeakable harm?

VA People died, in ordinary ways, probably too unspeakable.

rp What's your relationship to your mother?

VA We speak on the phone every night; I'm an only child; my father's been dead over twenty-five years. By this

time we should know each other, but neither of us asks the right questions; maybe, in spite of all the phone time, we leave each other alone too much.

rp Would you consider serving on the Supreme Court?

VA I don't want to make laws and commandments. I do want to make places that function as models, models for activities, but models can be tampered with, and added to and subtracted from, and there's no punishment.

rp What did you mean by "dumb literalness"?

VA I don't remember in which context I said this. What I would mean now is: I want a thing, a place, to just be there, and not look as if it's asking for interpretation—maybe you wonder about it later, or you wonder about it on the side, but you don't have to talk about it in order to use it—something that's so clear you can't believe your eyes, something without an inside, like a stone.

rp Can insanity be prevented?

VA For me, insanity would be like a vacation, or a belief in god; out of desperation, you let yourself fall into it.

rp When a person says gloomily, "No one understands me," are they telling the truth?

VA They're telling the truth in the sense that they're making a demand: "Don't understand me." (Underneath the imperative is a subjunctive: "I hope nobody understands me, because if somebody does, then I'm just like

everybody else. Who am I then?")

rp Do you think anyone understands how another person feels?

VA Everybody, in a particular culture, understands the language other people in that culture use when talking about feelings, and that's all understanding can do, it can understand language. Language is the realm of feelings when thought about or talked about, and that's enough to take us from language to some kind of action.

rp Did you ever play any sports?

VA When I was a child; all the usual sports, in the usual awkward way. At the same time, from the early sixties, I've had a make-believe baseball player. I follow his career, think about him when I'm falling asleep, when I'm drifting around the studio. He's my age, based on somebody I went to elementary school with (there had to be a real person to ground this on, though that real person was, as far as I know, nothing like this make-believe person; the real person functioned as a man without qualities, only the bones onto which all my storage could be grafted). The ballplayer's an outfielder (all alone like an American pioneer), he's batted .500 once, hit 121 home-runs one season, pitched a little toward the end of his career in the mid-eighties (relief pitcher, came in just when everybody needed him). He's played other sports off-season (the thing about this guy is that he has only basic skills, he's taught himself to be—willed himself into being—a superhuman player). One trouble is,

he's been traded a lot, he sticks out like a sore thumb, he's never been on a World Series-winning team. He has a personal life: he's gone out with actresses, rock singers. After he retired, he made a movie, twenty-four hours long, about the real invention of baseball, around the wagon trains on their way west (Jodie Foster plays the woman who began the sport). He's making a comeback now, trying to stretch his career into four decades (he tried a comeback a few years ago, but he had gotten into trouble with some kids at The Palladium, and was drummed out of baseball). Now he's playing with Oakland. After all, people forget. And anyway, they don't worry about that sort of thing in the birthplace of the Raiders, so now he has one last chance at a World Series, one last chance at being a team player on this team of individuals.

rp **Do you think women are more easily satisfied with their portraits than men?**

VA More easily satisfied with (painted) portraits, less with photographs. (I don't have any idea what you're talking about, I'm just playing your game.)

rp **I was wondering, do you think you can break a bad habit by practicing it to excess?**

VA By practicing it to excess, you can break the habit of calling it a "bad habit." It just becomes ordinary life.

rp **Do you think it is possible to reason with people who are in love?**

VA When I'm in love, I think I can be reasoned with most easily. On one hand, I'm always eager to find reasons to question my love, break that love; on the other hand, I'm determined to be in this love state, love event. But, in order to be really determined and adamant, I have to know all the reasons against it, and do it anyway.

rp **Is there one sure sign that you're not an emotional grown-up?**

VA When I'm stuck on a piece, or when I hate my work, and I complain about this to people around me, I'm making the assumption that other people would be interested in what are, after all, ordinary troubles, and just mine, and of no concern to them.

rp **What's the best way to conquer fear?**

VA My early pieces were based on stage fright. In every early performance, I spent the first few minutes having second thoughts: "This is the worst piece I've ever done. The only honest thing is to admit this and get out of here." But then, after a while, since the pieces usually involved some kind of talk, both to myself and to others, after a while I talked myself into it. I was hypnotized and the piece went on. (But, if I conquered anything, it was only the fear of performing. In everyday life, I'd be as afraid as I always was.)

rp **How would you cure an inferiority complex?**

VA Remind myself of some kernel of something in some piece I've done, tell myself that this could—just possibly—improve and range in the future.

That might be illusory, of course, but so might the inferiority complex. I'd be fighting it at its own level.

rp **Under what circumstances would you murder someone?**

VA I could see myself murdering the Fascists in *Salo,* the rapists in *MS 45.*

rp **Don't you think it's a little pes-simistic to believe you can read a per-son's character by the way they look?**

VA Yes, since it implies direct cause and effect. The character causes the look, and the look causes the character, and there's no escape. But it might also be said to be optimistic, the belief that things can be so solvable and han-dleable.

rp **Is anything worth worrying about?**

VA Yes. Falling into old habits, customary modes of working, already-used solu-tions. At the same time, I worry about not reusing solutions. I have a ten-dency, when starting a piece, to act as if I've never done a piece before, as if I have nothing to fall back on. I worry about that, so I have to assume it's worth worrying about. It's worth wor-rying about because it reveals a romanticization, a desire to divorce myself from history, from my own his-tory, a desire to think of myself as a person alone in a vast unanswering universe—I hate ideas like that so I'd better worry about it.

rp **What about anxiety, do you have any?**

VA Anxiety about exclusion from large group shows, particularly European shows, anxiety that certain directions aren't clear enough in my work. (E.g., I think of my work as more political than apparently a lot of other people think. I think the only way art should exist is as politics, as a critique of power and an impetus to change. I'm anx-ious: either I'm missing something or they're missing something, and if it's them then I'm missing an opportunity to change their minds.) My biggest anxiety is that my stuff just isn't good enough, and sometimes I can't even answer "good enough for *what?*" That's what causes the anxiety.

rp **Is there some piece you've wanted to put out there but thought, Even *I* couldn't get away with that?**

VA There have been pieces I didn't know how to do, so I never worked them out far enough to put out. In the early days, there was an idea of some per-formance on a floor filled with babies. In the early eighties, there were some vague ideas of walking houses and rolling homes. Doing a public space project always means adaptation, and modification, sometimes because of subject matter (no pricks, no cunts, no burning American flags), some-times because of safety standards (no holes, no heights without railings). But I don't think I've felt stopped from something I've wanted to do. I don't think I'd want to do something that didn't fit into the conventions of public space (the pieces aren't put out in front of people, they already con-tain within them at least a general idea of people, actions and customs). You don't put something out; you

infiltrate, you squeeze something
through.

rp What part of women do you like
best? I like the voice, I think, just
the way a woman can say your
name.

VA The vagina. If the person is someone
I'm not involved with, then the vagina
must be the reason that the character-
istics/qualities I'm drawn to in that
person are different from those similar
characteristics in a man. If the person
is someone I'm involved with, then
the vagina is, literally, my way to get
inside that person and that person's
way to envelop me.

rp What do you live for?

VA If I can't change the world, then maybe
I can at least change something about
the space in the world, the instruments
in the world. What keeps me living is
this: the idea that I might provide
some kind of situation that makes peo-
ple do a double take, that nudges peo-
ple out of certainty and assumption of
power. (Another way of putting this:
some kind of situation that might
make people walk differently.)

rp Do you eat pizza?

VA Yes. There was a time in the seventies
where I couldn't walk by a pizza parlor
I hadn't tried—I had to go in for a
slice. I wanted to eat every pizza in
New York.

rp Who do you think the Pat Boone
of the art world is?

VA This might be the question I love
most, but I have no idea how to

answer it. (Shit, I suddenly have one
or two ideas, but I won't say a word.)
Let me avoid the question. The thing
that means most to me about Pat
Boone is that for people of my situa-
tion and class, at a certain time, he
made black music available—distort-
ed, certainly—but enough so that you
could go and hunt down the real
thing.

rp What makes you cry? Is there
some kind of music, a scene in a
movie?

VA Twice, when a person I was in love
with left me, I cried. Now, in love with
someone, I cry sometimes when I'm
with her and I feel I'm part of her and
she's part of me and that's all there is
to that.

I cry at the end of *Last Year at
Marienbad,* when the narrator says
(and there's no one left on screen):
"You were alone—together—with
me."

I cry when Gloria Swanson comes
in for her close-up at the end of
Sunset Boulevard and she blurs out on
the screen.

I cry when John Wayne slips down
off his rearing horse in *The
Searchers*—the horse is just about to
pounce down on Natalie Wood—and
he picks her up in his arms and says,
"Let's go home, Debbie."

I cry (or something like it) when
Jeremy Irons in *Dead Ringers* drifts
around his dead brother's body (his
dead self) and says/sings, "El-lie, El-
lie, El-lie . . ."

I cry (or something like it) in the
middle of the Sex Pistols' "Bodies,"

when the music stops for an instant and then starts again, with Johnny Rotten's voice coming in, "Fuck this and fuck that."

I cry (or something like it) when I look up through the Guggenheim's spiralling ramps, up to the circle of light coming in at the top.

I'd probably cry, or something like it, at the Malaparte House in Capri, if I were there.

rp Do you think about what you are going to wear before you go out?

VA A little. If I'm going further than my immediate neighborhood, I take off my green pants (indoor pants) and put on my black pants (outdoor pants). I decide whether to wear a black collared shirt or a black turtleneck (the old one that's turning blue-gray, or the newer one still black, or the one with the hole in the sleeve). I choose between my black jacket (if I care about my image that day) or my green army jacket, I guess whether it's cold enough to wear my green army coat.

rp I've heard you referred to as "The Hunger Artist." The hunger artist supposedly leaves out or forgets about public opinion.

VA I never leave out public opinion, not public *appreciation* but public *consideration*, public *response*; people are part of all the pieces I do. I anticipate a range of responses, or at least actions.

rp Why do you think you're an artist's artist?

VA If I'm an "artist's artist," it's probably because: I don't make much money;

my work seems to change, so it looks as if I must be trying; I've been with a lot of galleries, so it looks like I'm my own person, no strings on me.

rp You once told me you've saved a lot of money by not having to go to a shrink. What did you mean?

VA Early work of mine might have been a substitute, I went through the motions of therapy, I physicalized therapy. (But I don't think that was the purpose, I thought I was doing art. I was shifting the focus from art object to "art doer." To prove I was focusing, I could target in on that art doer, myself, physically—by extension—I could knock that art doer out of existence and move out of self and on to place. So, if therapy is about getting rid of the problem, then my early work was getting rid of me.) Also, I used to be Catholic; I couldn't make myself go to another priest.

rp Did you really ever have an orgasm under the *Seedbed*?

VA Yes.

rp Have you ever seen someone murdered or executed? What do you think about capital punishment?

VA No. No use for it, and even if there were use, no justification for it.

rp Do you really describe yourself as a minimalist, can that be amended?

VA My early work came out of minimalism and also out of R. D. Laing and Erving Goffman and Edward Hall and Kurt Lewin and pop psychology of the time . . . but that's another

question. If minimalism was my father art, I had to find something wrong with it, I had to kill the father. The flaw in minimalism, as I saw it, was that it could have come from anywhere, it was there as if from all time, it was like the black monolith in *2001*. Well, if something just appears out of nowhere, then you never can tell where it might have come from, all you can do is bow down, kneel down, you'd better respect it. To get around this, I probably made the decision that, whatever I did, I would make its source clear: that source was me, I was the doer, I would present my own person. When I think of *Seedbed*, I think of the room as a prototypical minimal-art space: nothing on the walls, nothing on the floor, except in this case there was a worm under the floor. I still think of my stuff as making minimal moves: it bulges walls out, digs under floors, it's usually tied into buildings so it's based on right angles. But I don't know if that has anything to do with minimal art. It probably has more to do with cohabiting a space and fitting in, nudging in.

rp Would you shoot an animal for sport?

VA No.

rp Who do you do your art for?

VA For myself, to prove I can think. For other people, living people, to join in a mix of theories that might sooner or later lead to practices; for future people, to function as a track that might be renovated and taken from.

rp What kinds of food do you eat?

VA I could probably eat nothing but Chinese food everyday for the rest of my life. But I don't. What I eat is: if I go out, Indian, Chinese, Thai; if I stay home, which is what I usually do, basic chickens, basic pastas, basic salads.

rp Do you know any good jokes?

VA Best joke I've heard recently is an old Milton Berle routine.

A resort in the Catskills. Lots of women around: widows, divorcees, they're searching for men; one of them spots a man she hasn't seen before.

"You're new here," she says.

"Yeah," he says, "I've been in the can!"

She's confused. "You've been on the toilet?"

"No, no, I graduated."

She's confused again. "You're just out of college? You're that young?"

"No, no, when I say I've been in the can, when I say I graduated, I mean I was doing time."

She's still confused. "Doing time? What time?"

"Let me explain. You see, there was my wife. I took an axe, I chopped my wife into twenty-five pieces."

"Oh, you're single?"

rp Have you been married, any children?

VA I was married in 1962, just after I graduated from college, we lived together on and off until 1968, no children.

rp Do you have a good memory? How far back can you recall?

VA I remember scenes from movies well, and lines from books and movies and songs. I don't remember faces well or, more precisely, I don't connect names and faces. I don't think I remember further back than to the age of four and even then, it might be that I've been helped by photographs. What I remember most from childhood, around five or six or seven, is a recurrent childhood dream. I'm in the bathroom, I'm standing in front of the toilet, I'm pissing. I'm pissing blood. I draw back, shocked, scared: as I draw back, my piss shoots all over the place, all over the walls, over the ceiling. I see what's happening, I make a sudden decision, I grab my prick and direct my piss more determinedly over every inch of the walls and ceiling, I'm not scared anymore, I'm exulting. The color of the room is changing and it's all because of me. The real life incident I remember is: I'm over my father's knee, he's spanking me, I'm about five. As he spanks me, I throw up, I'm vomiting spaghetti all around his feet. (The spaghetti I had eaten had tomato sauce on it, I was sure of that, but as it came back out of my mouth, it came out all white, as if it was filtered through my insides).

rp What kinds of men and women do you dislike?

VA I like multidirectedness, and the look of a frightened colt, and the Little Engine That Could, and grasping at straws: I dislike smugness and self-satisfaction.

rp Did you find when you were growing up that people often frowned upon those who sought out psychiatric help? What about now?

VA When I was growing up, people had priests, or they assumed they had themselves. There are no individual bodies now, no skin, no separation between public and private. (If there was, would I be so earnestly trying to answer these questions?)

rp If fashion is what comes after art, what comes before art?

VA Probably everything. Let me put it this way: when I realized I wasn't writing anymore, in 1969, what drew me to "art" was that art was a non-field field, a field that had no inherent characteristics except for its name, except for the fact that it was called art: so in order to have substance, art had to import. It imported from every other field in the world. Let me put it another way: for me, what comes before art—in the sense of influence—is architecture, movies, (pop) music. (But probably literature and or philosophy come first. Books provide, literally, a text, theory. But of course, a book can provide a text, a theory, only because it's a storage of what really comes first: history, science . . .)

rp Do you write letters? To whom?

VA Three times in my life I've written a lot of letters, each time to a person whom I was in love with and who was, either physically or some other way, very far away.

rp What makes you really angry?

VA Being cheated, being tricked, being slighted in stores or at business offices because of the way I'm dressed. Right now what's making me angry is that I'm spending so much more time answering these questions than you spent writing them. (I work so much more slowly than other artists seem to work: that makes me angry.)

rp Do you ever hang out at topless bars?

VA No.

rp What sort of porn should be banned?

VA On the one hand, I believe that porn influences crime; if I didn't believe that, then there'd be no reason at all to do art, since art couldn't affect a real-life situation. On the other hand, I don't believe that porn should be banned. You can only ban the crime, not the influence. (All you can do is hope that other influences, colliding influences, might act as a buffer. That's what the electronic age is all about.)

rp Do you think art is one of the places in the world where something perfect can happen?

VA Visual art, architectural models, (concert) music, books . . . all those situations where there's a viewer, an audience, where there's a separation between person and thing: something perfect can happen only where there's visual distance. Which is why I resent the visual: the visual means you don't touch it, the visual means somebody owns it and that somebody isn't you. I prefer the perfect to come down to

earth and be imperfected: the architectural model becomes architecture, the architecture becomes renovated, music becomes pop music, blasting out of some radio while some other pop music blares out of the speaker in front of some store . . .

rp How many pairs of shoes do you own?

VA One pair for going out, another pair that used to be for going out but then wore out and now function as house shoes, and a pair of all-purpose sneakers, sort of on reserve in case one of the two majors breaks down and I need a quick replacement.

rp What artists do you like: old, peers, new?

VA Peers (we can commiserate and maybe my position can be buttressed); new (I can try not to be left behind).

rp Did you do your homework when you were in school?

VA Yes. All my life, I've never had particular skills, particular talents; I've just had will, and I've worked hard. I see myself as a drudgerer. (As for school homework, it wasn't pure academics, I knew I couldn't keep going to school unless I got scholarships, so I did what I had to do).

rp Do you wear underwear?

VA No.

rp Do you eat meat?

VA Yes.

rp I don't like it when men whistle at

women on the street. What about you?

VA I hate it, too. At the same time, walking down the street, in the city of the nineties, means putting yourself out in public, subjecting yourself to the public, you're up for grabs. This applies to men as well as to women, men realize they can be victimized, too. You don't have to accept this situation, you just have to guard against it. And I don't mean carry weapons, but I might mean wear armor: this is what late capitalism is all about. (At the same time, it's apparent that women are subjected to whistling and men aren't, except in specialized situations: women-whistling, therefore, should be a punishable crime.)

rp Has anyone ever tied you up?

VA Yes.

rp I heard that Elvis and Jerry Lee Lewis bought brand new Cadillacs with their first money. Have you ever gone out and blown a couple of inches of cash on something you really didn't need?

VA Just on books and records/tapes/CDs, and I always need them. And, at various times, on presents for a person I was in love with. And that person needed them, or *we* needed them in order to be a couple.

rp Would you ever trade places with a woman?

VA Yes. Except that, as in your previous trading-places question, I don't understand what it means: would I know I'd traded places, or do I

"become" that person? Do I keep doing "my" work, only doing it as a different person? Who am I anyway?

rp Have you changed your bedroom situation since I last visited you?

VA It's still the same. So that others can know what we're talking about: all the implements for living—bathroom, sink, stove, refrigerator, table and chairs, bed, clothes closet—are squeezed into what's probably less than 10 percent of a 3500-[square-] foot loft space.

rp What's the best place you've been to? I mean, do you ever see yourself away from New York?

VA L.A., maybe Paris. New York follows an old model of a city: it maintains the idea of a center, it keeps vestiges of piazzas and town-meetings. The new city would be more like a blob, like ooze, like L.A.; the new city would be a ground for floating privacies, floating capsules; the new city would have more to do with the curves of a highway than with the grid of streets.

rp Have you ever walked into a bar and picked somebody up or been picked up?

VA I've been in situations, not bars, where I've met someone, we talked, and then within a few hours we fucked. I assumed we were picking each other up. (I don't think the word "pickup" came up in anybody's mind: I assumed we were, simply, meeting each other).

rp Do you have call waiting?

VA No. I never answer my phone directly, always have my answering machine on; don't like to be surprised and at a loss for excuses; call waiting would be asking to be put on the spot: I want to avoid calls, not be in the middle of more.

rp **What is the connection between the bra sculptures and** *Seedbed?* **It seems like you've come full circle, from masturbation to nursing (a kind of regression).**

VA It's hard for me to pinpoint the meaning of a piece; I'd want the reference, the connotations, to free float. I want to make a situation where a passerby says: "It's a wall! No, it's a bra! No, it's a room-divider! No, it's the attack of the fifty-foot woman!" Then you could go on from there, and possibly have fleeting thoughts about sex and comfort and power and regression, etc., but by this time you'd be inside the space, and the space would be part of your everyday life. I'm afraid people pay attention to my stuff only when it has something to do with sex: that's

my art role, and I'd better live up to it. *Seedbed* started by taking architecture, something assumed as neutral and apart from person, and filling it with person: I'd be part of the floor, the wall would breathe. *Adjustable Wall Bras* started with taking a wall, the wall in front of you, and bringing it out to you, making it bulge. Now that it bulged physically, it could bulge with a person inside it, it could bulge with metaphor. (Seeing the world the way a baby might see the world, the breast as the baby's wall.) I hope the piece brings up other ideas besides nursing, I hope it brings them up all at the same time.

rp **Having to follow your show with mine, I feel like the Rolling Stones having to follow James Brown.**

VA Doing this interview, I feel like Eddie Constantine in *Alphaville,* answering the questions of Alpha 60. (One comment: the Rolling Stones sell a lot more albums than James Brown.)

Andrés Serrano, *The Morgue (Jane Doe Killed by Police)*, 1992, Cibachrome, silicone, plexiglass, woodframe; 49 ½" x 60".
Courtesy Paula Cooper Gallery.

ANDRES SERRANO anna blume

In 1989 Andres Serrano became internationally known after Senator Jesse Helms brought attention to his work. Helms was outraged that government money, through the National Endowment for the Arts, NEA, had gone to a show that exhibited Serrano's *Piss-Christ:* a photograph of a crucifix submerged in Seranno's own urine. His subsequent work has included photographs of the trajectory of ejaculated sperm, homeless people, and members of the Ku Klux Klan. Serrano's recent photographs of dead bodies raise questions about death and art, art and provocation. At first sight, these large color cibachrome prints make one wonder how and when and why Serrano made these images. To address these issues I have asked questions of process and intention. Awkward moments and mutual hostility ensued in the process. I suppose that is the commercial success of Serrano's work, his ability to provoke. This two-part interview was given in response to that provocation: it was meant to give the spectators someplace to go with their questions.

BOMB #43, Spring 1993

February 2, 1993

anna blume How did you get access to the morgue?

ANDRES SERRANO A great deal of luck was involved. I had the idea to photograph John and Jane Does many years ago. I found it wasn't that easy, and then last year, I developed the contacts. I'm a great believer in providence, and maybe there was a reason I was able to do the work now and not then.

ab Did you need permission from the families of the people that died, or were they all people without contacts?

AS No, they have contacts. My relationship with the people involved is through the pathologist in charge of the morgue, a well-known forensic expert. He gave me authorization to photograph them with the understanding that the people are disguised and not identified.

ab When you say disguised, did you actually place the cloth over the people's faces?

AS Yes.

ab So you chose the red cloth for the man who died of pneumonia and the white cloth for the black man?

AS But it wasn't a man with the red cloth, it's a woman. It's called *Infectious Pneumonia,* but I call her *The Woman in Red.*

ab That's a mistake that one would think is hard to make. And yet, not only gender, but race wasn't obvious. If you die by fire, it changes your skin color. There was one picture of a woman shot by the police; her race was a question in my mind.

AS You might have thought *The Woman in Red* was a man because she's a little hairy. The burn victim who was totally black is a white man. There could be a general misconception that there are a lot of pictures of black people in the show. Not so. There are only two black people in the show. The man who has a tattoo is a white man who drowned. As a result of drowning, white skin begins to turn black and blue and red, and in his case, it started to get green and purple.

ab Since color is an issue throughout the show, not just aesthetically, but also racially, and racial issues have shown up in your work before, was this in your mind when you edited for the show, thinking about which bodies to photograph?

AS In a manner of speaking. I photographed these people after the moment of death. I never knew them as human beings. I never knew what

languages they spoke, what their religious or political beliefs were, how much money they had, or who they loved. All I know about them is the cause of death. And, as they say, you cannot judge a book by its cover. The woman you referred to as not knowing whether she was actually black, is a bleached blond, brown-skinned woman. She's a black woman. But she's been in the morgue for over two months because she's a Jane Doe, and as a result, she's starting to decompose and if you look really closely, there are patches of white skin. I asked the doctor and he confirmed that there is white skin under black skin. A teacher of his once took a very thin slice of skin off a cadaver and showed it to his students and said, "This is the thickness of racism."

ab What materials did you bring into the morgue? Were they your own backdrops?

AS The second day of shooting, I realized that I only wanted to use a black backdrop, my own flash equipment, a tripod and a Mamiya RB 67 camera.

ab Why did you choose to work with the black backdrop?

AS I wanted them to have a uniformed look. For years people have come to my apartment and said, "Where's your studio?" But at this stage of my life, the studio is anywhere I make it. The world at large is my studio. And by using a device such as a black background, I'm able to alienate the subject from its environment and put it into a studio context. Also, I find

black a very inspirational color, and in the case of the morgue, it seems to suggest a void which is appropriate.

ab Did you actually touch the dead bodies? Did you move them, or did you have assistance?

AS I didn't touch them too often. They would tell me at the morgue, if a body has not been autopsied, and is a matter of a police investigation, then don't touch anything. But after the autopsy, you can touch anything you want, just be sure to wear two pairs of gloves. But, I pretty much left the bodies as they were, except to move an occasional arm here or there. I wanted for my hand to be felt as little as possible. Except for putting the blindfolds on those faces, I left everyone as I found them.

ab You covered the eyes of some of the people to preserve anonymity, but the show seems to focus on eyes or orifices or wounds. If you look at each image, your hand is not present in terms of touching things, but it is very much present in what you chose to photograph.

AS And as a result, I choose to let the audience see what I want to. This is what an artist does.

ab Were there many photographs from which these were edited?

AS There were hundreds of photographs.

ab Did you have a conscious focus on eyes, ears, mouths, wounds: orifices?

AS Not in the beginning. In the beginning, I photographed entire sections

of the body. As time went on, I felt that concentrating on a detail could tell me more than the whole. It was a progression going from mid-range to a close range.

ab What did focusing on the details tell you more about?

AS Right now, I want to simplify my art. And focusing on details helps me to reduce everything and make it more elegant and more direct. I don't think you can be more direct than the photograph of the eye in this show, which is hacked. This man was killed by his wife with about fifteen stab wounds all over his body. You can't see what I saw, but the eye tells you everything.

ab When you say hacked to death, it reminds me that the titles are curious. *Hacked to Death* implies a violent cutting. At other times you might say, *Knifed to Death*, which has a different connotation. In some cases you say *Burned by Fire*, which is almost biblical, and the one that's more clinical is *Burn Victim*. How do you account for variations?

AS It's just personal. While I have tried to be accurate with the causes of death, they are by no means scientific or medical.

ab They're not the terms that appeared on the death certificates?

AS No, not necessarily. I think it's important to be descriptive and poetic at the same time. I don't take these pictures as a clinician or as a technical photographer working in a lab. Since

doing my work, I've seen pictures in a book of forensic pathology, and the pictures are hard core, gruesome, very clinical and detached. The lighting is flat, there's no art involved, just technical representation. My approach is more personal and subjective.

ab What's somewhat engaging and disturbing about these images is that they're very seductive. Large cibachromes of particular body parts remind me of the aesthetics of pornography, which also focuses on body parts, usually genitalia. How are these different from pornography?

AS How are they similar? Pornography is meant to titillate and excite in the prurient sense. These are not. I can't imagine anyone getting horny behind this work. These are not sexual images. They don't devalue or degrade. There's a photograph of a rosary around a penis. And given my own background as an artist, I had to take that image. I don't know who put that crucifix there, but I've been told that in a hospital, they will put a rosary around a body once in a while. But, given the nature of the photograph, I don't know how you could call it sexual.

ab Sexual images don't necessarily devalue and degrade. But there is a similarity between your work and pornography for me in the way you fragment the body and display these fragments in a seductive and decontextualized way.

AS I would say that you're referring to

maybe a feeling of sensuality, a sensuous surface, in these pictures, but I would disagree that pornography is seductive in the same way that my work is. Most pornography is crude and artless. I think you're confusing pornography with advertising, which can be seductive.

ab Pornography and advertising cross paths in interesting ways and your photographs from the morgue take something from both. They are seductive, but not sensuous. Your images draw us in and they are beautiful at a certain level. You bring us close, very close to details of dead bodies, which sets off an alarm of feeling and thinking, but all this stops on the surface and we are left as voyeurs rather than as witnesses of death. I wonder, as I look at the photographs, what are you trying to do with this show, what are you doing with dead bodies?

AS The morgue is a secret temple where few people are allowed. Paradoxically, we will all be let in one day. I think you're upset and confused that I've brought you there prematurely. My intention is only to take you to this sacred place. The rest is entirely up to you. I explored this territory with fresh eyes and an open mind. I want the audience to do the same and to see it's a process of discovery for me too.

ab Discovery of what?

AS Discovery of what I can find there for myself as a human being and as an artist. I don't particularly set out with

an agenda for my work except to make it somewhat aesthetically pleasing and emotionally charged.

ab And these are aesthetically pleasing?

AS Absolutely.

ab What did you discover in making the photographs?

AS I felt that I was very lucky to be able to enter this private domain, a secret arena that is normally not open for laymen to explore. That was personally gratifying in much the same way as taking portraits of Klanspeople as a man who's not white, and challenging them to work with me was.

ab You said in an interview with Coco Fusco that your experience with the *Piss-Christ* and the response of the NEA brought you in contact with more people, that had been one of the benefits of the controversy. And in some ways it helped lead to the Klan/homeless people project. Is this part of that development of humanizing your work?

AS I'm at a point now where I've been able to enter into all these somewhat closed societies. And for me, sometimes, the adventure of getting into these situations is almost, but not quite, as interesting as the work. Because it is an adventure.

ab The only other picture I've ever seen of a person in a morgue was in Jean Marie Simon's book on Guatemala. She goes into the morgue to identify the body of

someone she knows who's been literally hacked to death. It's a photograph of a woman who's been dismembered and it's very difficult to look at. I trust that Simon's intention is to witness something. She has taken this photograph and printed it as a way to heighten our sensibility about both life and death. I feel that I am brought to the face of often violent death in your work. I feel confronted and then left there as a voyeur of death which you have sensationalized. This makes it difficult for me to trust these photographs beyond your desire to provoke and to be commercially successful.

AS Because you want me to lead you by the hand and make you feel like these are images that you can see in a political or social or feminist way that would fit with your thinking, and if I don't tell you you're right or point you in that direction, then you feel abandoned.

ab Many religious images or icons seduce or no one would look at them. The project of the church or the project of the artist is in some ways to bring people to their images and I think you do that very well, remarkably well. Some of your earlier work, like the *Piss-Christ* or the Klan photographs, are icons. They bring you to them, they keep you there and they engage you in one way or another. They're very successful that way. With these photographs you provoke my critical mind. But in this

case, ultimately, I feel brought to bodily carnage and left there as a gratuitous voyeur. You have raised the stakes in these photographs in a way that is different from your previous work. You are photographing the dead beyond their violation. You have entered the realm of the voyeur and you have brought all of us who look at your work to that same place. It is a difficult terrain which on some levels demands more than the spirit and props of an adventurer.

AS I photographed the morgue no differently than I photographed *Piss-Christ* or the Klan. Perhaps it is easier for you to accept that work because you feel morally superior to it. If you don't consider yourself a Catholic or a racist you can appreciate the work from a comfortable distance because you don't have the same investment or involvement that a Christian or a person of color has. Therefore, your acceptance and understanding of, say, the Klan pictures is very different from someone who has experienced the effects of racial discrimination. I remember when I first started that work, a friend of mine said, "These look so noble, they almost look like recruitment posters for the Klan." As repugnant as that thought was, I had to grapple with the idea that for some, these hooded figures would appear as heroic knights rather than symbols of hatred and oppression. So as much as I dislike what the Klan stands for, I had to put aside my personal feelings and photograph them in the spirit of tolerance and compassion. I think this surprised

a lot of people including the critics who are drawn to the work. But I have always said that I don't see anything wrong with provocative art and that I look forward to the day when I can make work that will even disturb me. But when you said I've brought you to a point and left you there, it makes me think of why some people need religion: They need to know why they live and where they're going when they die. Those of us who are not sure are left in limbo with no one to comfort us and that can be very frightening. The problem is not that I manipulate, but that I don't manipulate enough. I let you draw your own conclusions.

ab Based on what you assume my race or religion to be you ultimately are just avoiding my question about the puriant and sensationalist nature of this work.

February 5, 1993

ab You've talked about Buñuel as being important to your work.

AS I feel an affinity with Buñuel as well as other artists of Spanish descent who are attracted to violence and passion, whether it's a passion for living or for dying.

ab There is a great deal of aesthetic violence in many of Buñuel's films but there is also an element of subversion. In Goya as well, for that matter.

AS Buñuel deals with religion subversively, he's completely sacrilegious. And yet, this is the work of a man who holds some religious beliefs, if not all

that Catholicism embraces. He obviously has a love/hate relationship with the people and institutions he criticizes. Personally, I am drawn to the aesthetics of the Church but not to the Church itself. But, I don't go out of my way to criticize the Church because it's not important for me to crusade. I think you can be subversive just by asking too many questions.

ab Do you feel you're addressing taboos in the morgue?

AS Some people would like to see this remain hallowed ground, a place where we don't trespass. The idea of death being opened for scrutiny is very disturbing. Most of us assume we are going to go gently into that good night. What I found when I went to the morgue is that most of the people there died tragic, violent deaths.

ab We are constantly trespassing on death and it upon us. We have so many images of death, especially in the art community—not only the many people who have died and whose bodies we have watched become decimated, but also in newspapers, on television. We're constantly seeing images of death. How do these differ from those?

AS Some people feel really shocked and outraged that I've presented it so directly. These people act like they haven't seen death before. What you take for granted, others have not taken so lightly. The difference is that those images on television are constantly moving and these are not. My photographs are meant to be seen on

the walls of a gallery or museum. They engage the viewer in a dialogue that is difficult to escape. You can turn the pages of a newspaper or flip a channel easier than you can walk out of a gallery. The curious thing is that most people who have seen this work are compelled to stay.

ab Earlier, you said that focusing in on detail tells you more and allows for more elegance. Could you speak more about that?

AS As artists mature, they start to leave things out of their pictures. The work becomes simpler, more refined, more finished. Certainly, that is what I am striving for at this stage of my development. This desire to say as much as possible with an economy of visual tools.

ab Details, especially in regard to the body, make me think of the Host in Christian dogma. There is transubstantiation, where the Host goes from inert matter to being the life and body of Christ. It's a deeply felt mystery and is based on a part becoming the whole. Since a lot of your work in the past has been based on Christian iconography, and these images are about death in a very real way, is there something about the notion of transubstantiation in them?

AS Well, I won't say that I believe in a soul. But I do believe that I've captured an essence, a humanity in these people. For me, these are not mere corpses. They are not inanimate, lifeless objects. There is a sense of life, a

spirituality that I get from them. This is an important point for me. There is life after death, in a way.

ab Working with these people who have often died violent deaths, do you come into a relationship with them emotionally? Was there a conflict between encountering their "humanity," as you say, and maintaining their anonymity?

AS My relationship with the people that I photograph often begins after my work is finished. While I am shooting, I am more concerned with mechanical questions rather than metaphysical ones. I think we can encounter their humanity while maintaining their anonymity.

ab Was it a struggle for you on any level to make these images?

AS There was never any moral dilemma for me as to whether or not I should photograph these people. There is a fine line between exploration and exploitation and I have always been prepared to walk it and in doing so, put myself on the line. Life would be boring and art would be dead if we didn't take risks. If it was a matter of choosing whether or not I should explore this subject matter, or respect privacy and not do it, I never once thought that I should not do it.

ab Do you want to upset people?

AS No, not intentionally. I think more people feel moved by this work than upset. But, that's what happens when you do work that is emotionally provocative, it polarizes people on both sides of the fence.

ab Do you think your own background as a man of color affects your decision to go into places that are difficult to access and then come back out as Andres Serrano?

AS I'd be a liar if I said that I don't get satisfaction out of being able to do the things that I do.

ab In the midst of all this I wonder did this project change your relationship to death?

AS In a way, it's made me more at ease with the idea of dying.

ab How so?

AS It ain't so bad. I remember when I photographed the guy who had been hacked to death, a doctor at the morgue looked at him and said, "Poor bastard, at least he won't suffer anymore." A lot of us fear death because we envision this horrible, unimaginable end to our existence. We dread it. When you deal with something on a day-to-day basis you learn to fear it less. You demystify your fears and it becomes easier to overcome them.

ab Historically, in the fourth century, there was a trade in relics, parts of people who had died unusually violently. They were highly coveted. From the point of view of the populace at the time, it was thought that those fragments somehow had a healing function. Though your images do have a shock value, do you hope that they have some sort of healing power as well?

AS I've spent time with friends who have had recent deaths in their fami-

lies and they seemed to see the work in a way that other people may not be able to. It has a special meaning for them. It is part of a healing process, coming to grips with the loss of a loved one.

ab　For me, the photograph that was the most interesting was the image of the hands with the ink marks where fingerprints had been taken. There is something animated about it. Could you talk about what you learned about this individual? Why you chose to photograph him in that way?

AS　These are probably the hands of a criminal. He'd been fingerprinted by the police and when I photographed him, the hands were actually going in the opposite direction. I inverted the images because I wanted to make reference to Michelangelo's painting of God reaching out to Adam. So, they assume a religious persona and gesture. I like him reaching out in death because maybe he couldn't do it when he was alive.

ab　The woman who has died of infectious pneumonia, her prominent nose, the saturated red cloth on her forehead, has the aesthetic look of a painting. How did you make compositional decisions?

AS　For me, she is the most beautiful woman in the show. I initially found her very repulsive. She had died of AIDS, her hair was very thin. Her throat was enlarged. For a few days I avoided photographing her. At some point, there were no new subjects, I had a choice of either photographing this woman or some of the maggot infested bodies in the freezer. So, I did decide to look at her again, and I had to discover a way to make her beautiful, and I think I've succeeded. She is a painting. A Bellini.

ab　Do you have a sense of where you're going to go, what this has given you and where you're going to take it?

AS　[*laughter*] I do and I don't. I have no easy answers for you.

Jack Whitten, *First Gestalt*, 1992, Acrylic/canvas, 16" x16". Collection United Yarn Producers. Photo courtesy the artist.

JACK WHITTEN kenneth goldsmith

BOMB # 48, Summer 1994

On a blustery, early spring day, I visited Jack Whitten at the five-story Tribeca building where he has worked and lived with his wife Mary for many years. On the ground floor is a pizza parlor and directly above it is Jack's smallish studio with a few new works in progress. "Man, I have to work when I have a show up or I go crazy," he told me. He was being humble—in fact, he had two shows up at the time: a retrospective of paintings from the 1970s at Daniel Newburg and a show of brand new works at Horodner-Romley. "Oh, it's been kind of quiet around here. We live a quiet life," he said. Another underestimation. The phone was ringing off the hook. The previous day, *The New York Times* had proclaimed Jack to be the father of the much talked about "new abstraction" in painting of the last few years. No small feat indeed. We proceeded upstairs, past Mary's conservation studio to the top floor, where Jack opened the door to one of the most gorgeous living spaces that I have seen in this city. "Yep, I did it all myself," he proclaimed—this time with a bit of a boast—as I looked around at an interior worthy of *Architectural Digest.* His fetishistic wood sculptures and paintings from the 1960s to the 1990s commingled with luxurious handmade furniture and cabinetry. As we sat down, Jack offered me tea and bread soaked in olive oil pressed from his grove in Greece, where he vacations each summer. The wealth of contradiction infused with the incredible warmth of my host made me know that I was in for something special, loaded with quiet surprises.

kenneth goldsmith Looking at these two bodies of work, from the seventies and the nineties, what strikes me immediately is that the earlier work is more self-consciously invested and referential to the history of painting than the later work.

JACK WHITTEN As earlier paintings, they would have to be more of a historical reference. My background—coming to New York in 1959 and studying painting at Cooper Union art school, in and out of the museums and the Cedar Bar, knowing other painters, the abstract expressionists in particular—I had no choice but to be well-versed. It took twenty years to get into a position where I could work myself out of history. Every painter wants to

escape art history. And now there's a curve that's leading me out. My emphasis on pop culture, video, science, on the urban environment and everything on up to the big bang theory excites me. I see that as a way, using those metaphors, that I can escape art-historical references. I was impressed with you when we first met in Lodz, Poland at the Artist Museum for Construction in Progress, running around with your computer, engaging all of those people with sounds, compiling all those words—I instantly identified with that, that's why I wanted to meet you and touch base, because as a poet, you're into this pop thing, you're into this immediacy of the norm.

kg **What we both share in our recent works is that we're binding disparate things we find in the culture, in the newspapers, in the material that's all around us. I find a lot of my sounds on the street. I'm always listening. And when I look at your recent work, I know you've been scavenging the streets—molds off the sidewalk, metal grates and caps—you've been taking impressions from the world around you.**

JW Sure, sure. That button painting was inspired by a Lisa Hoke sculpture, but I lifted the composition from a Lalaounis jewelry ad in *The New York Times*.

kg **I wouldn't know that.**

JW No, you wouldn't. [*laughter*] It's not important that one knows that, but it's what gets me started.

kg **You transform material, you don't leave it as you found it; or do you?**

JW Transformation is very important. Materials are just raw materials, that's all. It's like a word, anybody can have access to the same word, but a word in your mouth is totally different from a word in mine.

kg **I tend to put a word into a context where it assumes a new meaning. It's like taking a word out of the popular context and reapplying it to art. Tell me, what was your relationship to pop culture in the seventies?**

JW What governs those early seventies paintings of mine is photography, and I don't mean a photographic picture, I mean the process of photography. What happens in a camera when you set that f-stop and a small amount of light comes through and places itself on a sensitive plate. The speed factor. Speed is an important part of abstract thought.

kg **Talk about your relationship with speed.**

JW First, in terms of abstract expressionism as a gesture, later in terms of the instant, what happens in a split second, as in photography. So when I was doing those paintings, to place the paint in a split second—the whole painting was conceived of as one line, the painting as a gesture.

kg **Physically, how long did it take you to make those paintings?**

JW Over an extended period of time I might go backward and forward in

layers. But the crucial part took place in three seconds, two seconds. I took the abstract expressionist gesture and amplified it. That speed removes it from relational thinking to nonrelational thinking. Because when that tool I was using would fall across the canvas, it did not allow for relational thought.

kg What tool?

JW Those paintings of mine from the 1970s were made with a tool of my design that was twelve feet wide, so that the act of painting was raked across the whole plane of the painting in one shot.

kg **But the funny thing is that the paintings have an unhandmade look. They look like a photographic process, in some way related to video. Obviously the hand is really important in your work, but somehow it was masked.**

JW It's an extension of the hand. I'm coming in back of Pollock, I'm extending Pollock's thinking, that's what's going on here. Let's consider Pollock for a minute. The paint leaves the hand, falls onto this canvas, I take that and extend it several steps further. The tool is a sort of medium, you might say, that stands between me and the painting.

kg **Buckminster Fuller always said that one of the best tools he had were his eyeglasses, which he saw as an extension of the eye. So everything to Fuller was an extension of himself. That's where the**

integration comes in. We're really not separate from our tools at all. There is no need to shun or fear any type of technology. It's all an extension of ourselves. Did you feel that the tool was an extension of your hand or was it something separate from you?

JW Very much like how Buckminster Fuller explained himself. That tool is an extension of my hand. It's like saying the computer is an extension of one's brain.

kg **It goes into McLuhan's old idea of an extended nervous system which has now come back full force into our lives with the Internet, global computer systems, and the new cellular satellite networks.**

JW My metaphors are found in scientific processes. Hydrogen bubble chambers turned me on in the seventies. Electronic scanning devices—that's where I found my images.

kg **What do you mean by electronic scanning devices?**

JW Let's say you have an atom, a particle you want to scan. You put it into these chambers and get a picture of what it looks like, its movements, its tracks. Scientists have experiments they do in particle physics, they have whole caves built out there just designed to try to chase particles so they can track them. All through the seventies these things were going through my head, they excited me very much.

kg **To bring it back to the idea of the**

computer and technology, I have a little hand scanner that I use as a vacuum cleaner. I can just suck up images and suck up text and put them into my work. Like the way you scavenge the streets and suck up all that's around you and put it into your painting.

JW This is beautiful, it is what I call the loop. Sucking in information, using technology and letting it go back and forth. It loops in and out.

kg In embrace of the world.

JW In embrace of the world. Let's dig it. We live in a modern technological society . . . but in truth, I think we are in a primitive technological society. That's where we are.

kg Primitive technological society. That's an interesting idea. It reminds me of modern painting or modern music—perhaps jazz?

JW In John Coltrane's music there is this phenomenon that we refer to as a sheet of sound. As a painter, I experience sound that way, light operating in a sheet . . . a sheet of light, a plane of light.

kg One thing I've always found remarkable about Coltrane's music is the sheer amount of air and light he gives into his work.

JW He penetrates the world . . . the man penetrates the world. I believe in equivalency as expressed in mathematics. My light in painting is equivalent to Coltrane's sound. Coltrane's music is nonlinear. It's circular. It's not one-dimensional. Coltrane is

multidimensional. And coming out of the sixties, this affected my painting. When I speak of space in painting, I'm speaking in terms of multidimensional space. A space that is infinite in all directions. This is what I got from Coltrane.

kg Haven't you dedicated works to friends who are musicians? There's been a great interaction with you and music over the years.

JW Music has had a great bearing on my painting. The music is what has kept me going, even in my lowest moments. I've had moments of depression, especially in the late sixties.

kg Knowing you as I do now, your spirit is so high and so generous that I can't imagine you being plagued with depression.

JW I went through a period in the late sixties of anxiety. I was catatonic, I was afraid to get out of bed. But the music was the thing that kept my perspective and comforted me. Growing up in Alabama, with my strict Christian fundamentalist background, we couldn't hear rhythm and blues in the house, because my mother wouldn't allow it. But my oldest brother always had one or two records that he would sneak on when my mother wasn't home.

kg Where did you grow up in Alabama?

JW In Bessemer, Alabama. Bessemer, Alabama is a steel mill town, the next-largest town to Birmingham. But the music I heard then was mostly gospel.

Local rhythm and blues stations, early 1950s, played rock and roll, rhythm and blues. That's the music I grew up with.

kg Getting it on the radio.

JW Getting it on the radio. See, things were very much divided, as they are today, unfortunately. But then, the polarity was greater, coming from a strict segregated society. You had a black radio station, you had a white radio station. White kids played Elvis Presley, and that whole crew of country western sort of sounds. Black radio stations played black blues, Detroit-sound music. Early Motown.

kg But it strikes me that everybody was copping everything from everybody. The blues guys were copping country licks and the country musicians were copping blues licks. It seems to me that there might have been some interaction, or am I wrong?

JW Well, I tell you, in Alabama, growing up in the fifties, there was a definite polarity. Definite. The word "crossover" didn't even exist then.

kg But don't you think it was happening? Wasn't everybody listening to what everybody else was doing?

JW I would say yes, everybody heard the same thing. No doubt about that. Coming from the South, I maintain that there's a certain Southern sensibility. The language has that same intonation in the voice, white or black.

kg In the house that you grew up in,

was there a lot of visual art?

JW My father was a coal miner. He died when I was young; my mom was a seamstress but she was a believer in education. There were books, magazines, a piano. My mother's first husband was a sign painter, and he did some painting on the side, probably the first painting that I saw as a kid. His name was James Monroe Cross. He was also a gospel singer, one of the original founders of the Dixie Hummingbirds. And the old people in my community claimed that out of my mother grieving for this man, I was a marked kid.

kg A what?

JW A marked kid. It's a term which means that something can be transferred to another person. James Cross was not my father, but old people would say things to my mother like, "Anabelle, if James hadn't died, I would have sworn you lied!" People were always pointing out that I had certain traits of his. I grew up with a painting that he did of a waterfall—I have it here. When my mom died, I requested from the rest of the family if I could have it.

kg What turned you on about it?

JW In those days, I had no idea what turned me on about that painting. Now I know that we carry ancient information in our head, in association to water. The first time we saw ourselves, the first image we saw of ourselves, was leaning over to have a drink of water. And we have carried that with us. So even today, water is

an archetypal image. We carry a certain information about fluidity, translucency, transparency.

kg To me, it comes across in Joyce's *Ulysses*, in the Ithaca episode, where there's a beautiful body of writing about the properties of water. The question is, "What in water did Bloom, water-lover, drawer of water, watercarrier, returning to the range, admire?" And he says, "Its universality: its democratic equality and constancy to its nature in seeking its own level: its vastness in the ocean of Mercator's projection: its unplumbed profundity in the Sun-dam trench of the Pacific exceeding 8,000 fathoms: the restlessness of its waves and surface particles visiting in turn all points of its seaboard: the independence of its units: the variability of states of sea: its hydrostatic quiescence in calm: its hydrokinetic turgidity in neap and spring tides . . ." This is exactly what you're talking about.

JW Exactly what I'm talking about. The first painting I saw, that painting stayed with me all my childhood.

kg I'd like to pause for a moment, with this painting, and make a metaphor of Odysseus' which Joyce used in *Ulysses,* around the islands surrounding Greece. In your journeys, in a sense, your wanderings, from Alabama to New York, and every summer to Crete and then back to New York,

there's a parallel between Joyce's character, this painting (which was a forbearer for the future) and your life as somebody who travels and lives in many places.

JW And it's carried on water.

kg It's carried on water. As was Odysseus. It seems to me that you're very connected to the flow of life itself, the sequence of events. You're not fighting events as much as you're going with things.

JW Part of that is my 1960s upbringing. I'm fifty-four years old, and you are . . .

kg Thirty-two.

JW That's a considerable gap. In the sixties, we grew up with a kind of philosophy. My generation never knew about the destination of the journey, our interest was being part of the journey. You'd ask somebody, "Where's the destination?" Response: "Man, we don't know."

kg Well, the final destination is what, death? [*laughter*]

JW It wasn't even death, because we didn't accept that.

kg There's a cornering of everything now, and a commodification, a tracking, and a counting, a competition and neurosis that's based around professionalism and packaging. That goes against a lot of the type of flow that you're talking about.

JW Well, my spirit from the sixties was one of rebellion. We didn't want to be

packaged. You have to understand, Ken, that my generation, coming from the sixties, we never really arrived. It's like we've been holding on to something all these years. I'm not talking from just a black perspective. White and black, everybody, it's like we've never had our shot, we've never had our due, it's never really resolved itself. And I'm beginning to see now that there's a pretty good chance that this philosophy of life, now it's ripe for the pickings. It's time to collect interest on that. That shit has been lying dormant all this time. I say tap into it. And I can see where it would play a role, primarily in terms of media, computers, technology.

kg **When I look at the most progressive of the computer networks, it's the Well, which is run by the people who did the** *Whole Earth Catalog*. **I don't know, Jack, my idea of being an artist is in step with that philosophy; you're living for the moment, very much involved with what's happening, it's about living life, and it's not about the goals, it's more about the journey. These ideas have come to me via my parents. How did you feel during the eighties?**

JW See, the eighties were a bad time for me as far as the commercial world was concerned. The eighties really hit a peak of materialistic thinking. My work didn't suffer. What happened to me in the eighties is that I buried deeper into my mind. I got ten years of work out of the eighties that is a

solid body of work. I'm not one for knocking my head against a brick wall, so I went underground into the woodshed. But I realized that the work I was doing could not participate in the sort of thing that was going on in the eighties.

kg **Art has traditionally taken a long time to assimilate—if it ever does within an artist's lifetime—which was absolutely not the case in the last fifteen years or so, where you saw people reaping fortunes and benefits instantly.**

JW When I came to New York and first met Bill de Kooning I was nineteen years old, and the man was in his upper fifties before anything started truly happening for him. I know artists today that have been working forty, fifty years and nothing happens. But there's that love there that keeps them going. But there are no guarantees in art. There's nothing out there which says, you work twenty years, thirty years, you're going to get this fantastic benefit. There's no such thing.

kg **You have emerged in a big way in the nineties. Did those ten years of interior work strengthen your projects and strengthen your resolve?**

JW Sure. It strengthened me spiritually, it strengthened me conceptually. Those site paintings, which were acrylic skins, came out of the early eighties when I first started laminating a piece of acrylic back down to the canvas. I took the paint up off the canvas and then put it back down on the canvas. This was a major break-

through. I'm dealing now with paint as a collage, paint as sculpture. I have changed the verb "to paint:" I don't paint a painting, I *make* a painting. And in doing that, I've broken through a lot of illusionistic qualities.

kg Dancers always talk about "making" dances. There is a physicality involved in the word "make" that reflects in your work. What role does the construction process play in your work?

JW Well, it's how I made my living. And in terms of my art, my building that big platform in the seventies, that came out of carpentry . . .

kg What big platform?

JW Those were the paintings that came out of the Whitney Museum show in 1974. I built a heavy duty drawing board, which was 14 feet by 20 feet. I built it out of 16-inch honeycomb centers of 2 by 4, covered with 3/4-inch plywood and industrial grade linoleum. I built it to my specifications, as flat and as level and as accurate as I could get it. And all those experiments in the seventies took place on this drawing board.

kg So you would stretch a huge piece of canvas over this?

JW Yes, I would stretch canvas right down over this platform. All those marks that you see coming out of those paintings, those are not arbitrary markings, those are set up conceptually. I developed a process of drawing where I would place things beneath the canvas, between the canvas and the board, and that way, I would get a shape to come through, that's how I would get line and form. I was using a process of drawing where the shapes, a piece of wire or a pebble, were placed beneath the canvas in a very precise pattern, wedged against the board. And when that big tool I was using would come across the platform with that much acrylic . . .

kg It would print, like photography.

JW . . . it would print—you got it—it would be like a kid working with a rubbing. All I've done in the new works is to lift that skin of paint up off the canvas and put it back down. And that's a revolutionary step.

kg I keep coming back to the idea of integration with you. It's hard to separate the things in your life and your attitudes, your furniture and your house. I look at these cabinets that you built with as much attention and love as the paintings, as the music you talk about. It is really remarkable, really, admirable and rare.

JW It's very simple, Kenny. The reason for this is survival. I found out at an early date that in order for me to survive and to do what I wanted to do as an artist, first I had to establish priorities. I had to send a clear signal to people around me what I wanted to do. And I knew that I had to set up my life and a lifestyle that was totally integrated to serve this purpose. So I wouldn't have any hassles. There's a lot of shit out there I can't control. I don't fight the world. I'm in it. I'm in the world. I don't fight it.

kg I'm wondering if it wasn't some person who helped you bridge into this philosophy.

JW My mom, and growing up in the South in a segregated racial society. When you are raised with hate all around you, and then you've got a family who teaches you love, you have people in the church who are teaching you love, you have a family network. And making an emphasis on how much hate surrounds you, you don't have to be that way. That's a sickness, when people hate, when people get all into this racial stuff, that's a sickness. My mom and grandmom would quote from the Bible: "Revenge is mine, said the Lord." You can't go out there seeking revenge, you can't go the hate pattern, it's just gonna destroy you. If you get involved with that, you self-destruct.

kg It's a very Eastern idea.

JW I very much enjoy your bringing me *Ulysses*, that completes a circle in my mind. I love experiences like this, my life is built on experiences of this nature. I learn primarily through revelation. And I've just experienced one. Even today, a lot of things in society still bother me, racial issues and so forth. I'm not pleased with what I see. I'm not. I was thinking in my little naive mind, thirty-five, forty years ago, that things would be much better, but hey, it's depressing, I must admit. One of the most depressing aspects of my life at this point is that society has proven me wrong. Growing up with what I grew up with in Alabama, whoa, I figured, my God, man, anoth-

er forty years, this shit will be over with, and it's not, man, it's not. Don't kid yourself, it's not. And when I look back and see what's happening in Germany, to think that young people in Germany today would get involved in that kind of action. I don't have the hope that I had. I don't have the optimism that I had forty years ago, that it will not repeat itself. It can repeat itself and all of us better wake up to the fact that it can repeat itself, the handwriting is on the wall. I see art as the only hope. That's what I see. I don't see religion, or politics.

kg You see art as something that can heal?

JW You ask me, what's the purpose? What purpose does it serve? I'm not in art for art's sake, or for decoration. It's about dialogue. Romare Bearden spoke about art as a bridge. Art is the last hope.

kg Do you see, then, art as being a social experience?

JW Well, any involvement between two people is social.

kg But a lot of the time you're alone in the studio . . .

JW We are alone, but the object is there. We are doing what we do now because of art. I never would have known you if it hadn't been for art.

kg So when you send your work out to the gallery, you're feeling that it's a stand-in, that it's an energy of Jack Whitten. And it's communication even if you're not there.

JW It communicates.

kg Did you get a lot of critical atten-
tion from your show at the
Whitney Museum in '74?

JW No, no. Black artists at that period
were not getting any kind of atten-
tion. My having that show at the
Whitney Museum was primarily
because of Marsha Tucker, who was a
curator at the Whitney at the time.
There was a social consciousness in
'74. The gallery at the Whitney that I
used was set aside for people who did
not have commercial representation,
and I fit the bill.

kg It seems that stuff would have
been snapped up and sold, with
the museum confirming a sort of
status and value of the artwork.

JW Only if you have commercial represen-
tation and you have someone who is a
believer in you and the work, and is will-
ing to promote it, is work sold. Work
sold through gallery situations comes
through an endorsement of the
gallery/museum world with a bag of col-
lectors to back it up. If you don't have
that kind of an interest, you can stand
on your head out there for twenty years,
and it won't sell. It's just recent, what
you see, people like Lorna Simpson,
Adrian Piper, Martin Puryear, myself,
David Hammons . . . this is recent
man, very recent, we've had to live with
this right from the beginning.

kg So why not become an artist? It's a
crapshoot, anyway—it's like that
old Dylan line, "When you ain't got
nothin', you got nothin' to lose."

JW Yeah, but you see most kids coming
out of the African-American commu-
nity will take that line, and you know
where they take it? Over into violence
and criminality and drugs . . . it's the
other end of your coin, I'll go the
other way, I've got nothing to lose.

kg Coming from a sixties experience,
that whole "tune in, turn on, drop
out" was strong. There was an ide-
alization about dropping out.
How, as an African-American, did
you feel about "dropping out?" Or
were you already dropped out in
some sense?

JW One thing you have to remember about
Jack Whitten is that I have a Southern
sensibility. That's different from North,
East, West, white or black. There is
something instilled in you from the
beginning. Where I grew up you didn't
ask for nothing. You worked for it. I
remember as a kid, my uncle didn't
have any money to buy a Chevrolet. He
went to the junk yard, bought a chassis,
a motor, he bought some doors, he
bought a frame. He made the damned
thing. He took a paint brush and he
painted it. He drove to work in it.

kg Cool!

JW You understand what I'm saying to
you? This is my ground. My mom,
when we needed clothes and we didn't
have any money, you know what she
would do? She would go to the army
surplus store and buy old clothing,
bring them home, take them apart
seam by seam, and rebuild them. And
when I hit the street, hey Kenny, I
had a new pair of pants on.

kg There was this positive idea coming from your home that said you were somebody —that you could get by in the face of adverse conditions. We come back to the word "make" again. It brings us back to the idea of the hand.

JW This is beautiful. You see when I speak today of the processes I use in painting, when I use words like construct and deconstruct, reconstruct, I'm doing what my mom did. My mom was the first great recycler.

You know, speaking of my home, when I got out of high school, I went to Tuskegee Institute as a premed student, on what was called a work scholarship program . . . an all-black college where the African-American scientist George Washington Carver did all his experiments. His laboratory is still intact. He was also a painter. I'm convinced today that a lot of my attitudes toward painting and making and experimentation came from George Washington Carver. He made his own pigments, his own paints, from his inventions with peanuts. The obsession with invention and discovery impressed me.

kg So what happened after Tuskegee?

JW Went down to Baton Rouge, Louisiana as an art student. Stayed there for a year. Got involved with sit-down demonstrations and all the upheaval that was going on down in the South. I'm one of the people who led a march through downtown Baton Rouge. Horrible experience . . . we marched to the state capital, with people throwing shit on you, piss on you,

hitting you with pipes; people bleeding. Horrific experience. I will never forget at the steps of the state capitol building, praying and people throwing piss out of the offices, bottles and eggs, all kinds of shit. Then I took a bus from Baton Rouge to New York City. Ended up on the Lower East Side. In 1960, beautiful artists down there; poets, writers . . . Jack Kerouac, Allen Ginsberg, Leroi Jones [Amiri Baraka], David Henderson, Calvin Hernton, Ishmael Reed . . . there is a community in the arts. A lot of people don't know this. A lot of people read things in glossy magazines, they read about the exciting lives of certain artists who are making a lot of money, but they fail to point out that there is a community in the arts. I had a brother here, dying in St. Vincent. He was in a bad fire. Took him twenty-eight days to die in intensive care. He needed blood. All I had to do was pick up the phone and people in the art world, [bangs on the table] as much blood as we needed. That's real stuff.

kg Do you find your life to be glamorous?

JW People think so. People in Western society have this view of the artist, some romantic thing. We live our lives and we do what we have to. But people outside see us as some glamorous, exotic creature. I don't see that . . . [laughter] I work. I do my work. I teach. Art is something we do. It's like we have a purpose in life, being artists. That's a position. That's a job. So where's the glamour? We're doing what we're supposed to do. People do

not understand the sacrifice that artists go through to do what they have to do. If they went into the artist's life and saw what the artist has to do on a daily basis to keep their act together.

kg Not to mention the psychic torments.

JW Which we have no way of measuring.

kg You must have a feeling of satisfaction to see that the work you have been doing all these years is now being recognized by a lot of younger abstract artists.

JW It's a confirmation. It says your intentions were right, your feelings were correct. Even though it took twenty years for it to surface, for it to complete the circle. Artists tend to remove the notion of doubt from their vocabulary. We do that for self-preservation . . .

kg And the future for you?

JW I'm desperately trying to erase notions of past/present/future, I'm in something that's going back to Zen. I'm into factualism. I'm sensing time now as being compressed. I want to erase in my mind this presence of past/present/future. I want to learn to do that. I would like my being totally immersed in the act of what I'm doing. No past. No present. No future.

George Condo, *The Indian Chief*, 1990-91, Oil on canvas, 59" x 84¼", three panels. Photo A. Mogain, Paris. Courtesy PaceWildenstein.

GEORGE CONDO anney bonney

BOMB # 40, Summer 1992

Everything enchants him and his incontestible talent seems to be at the service of a fantasy that is a balanced combination of the delicious and the horrible, the abject and the delicate.
—Apollinaire on Picasso, 1912

The same can be said of the mercurial George Condo, whose revelatory paintings span the centuries between madness and beauty. During the early 1980s, George lived in the East Village. Since then, he's traveled and exhibited all over the planet, eventually settling in Paris and New York. He has collaborated with William Burroughs, producing four etchings and twelve paintings for Burroughs' text *Ghost of Chance*, published last fall by the Whitney Museum, and recently completed his own book, *The Big Chief*. Besides being the most worldly/otherworldly artist I know, he's also a great natural wit, bon vivant and musician.

anney bonney I have a quote for you: "Personifying is the soul's answer to egocentricity."

GEORGE CONDO Um . . . that sounds nice. If the soul and the ego were objects we could look at, the soul would be a translucent heart beating. If you broke away the tissues, you'd destroy a very delicate pulse. And the ego would be an armored unit designed to protect the soul. The soul is in need of protection from people's inability to restrain from vices, like jealousy, lust, greed . . . forms of intrusion that the soul and ego try to control. But the need to control brings about more of

the same. The ego is a process of elimination that we go through. In order to have this capacity to eliminate, you need the ego to guide the sword.

ab Say that again.

GC Here we are in the ambient soul section room. This is the sound . . . [*George rubs something against the microphone*].

ab You transgress abstraction and figuration, that's what your personification's about.

GC Right.

ab That's what it really represents. There's something of the trickster, Hermes, in you. You're taking us to the underworld.

GC Yeah.

ab The land of plurality.

GC Mmm-hmm.

ab Wilfried Dickhoff beautifully described your work of expanding canvas and alter egos. To me, shadow figures in the world without shadows allude to soulfulness.

GC Mmm-hmm. Right.

ab The darkness, the dogs, the witches you depict.

GC When you add them all up, it's quite a crew: Indian chiefs, cavemen, office bosses, the nun, two-bit hustlers, lowlife criminals, people with one tooth, one eye, protruding chins, enlarged facial features.

ab The alchemists had a term for that "look;" they called it *vile figura* [ugly face], and they considered it *prima materia*, the primal stuff of soul [gold] making.

GC But they're the ordinary, nice people, you know. That's what my relatives look like. That's what the early American settlers looked like.

ab Excuse me, we'll check your family portraits later.

GC Listen, if you grow up in New England, you see an old fisherman on the pier very differently from Norman Rockwell, who sees him as a stereotype, which is patronizing and conde-

scending. There's no sympathetic equality involved. I absolutely feel there's no intrinsic difference between people. Somebody might say, "George, you're completely full of shit. Fishermen and bums don't live in apartments on Madison Avenue or in expensive hotels." But I say this: "Yes, they do."

ab [*laughter*]

GC I tend to turn everything into a battle against the world. Eventually, it comes back to the one thing that's bugging me at the moment. I relate to people like the fisherman and the bum because they can't get out of their trash pack, no matter what happens. That I can understand. Artists tear themselves apart. Do you know what I mean? I get so far away from the questions you ask me, I don't even remember what I'm talking about, like the bum walking down the street, screaming at everybody—one minute is just as good as the next.

ab And one state of mind is just as good as another. So welcome back to the underworld, land of the free, home of the unconscious. How would you describe your use of psychological foreshortening?

GC It was an idea of Alfred Brendel's, describing the way a motif in music could be very minor, but because of the placement in the musical composition, it would affect you first. You may be hit on the street by something totally insignificant that just blows you away for the day, and not even register its importance. And some-

times when I paint, and I walk into a painting expecting to see Vermeer, I get punched in the nose by the old, star-spangled bum with his magic wand, trembling dust, bumming five cents again. These people have a memory bank that they're working with, a code in life, a little map through the world that they fill. It doesn't have a lot to do with things like the president of the country or the ruler of a nation. But it does have to do with artists. The Big Chief figured it out.

ab Who is the Big Chief?
GC The Big Chief is anybody who can take on a number of personalities and fit them all into his heart.

ab He "bites boundaries" and "expels the insipid affectations of everyday life."
GC The affectations I'm dealing with are a miniaturized, diminutive form of politics, more in terms of an eighteenth-century perspective. Take a Canaletto painting: from where is he sitting? He always seems to be above the Piazza San Marco, in some nice place, probably just inside one of the buildings you see inside the painting. He manages to catch the street life and shed light on daily politics. He might show two types of characters meeting. But in that particular year, their meeting would convey a peculiar change in the political atmosphere and it would be extremely miniaturized in the painting. My idea is to release this humanizing onto the canvas. William Burroughs said to me,

down in Kansas, "What is painting? You know, that's probably what you have to write about. What is in the middle of trying to put it into words?" So I brought out "The Shattered Line" excerpt and read it to him. He perfectly understood that it wasn't intended to make a broad remark, it was meant to limit itself to a point that is extremely human. Because the affected part of people is the interesting side to me. It's the real side of them that's boring. *[laughter]*

ab "Real?" Compared to what?
GC In the mirror of ideal reality, every side is equally off balance. People try to rationalize the center.

ab Compositionally, I noticed that your earlier portraits focus on a central figure. Of course, there is a major distortion within that figure. That is the irony, that sense of jest and mockery.
GC There was a time when I realized that the central focal point of portraiture did not have to be representational in any way. You don't need to paint the body to show the truth about a character. All you need is the head and the hands. There's inherent perceptual distortion when you look at a picture, never mind trying to deal with what it is, try to deal with what it's not. I like what Miles [Davis] said: "Play what's not there." That's why people like Rembrandt's portraiture. He really painted what was not there. He used paint. That's what painting is all about, discovering a way to paint because you love paint. I could roll

myself in it, drink it, eat it and kill myself, suffocating in it. Some people hate paint and I understand that, too. I can understand people who claw through it, can't get out of it, can't put it away.

ab I have two thoughts. One is that you use baroque ornamentation as an affectational background to off-set the "realness" of faces with, say, a green nose, blue flesh, a vertical eyeball, and dogs' ears. It sweetens the transmutation. Also, I think you've been placed in places you're not, critically speaking that is, such as graffiti and appropriation.

GC At one time they said, "Condo is a graffiti artist." Why? Because, at the Basel Art Fair of 1984, Rammelzee, A-1, Crash, and Toxic showed at the Sidney Janis Gallery and I had the box for the Perspective. And they started coming over to my place all the time. I realized that they had checked my work out at Keith's [Haring]. They came over and they saw my stuff and they were totally into the wild faces. They were like, "Yeah, man, Condo's in Basel, let's check him out." They didn't copy, you know, they were not into copying. They had already developed their own rigid, perfected styles.

The appropriation artists said, "Why should we invent something when it's already there? Let's just bring it to light." This last conceptual aspect of discovering it as an overlay, a transparent overlay, was a real breakthrough. It allowed people to relate

more than one idea simultaneously without having to be just abstract painters. But I found a way to do this without dealing with appropriation.

ab And it's not conceptualization.

GC No, it's not. But it's my way of saying, "This is a painting. It's not a fake painting, it's a painting from an imaginary character's reality." That's why I work with a cast of characters, all created carefully. As each of them becomes real, so do their environments, their place of being. Sometimes, I think they even come from some imaginary character's mind.

ab I like the sense of hysteria, pandemonium, in your pictures.

GC Mmm-hmm.

ab You approach them from a night face.

GC That's a nice idea. A god of panic.

ab Exactly, anxiety and desire.

GC You can see the Pan pipes of panic screeching off into the night, conjuring up images in smoke, images of the faces you see in the night face, as you call it.

ab Actually, that's what Fechner, the founder of psychophysics, called it.

GC The anxiety is counterbalancing, is counteraffecting the desire, counteracting it, deflecting it, hurting it, and making it impossible for it to reach its satisfaction. Once the anxiety is gone, you could give it the old Dalai Lama rap, you know, "Don't worry, be happy." Possibly, there's nothing

wrong with that angle, except that it's easy for him to say, while he's on the Concorde, flying around the world. Of course, that's what they say about me, too, you know. [*laughter*] Help straighten them out. How deep. It's like acupuncture to me. It's the difference between acupuncture and driving a stake through your heart. I'm into killing vampires more than healing right now.

ab **The Big Chief mentions healing.**

GC "It's a self-healing world without the cancers of humanity to destroy it."

ab **I see the paintings more as metaphors of an ancient text, healing like,** *similis similibus curantur.* **Your willingness to create characters as painful deformities that come from the soul, your willingness to present them centerstage, that's really about taking the cure.**

GC You know what else it's about? You just made me realize that it's also about, believe it or not, the Actors' Studio, Lee Strasberg (via Stanislavski) and his acting method of breaking down. Movies written during that time by people like Tennessee Williams were designed for the main characters to really break down, crack up, totally reveal their rudimentary anxiety, desire, fear, et cetera. Those are the make-it-or-break-it moments in these pictures. In terms of painting, I think of Picasso's shrieking women with three fingers from the little studies for *Guernica*. And I think of great performances in the theater.

ab **They share the legacy of mysteries and myth. I was thinking of Dionysus and the origins of Western drama. The tragic flaw. It's not hubris but fantastic pathology that your paintings expose, over and over again.**

GC Exactly. This is what it is. You know, who is the loser in the story?

ab **Guess who—that one-time hero.**

GC Imagine that's the guy who's standing there with the elegant fabric behind him on the wall, who looks like he came from Venice. His face is ravaged, and maybe twenty years ago, there was no fabric on the wall, but he was a beautiful person.

ab **I think a lot of your imagery comes out of the consciousness crisis between young man hero and old man wisdom, e.g., you and William Burroughs, you and Big Chief, you and Picasso, you and you. Also, you brought up the** *Guernica* **women, and to me, they are the Bacchantes, frenzied, feral, dismembering their own children. Picasso's main myth may have been the minotaur, but even that takes you back to mom consorting with monsters. Your women are wildly disproportionate, with enormous bodies, tiny heads perched on elongated spaghetti necks.**

GC What do you think of all these paintings of women? You know, I've done so many of them.

ab **They look like sensuous, intuitive anima portraits. Call it soul, psyche,**

whatever, that's how I see them.
There's Hecate, the night goddess
who rules over garbage. She's a
dark angel. I see Circe, Demeter,
Persephone, Nausicaa and/or their
equivalents. Sometimes they're
monsters, the Great Mother, fear-
some authority figures . . .

GC Monsters are just as beautiful as
maidens.

ab Maybe more so.

GC The way that, in a Bosch painting, a
beetle can have a human head and
cellophane-like wings, hairy little
flesh-tone legs and spots on his back,
with a glowing pink underbelly, exquis-
ite like a jewel. There's no interest in
painting an ordinary pretty woman or
pretty-looking man. It's all about the
imagination. I look at women as
being art. In my paintings, you never
see them enacting against the male
world, they're only in communion
with other females.

ab I glimpsed a few in Paris at your
apartment before you sent them to
Cologne. One of them actually
looked like a chair. I wanted to sit
in her.

GC One was called *The Insulated Woman*.
She was made entirely out of cotton.
[*laughter*] Another looked like a
motorcycle. They had nothing to do
with making a statement about
"female" . . . Sometimes, there's no
difference in my paintings between
what can happen to a woman, an
object, a landscape, or an abstraction.
A face could be treated like a very
abstract passage in a landscape.

ab But they're all brought to life, they're
animated, the root is still anima.

GC It's not the "masculine anatomy"
as form.

ab Obviously, but subjects and objects
in your paintings have gender just
as French nouns do. Figuratively
speaking, the ego is masculine and
the soul is feminine, the actual
forms of your women carry their
core qualities like dreams. So, of
course, you're not making a state-
ment about "female," you're offer-
ing up poetic images that happen
to be feminine. It's not even sexu-
al, it's beyond that . . . you are a
soul painter.

GC I don't want to deal with people, not
even women, in any way other than
those paintings. If you have . . . uh . . .
sexual designs on a person, then it's a
question of taking their clothes off,
getting them into the studio, putting
them on a podium, and painting them
from a detached academic point of
view. The sexuality revealed is a dis-
honest one, like Ingres. He creates an
idealization of sex. That's very inter-
esting to surrealists and Freudians.

ab But not to irrealists. It's about
seduction.

GC Seduction of the viewer by the paint-
ing. The sexual aspects of my women
paintings . . . what are those?

ab That's a good question, George.

GC From my point of view, they are used
to enhance any sexual qualities that
humanity may have left, not to
diminish them. I try to make sexuality

into something else, maybe it's not what you'd want, because it can assume any form. And yet, it's not repelling sexually. For example, the food chain could be an analogous subject. I've discussed this with Felix Guattari, he's a good friend of mine. He deals with incredibly hard-core cases of schizophrenia. He does rip things apart, but not to degrade them.

ab I think I missed something . . . what's the link between sexuality and schizophrenia, besides Salvador Dali? [There's talk about George not feeling well, wondering about a twenty-four-hour hot water bottle delivery service,and Anney saying she'll get one for him, if he makes it through the interview.] That's another traditional female aspect—the Nurse.

GC And another reason I like them. [*laughter*]

ab The witch paintings to me are about female intelligence/knowledge as dark, powerful and secret. The clowns are about male vulnerability, suffering and foolishness. You are redeeming rejected aspects of sexual archetypes; that's what people may not want to see, but may need to remember. Memory was the first muse. Guattari talks about your use of infantile memory. By creating memories that you're not even sure are memories, you fuse the need to historicize and the need to invent. What if the imaginal is *a priori*? Imaginary characters preexist. It's not that we make them

up, they're making us up.

GC Right. Because we don't exist, we're not really here now. What's in the next room isn't there. There's no baby, no Anna, no house. You invent it, it's what you can see in front of your eyes. That's my interest in Cézanne's paintings, because it's as if they're not really there. He shows you that even by walking around the room and seeing it from a few different points of view, it's still not there. Picasso supposedly allowed you to see an object from all perspectives, but Cézanne had already done that by lifting it and placing it again.

ab I think it's more about the invisible.

GC The gravitational force more than what's being gravitated.

ab Reenvisioning the relationship between the seen and the unseen. You abstracted that idea in your *Shattered Line* paintings.

GC I had done those in my house in Chelmsford, Massachusetts, where I grew up, and that's a deep, pine forest feeling. It's got green, it's got space, it's got pause, it's got good punctuation. It's the oldest town in America, consecrated in 1656. When I brought Anna, my wife, there, she said, "We should just live here. This place you come from is the most beautiful place." At the time, I really wanted to abandon my admiration for European aesthetics and European things. I realized that, ironically, Chelmsford was older than some sections of Paris. I was tired of the pretension some Europeans have about

being older and wiser. I was entwined in this happiness of being home, in the States, in Chelmsford. I had just found this beautiful color of paint down at the hardware store. I was happy *not* to go to the LeFerre Fauneil where they ground pigment in special recipes for Bonnard, Léger and Vlaminck. I went to a real American paint store and I picked up this charcoal gray latex. I came home, put down the canvas, got out some Scotch tape and put it on. I was just about to make this white line all the way down, I made the stroke and suddenly—the gray—when the light went on, the gray became a deep forest and the white became a streak of light that started to move between the pines. And it broke like a shimmering apparition. And then it paused, left a space, a black space and a charcoal gray space, and then it continued again. I looked at it. I went over and took some paper towel to scruffle the edges of each of the white lines. This painting had just become a shattered line, a line that could never be connected again. Barnett Newman could have done it. He did it. A lot of people did it. But there was no truth in it for me until that moment. And that feeling came through for me in two colors, charcoal gray and white. It came through again in a later painting of black and white where both sides of the black flowed into one another, with the white line just broken. That's the pushing for a cultural progression, human rights; and that had started in the paintings with charcoal gray, which is such an

altered state of black in American terminology.

ab Do you know what *Tsim Tsum* means?

GC No.

ab It's a mystical Jewish doctrine. Barnett Newman investigated it in a sculptural piece. Basically, the question is: How could God have created the universe if he's everywhere? Where was there room for the universe? The answer is that God's ability to withdraw allowed him to create the space for the world. And I think your shattering of the lines contains that truth whereby existential nothingness and the fullness of faith coexist.

GC That really makes sense. And there's humor in the idea that, ultimately, all we can do is practice withdrawal and look it over. Like the guy with the third eye and no second one. [*laughter*]

ab I get this picture of you and William Burroughs working together in a seance of the unconscious. It starts as a two-character, one-act black comedy and ends as a cast of thousands, an epic that's accidentally looped.

GC There was a strange dialogue of unconscious mumbling, a recollection of different characters between us. He would scrape the palette knife and I would say, "Look, there's the Maharajah, sitting there. You can see the temple crumbling behind him. It was just bombed."

And he would say, "Look, that

building just blew up and turned into a substructure for another operation. Okay, let's crystallize that unit, and get that one moved out." So we would scrape out a whole regiment of brush strokes. It was like travelling into Céline's *Journey to the End of the Night*, coming from the comic aspect of it, right into the real blood and guts. And it was always a recollection. In just the color application, the way burnt umber and white tones over a brick-orange build up to a flesh that recalls Goya or Joshua Reynolds. Cracks between some leaves become that red undertone of canvas. It can come from anywhere at all, from hell, or a rusty old maple leaf.

ab Your new combinations deal with separation and collaboration differently, in an eccentric formality.

GC Like an artist's reaction to a soup can sparking off a work of art, a lot of these paintings were obvious responses to being in my studio, seeing my paintings stacked against one another. Their stylistic interrogations conflicted and contrasted, but together they made a whole.

ab That's an inversion of your earlier expanding canvas strategy.

GC It is.

ab At first glance, these combinations seem harmless and familiar, but then they sneak up behind you and implode. They dare you to accept the unity of multiple dimensions.

GC I think so, because the human mind now has the task of watching a TV show with commercials in the middle of it. What if you're seeing a news broadcast, they just bombed the White House and in the middle of that you have little Miss Daisy doing her dishes? This is the ideal psychological foreshortening we talked about earlier. This is not cubism and walking around the canvas. This is psychological cubism.

ab Which may produce unwanted awareness in the age of information addiction.

GC I think that, in the future, people will be able to see like that, their minds are already being conditioned. For example, if the eye were a wheel calibrated like a clock, between twelve and one, and there were so many seconds and that area was unrelated to eight and nine; that's the way the eye is perceiving the combinations. It's a lot to take in, it's a capsulization of a lifetime in each piece, but it's a way for me to open a painting up, like Rembrandt's anatomy lesson. In order for the depth of psychological experience to take place, everything has to be like a dentist's chair—you sit down and they're nice and they put the gas on . . . then they just rip your mouth open. [*laughter*] Rip your teeth out.

ab Well, thank you, Dr. Condo. Where's the nitrous?

GC It's hanging over your head in the safety compartment.

Ross Bleckner, *Poverty Bouquet*, 1986, Oil on linen, 48" x 40". Photo Zindman/Fremont. Courtesy Mary Boone Gallery, New York.

ROSS BLECKNER aimee rankin

BOMB # 19, Spring 1987

Ross Bleckner's paintings provoke passage into haunted chambers emptied of all but light and dark in which float perhaps, a hummingbird, a chandelier, a trophy . . . Other paintings stand like sentries, shades whose shadows obscure our vision and revoke passage into this nether world we cannot yet imagine. Ross Bleckner, on the other hand, loves to laugh and can almost never conceal the humor beneath his gaze. He and Aimee Rankin sat down over Chinese takeout in his studio in Lower Manhattan to discuss his work.

aimee rankin We're constituting fragments of lost speech around Ross Bleckner's paintings, having this long discussion about . . .

ROSS BLECKNER Repression and adventure.

ar We're going to pick up in the middle and see if it doesn't get lost in the baffles of the tape recorder this time. What we were talking about were the issues that artists seem to have inside them that come out through a body of work, the one or two things the artist has to say that are consistent. We spoke of ambivalence. We spoke of desire.

RB Imprisonment. Repression. You don't always know that your intention is polymorphous.

ar You've done two very different types of work. You've done atmospheric, dark, moody, illusionistic, almost funereal paintings on the one hand. And then you've done very abstract stripe paintings on the other.

RB Essentially, I want a world to exist that I can get into. A world that has to do with certain kinds of illusion and also a world that is confrontational. The stripe paintings hold you outside of their making. I work very much like a rubber band. I start with an idea or an image and then I stretch it out and let it collapse back into itself. That's how the stripes in my abstract paintings have always functioned. They are confrontational in that they collide with what is represented in my other paintings. The imagery is more phenomenological in the stripes. It has to be constructed within the relationship of the spectator to the painting, because

it isn't in the painting and it isn't in the spectator.

ar You use theatrical conventions of illusion in the atmospheric paintings, which we compared to "scrims." You can set up an illusionistic structure of depth and make apparent its artifice by having globs of paint on the surface that make everyone aware of the canvas. I think you do that in a reverse way in the stripe paintings. In other words, the stripe paintings start with a surface and then bring up the illusion of depth. So the two types of paintings are working on the same issues: depth and surface, illusion and types of abstraction, but from opposite standpoints. You brought up the issue of the stripe paintings being about a kind of repression?

RB I think that we don't really know what we do until we've done enough things to look back on them and let those things construct a reality. The intersection in which we locate ourselves psychically and socially is always shifting. Contradictory shifts that are concurrent and simultaneous take place and compete within our consciousness. All of us have the possibility or the capability of being any number of things at once.

ar That's the other issue that's extremely important in your work—ambivalence. The works are all about a sliding of meaning.

RB That contradicts what you said about a consistent . . .

ar No, no. It can be consistently ambivalent. That's not a contradiction. By ambivalence I mean the fact that you refuse to do one type of painting. You slide from a wish to be abstract to a wish to be illusionistic, a wish to concentrate on the surface of a painting and a wish to create depth. But that kind of slipping that exists in both types of work points out certain consistencies even if that consistency is an interest in contradiction.

RB I like that idea of slippage. When you set up a hierarchy, an icongraphic hegemony, you are stating a position and essentially what occurs at that point is that you close down or rather you stop opening up to a place where that position might become vulnerable. The way that we arrive at meaning, the way our consciousness is constructed, has more to do with what's repressed than with what we express by using language. But as a condition of our daily lives, all that goes repressed has to be accounted for, somehow. Ambivalence is more true to the way things really are than an iconographic identity.

ar The meanings in your work are often very emotional, very powerful, especially in the darker paintings. They seem very much about death. They're beautiful and yet very sad. That kind of powerful emotional force, to me, is repressed in the stripe paintings. The stripe paintings are almost symptomatic of that kind of denial except that they're so obsessional.

They're so focused on the purely abstract.

RB There is no such thing. I've tried to find a methodology in which light and its relationship to the atmosphere of a painting is like a psychotic hallucination. All of the possibilities of a space or of a world inside a painting vibrate optically so that it creates a profusion of both meaning and sensation. In a way, the paintings run parallel . . . you know, I don't really see them as being ambivalent.

ar I was using ambivalence to describe the whole body of your work. In other words, in relation to certain issues.

RB Which issues? The issue of death?

ar **What you've described in both aspects of your work is a kind of hallucinatory brilliance. In the atmospheric paintings, you speak of their hallucinatory aspect as being little worlds that you can enter, these phantasmic spaces. Whereas in the stripe paintings, it's purely perceptual. You seem to be talking about the way the unconscious works. If you mention words like psychotic and hallucinogenic, you must want to bring the viewer to some kind of altered emotional or physical state in your work.**

RB The disallowance to construct a palpable image, as in the stripe paintings; or a recognizable place, as in the illlusionistic ones, alters expectations about a painting. It's almost like death and belief. We all make our

work so that we can look at what interests us. It's very difficult to say, "I believe in this" or "I think that," but you can make work that's deceptive in how you actually express your desires. There's always a running subtext. You're saying one thing and your work is doing another. Now, I like that kind of tension. "We lament and never explain why." Kafka said that.

ar **That's the contradictory aspect, what I mean by ambivalence.**

RB A lot of my work deals metaphorically and literally with the idea of death. I've read the obituaries since I was a child. I used to want to be the obituary writer for *The New York Times*. Only because I thought that's the ultimate criticism. You live your life and somebody sums it up, what power. When somebody takes my picture, for instance, in my head I always think: If I get killed after this, this is the last image. This is how I will be remembered. A camera, in a way, makes me reflect instantly. A camera does for me what film does in a projector—images roll around inside. The idea of death isn't only of literal death but also the death of ideas. My own personal, as well as all our cultural, disappointment. We've all come to believe certain things about social reality, in the invincibility of technology, that it will save us. A lot of our beliefs have to do with an infantile idealism that things get better and life gets more equitable. I had an aunt who was dying of pancreatic cancer, the worst kind of cancer, very painful, very slow. I remember her saying as she was

withering away, "If I could last a few more weeks there'll be a cure." Well, here we are twenty years later and God knows how many billions of dollars and there's not a cure. These diseases are cultural problems. It's not about technology or progress. That's the kind of death that the twentieth century is going to be seeing in its reposing years. We're ending it with a plague that's totally, totally unstoppable. Totally out of control.

ar You brought up the one issue about representation of death. Whenever someone takes a picture of you, you are reminded of your own death. To me, all representation is about death. Making art is about a very limited transcendence of death. People make art knowing that it will outlast them. The necrophilic aspect of your work is very powerful. I wanted to mention the striped painting with "remember me" written under it. As someone who's fantasized about being a *Times* obituary writer, have you thought of an epitaph for yourself?

RB Yes, I have: "I'd rather be eating ice cream."

ar That's it?

RB Yes. Although I could die from eating one of these undercooked crabs we've got here.

ar We were talking general issues— death and representation. Now we're talking about a specific issue: We're seeing a preoccupation with death that's cultural. We're reading everywhere in theory about the death of history, the death of the subject, the endgame argument. At the same time, we're moving toward the end of a century, and that has traditionally been a time of fear and decadence. There's also this real situation of plague, so everyone's fear of death is brought home in a very literal way. Your work makes an important statement about this particular point in culture. I think people should really begin to pay attention to this idea in art.

RB Which idea?

ar That art is about a confrontation with mortality; the mortality of the individual and of the human race.

RB Art should be something that you inspect and pull apart and open up. It's a temporary reprieve. I believe in some corny way that there's life after death, but if I would have to explore what the possibilities of that life are . . . I can't pursue the spiritual tangents to what I just said because I don't believe in them. But that doesn't mean I want to make work that might close the door to all those things that intellectually I'm just not ready to deal with.

ar Your dark atmospheric paintings have similarities to the turn-of-the-century symbolist and decadent painters. The iconography is similar. They were inspired by religious ideas. The Rosicrucians used the

grail images and many symbols that I see elements of in your work.

RB There is something self-effacing about my work and that might be it. I want my work to do what I say it doesn't do. I want my work to do things that I would have to be dragged, screaming and kicking to even admit that I thought of. You could pull teeth and you wouldn't get the true meaning of somebody's work out of them. Because, number one, it should be open to different readings and, number two, only a failed work ends up being about what you say it's about. That's what I meant by "in that little world there." There are senses that hover. To pursue them intellectually, I think, you could get into some kind of murky . . .

ar Murky's a key word.

RB I like murky if he's one of the seven dwarfs.

ar Any time we grapple with the issue of death, mystical confusions are going to come up.

RB Because everybody would like to believe that they're going to have left something worthwhile after they're dead. That's life after death for every artist.

ar It's the terror of the abyss, the terror of not knowing.

RB That word "abyss" is just too much of a silly abstract expressionist term.

ar It's not silly.

RB It's like a cartoon.

ar It's been used in that way but that doesn't mean that it's not something very real that individuals have to confront when they think of dying. And just because it's been sullied by a few opportunists . . . the whole history of art is about the abyss.

RB A lot of words come in and out of fashion. The truth is you have to take someone kicking and screaming. Out of every formalist you'll have this closet transcendentalist.

ar Ross, where are these dark paintings situated except in the abyss? Look at them. There's no ground. There's no sky. There's just this darkness that envelops everything; this formalist void.

RB But you know what I'm saying.

ar You have a very critical relation to your paintings. That's where the issue of theatricality and the scrims come in. The fact that you paint these void-like, very disorienting spaces and then paint on the surface so that you're criticizing your illusionistic production even as you're doing it.

RB It's important to be transparent.

ar I'm not saying that you're wallowing in that tainted expressionist subjectivity.

RB Hopefully not, I despise my subjectivity: but I despise others' more—just kidding. It's almost like the production contained within it has to have all the elements for its recapitulation psychically and socially.

ar Let's talk about trophies.

RB They're images of trophies, but a trophy signifies a disembodied counterphobic triumph. A painting is a trophy and something more. I think that "something more" aspect is very important. A trophy is incidental to the development of a relationship. A painting is a relation to relationships. You have a trophy and after a while the activity is forgotten. The traces of what you remember about it are all undifferentiated.

ar A trophy is cut off from that kind of subjective relationship. It commemorates it.

RB It commemorates it, but it's interchangeable with any other one. A painting always has within it the possibility through this subjectivity, of reconstructing its own making. A trophy expresses adventure. A painting understands the adventure of expression. Painting is what comes instead of truth after the object has been lost. A trophy articulates and valorizes hysteria. A painting is an inarticulate hysteria.

ar It's about the difficulty of inserting oneself in the proper place in the symbolic.

RB Exactly.

ar One of the interesting things about hysteria was that it was a way of signifying with the body things that were repressed from the patient's discourse. Perhaps that's what you're doing in your work as well.

RB I like that psychoanalytic tone.

ar That's my theoretical background. The stuff you were talking about in the painting, that you would have to be dragged kicking and screaming to actually say. It's nice that when you paint, you're letting yourself go in a way that the unconscious is able to speak. That's one of the powerful things about these paintings. They have an unconscious resonance, force.

RB It's my confusion about gender differentiation.

ar That's the clinical definition of hysteria. There are two definitions in psychoanalysis that are relevant here: hysteria is when you don't know if you're a man or a woman, and obsessionality is when you don't know if you're alive or dead.

RB Oh my God! So I'm hysterical and obsessional. I would say that painting has to do with being able to embody all these social and personal possibilities and we just make decisions about what we bring up and what we put down. There are forces that we repress and those that we decide to be conscious of. I'm not romanticizing the idea of schizophrenia, but I'd say that all painting is also schizophrenic.

ar Critics such as Jameson have characterized postmodern culture by its schizophrenic tendencies. Jameson gives an example of a schizophrenic patient who talks about things having a hallucinatory brilliance. There's a wash of

intensity to the world which isn't coded and permeates the mind in a very disorienting manner. Your work has elements of that hallucinatory effect.

RB Clinical schizophrenia is not like the French idea about schizophrenia as some kind of "romantic otherness." We must recognize that actual clinical schizophrenia is a very depressing and hollow, horrifying existence. The idea that we exist in a social schizophrenia is probably what we're really talking about. It has to do with those breaks in how representation is coded. I think things shine with their maximum brilliance just at the point that they're about to die.

ar Exactly. That's the beautiful decadence.

RB The relationship between my paintings with images and those without images is really about trying to eke out of a formal code, a maximum amount of light. It is a small space with a lot of light.

ar There was that article in *Art in America* by Peter Schjeldahl in which he was describing your work and he used this phrase, "making disappointment dance." The disappointment you're making dance is just the disappointment of someone who knows they have to die. That we all have to die. It's that disappointment with the ephemeral qualities of life—which the artist has always made dance.

RB I completely agree. You can make work that has to do with light, and light can

be blinding because at some point you could set up a series of hallucinations that would fragment how you might regard your own interests to be continuous. So you're always dislocated within your own desire. The other point is the liberating element, that's the sexual thing. A lot of artists see their work as being liberating. It liberates them to create the maximum amount of possibilities at any one time. That's what I have to get out of my work—the sense of liberation and the sense of hallucination. It frees me and dislocates me. It also gives me pleasure.

ar It's funny that you use terms like liberation because you have said the stripe paintings were like bars. They weren't about liberation at all, but about you being trapped within this representation.

RB Yes, but what I think they do is repress everything I want to come out *through* them. That's why that painting has the words "remember me." What's repressed in there is everybody's secret desire. Like the last scene in *Carrie* where that arm comes flying up from the grave. It scares you to death. It's this little, desperate plea that we all make with the world: "Remember me."

ar No, what *Carrie* was trying to do was to grab that girl and pull her down.

RB That's what we also want to do. As much as we find a way to, in a sense, glorify our own existence, we also would like to have the fantasy that we're going to bring everyone down with us.

ar "The flame that burns half as long burns twice as bright," that's a line from *Blade Runner*. In *Blade Runner* the replicant comes back to find the man who created him, Tyrell. And Tyrell says, "What seems to be the problem?" And the replicant replies, "Death seems to be the problem. I want more life, fucker." That's an intense moment, an intense sentiment. A sentiment in your work, too.

RB These paintings narrate that, they go from the beginning to the end of something. It really has to do with getting out of one thing and into another and being trapped along the way. One wish, one day fever—this painting is infatuation. The moment of infatuation is that moment before the bud falls off the bloom and everything is idealized. And then you blow that moment up. Making art, obviously, always becomes an interface. It's like a theoretical tool, a place where we can all focus and have something to talk about. Making art creates the conceit that the critic is actually at the center of the theoretical discourse. When in fact, the objects are being planted in the world as decoys. All of the stuff that we make are decoy objects. What we're actually doing is creating meaning, we're not ending meaning. Artists throw out decoys so they can, in a sense, go on their way. I think the most important thing is that we create new meanings.

ar Not that meaning comes out of a void, but that meanings that already exist are put together and new tensions and conditions arise from that meeting. It's like a cultural alchemy. And that's happening constantly.

RB Every point in a culture is an intersection. Every intersection is about desire.

ar It's the ultimate conceit now that people think they can make the last painting.

RB They think that we think we're living in that moment in history that's the last moment. That's so grandiose, it's a joke.

ar The whole twentieth century is . . .

RB . . . dotted with the history of the end. Now we can make a comment about how people see things at a particular moment. People see things in the most narrow, immediate, and obvious ways. Art history works in tandem with the speculative creation of the marketplace. The creation of the marketplace doesn't have to do with how things investigate desire, death and history. It has to do with how things look different than what came right before them, what kind of novelty appeal they have. What Joseph [Kosuth] said is very interesting in that regard: making art is not the relationship of a human subject to an object, it's the relationship of a subject to a subject. It's a relationship of a subject to relationships. My paintings memorialize a lot of different things simultaneously: the culture; immediate ends, relationships and people who have just passed. The people who've died from, in this case,

AIDS. They memorialize the death of our own ideas about all that so that as an artist you can continue to grow and go on. In a way they memorialize the tragedy of being subsumed in the marketplace, too, because in order to keep your art going, you have to keep upping the stakes formally. You keep opening up all your artistic options and as soon as you make it in the marketplace, things close because they expect you to maintain a style. Then you have to fight harder to keep things open, to keep your confusions. You keep experimenting with your sense of self and the world until this sense of yourself and the world gets confirmed by the world. And it might initially seem like a fantastic thing that all artists want, but there's that other part that's a drag.

ar It's very frightening to feel the machine of hype breathing down your neck. Especially if your work comes from an introspective, emotional place.

RB Especially when you know that the weight of things outside you always wants to pin you down. It wants to eat you not even as a full meal but as a little side dish. The point is that each artist has to keep growing and mutating and *being* after all that leaves. And that's also what that painting— "Remember me"—is about: "I know how things were."

All the things that people don't talk about or can't talk about are the things that are most interesting in the art that they make. Because they have to do with these words that I object to like "abyss."

ar Why do you object to it?

rb You're younger than I am so you're coming to it with a fresher look. To me it's just an old tainted word that got dragged down.

ar I like tainted things as a rule. They're more interesting.

RB A lot of artists do. It's like appropriated things. But it's also a question of exhaustion. Everybody's so exhausted that nobody can imagine making art that has even a glint of originality left in it. I don't think that's why one should retreat into past art. As we were saying before, eking out the most amount of light also has to with eking out a little bit of difference.

biographical notes

Vito Acconci by Richard Prince. *BOMB#36, Summer 1991* Born in the Bronx in 1940, **Vito Acconci** began his career as a poet. In his first visual work in the late 1960s and early 1970s, he used his own body as the subject for photography, film, video, and performance. These early works, which explore the self in its relation to others, have exerted a profound influence on the current generation of young artists. During the next two decades, the artist's relationship to his audience changed as viewers ceased to be mere spectators and became more and more an integral part of his work. In the mid-1970s, Acconci created audiovisual installations that turned exhibition spaces into community meeting places. In the early 1980s, he turned to the creation of furniture and to prototypes of houses and gardens. More recently, the artist has focused his creative energies on architectural and landscape design that integrate public and private places. As a group, the Acconci Studio designs and constructs public projects in parks, city streets, and city buildings.

Solo exhibitions of the artist have been organized by the Museum of Modern Art, New York; the San Diego Museum of Contemporary Art, La Jolla; Centre d'Art

Contemporain, Grenoble; and the Museum of Applied Art, Vienna. In the past few years, the Acconci Studio has designed and built a plaza at Queens College; a public garden at Metrotech Center, Brooklyn; a wall used as seating at the Arvada Community Center, Colorado; and street furniture for Tachikawa City, Japan. The artist has collaborated with musicians, artists and architects, including Steven Holl (in the renovation of the Storefront for Art and Architecture, New York) and Stanley Saitowitz and Barbara Stauffacher Solomon (at the Embarcadero Promenade, San Francisco). Additional public projects are underway in Liverpool, Chenove, and The Hague.

Richard Prince was born in 1949 in the Panama Canal Zone and presently lives in New York. His most recent solo exhibitions include: Museum Haus Lange/Museum Haus Esters, Krefeld, Germany (1997); White Cube, London, England (1997); Maximilan Verlag-Sabine Knust, Munich, Germany (1996); Haus der Kunst/Süddeutsch Zeitung, Munich, Germany (1996); Jablonka Galerie, Cologne, Germany (1996); Barbara Gladstone Gallery, New York (1995); Theoretical Events, Naples, Italy (1995); and Regen Projects, Los Angeles (1995); as well as the San Francisco Museum of Art (1993), and the Whitney Museum of American Art, New York (1992). His most recent group exhibitions include: *Birth of Cool: American Painting from Georgia O'Keefe to Christopher Wool* at Diechtorhallen, Hambourg, Germany (1997); *New York Scene*, Gotlands Konst Museum, Visby, Sweden (1996); *Young Americans: New American Art in the Saatchi Collection*, Saatchi Gallery, London, England (1996); *The American Trip*, The Power Plant, Toronto, Ontario (1996); *Who Do You Think You Are?* Bard College, New York (1996); and *Passions Privee*, Musée d'Art Moderne, Paris (1996). He is represented by Barbara Gladstone Gallery, New York.

Ross Bleckner by Aimee Rankin. *BOMB #19, Spring 1987*

Ross Bleckner has been an artist for the past twenty five years. He attended New York University and California Institute for the Arts. He moved back to New York City after graduating and has been showing since 1974. He has had solo exhibitions at Mary Boone, New York; Max Hetzler-Koln, Germany; Soledad Lorenzo, Madrid, Spain; Kunsthalle Zurich, Zurich, Switzerland; Moderna Museet, Stockholm, Sweden; Fred Hoffman, Santa Monica, California; and Ghislaine Hussenot, Paris, France. His group exhibitions include: *The Binational*, Düsseldorf, West Germany; *Carnegie International*, Carnegie Museum, Pittsburgh, Pennsylvania; *Biennial,* Whitney Museum, New York; and *10 + 10: Contemporary Soviet and American Painters*, The Corcoran Gallery of Art, Washington, D.C. In addition, he has taught as a visiting artist at Yale, Princeton, Brown, Rhode Island School of Design, Parsons, New York University, Chicago Art Institute, Rutgers, Skowhegan, and the School of Visual Arts. Ross has also been active in AIDS charity work since 1985. He is currently serving as President of CRIA (Community Research Initiative on AIDS). In January 1995, he had a mid-career retrospective at The Guggenheim Museum in New York. His most recent paintings have been shown at the Mary Boone Gallery in New York City and at the Larry Gagosian Gallery in Los Angeles.

George Condo by Anney Bonney. *BOMB #40, Summer 1992*

George Condo was born in Concord, New Hampshire in 1957. He moved to Massachusetts in 1960, and attended Lowell University from 1976 to 1978. In 1979 he moved to New York City. His first painting was exhibited in 1981 at The Terminal Show.

His first encounter in the art world was as a writer for an exhibition of Andy Warhol. Warhol read his page and asked to have Condo hired at The Factory as an observer who could translate into words exactly what he saw—after just two pages Condo began working as a printer. From then on his paintings began to be seen—he had already done 500 paintings.

His first exhibition in New York City was at the Pat Hearn Gallery in 1984. He was then plucked from her nest by Barbara Gladstone, and was plucked again by the Pace Gallery in 1987, where he currently shows. The highlights of Condo's life are the days and nights spent in collaboration with Warhol, Basquiat, Haring, Burroughs, Gysin, Ginsberg, and Guattari. Since his interview with Anney Bonney in 1992, he came upon the term Artificial Realism to describe his own work, as well as all important art since. He has given this term the definition "the realistic representation of that which is artificial."

Anney Bonney grew up in the Midwest and was educated on the East coast. She left Wellesley College to live in a tree house on Hanalei Bay, Kauaii, before settling briefly in Rio de Janeiro. Since 1976, she's lived in New York City as a painter, videomaker, and installation artist. She sold her first painting when she was twelve and has been working ever since. Her first film, *Pygmalion Alien*, won a NYSCA grant. Last year the Kitchenette (at The Thread Waxing Space) exhibited *Confabulating Chaos*, and her homage to Jimi Hendrix, *Neptune Rising*, premiered at The Kitchen's Spring Benefit. She cofounded Antenna TV with Kathryn Greene in 1992, and is currently Hybrid Curator at The Kitchen, which is the exclusive distributor of her video work.

Carroll Dunham by Betsy Sussler. *BOMB* #30, Winter 1990

Carroll Dunham was born in 1949 in New Haven, Connecticut, and lives and works in New York. He studied at Trinity College. His one-person exhibitions include: *Recent Drawings*, Nolan/Eckman Gallery, New York (1996); *Carroll Dunham: Paintings and Drawings 1990–1996*, Guild Hall, East Hampton, New York (1996); Santa Barbara Art Forum, Santa Barbara, California (1996); Forum for Contemporary Art, St. Louis, Missouri (1996); Bobbie Greenfield Gallery, Santa Monica, California (1995); and *Carroll Dunham: Selected Paintings 1990–1995*, School of the Museum of Fine Arts, Boston, Massachusetts (1995). Selected group exhibitions include: *Now on View*, Metro Pictures, New York (1997); The Carpenter Center, Harvard University, Cambridge, Massachusetts (1996); *How the Chicken Crossed the Road*, Mai 36 Galerie, Zurich, Switzerland (1996); Galerie Thaddaeus Ropac, Paris, France (1996); *Nuevas Abstracciones*, Museo Nacional Centro de Reina Sofia, Madrid, Spain (1996); Kunsthalle Bielefeld, Germany (1996); Museu d'Art Contemporani, Barcelona, Spain (1996); and Sandra Gehring, New York (1996).

Betsy Sussler, writer, co-founded *BOMB* magazine in 1981 and has been its Publisher and Editor-in-Chief ever since. Some of her many interviews for *BOMB* include artists Sarah Charlesworth, Keith Sonnier, Robin Winters, James Nares, and Cindy Sherman; writers Nancy Lemann, Gary Indiana, Suzannah Lessard and Honor Moore; actors Eric Bogosian, Richard Caliban and Al Pacino. City Lights published a compilation of *BOMB* interviews edited by Sussler in 1992.

In the late 1970s, Sussler wrote and directed several independent features, most notably *Tripe* and *Menage*, which she screened at the Bleeker Street Cinema and The New Cinema in New York, and the Corcoran Gallery of Art in Washington, D.C. She wrote for and acted in Rosa von Praunheim's German feature, *Red Love*. From 1978–82 she acted with the theater group, NIGHTSHIFT in Melbourne, Sydney, and New York. Plays include: Marguerite Duras' *The English Woman*; Fassbinder's *Pre Paradise Sorry Now*; and Joe Orton's *Ruffian on the Stair*. In 1991 she won a NYFA Fellowship in playwrighting for her first feature length screenplay; her second is *Nod's End*. She has just completed a novel, *Cane River*.

Eric Fischl by A.M. Homes. *BOMB* #50, Winter 1994

Eric Fischl was born in New York City in 1948 and was raised on Long Island. He studied painting at California Institute for the Arts, where he graduated in 1972. In 1979 he had his first solo exhibition at the Edward Thorp Gallery.

Fischl's paintings, drawings, and prints have been the subject of a number of solo exhibitions, the largest of which was *Fischl: Paintings*, which originated at the Mendel Art Gallery in Saskatchewan, Canada in 1984 and travelled to Stedelijk Van Abbemuseum, Eindhoven; the Kunstalle Basel; the Institute of Contemporary Arts, London; the Art Gallery, Ontario; the Museum of Contemporary Art, Chicago; and the Whitney Museum of American Art, New York. His most recent solo exhibitions have been at Mary Boone Gallery, New York; the Galerie Daniel Templon, Paris; Off Shore Gallery, East Hampton, NY; and Laura Carpenter Fine Art, Santa Fe, New Mexico. In 1988 a compendium of Fischl's work, edited by David Whitney, with an essay by Peter Schjeldahl, was published by *Art in America* and Stewart, Tabori and Chang.

Fischl's work is represented in numerous private, museum and corporate collections, including the Whitney Museum of American Art, the Museum of Modern Art, Museum of Contemporary Art in Los Angeles, St. Louis Museum of Art, Louisiana Museum of Art in Denmark, and the Paine Webber Collection, among others.

He lives in New York City and Sag Harbor, New York.

A.M. Homes is the author of the novels *The End of Alice*, *In a Country of Mothers*, and *Jack*; the short story collection, *The Safety of Objects*; and the artists' book *Appendix A*. Her work has been translated into eight languages and is much anthologized. A.M. Homes' fiction and nonfiction have appeared in *Artforum, Bomb, Blind Spot, Elle, Mirabella*, the *New Yorker*, the *New York Times Magazine, Story, Vanity Fair*, and numerous other magazines and newspapers.

A.M. Homes was born in Washington D.C. and is a graduate of Sarah Lawrence College and The University of Iowa. She currently teaches at The Writing Program at Columbia University and lives in New York City.

Adam Fuss by Ross Bleckner. *BOMB #39, Spring 1992*

Adam Fuss was born in London, England in 1961. Since 1982 he has been living and working in New York City. His solo exhibitions include: *Mary and Love Machine*, Rhona Hoffman Gallery, Chicago, Illinois (1996); *Pinhole Photographs*, Baumgartner Galleries, Washington, D.C. (1996); Robert Miller Gallery, New York (1995); Charlotte Lund, Stockholm, Sweden (1995); Galerie Ghislaine Hussenot, Paris (1994); *In Between*, Laura Carpenter Fine Art, Santa Fe, New Mexico (1994); and Fraenkel Gallery, San Francisco, California (1994). His group exhibitions include: *The Mythic Image*, David Adamson Gallery, Washington, D.C. (1997); *Hope Photographs*, National Arts Club, New York (1997); *Small Scale*, Joseph Helman Gallery, New York (1996); *Intimate Objects*, The Ralls Collection, Washington, D.C. (1996); *Open Secrets: Pictures on Paper from 1815 through the Present*, Matthew Marks Gallery, New York (1996); and *Into the Deep Surface*, PaceWildensteinMacGill, Los Angeles, California (1996). His work is in the permanent collections of The Metropolitan Museum of Art, The Museum of Modern Art, the Whitney Museum of American Art, and the Israel Museum.

Sally Gall and April Gornik. *BOMB #44, Summer 1993*

Sally Gall grew up in Houston and now lives in New York, though she often travels to places wild and far from human habitation to create her photographs.

Occasionally she teaches and does editorial photography, though her main activity is to make and exhibit art (photographs). She has had regular exhibitions over the years at the Julie Saul Gallery, New York and the Texas Gallery, Houston. Recently she had work shown at G. Ray Hawkins Gallery, Los Angeles; Robert Koch Gallery, San Francisco; and Town Hall, Montalcino, Italy, among others. She is the recipient of a National Endowment for the Arts grant and two MacDowell Colony Artist's Fellowships. *The Water's Edge*, a collection of her photographs, was published in 1995 by Chronicle Books.

April Gornik lives and works in New York City, where she has been a resident since 1978. Born in Cleveland, Ohio in 1953, she received a B.F.A. from the Novia Scotia College of Art and Design, Nova Scotia, Canada, in 1976. She has work in the Metropolitan Museum of Art, New York; the Whitney Museum of American Art, New York; the National Museum of American Art, Washington, D.C.; the Cincinnati Museum, Ohio; the High Museum of Art, Atlanta; the Modern Art Museum of Art of Fort Worth, Texas; the Orlando Museum of Art, Florida; and other major public collections. She has shown extensively, in one-person and group shows, in the United States and abroad.

Some noteworthy one-person shows have been at the Guild Hall Museum, East Hampton, NY, (1994); the Frederick R. Weisman Museum of Art, Pepperdine University, Malibu, CA, (1993); and the Parrish Art Museum, Southampton, NY, (1988). Her work was represented in the 1989 Whitney Biennial, NY; the *10 + 10: Contemporary Soviet and American Painters*, originating at the Fort Worth Museum in 1989; the Art Museum of the Rhode Island School of Design in 1988; and *Paradise Lost; Paradise Regained*, at the American Pavillion of the Venice Biennale in 1984. Since 1981 she has had one-person shows regularly at the Edward Thorp Gallery in New York and is in numerous notable private collections.

Robert Gober by Craig Gholson. *BOMB #29, Fall 1989*

Robert Gober was born in Wallingford, Connecticut in 1954. He studied at Tyler School of Art, Rome, and received his B.A. from Middlebury College in 1976. His selected one-person exhibitions include: *Robert*

Gober, The Art Institute of Chicago (1988); Museum Boymans-van Beuningen, Rotterdam (1990); Galerie Nationale du Jeu de Paume, Paris (1991); Serpentine Gallery, London (1993); *Robert Gober*, Museum für Gegenwartskunst, Basel, Switzerland (1995); and the Museum for Contemporary Art, Los Angeles (1997). His selected group exhibitions include: *Views from Abroad 2: Perspectives on American Art 2*, the Whitney Museum of American Art (1996); *Playpen & Corpus Delirium*, Kunsthalle, Zurich (1996); and *Magritte*, Musée des Beaux-Arts, Montreal (1996). He has shown regularly with the Paula Cooper Gallery in New York and Daniel Weinberg in Los Angeles.

Craig Gholson (December 30, 1951–April 30, 1992) was a playwright and Associate Editor of *BOMB*. He founded and edited the music magazine *New York Rocker* and interviewed for *Interview*. His short fiction appeared in the *East Village Eye* and *BOMB*. His play, *Chaos in Order*, opened at BACA in Brooklyn and played in Los Angeles at Ensemble Studio Theater. A series of one acts, including *First Proof*, which was optioned by David Bowie, and *Full Tilt* about a young woman (performed by Galaxy Craze) obsessed with Janis Joplin, played off-Broadway. He had just completed a full length play, *The Mother*, before his death in 1992.

Emmet Gowin by Sally Gall. *BOMB #58, Winter 1997*
Born in Danville, Virginia in 1941, **Emmet Gowin** received a B.A. in Graphic Design from the Richmond Professional Institute in 1965. In 1967 he received an M.F.A. in photography from Rhode Island School of Design, where he studied with Harry Callahan. He has had exhibitions at the Museum of Modern Art, New York, with Robert Adams (1971) and at The Corcoran Gallery of Art, Washington, D.C., (1983). Gowin is Professor of Photography in the Council of the Humanities, Princeton University, and has been teaching in the Visual Arts Program since 1973. In 1990, a retrospective of his work, *Emmet Gowin/Photographs; This Vegetable Earth is but a Shadow*, was published by the Philadelphia Museum of Art. A recipient of a Guggenheim (1974) and two National Endowment for the Arts grants (1977 and 1979), he has also received awards from the Southeastern Center for Contemporary Art (1983); the Seattle Arts Commission (1980); the 1983 Governor's Award for Excellence in the Arts from the State of Pennsylvania; the 1992 Friends of Photography Peer Award; and a Pew Fellowship in the Arts for 1993-94. *Emmet Gowin/Photographs* was published by Knopf in 1976. His work is represented by PaceWildensteinMacGill Gallery in New York.

Dave Hickey by Saul Ostrow. *BOMB #51, Spring 1995*
Dave Hickey is a free-lance writer of fiction and cultural criticism. He has served as owner-director of A Clean Well-Lighted Place gallery in Austin, Texas, as director of the Reese Palley Gallery in New York City, as Executive Editor of *Art in America* magazine in New York City, and as Contributing Editor to *The Village Voice*. He has written for major American cultural publications including *Rolling Stone, Art News, Art in America, Artforum, Interview, Harper's, The New York Times*, and the *Los Angeles Times*. He has written numerous exhibition catalogue monographs on contemporary artists including: Ann Hamilton, Lari Pittman, Richard Serra, Robert Gober, Edward Ruscha, Terry Allen, Andy Warhol, Vija Celmins, Vernon Fisher, Luis Jimenez and Michaelangelo Pisteletto.

Hickey presently holds the position of Associate Professor of Art Criticism and Theory at the University of Nevada, Las Vegas, and serves as contributing editor to *Art issues* magazine and to *Parkett* magazine. He was the selected lecturer for The Preston H. Thomas Memorial Lecture Series on architecture theory at Cornell University in 1992; and in 1994, he received the Frank Jewett Mather Award for Distinction in Art or Architectural Criticism for the Year 1993, presented by the College Art Association. His latest book, *The Invisible Dragon; Four Essays on Beauty*, published by Art issues Press in 1993, is in its fourth printing; and his column "Simple Hearts," appears regularly in *Art Issues* magazine. His new book, *Air Guitar, Essays on Art and Democracy* was published this spring by Art Issues Press.

Saul Ostrow is an artist, critic, and organizer of exhibitions. Art Editor for *BOMB* magazine, Coeditor of Lusitania Books (publishing anthologies focusing on cultural issues) and the Editor of the book series

Critical Voices in Art, Theory and Culture, Ostrow's own writing has appeared in *Flashart International, ArtPress* (France), *Neue Bilde Kunst* (Germany), the *International Review of Art* (Columbia), *Arts Magazine, World Art* and the *New Art Examiner* (USA) as well as interviews for *BOMB* magazine. He has also written numerous exhibition catalogs.

Since 1987 he has curated over 40 exhibitions in the USA and Europe, half of which have dealt with abstract art, the rest with issues inherent in other forms of representation. He recently curated and wrote the catalogues for the exhibition *Painting All-Over: Again*, Zaragoza, Spain, and *Divergent Models* (for the Kunstverien in Wiesbaden, Germany). Since 1975, his own work has appeared in solo and group exhibitions in both the U.S. and Europe.

His teaching experience includes courses in Critical Theory and Art History at New York University, School of Visual Arts, and Parsons School of Design, as well as visiting Artist/Critic at Cranbrook Academy, Columbia University, Claremont Graduate School, Rhode Island School of Design, Hunter College, Ohio State University, Kent State, White Columns' Seminars in Theoretical Studies, University of Texas, San Antonio, University of Houston, and Rice University.

Roni Horn by Mimi Thompson. *BOMB #28, Summer 1989*

Roni Horn was born in New York in 1955. She received a B.F.A. from Rhode Island School of Design and an M.F.A. from Yale University. Her one-person exhibitions include: *You Are the Weather*, Fotomuseum Winterthur, Winterthur, Switzerland (1997); *Earth Grows Thick*, Wexner Center for the Arts, Columbus, Ohio (1996); Matthew Marks Gallery, New York (1994, 1995, 1996); Galerie Ghislaine Hussenot, Paris (1996); Jablonka Galerie, Cologne (1995); Sammlung Goetz, Munich (1995); and *Making Being Here Enough*, Kunsthalle, Basel (1995). Her selected group exhibitions include: *Elsewhere*, John Hansard Gallery, University of Southampton, Southampton, U.K. (1996); *In a Different Light*, University Art Museum, Berkeley, California (1995); *Word for Word*, Beaver College Art Gallery, Glenside, PA (1995); and *Das Americas*, Galeria Luisa Strina, Sao Paulo (1994). She has received three National Endowment for the Arts Artist's Fellowships and a Guggenheim Fellowship. She is represented by Matthew Marks Gallery.

Mimi Thompson was born in Schnectady, New York in 1954, and grew up in Kentucky, Massachusetts and suburban Connecticut. After graduating from Denison University, she moved to New York City and worked at many different places including several tatty restaurants, the Whitney Museum of American Art and the Leo Castelli Gallery. She has shown her paintings at the Wolff Gallery and the New Museum of Contemporary Art and writes for a disparate group of magazines: *BOMB, Town and Country,* and *Vanity Fair*, mostly on art-related topics.

Brice Marden by Saul Ostrow. *BOMB #22, Winter 1988*

Brice Marden was born in Bronxville, New York in 1938. He received his B.F.A. from Boston University of Fine and Applied Arts in 1961, and his M.F.A. from Yale University in 1963. He had his first solo exhibition in 1964 at the Wilcox Gallery of Swarthmore College. He was thirty-six when he was accorded a retrospective at the Guggenheim Museum in 1975. His most recent solo exhibitions were at Thomas Ammann Fine Art AG in Zurich, Switzerland, and at the Matthew Marks Gallery, New York. Marden's group shows include: *A Romantic Minimalism*, the Institute for Contemporary Art in Philadelphia (1967); *Modular Painting* at the Albright-Knox Gallery in Buffalo (1970); *The Structure of Color* at the Whitney Museum of American Art, New York (1971); the 1972 Documenta, Kassel; and *The Spiritual in Art: Abstract Painting 1890–1985*, the Museum of Contemporary Art, Los Angeles; the Museum of Contemporary Art, Chicago; and the Gemeentemuseum, The Hague, in 1986-87. Marden's most recent group exhibitions are the 1995 Whitney Museum of American Art Biennial, New York; *Painting—Singular Objects*, The National Museum of Modern Art, Tokyo; *ARS 95 Helsinki*, The Museum of Contemporary Art, Helsinki, Finland; and *About Place: Recent Art of the Americas*, The Art Institute of Chicago.

From 1969 to 1974, Marden served as an instructor at the School of Visual Arts in New York, and

prominent young artists such as Julian Schnabel and Elizabeth Murray have acknowledged his influence on their work. Marden's work is in the permanent collections of the Museum of Modern Art and the Whitney Museum of American Art, New York; the Walker Art Center, Minneapolis; the San Francisco Museum of Modern Art; the National Gallery of Canada, Ottawa; the Beaubourg Museum, Paris; the Stedelijk Museum, Amsterdam. Marden lives and works in New York City.

Catherine Murphy by Francine Prose. *BOMB* #53, Fall 1995

Catherine Murphy was born in 1946 in Cambridge, Massachusetts. She studied at the Skowhegan School of Painting and Sculpture in Maine and received a B.F.A. from Pratt Institute in 1967. Her most recent solo exhibitions include: Greenville County Museum of Art, North Carolina, and Lennon, Weinberg, Inc., New York. She has been in numerous group exhibitions which include: the Whitney Museum of American Art Annuals and Biennials, 1972, 1973, 1995; *American Still Life 1945–1983*, Contemporary Arts Museum, Houston, travelled 1983–89; *American Realism; 20th Century Drawings and Watercolors*, San Francisco Museum of Modern Art, travelled 1986–87; *American Realism and Figurative Art 1952–1991*, Miyaqui Museum of Art, Japan, travelled 1991–92; *New York Realism: Past and Present*, Tampa Museum of Art, Florida, travelled to Japan 1994–95; *Reality Bites*, Kemper Museum of Contemporary Art, Kansas City, 1996; and *Reality Check*, Nassau County Museum of Art, New York, 1997. She has received two grants from the National Endowment for the Arts, a Guggenheim Fellowship, an Ingram Merrill Foundation Grant, and an American Academy of Arts and Letters Award in Art.

Francine Prose is the author of nine novels, two short story collections, and most recently a collection of novellas, *Guided Tours of Hell*. Her stories and essays have appeared in *The New Yorker, The New York Times, Antaeus,* and other publications. The winner of a Guggenheim and Fulbright Fellowships, two NEA grants, and a PEN translation prize, she has taught at the Iowa Writers' Workshop, and the Bread Loaf and Sewanee Writers' Conferences. A film based on her novel, *Household Saints*, was released in 1993.

Guillermo Gomez-Peña and Coco Fusco by Anna Johnson. *BOMB* #42, Winter 1993

Born and raised in Mexico City, interdisciplinary artist/writer **Guillermo Gomez-Peña** came to the United States in 1978. Since then he has been exploring cross-cultural issues and North-South relations through performance, bilingual poetry, journalism, video, radio, and installation art.

He has contributed to the national radio magazines *Crossroads* (1987–1990) and *Latino USA*, and is contributing editor of *High Performance* magazine as well as *The Drama Review.* He is a 1991 recipient of the MacArthur Fellowship. *Warrior for Gringostroika*, a collection of his essays and performance texts, was recently published by Graywolf Press, and his second book, *The New World Border,* was released in 1996 by City Lights. A third book in collaboration with artist Enrique Chagoya entitled *Friendly Cannibals* will appear from Art Space Publishers, and the catalog for the exhibit *The Temple of Confessions* was published by PowerHouse Books in June 1997.

Coco Fusco is a New York-based writer and interdisciplinary artist. She has lectured, performed, exhibited, and curated programs throughout the U.S., Europe, Canada, South Africa, and Latin America. She is the author of *English is Broken Here: Notes on Cultural Fusion in the Americas* (The New Press, 1995). Her writings have appeared in *Art in America, The Village Voice,* the *Los Angeles Times, Ms., The Washington Post,* the *Nation,* and *Frieze*. Fusco's videos include *The Couple in the Cage* (1993) and *Pochonovela* (1995).

Fusco collaborated with Guillermo Gomez-Peña between 1989 and 1995. The projects include *Mexarcane* (1994–95), *The Year of the White Bear* (1992–93), *Two Undiscovered Amerindians Visit the West* (1992-94), *La Chavela Realty* (1991), and *Norte: Sur* (1990). Fusco's latest performance, "STUFF," commissioned by London's Institute of Contemporary Art, is a collaboration with Nao Bustamante that has been presented in Europe, the U.S., Australia, and New Zealand. Fusco is currently developing a site-specific installation for the 1997 Johannesburg Biennale.

Lari Pittman by David Pagel. *BOMB #34, Winter 1991*

Lari Pittman was born in 1952 and lives and works in Los Angeles. He studied at the University of California, Los Angeles, and received a B.F.A. from the California Institute of the Arts, Valencia, where he also received his M.F.A. Lari Pittman has shown extensively with Regen Projects and Rosamund Felson in Los Angeles and at Jay Gorney Modern Art in New York. A selection of his solo exhibitions include: the Los Angeles County Museum of Art (1996); *Lari Pittman: Works on paper, 1982–1995*, at The Armand Hammer Museum of Art and Cultural Center, Los Angeles (1996); *Lari Pittman: Code of Honor*, Newport Harbor Art Museum, Newport Beach, California (1982); and *Lari Pittman: Sunday Painting*, Los Angeles Contemporary Exhibition, Los Angeles, (1982). Pittman has been in numerous group shows throughout the U.S. and Europe, and has received three National Endowment for the Arts grants in painting. His work in the public collections of the Whitney Museum of American Art, the San Francisco Museum of Modern Art, Corcoran Museum of Art, Los Angeles County Museum of Art, and the Carnegie Museum of Art.

Born in Lexington, Kentucky in 1961, **David Pagel** grew up in Green Bay, Wisconsin. After receiving a B.A. from Stanford University, Pagel began a doctoral program in Art History at Harvard. More interested in art than history, he took an M.A., moved to Los Angeles, and has been making a living as a free-lance art critic ever since. Since 1991, he has written a biweekly art review column for the *Los Angeles Times*, and since 1988 has published many articles and reviews in international art magazines. In 1990, he received an Andrew W. Mellon Fellowship in Contemporary Arts Criticism. He is a contributing editor to *Art Issues* and *BOMB*, and is currently working on a book about contemporary art's ambitions—or lack thereof.

Richard Serra by David Seidner. *BOMB #42, Winter 1993*

Richard Serra received a B.A. from the University of California, Berkeley in 1961, and received his B.F.A. and M.F.A. from Yale University in 1964. His association with the Leo Castelli Gallery began in 1968 when he made a series of cast- and molten-lead pieces. In 1977, he exhibited drawings at Stedelijk Museum, Amsterdam, worked on *Berlin Block for Charlie Chaplin* for Nationalgalerie Berlin, and installed *Terminal* at Documenta 6. *Tilted Arc*, a sculpture commissioned by the federal government, was installed at Federal Plaza, New York in 1981, which was then destroyed by the federal government in 1989. In 1983, he had a one-man exhibition at Musée d'Art Moderne, Centre Georges Pompidou, Paris, and installed *Clara-Clara* in conjunction with the show. The Museum of Modern Art held a retrospective of his work in 1986. *Street Levels and Spiral Sections* for Documenta 8 was built in 1987. In 1990, he completed *Áfangar*, a large site-specific work on Videy Island, Reykjavik, Iceland, and in 1991, he received the Wilhelm-Lehmbruck Award for sculpture. In 1996, the first of the series of elliptical structures were bent at Beth Ship, Sparrows Point, Maryland. His selected one-person exhibitions include: Leo Castelli Warehouse (1969-70); *Richard Serra: Drawings 1971–77*, Stedelijk Museum, Amsterdam (1977-78); *Richard Serra*, Musée Nationale d'Art Moderne, Centre Georges Pompidou, Paris (1984); *Richard Serra: 7 Spaces—Seven Sculptures*, Lenbachhaus Stadtische Galerie, Munich (1987); *Richard Serra: 10 Sculptures for the Van Abbe*, Stedelijk Van Abbemuseum, Eindhoven, The Netherlands (1988); *Richard Serra: Tekeningen*, Bonnefantenmuseum, Maastricht, The Netherlands (1990); *The Sculpture: The Hours of the Day*, Kunsthaus Zurich (1990); *The Sculpture: Threats of Hell*, cape Musee d'Art Contemporain, Bordeaux (1990); *Richard Serra*, Museo Nacional Reina Sofia, Madrid (1992); *Running Arcs, for John Cage*, Kunstsammlung Nordrhein-Westfalen, Düsseldorf (1992); *Weight and Measure*, The Tate Gallery, London (1992); *Installation Drawings*, The Serpentine Gallery, London (1992); and *Props*, Wilhelm-Lehmbruck-Museum, Duisburg, Germany (1994).

Born in Los Angeles in 1957, **David Seidner** began exhibiting his photographs in 1978 at the age of twenty-one, two years after his first published magazine cover. For several years he was under exclusive contract to the house of Yves Saint Laurent. Seidner has exhibited widely in galleries and museums internationally. He has also written extensively on art for *French Vogue* and is a contributing editor to *BOMB*. He has recently completed his sixth book, a collection of portraits of artists published on the occasion of an exhi-

bition at the new contemporary photography museum, La Maison Européene de la Photographie in Paris. His other books include *David Seidner, Photographs* (1989) and *David Seidner NUDES* (1995). His most recent solo exhibitions include the Robert Miller Gallery, New York (1995) and Baumgartner Galleries, Washington, D.C. (1995). His work appears regularly in *Vanity Fair* and *The New York Times*.

Andres Serrano by Anna Blume. *BOMB #43, Spring 1993*

Andres Serrano was born in 1950 in New York City. He studied at the Brooklyn Museum Art School, New York, from 1967–69. His one-person shows include: *Andres Serrano: A History of Sex,* Paula Cooper Gallery, New York and Yvon Lambert Gallery, Paris (1997); *A History of Andres Serrano: A History of Sex,* Groninger Müseum, The Netherlands (1997); *Andres Serrano: Works 1983–1993,* which travelled to The New Museum of Contemporary Art, New York, Center for the Fine Arts, Miami, Contemporary Arts Museum, Houston, Museum of Contemporary Art, Chicago, and Malmo Konsthall, Sweden from 1995–96; *The Morgue,* Museum of Contemporary Art, Montreal (1994–95); and *Budapest,* Paula Cooper Gallery, New York (1994). His group exhibitions include: *Pursuit of the Sacred: Evocations of the Spiritual in Contemporary African-American Art,* The School of the Art Institute of Chicago (1997); *Absolute Landscape-Between Illusion and Reality* Yokohama Museum, Yokohama, Japan (1997); *Black and Blue: Eight American Photographers,* Groninger Müseum, The Netherlands (1996); and *The Dead,* National Museum of Photography, Film and Television, Pictureville, Bradford, West Yorkshire, England (1995–96). In 1986 he received a National Endowment for the Arts Grant. He is represented by Paula Cooper Gallery, New York.

Anna Blume was born December 4, 1958 in Los Angeles, California. She received her B.A. in English and Art History at Williams College and her Ph.D. in Art History at Yale University. From 1987 to 1990, she received a Fulbright Grant for research on the importation of images of saints into Indian communities in the highlands of Guatemala. Her doctoral thesis, entitled "The Afterlife of Images," was completed in February of 1997. Over the last seven years, she has lived in New York City and has most recently worked on the Plains Indian drawing exhibition at The Drawing Center, for which she wrote an essay for the exhibition catalog entitled, "In a Place of Writing." From 1992 to 1996, she worked on a National Institute of Health grant, documenting the effects of HIV disease on children at Kings County Hospital in Brooklyn. She currently lives in New York City and is working on a book of interviews with the artist Zoe Leonard.

Kiki Smith by Chuck Close. *BOMB #49, Fall 1994*

Kiki Smith was born in Nuremberg, Germany in 1954. Her one-person exhibitions include: Musée des Beaux-Arts, Montreal (1996–97); "Photographs," PaceWildensteinMacGill, New York (1996); *Works 1988–1995,* St. Petri-Kuratorium, Lüebeck, Germany (1996); *New Sculpture,* PaceWildenstein, New York (1995); *Photography,* PaceWildensteinMacGill, Los Angeles (1995); and *Sculpture & Drawings,* Anthony d'Offay Gallery, London (1995). Her group exhibitions include: *Everything That's Interesting Is New: The Dakis Joannou Collection,* DESTE Foundation, Athens, Greece, which travelled to the Museum of Modern Art, Copenhagen, and the Guggenheim Museum, SoHo, New York (1996–97); *The Human Body in Contemporary American Sculpture,* Gagosian Gallery, New York (1996); and *Art Works: the Paine Webber Collection of Contemporary Masters,* Museum of Fine Arts, Houston, Texas, which travelled to Detroit Institute of Arts, Detroit; Michigan, Museum of Fine Arts, Boston, Massachusetts; Minneapolis Institute of Arts, Minneapolis, Minnesota, San Diego Museum of Art, San Diego, California and Center for the Arts, Miami, Florida (1995–97). Her work is in the public collections of the Fogg Art Museum, Yale University Art Gallery, the Museum of Modern Art, the Tate Gallery, the Whitney Museum of American Art, and the Art Institute of Chicago.

Born in Monroe, Washington in 1940, painter Chuck Close was educated at the University of Washington, Seattle, the Yale University School of Art and Architecture, and the Akademie der Bildenden Kunste, Vienna. He has had solo exhibitions at the Museum of Modern Art, New York; the Art Institute of Chicago; the Los Angeles County Museum of Art; the San Francisco Museum of Art; the Centre

Georges Pompidou, Paris; and the Contemporary Arts Museum, Houston. A retrospective, *Close Portraits,* originated at the Walker Art Center, Minneapolis, and travelled to the Museum of Contemporary Art, Chicago, the St. Louis Museum; and the Whitney Museum of American Art, New York from 1980–81. A retrospective originating at the Kunsthalle Baden-Baden toured Europe in 1994. A major retrospective will open at the Museum of Modern Art, New York in the spring of 1998, which will tour the United States.

Chuck Close's paintings are represented in major museum collections around the world. Awarded the Skowhegan Arts Medal in 1991, Chuck Close has also received the Infinity Award from the International Center for Photography in 1990 and the Academy-Institute Art Award of the Academy of Arts and Letters in 1991, and was elected member of the Academy of Arts and Letters in 1992. He has received numerous honorary doctorates, most recently from Yale University in 1996.

Larry Sultan by Catherine Liu. *BOMB #31, Spring 1990*
Larry Sultan was born in Brooklyn, New York in 1946. He received a B.A. in political science from the University of California in 1968, and an M.F.A. in photography at the San Francisco Art Institute in 1973. He has had one-person exhibitions at the San Francisco Museum of Modern Art (1977); Fogg Art Museum (1978); Los Angeles Institute of Contemporary Art (1978); Chicago Museum of Contemporary Art (1979); University Art Museum, Berkeley, California (1983); Stephen Writz Gallery, San Francisco (1992); San Jose Museum of Art (1992); Janet Borden Gallery, New York (1989/1993); Corcoran Museum of Art, Washington D.C. (1994); Chicago Cultural Arts Center (1994); Manchester Craftsman Guild, Pittsburgh, Pennsylvania (1994); San Diego Museum of Contemporary Art (1994); and the Queens Museum, New York (1996). Between 1973 and 1993, he created over twenty-five billboard and kiosk projects with Mike Mandel. His other public projects include an Artist in Print Project, *Have you Seen Me?* images and text by and/or about children distributed on 750,000 milk cartons and 250,000 grocery bags and cartons in collaboration with Kelly Sultan. He has received a Guggenheim Fellowship and Individual Artists Fellowships from the National Endowment for the Arts. Sultan is Professor of Art and Chair of the Photography Department at the California College of Arts and Crafts.

Catherine Liu is an assistant professor in the Department of French and Italian at the University of Minnesota, Twin Cities. At present she is working on various projects having to do with telecommunications, psychoanalysis and deconstruction. This year she will publish her first novel, *Oriental Girls Desire Romance*, with Kaya Press, New York. She is also completing an academic book, *Copying Machines: Taking Notes for the Automaton.*

Over the past decade, Liu has been active as both an art critic and curator. She continues to be interested in the relationship between contemporary theory and contemporary art practice. She publishes regularly in art magazines such as *Flash Art* and *Artforum*. She has also curated a number of exhibitions, including *Plastic Fantastic Lover (object a),* at BlumHelman Warehouse in New York. In 1992, she edited a special issue of *Lusitania* called "The Abject, America" that included the work of theorists as well as special projects by contemporary artists.

Philip Taaffe by Shirley Kaneda. *BOMB #35, Spring 1991*
Philip Taaffe was born in Elizabeth, New Jersey in 1955 and studied at the Cooper Union in New York. His first solo exhibition was at the Roger Litz Gallery in New York in 1982, followed by one-person exhibitions at Galerie Ascan Crone, Hamburg (1984); Pat Hearn Gallery, New York (1985, 1986, and 1987); Galerie Lucio Amelio, Naples (1988); Mary Boone Gallery, New York (1989); Galerie Samia Saouma, Paris (1990); Galerie Max Hetzler, Cologne (1991); Gagosian Gallery, New York (1991 and 1994); the Center for Fine Arts, Miami (1991); Galerie Max Hetzler, Berlin (1994 and 1996); the Vienna Secession (1996); and Gagosian Gallery, Los Angeles (1997). He has travelled widely in the Middle East, India, North Africa, and South America. His work is in the permanent collection of the Museum of Modern Art, New York, and has been exhibited in numerous museum exhibitions including Carnegie International, the Hayward Gallery, and two Whitney Biennials. In 1990, his work was the subject of an extensive critical

study in *Parkett* no. 26 (Zurich and New York). He lived and worked in Naples from 1989–91, and currently resides in New York City.

Shirley Kaneda is an abstract painter living and working in New York City. She has had numerous solo exhibitions in the United States as well as in Europe since 1992. She has also been included in group exhibitions in the U.S. and abroad. Most recently, she was included in a show at List Visual Arts Center at M.I.T., called *Face to Face: Recent Abstract Paintings.* She also cocurated an abstract painting show for the Contemporary Art Museum at the University of South Florida in Tampa in 1995 called *RE:FAB,* which travelled to Miami Dade College and Vermont College.

Kaneda began publishing her writing in 1989, which included critical reviews and a theoretical article on the feminine aspects of abstract painting titled "Painting and Its Other; In the Realm of the Feminine" in *ARTS Magazine.* Based on this article, she curated a show for Sandra Gering Gallery in New York in 1991. She has conducted interviews for *BOMB* magazine since 1991 with other abstract painters such as Philip Taaffe, Jonathan Lasker, and Valerie Jaudon. In addition, Kaneda has been a visiting artist at Yale University, Claremont Graduate Center, Rhode Island School of Design, University of New Mexico, and Cranbrook Academy among others. She has also taught at New York University and School of Visual Arts.

She has been the recipient of the National Endowment of the Arts Regional Fellowship/Mid-Atlantic Arts Foundation Grant in 1996 as well as a Pollock Krasner Foundation Grant in 1997.

Jack Whitten by Kenneth Goldsmith. *BOMB #48, Summer 1994*

Jack Whitten was born in Bessemer, Alabama on December 5, 1939. Originally a premed student at Tuskegee University, after two years he moved to Southern University in Baton Rouge, Louisiana to study art. Student strikes closed the university and inspired a large-scale protest throughout Baton Rouge. Determined to stay in school, Whitten took a Greyhound bus to New York City where he completed his studies at Cooper Union. His education there was supplemented by frequent visits to the Cedar Bar, where he met Willem De Kooning and Franz Kline. In early 1962, he met Romare Bearden, Jacob Lawrence, and Norman Lewis. He had two solo shows with Allan Stone, his first art dealer, in 1968 and 1970. His first museum show was at the Whitney Museum of American Art in 1974. In 1975, Henry Geldzahler, curator at the Metropolitan Museum, selected *Delta Group II* for the Museum's collection. After a solo exhibition at the Robert Miller Gallery in 1976, the Museum of Modern Art chose *Kappa I* for their collection. He has had one-person exhibitions at The Studio Museum in Harlem and at the Newark Museum, both of which have selected works for their permanent collections.

Since graduating from Cooper Union in 1964, he has received the John H. Whitney Fellowship (1964); National Endowment for the Arts Grant (1973); Xerox Corporation Grant in Xerography (1974); CAPS Award (1975); Solomon R. Guggenheim Fellowship (1976); Sambuca Romana Contemporary Fellowship (1984); Joan Mitchell Foundation Grant (1995). His most recent solo exhibition was in 1996 at the G. R. N'Namdi Gallery, Chicago, Illinois.

Whitten has lived in New York City since 1960, and summers in Crete, Greece.

Kenneth Goldsmith is an artist and writer. He was born in 1961 in Freeport, New York. He received his B.F.A. in sculpture from Rhode Island School of Design in 1984. He is represented by Bravin Post Lee Gallery, where he has had one-person exhibitions in 1994, 1995, and 1997. His group exhibitions include *Limited Edition Artist Books Since 1990,* Brooke Alexander, New York (1997); *Too Jewish? Challenging Traditional Identities,* The Jewish Museum, New York (1996); *Collaborations Between Artists and Writers,* Deutches Haus, Columbia University, New York (1995); *Construction In Process IV: My Home is Your Home,* The Artist's Museum, Lodz, Poland (1993); *In The Spirit of Fluxus,* Gallery 400, University of Illinois, Chicago (1993); and *Selections/Winter 1993,* The Drawing Center, New York (1993). He is the

author of *73 Poems* (Permanent Press, compact disc Lovely Music, Ltd., 1993) and *No. 111 2.7.96-19.20.96* (The Figures, 1997). He is also a DJ at freeform radio WFMU 91.1. He lives in New York City with painter/video artist Cheryl Donegan.

Sue Williams by Nancy Spero. *BOMB #42, Winter 1993*

Sue Williams was born in Chicago Heights, Illinois in 1954, and received her B.F.A. from the California Institute of the Arts. Her most recent exhibitions include: the Centre d'Art Contemporain, Geneva (1997); 303 Gallery, New York (1996); Galerie Ghislaine Hussenot, Paris (1996); Jean Bernier Gallery, Athens (1996); Regen Projects, Los Angeles (1996); and Modulo Gallery, Lisbon, Portugal (1996). Her most recent group exhibitions include: *Ideal Standard Life,* at Spiral Wacoal Art Center, Tokyo (1996); *Sue Williams and Wiebke Siem,* Johnen & Schottle, Koln, Germany (1996); *The Comic Depiction of Sex in American Art,* Galerie Andreas Binder, Munich, Germany (1996); *Comic Inspirations,* Adam Baumgold Fine Art and Simon Capstick-Dale Fine Art, New York (1996); *Nudo and Crudo,* Claudia Gian Ferrari Arte Comptemporanea, Milan (1995); and the Whitney Museum of American Art Biennial, New York (1995).

Nancy Spero was born in Cleveland, Ohio, August 24, 1926. She resides and works in New York City. Spero received her B.F.A. at the Chicago Art Institute in 1949, and studied at Atelier Andre L'Hote and Ecole des Beaux-Arts, Paris, 1949–50. Her husband, Leon Golub, the painter, has characterized her publicly as a radical feminist and an avant-garde grandmother.

Selected installations since 1994 include: *Installation der Erinnerung;* permanent installation, Heeresspital Innsbruck, Tyrol, (1996); *Sacred and Profane II,* banner installation for *Leon Golub and Nancy Spero,* Third Hiroshima Art Prize, Hiroshima City Museum of Contemporary Art, Japan; *Raise/Time* Arthur M. Sackler Museum, Harvard University Art Museums, Cambridge, Massachusetts, 1995; and *Feminin-Masculin, Le Sexe de l'Art,* Centre Georges Pompidou, Paris, 1995.

Selected solo exhibitions since 1994 include simultaneous three venue exhibitions: *The Black and the Red III,* P.P.O.W., New York; *Sheela at Home,* Jack Tilton Gallery, New York; *A Cycle in Time,* and her installation *Rehearsal* at New York Kunsthalle (1996); and *Nancy Spero,* Barbara Gorss Galerie, Munich (1995); *The First Language,* and *The Black and The Red,* Malmö Konsthal, Sweden.

Nancy Spero, a comprehensive survey of her work, was recently published by Phaidon Press Limited, London.

Lawrence Weiner by Marjorie Welish. *BOMB # 54, Winter 1996*

Lawrence Weiner was born February 10, 1942 in the Bronx, New York. He attended the New York City public school system. The late fifties and early sixties were spent in travel throughout North America (U.S.A., Mexico, and Canada). The first presentation of his work was in Mill Valley, California in 1960. He has since returned to New York where he continues to live, as well as dividing his time with his boat in Amsterdam. He has continued to participate in exhibitions both public and private in both the old and new world, maintaining that art is the empirical fact of the relationship of objects to objects, in relation to human beings and not dependent upon historical precedent for either use or legitimacy.

Marjorie Welish was born, raised, and is currently living in New York. She began writing art criticism while in college studying art history and literature at Columbia University. She has had articles published in *Art Criticism, Artsmagazine, Partisan Review*, and *Salmagundi*, among others, with focus on the generation of "respondents" to the New York School that includes Robert Rauschenberg, Jasper Johns, and Cy Twombly, Donald Judd and Sol Lewitt.

A poet and artist, Marjorie Welish has four books of poems, the most recent being *The Windows Flew Open* (1991), and *Casting Sequences* (1993). She has received grants from the Fund for Poetry and the New York Foundation for the Arts.

The Whitney Museum Arts Resources Center presented the first one-person exhibition of Welish's paintings in 1975. Since, she has shown at Donahue/Sosinski in New York; Herter Gallery, University of Massachusetts, Amherst; Ben Shahn Galleries, William Patterson College, and elsewhere. She received a Pollack-Krasner Foundation grant for 1997.